Vincent van Gogh
Christianity versus Nature

OCULI

Studies in the Arts of the Low Countries

Series Editors:

Bert W. Meijer
*Istituto Universitario Olandese
di Storia dell'Arte, Firenze*

Rob Ruurs
University of Amsterdam

Volume 3

VINCENT VAN GOGH
CHRISTIANITY
VERSUS NATURE

Tsukasa Kōdera

John Benjamins Publishing Company

Amsterdam/Philadelphia

1990

Illustration on dust cover:
Vincent van Gogh, *The Starry Night* (1889).
Oil on canvas, 73.7 x 92.1 cm.
Collection, The Museum of Modern Art, New York. Acquired through the Lillie P. Bliss Bequest.
Photograph © 1989 The Museum of Modern Art, New York.

Cover design: Françoise Berserik

Library of Congress Cataloging in Publication Data

Kōdera, Tsukasa.
 Vincent van Gogh : Christianity versus nature / Tsukasa Kōdera.
 p. cm. -- (Oculi : studies in the arts of the low countries : v. 3)
Revision of thesis (Ph.D.) -- University of Amsterdam, 1988.
Includes bibliographical references.
1. Gogh, Vincent van, 1853-1890 -- Religion. 2. Nature -- Religious aspects -- Christianity. 3. Nature (Aesthetics) I. Title. II. Series: Oculi ; v. 3.
ND653.G7K64 1990
759.9492 -- dc20 89-18335
ISBN 90 272 5333 1 (Eur.)/1-55619-076-X (US) (alk. paper) CIP

For Kuniko Ukai

Contents

Foreword

This book is a revised version of my doctoral dissertation which was submitted to the University of Amsterdam in 1988. Some chapters of the dissertation were first published as articles (see bibliography). They were later revised and supplemented with new documentary material and bibliographic references.

Even the most individual scholarly work turns out to be a social enterprise and I am now conscious of the magnitude of personal help and institutional support received along the way. First of all, I would like to thank my supervisor, Professor Evert van Uitert. He first stimulated my interest in the iconological approach to Van Gogh's works and later offered me invaluable suggestions and generous help. The late Professor H.L.C. Jaffé, supervisor of my M.A. thesis, encouraged me to continue my work on Van Gogh. Without their help this book would never have been written.

I am extremely grateful to the Vincent van Gogh Foundation and to the staff of the Rijksmuseum Vincent van Gogh. They created a pleasant atmosphere in which to work and offered me invaluable assistance on many occasions. I would like to single out a number of people by name for special mention. Ronald de Leeuw, Director of the museum, and Han van Crimpen and Louis van Tilborgh, Curators, allowed me access to the paintings, drawings and various documents. Fieke Pabst, the museum's documentalist, always seemed to understand my research and to anticipate my needs as regards information essential to my subject. Lily Couvée-Jampoller, former librarian of the museum, and Anita Vriend, the present librarian, were enormously helpful during respectively the earliest and the last phase of my research. The staff of the Netherlands Institute for Art History (RKD) in The Hague, and in particular Martha Op de Coul and Hans Kraan, were instrumental in broadening my knowledge of the

œuvre of the painters mentioned in Van Gogh's letters.

Many scholars have offered me help and advice. In his long letters Dr. Jan Hulsker shared his great erudition with me regarding various aspects of Van Gogh's works. Dr. V. Jirat-Wasiutyński very kindly read my articles and gave me specific criticism concerning Van Gogh's exchange of works with Gauguin. Professor G.J. Hoenderdaal and A. Verkade-Bruining assisted me in the areas of theology and the hymnal during Van Gogh's era. Professors R.W. Scheller, E. van de Wetering and Dr. Jochen Becker read my dissertation and kindly pointed out mistakes and shortcomings. Andrea Gasten edited the manuscript with scrupulous care and patience and gave me numerous suggestions for the improvement of the text.

I am enormously grateful to Professors Shigenobu Kimura, Shigebumi Tsuji and Eiko Wakayama for their encouragement and support since I was an undergraduate student at Osaka University.

I would further like to record my special gratitude to a number of the many other scholars to whom I am enormously indebted. Professor Ronald Pickvance guided me around many a pitfall with his great erudition and connoisseurship. Professor Shūji Takashina's writings first introduced me, along with many other Japanese art historians of my generation, to art history in general and to Van Gogh studies in particular. I also owe a great debt of gratitude to professors John Rewald, Mark Roskill, Chūji Ikegami and Bogomila Welsh-Ovcharov, Dr. Roland Dorn, John Sillevis, Annet Tellegen and Artemis Karagheusian.

The Netherlands Ministry of Education and Sciences, the Rotary Foundation and the Kajima Foundation for the Arts offered financial assistance in support of my research.

I owe a debt of gratitude to the publisher of this edition, John Benjamins, and to the series editors of Oculi, Bert W. Meijer and Rob Ruurs.

Finally, I would like to thank my parents for their infinite patience and support throughout the years.

Hiroshima, February 1989.

Abbreviations

F : J.B. de la Faille, *The works of Vincent van Gogh, his paintings and drawings*, Amsterdam 1970.

JH: Jan Hulsker, *Van Gogh en zijn weg*, Amsterdam 1977. (English translation: *The complete Van Gogh*, New York 1980)

Letter: *Verzamelde brieven van Vincent van Gogh*, Amsterdam & Antwerp 1974. The numbers following the quotations are from this edition. (English translation: *The complete letters of Vincent van Gogh*, New York 1953.)

Introduction

Study of the thematics in the œuvre

In his article "Les isolés: Vincent van Gogh" published in January 1890, Albert Aurier signalized the existence of persistent basic motifs or "idées fixes" under the naturalistic appearance of Van Gogh's works.

"If one refuses, in fact, to recognize the existence of those idealistic tendencies under the naturalistic art, a large part of the œuvre which we are studying would remain incomprehensible. How should we explain, for example, *The Sower* ..., if we do not want to think of this *idée fixe* which obsesses his mind with the actual necessity of the arrival of a man, of a Messiah. ... And also the obsessive passion for the sun disk, which he likes to make shining in his burning sky and, at the same time, for the other sun, for the vegetal sun, the gorgeous sunflower, ... how should we explain it, if we refuse to recognize his persistent preoccupation with the somewhat vague and glorious heliomythical allegory?"[1]

Since the appearance of Aurier's article, numerous critics and scholars have discussed the idiosyncrasies in Van Gogh's symbolism; some of them stressed the importance of viewing Van Gogh's œuvre in its entirety. Maurice Beaubourg wrote in his obituary of Van Gogh: "One must not see only one work of Mr. Vincent van-Gogh [sic]; one must see all, to understand this complex and agitated nature..."[2] Karl Jaspers, in his *Strindberg und Van Gogh*, published in 1926, analyzed Van Gogh's mental disease and discussed with more lucidity what Aurier and Beaubourg had vaguely recognized. "His (Van Gogh's) personality, activity, ethos, existence and artistic creativity must be understood as a complex unity to an extraordinary degree. An isolated contemplation of his works of art, much less a few of them, will hardly lead toward an understanding of the very

meaning of this art. ... Perhaps not a single painting of Van Gogh is absolutely perfect and complete in itself. ... He simply wants to paint present actuality; in return he conceives this presence as a mythos; by emphasizing the reality he sees it transcendentally."[3] Jaspers stressed the fragmentary character of Van Gogh's individual works and the importance of interpreting Van Gogh's works and existence as a coherent entity.

The aim of the present study is to show the significance of Van Gogh's principal themes and motifs in the thematic structure of his entire œuvre. But how can we approach the "thematics" — that is, the coherent thematic structure — of a painter's œuvre?[4] Since Aurier, numerous critics, iconologists, psychologists and psychoanalysts have attempted to interpret Van Gogh's themes and motifs, using literary and pictorial sources, biographical and historical data, psychological and psychoanalytic theories, to say nothing of Van Gogh's own writings and works. The number of motifs interpreted so far has become quite extensive; most of the principal motifs, especially those described in the letters, seem to have been interpreted, although the reliability of those interpretations is another matter. However, we cannot approach the problem of the thematics of Van Gogh's œuvre simply by accumulating interpretations of individual motifs or individual works.

In his *Michelet par lui-même*, Roland Barthes analyzed the thematics in the œuvre of the French historian, who incidentally was one of Van Gogh's most favorite writers, and showed how the structure of Michelet's existence could be read in his thematic network.[5] Michelet's basic themes recur throughout his entire works like themes in a symphony and, therefore, we should not read Michelet's text in a linear fashion but as a polyphony in order to understand the substantial, personal meaning of his themes. Michelet's basic themes have two roots, namely, historical and existential roots, and the repetition of the descriptions of certain historical events (such as the conflict betweeen the Guelph and the Ghibellines) in Michelet's works is the expression of an existential choice. Therefore, a reading of Michelet's text first becomes complete when one recognizes these basic themes, which occur in various elliptical forms, their personal meanings, their relation to other themes and reduces them to certain groups of themes. Barthes concludes that Michelet's thematics should be decoded with the aid of a code book, which is the structure itself of his œuvre.

It is not without reason that I have mentioned the analysis of historical writings, in particular Michelet's works, and not of literary or poetical works. In contrast to poets or writers of fiction, an historians' work is bound by historical facts. However imaginative he may be, he must comply with this restriction while writing. This is to some extent comparable to the painters who set themselves the task of working after nature. Just like Michelet's existence reveals

itself in the form of historical narrative discourse, or under the restriction of historical facts, the existence of such painters can be expressed in principle in the form of the represention of visible objects within a coherent "realistic" pictorial space. Although *Michelet par lui-même* is not a historical study, as the author himself admits, nor is it directly applicable to the thematic aspects of a painted œuvre, it does offer a model for the study of the thematic structure thereof.

Van Gogh's works not only require such an approach but also provide many favorable conditions for a study of the œuvre as an entity. A large and important portion of Van Gogh's works were preserved by Theo and his offspring. The painter's extensive correspondence gives us a detailed account of his life, personal meanings of motifs, his creative processes, and lost or destroyed works. Nevertheless, the thematics — not individual basic themes — of his œuvre has never been studied systematically. The main reasons for this and the obstacles presented by such a study to art historians can be summarized as follows.

Firstly, we do not know, strictly speaking, the entire œuvre of any painter. We do not know how many works were made during the painter's lifetime, how many have been lost or were destroyed and how many remain unknown to art historians. In the study of a painter's œuvre, the incompleteness and the possible limitations caused by this incompleteness must be accepted and always be taken into consideration when drawing any conclusions. In addition, for a study of the œuvre, it is necessary that the basic research into the works — authenticity, dating, identification of motifs etc. — has been done to a considerable extent and that a relatively high percentage of the painter's artistic output be known. However, a study of the thematic structure of the œuvre does not necessarily require quantitative completeness. Of course, it is ideal to have more than 80 or 90 percent of all the works made by the painter, but with only a half, one third, or even one fourth of all the works we would be able to elucidate some of the thematic characteristics. One might say that any discoveries of unknown works could change the conclusions drawn from the incomplete œuvre, but such a hypothetical character is absolutely not specific for the study of thematics. The authentication, the attribution and even the dating of paintings are also subject to possible change by new discoveries.

Secondly, effective methods for a thematic interpretation of the œuvre have not yet been established. The iconological approach remains quite effective, and methodologically it does form a basis for the present study together with the *Motivkunde* developed by some German scholars and the "Romantic Iconography" advocated by Jan Białostocki, both of which might be called applications of iconological principles to nineteenth- or twentieth-century paintings.[6] Iconological investigations have already been undertaken into the work of Van Gogh as well as many other nineteenth-century painters.[7] Iconologists have

interpreted the meaning of one or more motifs in a painter's œuvre or in a certain historical period, using as their material the literary or pictorial sources of the painter, writings by the painter himself or by his contemporaries and so on. It is possible to extend such a study quantitatively, from one motif to ten or even most of the motifs in a painter's œuvre, but however extensive it may be, it should not be called a study of the thematics, for it is not concerned with the thematic structure of a painter's œuvre.

The same is true for psychological and psychoanalytical studies. Apart from the lack of a systematic approach to the thematics, there is another reason why I do not share their standpoint. In the 1960s and also 1970s several psychological and psychoanalytical studies on Van Gogh were published and were even welcomed, at least temporarily.[8] Although I do not reject all the interpretations of Van Gogh's motifs by psychologists and psychoanalysts, they were often following ready-made, schematic or Freudian patterns of interpretation, and as a result many of their interpretations were not sufficiently convincing; some of them seemed implausible or even unbelievable to Van Gogh scholars. Psychologists and especially psychoanalysts often have patterns of interpretation which determine their interpretations of specific works and they tend to apply them too readily when they find the works which fit the patterns in their repertory. In other words, their interpretations are imposed from without. They are decoding Van Gogh's motifs, as it were, with an all-round code book which is applicable to a wide range of creative activities. Since psychoanalytic interpretative patterns are widely known today and little specialized knowledge is used in their decoding process, their interpretations are sometimes more appealing to the public than those by art historians. But it is undeniable that they often misread or overinterpreted by using their all-round code book. Although psychological factors cannot be totally excluded from a study of Van Gogh's motifs and themes, as a layman, I will not take this approach, nor will I employ psychoanalytic interpretative patterns.

An attempt at a comprehensive interpretation of the motifs in a painter's entire œuvre was made in Helmut Börsch-Supan's study of Friedrich.[9] Börsch-Supan was probably the first to try to interpret all of the major motifs in a painter's œuvre. He insisted on the importance of looking at the entire œuvre in order to decipher Friedrich's symbolism and he did analyze some combinations of motifs. Although his approach is still an extension of iconographical research and not a study of the thematics, it can be considered as a pioneering work in this field. Börsch-Supan's approach, however, contains a misconception about Romantic iconography. Extensive iconographical study is in itself an important task, which I also wish to undertake in the present study, but Börsch-Supan, trying to overcome the difficulties of Romantic iconography, compiled a kind of

dictionary or code book with which Friedrich's symbolic language was to be decoded. As some of the reviewers pointed out, this is a misreading of Romantic iconography.[10] Moreover, in trying to make the code book as complete as possible, to give static, conceptual meanings to almost every motif in Friedrich's œuvre, Börch-Supan could not always adequately support his interpretations of all those motifs. For iconological interpretations it is always necessary to verify whether a certain traditional meaning can be applied to the motifs to be interpreted. This verification process is insufficient in Börsch-Supan's study. When I apply traditional — often Christian or emblematic — meanings to the interpretation of Van Gogh's motifs, I try to verify them not only by Van Gogh's accounts in the letters but also by the way the motifs occur in his individual works as well as in his entire œuvre.

As noted above, the thematics in a painter's œuvre cannot be studied only by accumulating iconological interpretations of individual motifs. In addition to iconological research and an extensive inventory of motifs such as Börsch-Supan made, combinations, manipulations, transformations, frequency of occurrence and thematic functions of motifs should be analyzed and interpreted within the framework of the œuvre. On the basis of Van Gogh's letters and pictorial as well as literary sources, iconologists have attempted to interpret many of Van Gogh's basic motifs such as sunflowers, the starry sky, the sower and the cypress. They occasionally paid attention to combinations of motifs in their interpretation of individual motifs, but various forms of relationships among the motifs and the significance of the relationships themselves have never been studied systematically. Even if it is difficult to give a convincing interpretation of some individual motifs, we may be able to give clear explanations of their relationships. It is in the thematic structure of the œuvre that we should be able to find and verify the significance and meaning of individual motifs and seek the expression of the painter's existence.

Methodological problems

First of all, I wish to give definitions of the terms which are often used in this study. These definitions are by no means different from the common use of these terms, but their meanings need to be confirmed in order to avoid possible confusion or misunderstanding. The term "œuvre" is used here in the meaning of the entire body of work left by a painter. I have included all the paintings, drawings and even the rough sketches in Van Gogh's letters which are known today, and in some cases I have taken into account lost works which are known only from descriptions in the letters. Since the present study is concerned with

the thematic aspects of the œuvre, all the works are in principle given equal treatment without taking into consideration the esthetic quality of the work, the importance attached to it by the painter himself, differences in medium and so on. This is for the simple reason that a tiny rough sketch can sometimes reveal the painter's idea as well or better than full-scale masterpieces. Series and œuvres which were intentionally conceived by the painter are also treated in this study, since they of course form an important part of the entire œuvre. I have however concentrated especially on the thematic aspects of the œuvre which were not clearly recognized or explained by the painter himself and which up till now have escaped the attention of art historians or psychologists.[11]

"Thematics" is used in the sense of a coherent structure of themes and motifs in the œuvre. The œuvre of a painter is a purely quantitative whole of his entire artistic production, while thematics can be understood as a qualitative entity which has its own system and structure. With the term "motif" I mean the minimum recognizable entity of a form within the pictorial space such as the representation of a real object or, in some cases, an imaginary object. Of course, this definition is not valid for abstract paintings, but in Van Gogh's case this definition of the term motif does not seem to cause any serious problems. The concept "theme" has a more abstract character. It is a unit of meaning or of a complex of meanings, and one theme can consist of a single motif or, more often, of a group of motifs. For example, the "harvest" theme consists of a wheat field, sheaves of wheat and a reaper, or a vineyard and a group of peasants.

Van Gogh's motifs and themes have two principal sources: natural and artistic. Natural sources include the visible world: landscapes, objects or figures in the environment of a painter. Since Van Gogh, who painted before the birth of the abstract art, composed his works by depicting natural objects and worked in principle after nature, visible reality was an extensive and principal source for the painter. Therefore, the natural sources were extremely essential to the creative process of Van Gogh's works. Occasionally painters depict natural objects from memory or the imagination. Indeed, some of Van Gogh's motifs such as small figures and the sun were often depicted without models, and such motifs do play a significant role in his works. In the case of Van Gogh the sources of such "imaginary motifs" can most often be traced to natural sources.

Artistic sources are works by other artists; in Van Gogh's case mainly literary and pictorial sources. Recent studies of these sources have shown how Van Gogh borrowed motifs from other artists and learned modes of seeing fragments of nature. To mention just a few of the major artistic sources: English prints, Victorian novels, Impressionist paintings, French Naturalist novels, Japanese prints, paintings of The Hague school and so on.[12] Thus, natural sources offer

the painter extensive motifs, and artistic sources give him motifs as well as various modes of treating them. Natural sources can be identified through topographical investigation of landscapes and by identification of the objects or figures represented. Artistic sources can be found by identifying pictorial sources or by listing the works of art and literature which were known to the painter. Art historians have made a study of these sources with respect to almost every major painter, and the methodology of approaching these two sources has been established to a considerable degree.

Natural and artistic sources are quite extensive, and both their inspiration and limitations greatly influenced Van Gogh's choice of motifs. But these two sources do not always satisfy the painter's need to express what he wishes. When he feels that his present repertory of themes and motifs is not sufficient, he must alter them or even invent new ones. Moreover, it is the painter who chooses or ignores certain motifs which are available in his environment or in his collection of prints.[13] When he set up his easel or sat down with a sketchbook on a certain spot, he chose one motif or a group of motifs among innumerable possibilities.

Although Van Gogh's choice of motifs was most often determined by his surroundings, he occasionally used imaginary motifs, which he could not see in actual scenes. In the following chapters I will show examples of such imaginary motifs. In addition to incidental imaginary motifs, there are some habitual imaginary motifs which the painter could easily add to or manipulate within the pictorial space. In landscapes and interior scenes, very small figures were in most cases depicted without models; neither were they based on his earlier study drawings. In several paintings and drawings, we can find small figures and objects which were added after the whole scene was nearly completed. As I will show in Chapter 2, the sun is often depicted in this way. Such motifs, which the painter had in stock and which he often used in his works, have as yet been paid insufficient attention. Small strolling figures, for example, have been totally neglected. These motifs often occupy minor places in the compositions and their meanings are often difficult to uncover, since they are seldom described in Van Gogh's letters. Yet, to know why they were added and how they were manipulated can contribute to the understanding of Van Gogh's thematics.

The intentional manipulation of motifs — the choice, alteration or arrangement of motifs — in individual works or in a series of works, is an important key to the understanding of the thematics of the painter as a manifestation of his existence. However, even if noteworthy alterations, additions or any other manipulations cannot be recognized in individual works or in a series of works, it is still possible to find the existential root by making a survey of the painter's choice of motifs throughout his œuvre. No painter can compose his entire œuvre intentionally, but however arbitrary or incidental it might seem, Van Gogh's

choice of and manipulation of motifs and themes must have some general tendencies and characteristics, which we can find only by a systematic survey of his œuvre. The ultimate aim of the present study is to find the thematic structure, which underlies the intentional manipulations of motifs and themes in Van Gogh's work.

The methods employed in my basic research are as follows. First, I made two basic lists; one a list of the principal motifs in the œuvre and the other a list of the descriptions of these motifs found in Van Gogh's letters. The first is presented in the form of a chronological table which enables us to survey the frequency of occurence of a motif in each period (see Appendix I). The second is an index of the descriptions of motifs in the letters; a simple card system with letter numbers. This list is used to find the pictorial or literary sources of certain motifs which are mentioned in the letters and to reconstruct the personal meanings of the motif from Van Gogh's own descriptions as well as from its artistic sources. Even if the descriptions of the motif have nothing to do with Van Gogh's works, they are included in this list. There are some problems with the first list; the most important one is the question of how to classify and distinguish the motifs. For example, plowing and digging a field are the same kind of labor in the annual cycle of work on the land. But we must keep in mind that only poor peasants who could not afford to buy a plow and horses had to do this type of backbreaking labor. Therefore, the meanings of these two images within Van Gogh's œuvre are also different. Moreover, it is sometimes impossible to distinguish between a digging figure and a potato digger in rough sketches. I have paid special attention to certain ambiguous cases and have drawn some tentative conclusions from them as shown in the chapter on diggers. Very small motifs can be discerned only in the original works or in relatively large reproductions, but I was not able to see all the works in the original or in large reproductions. Therefore, some additions might be made to the chronological table in Appendix I.

The second step in my basic research was to make small reproductions of all the works and then to make thematic groupings by photocopying the reproductions with the same motifs to large sheets. These sheets enable us to make a general survey of how the motifs are combined with one another or manipulated in the œuvre. Such comparison and analysis is extremely difficult if one relies on the œuvre catalogues, which present the works in chronological order. The small reproductions were used to analyze the combinations of motifs. Although the purpose of and procedure followed in the analysis are not the same, the working method itself is comparable to the *Bilderatlas* which Aby Warburg used.[14] The frequency of occurrence of a motif during a certain period and the combination with other motifs can be important factors in determining the significance of the motif.

The reconstruction of the significance of a motif is mainly based on the second list, the card system of Van Gogh's descriptions of motifs, but the results of the sheets of motifs can also offer definite keys or sometimes even more objective and reliable material for the reconstruction of meanings. Needless to say, descriptions of themes or motifs by the painter himself are very important keys for the interpretation of the layers of meanings, and many art historians and psychologists have taken advantage of the rich source of information offered by Van Gogh's letters. However, we must take into account that these are in essence self-interpretations, that is to say, the painter himself is not always fully aware of the significance of his own themes or motifs, nor is he always able to articulate this significance clearly. Moreover, descriptions in letters are intended for people with certain backgrounds who had certain views of Van Gogh's works. Therefore, the descriptions can of course vary in letters addressed to different persons. On the other hand, the frequency of occurrence and general trends in the combination of motifs do not have such problems and offer objective material for interpretation. Although there are some difficulties and dangers in drawing conclusions from the results of these investigations, this approach is not necessarily less reliable or less effective than the careful reading of descriptions. On the contrary, there are some important thematic aspects of the œuvre which can be revealed only by this approach.

Religious background: Christianity versus nature

The religious background of Van Gogh's time occupies an important place in the present study. It was not my initial intention to discuss this aspect when I started research on the thematics of Van Gogh's œuvre, but during the course of my research I found it necessary to place increasing emphasis on the religious context. This in itself is not at all surprising, for Van Gogh's father was a Dutch Reformed (Nederlands Hervormd) preacher and Van Gogh himself had wanted to be a preacher before embarking upon his artistic career. But, despite its apparent importance, the relationship between Van Gogh's artistic career and his religious background has been studied only sporadically. Strictly speaking, there has been not one serious study on this subject. The theological background of late nineteenth-century Holland has been treated by several scholars,[15] but they have pointed out only the theological trends at Van Gogh's time. Van Gogh himself had little interest in dogmatic problems in theology, and the theological trends at the time have revealed few essential aspects of Van Gogh's works.

The religious and cultural background of Van Gogh's time, the dominating role of clergymen in the Netherlands during the first three quarters of the

nineteenth century, is discussed here for the first time in relation to Van Gogh. The first chapter, dedicated to this neglected field, will show how this religious background is essential to our understanding of Van Gogh's whole artistic career. Unfortunately, little comprehensive study on the role of clergymen in Dutch nineteenth-century culture has been done. In the field of art history, there are only a few articles and these are on specific themes.[16] I was obliged to start my research by looking for clergymen's writings on art. This necessitated consulting archives, for clergymen's books have been widely scattered during the last hundred years and some of their books, which seemed important for this study, were not to be found in any of the public libraries in the Netherlands. The inaccessibility of this source material has historical reasons. The heyday of clergymen's activities in the cultural field ended around 1880 with the appearance of the *Tachtigers* (Dutch literators of the 1880s). The clergymen's former roles as poets, literary and art critics and especially as cultural leaders were rapidly forgotten and have not been sufficiently reevaluated until today. However, this turning point and the period before 1880 are undoubtedly important for our understanding of Van Gogh, for the turning point corresponds to Van Gogh's "conversion" from preacher to painter.

I will therefore begin the present study by reconstructing the religious and cultural backgrounds shortly before Van Gogh made his decision to become a painter. After that I will show various aspects of the conflict between Christianity and nature and the process of naturalization in the thematics of Van Gogh. Since the concept of "nature", which is often used in this study, contains numerous layers of meaning and can be quite confusing, I should briefly clarify the meanings of these essential concepts, at least those used by myself and by Van Gogh.[17] Firstly, the word "nature" is used here mainly as opposed to the concept of "culture". Cities, institutions, conventions, academism in art and especially the Church, orthodox dogmatic Christianity; all of these belong to "culture". As an opposite of culture, nature implies a primitive state of man, which was considered by primitivists to be superior to the sophisticated product of a corrupt civilization. Therefore, people in primitive societies, peasants and children are all counted among the inhabitants of "nature". Secondly, natural is opposed to "supernatural" or "unreal" forms of existence such as superstition and miracles. But (undogmatic) religion, divinity and even God are not opposed to nature, for, in the eighteenth and nineteenth centuries, the concept of nature often implied a synthesis of the religious notion of divine Providence and the scientific notion of universal laws, and Van Gogh and other artists and writers quoted in the following chapters often use the word in this sense. Although the concept of nature contains many more layers of meaning, I will confine myself to the two definitions mentioned above. If we keep these two definitions in mind, we can at

least avoid serious misunderstanding or confusion, and the more detailed conno-
tations of nature will be understood much better in the concrete discussions of
Van Gogh's works.

The words "Christianity", "the Church" and "clergyman" often had nega-
tive connotations in Van Gogh's letters written after he became a painter, and
from time to time I also employ these words in a similar negative sense. What
Van Gogh actually hated was, needless to say, not Christianity in general but the
dogmatism of the Church. All through his life, Van Gogh retained a strong need
for religion and a great admiration for Christ. Thus, the subtitle of this book
should be, more precisely, "Dogmatic Christianity versus Nature". But, like
Van Gogh, I have not always taken the trouble to include the word "dogmatic".

In the following five chapters, some of Van Gogh's motifs and their thema-
tic significance in the œuvre will be discussed; the church and the sun in Chapter
2, French novels in Chapter 3, Japanese motifs in Chapter 4, diggers in Chapter
5, the starry sky in Chapter 6. Occasionally, I will treat other motifs such as
sunflowers, oleanders, strolling couples and representations of agrarian labor.
My approach and viewpoint are not identical in all the chapters, but in principle
I am following the method discussed above. In the conclusion "Triumph and
defeat of nature" the results of the preceding chapters will be surveyed within
the historical context of the nineteenth century. Let us now begin by reconstruct-
ing the cultural background against which the clergyman's son converted to a
painter.

1. *Dominocratie*: Van Gogh and the theologians' culture in nineteenth-century Holland

Bijschriften-poëzie and the emblematic tradition

In 1877 and 1878 Vincent van Gogh studied for the ministry in Amsterdam. His teacher of Latin and Greek was M.B. Mendes da Costa (fig.1), who later published an interesting memoir of Van Gogh. Among Van Gogh's many eccentricities, Mendes da Costa relates, was the fact that Van Gogh often brought prints to him, "but they were always completely spoiled: the white borders were literally covered with quotations from Thomas à Kempis and the Bible, more or less connected with the subject."[18] One of these prints was kept by Mendes da Costa and later donated to the library of the University of Amsterdam (fig.2). This lithograph is after J.J. van der Maaten's painting *Funeral procession in the wheat field*, and as Mendes da Costa wrote in his memoir, the borders and the reverse side of the print are filled with pencilled quotations. Under the image there are four Latin quotations from the Gospel, namely John 12: 24, 25, Mark 4: 26-29, John 5: 24, 25, 28, 29 and Luke 9: 24. On the reverse side there is a long quotation from John 20: 1-17, also in Latin, as well as Mendes da Costa's stamp and a certification that the print was given to him by Van Gogh (fig.3). To the left of the picture there is a verse in Dutch, and to the right one in English.[19] The quotations and the verses all bear some relation to the subject of the picture. The five biblical quotations are on "the corn of wheat", the raising of the dead, the resurrection of Christ and so on. The source of the Dutch verse is hymn no. 189 from the hymnal of the Dutch Reformed Church.[20]

> Zoo bly de landman moe van 't ploegen
> De neigende avondscheemering groet
> Zoo bly zien wij na al ons zwoegen

Dat onze dag ten einde spoedt
Niet eeuwig zal de hope kwijnen
Die naar het uur der ruste smacht
Maar 't oogenblik zal eens verschijnen
Zoo lang hier hijgend ingewacht
Die hoop kan alle leed verzachten
Komt reisgenoten 't hoofd omhoog
Voor hen die 't heil des Heeren wachten
Zijn bergen vlak en zeeën droog
Zaligheid niet af te meten
Vreugd die alle smart verbant
Eens is de vreemdlingschap vergeten
En wij wij zijn in 't vaderland

The English verse is H.W. Longfellow's poem *Afternoon in February*, which Van Gogh transcribed incompletely. It corresponds most closely to the subject of the picture.

The day is ending
The night is descending
The marsh is frozen
The river dead
Through clouds like ashes
The red sun flashes
On village windows
That glimmer red

The snow recommences
The buried fences
Mark no longer
The road o'er the plain
While through the meadows
Like fearful shadows
Slowly passes
A funeral train

The bells are pealing
And every feeling
Within me responds
To the dismal knell

Van Gogh also wrote this poem in the autograph book of Anne Slade Jones which has been partly published. In this book Van Gogh copied some quotations from the Bible, hymnals and works by Rückert, Michelet and H. Conscience. After these quotations the print *Christ in Gethsemane* of Paul Delaroche was pasted in probably by Van Gogh.[21]

In the collection of the Rijksmuseum Vincent van Gogh, there is a small card with a picture of Christ's head, entitled "Ecco Homo! met dichterlijk

bijschrift van J.J.L. ten Kate (fig.4). In the margins of the reproduction is an inscription reading "NOTHING SHALL SEPARATE US FROM THE LOVE OF CHRIST NOR THINGS PRESENT NOR THINGS TO COME". The source of this inscription is Romans 8: 38-39, but the text has been altered and abridged. On the reverse side Ten Kate's verse (*bijschrift*) is printed, and the inscription "bijschrift van Vincent van Gogh" appears, possibly in the hand of Jo van Gogh-Bonger. This is one of the series of picture cards with *bijschriften* published as *Photographiën met dichterlijke bijschriften van J.J.L. ten Kate* (Photographs with poetical notes by J.J.L. ten Kate).[22]

Such a combination of image and poem, called "bijschriften-poëzie", was very popular until about the 1870s.[23] The authors of such poems were mainly clergymen and Van Gogh must have been familiar with their works before he became a painter. Ary Scheffer's paintings and J.J. van der Maaten's *Funeral procession in the wheat field* were very popular with these writers for their religious implications. Together with Ary Scheffer's prints, a lithograph of the *Funeral procession* hung in Van Gogh's room as well as in his father's study.[24] Interestingly, at least two Dutch preachers mentioned this painting in their sermons, namely Bernard ter Haar and Eliza Laurillard. During his Amsterdam period, Van Gogh heard Laurillard's sermons several times, and he reported in one of his letters that Laurillard mentioned the painting.[25] It was not unusual for preachers to refer to paintings in their sermons. Not only in the church, but also in books, lectures, articles and poems, they often addressed subjects such as art, music, literature and so on. Their influence on Dutch culture as a whole during the first three quarters of the nineteenth century was so strong that I should first discuss the significance of the clergymen's culture. After that I wish to show how this culture left its traces on Van Gogh's ideas and works.

In the first three quarters of the nineteenth century, clergymen played a dominant role in Dutch society and culture. In his *De dominee in onze literatuur* (The clergyman in our literature), Gerard Brom termed this phenomenon in literature *dominocratie*.[26] Indeed, neither the history of literature nor the cultural history of the Dutch nineteenth century can be written without the names of clergymen such as J.J.L. ten Kate, N. Beets, B. ter Haar, C. Busken Huet and P.A. de Génestet. In almost every aspect of Dutch society and culture, clergymen were the most respected intellectual leaders. They gave lectures on various subjects ranging from art to the natural sciences, and edited theological, literary and art periodicals. Their role during the middle of the century was in every respect incomparably greater than at its close. At the University of Utrecht, for example, students of theology accounted for more than half of all those registered.[27]

To show the clergymen's broad range of activity, I should like to take the

case of J.J.L. ten Kate (1819-1889), a preacher in Amsterdam, one of the most famous poets at the time and one of the most productive writers in nineteenth century Holland (fig.5). Van Gogh, of course, was familiar with Ten Kate's activities and publications. We have already seen the picture card with Ten Kate's *bijschriften*. From Van Gogh's letters, we know that he saw a number of beautiful books by Ten Kate, probably in Stricker's study, and heard at least one of Ten Kate's sermons. When Ten Kate preached in Amsterdam, people formed long queues in front of the church, and during the sermon the congregation would wait expectantly for an improvised poem. He translated numerous foreign literary works such as Goethe's *Faust*, Schiller's *Maria Stuart*, Milton's *Paradise Lost*, Andersen's fairy tales, Dante, Tasso, Hugo, and Alfred de Vigny. Among his own works, *De schepping* (The creation) was to prove the most famous. This series of long poems based on the Book of Genesis was translated into English, German and Swedish. He often gave a recitation of this book which took about two hours.[28] Many of his major works are richly decorated. *De schepping*, *De planeeten* (The planets), *De Nieuwe Kerk van Amsterdam* (The New Church in Amsterdam), *De jaargetijden* (The seasons) and *Kunst and leven* (Art and life) may have been given as gifts and owned by clergymen and rich families.[29] In addition to *Kunst en leven*, Ten Kate wrote other books and articles on the fine arts. Together with many other clergymen, he was one of the regular contributors to the *Kunstkronijk*, the most important art periodical at the time, with which van Gogh was also familiar.[30] He also published *Christus Remunerator* on Ary Scheffer's painting of the same title and *Nieuwe photographiën met dichterlijke bijschriften* (New photographs with poetical notes).[31] *Kunst en leven* and *Nieuwe photographiën* contain photographs of paintings by Rochussen, Scheffer, Roelofs, J. Weissenbruch etc. The texts (*bijschriften*) accompanying the reproductions are religious or moralistic verses (fig. 6, 7, 8, 9). Such books which can hardly be called "art books" in the present sense of of the word, were also published and edited by many other clergymen (fig. 17, 18).

The popularity of the *bijschriften-poëzie* and similar forms of the image-text combination must have been quite influential in a variety of senses. First of all, reproductions of modern paintings were widely disseminated to the public, accompanied by the moralistic texts of clergymen, that is to say, the public often came into contact with Dutch as well as foreign modern paintings through the selection and interpretation of clergymen. Secondly, it was especially in clergymen's publications that the emblematic tradition survived. This fact is quite significant for the present study, because I will be using some emblematic images for the interpretation of Van Gogh's motifs in the following chapters. For Dutch seventeenth-century paintings emblem books have been used, especially in recent years, as an effective key to the interpretation of the meaning of various

motifs. Despite some objections, this iconological method and its validity are widely recognized.[32] As is well known, the publication and the popularity of emblem books decreased during the eighteenth and nineteenth centuries, and for this reason emblem books have seldom been used for the interpretation of nineteenth-century paintings. However, the emblematic tradition was strongly represented in the clergymen's writings with which Van Gogh was familiar, and I wish to demonstrate some points of contact between Van Gogh and this tradition.

In Van Gogh's letters we cannot find any titles or authors of emblem books mentioned, but numerous books were published by Dutch clergymen such as Ten Kate and Laurillard in the style of emblem books or of the *bijschriften-poëzie*. Therefore, Van Gogh must have been familiar with the emblematic tradition through these publications. According to the memoirs by P.C. Görlitz and M.J. Brusse, one of Van Gogh's favorite writers during his Dordrecht period (1877) was Charles Haddon Spurgeon (1834-1882), an English preacher who enjoyed a great popularity in his homeland and whose publications were widely disseminated in other countries.[33] Görlitz mentions the title *Juweeltjes* (Gems) as the only book of Spurgeon's read by Van Gogh, but it is quite probable that Van Gogh read other books in Dutch or in English. Even before 1880 numerous translations of Spurgeon's writings were available in the Netherlands (fig. 10, 11),[34] but Van Gogh, who lived in London from 1873 to 1875 and later in 1876, must have been familiar with the activities and publications of this celebrated preacher during his English periods. One of the important aspects of Spurgeon's books is that he borrowed illustrations from emblem books by Robert Farley, Francis Quarles, Jacob Cats and Gilles Corrozet. This was not an exceptional phenomenon in the Victorian period. As recent studies on the Victorian emblematic revival show, emblem books and the emblematic way of thinking occupied an important place in Victorian art and literature.[35] John Leighton and Richard Pigot published *Moral emblems with aphorisms, adages, and proverbs, of all ages and nations, from Jacob Cats and Robert Farlie* in 1860, containing emblems from both Cats and Farley.[36] In addition to the publication of new and revised emblem books, the revival can be recognized in the works of many Victorian painters and novelists such as William Holman Hunt, John Everett Millais, George Eliot, Charles Dickens and Thomas Carlyle.[37] Most of these were, needless to say, favorite artists of Van Gogh's, and through his stay in England and through his reading Van Gogh was quite familiar with the Victorian emblematic revival.

In the Netherlands, too, an important nineteenth-century edition of *Alle de wercken van Jacob Cats* was published in 1862 by J. van Vloten with new illustrations by J.W. Kaiser.[38] At the beginning of the first volume of this book, there is a list of about 3000 subscribers in 9 pages, including C.M. van Gogh in

Amsterdam and Blussé & Van Braam in Dordrecht. The former is Vincent's uncle and an art dealer in Amsterdam and the latter is the name of the bookshop where Van Gogh worked during his stay in Dordrecht in 1877. If C.M. van Gogh or Vincent van Gogh, another uncle of the painter's and an art dealer at Goupil's in the Hague, had collections of emblem books, Van Gogh might have seen the original books there.[39]

Aside from reprints of old emblem books and the *bijschriften-poëzie*, there is another source which may have been quite influential for the diffusion of emblematic views. These are the reward prints (*beloningsplaatjes*) which were given to pupils at school, especially at Sunday schools. Until the middle of the nineteenth century, biblical scenes were depicted in these prints together with the corresponding biblical texts, but around 1850 a new kind of reward print for Sunday schools was published with illustrations of profane subjects: *Nieuwe Belooning*, Kindergedichtjes edited by J.J.L. ten Kate (fig.12). According to R.P. Zijp, the illustrations were presumably imported from England, and the texts were added and partially translated by Ten Kate.[40] The design of the prints, chosen by Ten Kate, is apparently based on emblem books. Unfortunately, few of the nineteenth-century reward prints have been preserved, probably because the artistic quality of the illustrations was not very good. The significance of Sunday school reward prints should however not be underestimated, as emblematic thinking was spread by this educational medium. Furthermore, Van Gogh actually worked as a Sunday school teacher at the English Episcopal Church in Amsterdam in 1878. (See Appendix II).

This background information clearly reveals that Van Gogh was deeply rooted in Victorian as well as Dutch emblematic revivalist traditions. Of course, nineteenth-century emblem books and *bijschriften-poëzie* cannot simply be used as a "dictionary" to interpret the meaning of Van Gogh's motifs. Van Gogh was not simply using motifs and themes in conventional emblematic meanings. However, as shown by the print of Van der Maaten's *Funeral procession in the wheat field*, the only *bijschriften-poëzie* by Van Gogh himself known today, the painter's subject matter was undoubtedly rooted in the emblematic thinking of nineteenth-century clergymen. Emblematic writings are important keys to the understanding of Van Gogh's themes, but we cannot use them in the same way that we do for seventeenth-century paintings.

Theological background

The problem of "Van Gogh and religion" has so far mainly been studied in connection with theological developments in the Netherlands during the nineteenth

century. Although it is not necessary to discuss in detail the dogmatic problems of the theological schools during Van Gogh's time, theological tendencies do have some bearing on Van Gogh's later career. Within nineteenth-century Dutch Protestantism, several new schools of thought arose: the *Réveil* which tried to revive old Protestant dogmas, the Groningen School and the school of Modern Theology. We know that Van Gogh's father belonged to the Groningen School and that his uncle J.P. Stricker (fig.13) was a Modern Theologian.[41] The Groningen School was characterized by evangelistic, humanistic and undogmatic theology. They located the essence of religion in the individual soul, and in various respects their theology shows strong affinity to Schleiermacher's *Vermittlungstheologie*. Modern Theology had its roots in David Friedrich Strauss's *Das Leben Jesu* published in Tübingen in 1835, which is undoubtedly one of the landmarks of nineteenth-century religious thought. Two characteristic features of this book are its historical Bible criticism and its exclusion of dogmatic supernaturalism. Influenced by Strauss, some Dutch theologians such as J.H. Scholten, J.J. Oosterzee and C.W. Opzoomer established a "realistic" theology trying to integrate new discoveries in the natural sciences.[42] Apart from the theological problems, which I as a layman will not and cannot discuss in detail, the following characterization by Roessingh is especially important in understanding the activities of the Modern Theologians: "In the depth of their hearts, the modern theologians of the last century felt urged to be apologists; the unspoken question in all their work was: How can we preach Christianity to 'modern people'?"[43]

In addition to these Dutch schools of theology English Methodism should also be mentioned. During his stay in England in 1876, Van Gogh gave a sermon on Psalm 119: 19 "I am a stranger in the earth..." in his capacity as an assistant preacher at the Methodist Church in Richmond. Although his direct contact with Methodism was brief, this English school probably had some influence on Van Gogh's religious thought.[44]

How was Van Gogh influenced by the theological background of his time? Two art historians, Tralbaut and Murray, have discussed the influence of the Groningen School.[45] Tralbaut concludes very cautiously that the undogmatic and evangelistic character of the Groningen School perhaps influenced Van Gogh through his father. In this regard Tralbaut points out the fact that Van Gogh sometimes visited a number of churches in one day. He quotes Van Gogh's words in P.C. Görlitz's memoir: "Well, in every church I see God, and it's all the same to me whether a Protestant pastor or a Roman Catholic priest preaches; it is not a matter of dogma but of the spirit of the Gospel, and I find this spirit in all churches."[46] The undogmatic character pointed out by Tralbaut is undoubtedly common to the Groningen School and Van Gogh. Possibly we can find further characteristics which the two had in common.[47] It would be inapprop-

riate, however, to attribute Van Gogh's views on religion and nature only to the
influence of the Groningen School through his father, because the undogmatic
character of these beliefs can also be found in other theological schools and in
the writings of Van Gogh's favorite authors such as George Eliot, Ernest Renan,
Carlyle and Michelet. Comparison between Van Gogh and Mondrian might also
be fruitful, because Mondrian's father had strong connections with Groen van
Prinsterer, one of the representatives of the orthodox *Réveil*.[48]

Ann Murray has a somewhat different approach. She speaks of the "influ-
ence" of Schleiermacher on the Groningen School and claims that Van Goghs
affinity with German Romantic painters, the problem discussed in Robert
Rosenblum's *Modern painting and the northern Romantic tradition*, is indirectly
the consequence of the influence of Schleiermacher intermediated by the artist's
father. But in various respects her discussion is misleading. The Groningen
School was not the only one to be involved in studying German thought. Propo-
nents of Modern Theology introduced and studied Krause's Panentheism which,
according to Lankheit, formed the spiritual background of C.D. Friedrich and
C.G. Carus.[49] Moreover, nineteenth-century Dutch theologians were mainly
interested in German theology and culture, at least during the early and middle
decades of the century. Consequently, Dutch culture as a whole was oriented
towards Germany. For example, the *Kunstkronijk* contains many articles on
German art, especially in the 1860s, bearing such titles as "Art in Germany",
"Heinrich Heine on Romanticism", "The Goethe gallery, Goethe's women after
the drawings by Wilhelm von Kaulbach", "Leo von Klenze", "Peter von Cor-
nelius" and "Friedrich Overbeck".[50]

In the 1870s Van Gogh also read works by such German writers as Heine,
Uhland, Rückert and Goethe. These names do not appear often in his letters,
but from other sources we know that he was well acquainted with German liter-
ature or at least much better acquainted with it than we might assume from his
published letters. In a small notebook, now in the collection of Teylers Museum
in Haarlem, Van Gogh transcribed poems by Goethe, Heine and Uhland.
Numerous letters from Matthijs Maris to W. van Meurs came into the museum's
possession together with this notebook, and a short note was added by Van
Meurs. According to this note, this small book was given to M. Maris by Van
Gogh in Paris and the portrait sketches in this notebook are by Van Gogh.[51] If
we accept the information in the note by Van Meurs, this notebook was proba-
bly given to Matthijs Maris in 1875 or 1876 when Van Gogh was working at
Goupil's in Paris. At this time Maris was also in Paris and he was in contact with
Goupil's. Though personal contact between Van Gogh and Maris cannot be
proved from Van Gogh's letters of this period, several letters from 1875 reveal
that Van Gogh was making some notebooks with quotations of Heine and

Uhland for Theo.[52] Goethe is mentioned only twice in Van Gogh's letters, but in the notebook now in Teylers Museum, poems of Goethe's such as *Heidenrös-lein*, *Mignon*, *Die Spinnerin* and *Harfenspieler* are quoted (fig. 14). It was in the 1880s that Van Gogh showed great interest in French naturalist literature, and even before 1880 he had read Michelet, Ernest Renan, Victorian novels and some German novelists. It should also be noted that Victorian writers such as Carlyle and Eliot had been strongly influenced by German philosophy, literature and theology.[53] When discussing Van Gogh's "northern Romantic" character, there-fore, we should stress the influence of *dominocratie* and his cultural background as a whole rather than the Groningen School or Schleiermacher in particular.

In this regard I should like to draw particular attention to the writings of Eliza Laurillard (1830-1908) (fig. 15). As a theologian-poet he did not enjoy the same great reputation as Ten Kate, and his name has been almost forgotten today. But with regard to Van Gogh he is the more interesting of the two. His writings and sermons are especially unique for their undogmatic and popular character. Among his numerous writings, there are three books I should like to mention here, namely *Vlechtwerk uit verscheiden kleuren* (Wickerwork with var-ious colors), *Geen dag zonder God* (No day without God) and *Met Jezus in de natuur* (With Jesus in nature).[54] *Vlechtwerk* is a collection of his lectures and is quite interesting with respect to German color theory. The chapter "colors" is written in the form of a discourse among five men on the symbolic meaning of color. In the exchange of views on the color yellow, references is made to Goethe's *Farbenlehre*: "And Goethe, in his *Farbenlehre* calls yellow the color which comes nearest to light..."[55] The chapter called "The musical notes" is even more interesting. Here Laurillard is supposedly in a music school classroom, giv-ing a lesson on music theory, and he again mentions the *Farbenlehre*: "There is truly an affinity between tone and color. In his *Farbenlehre* Goethe says that tone and color are as two streams rising from one mountain but then flowing through different landscapes... Well then, it can be clearly perceived, in that respect too, that tone corresponds with *color*. A bright color has a clear tone, a glaring color has a sharp tone, a dingy color has a whining tone, and so forth."[56] Finally, Laurillard speaks of God's creation: "The whole of God's creation is music, and the notes are sun and cloud, mountain and stream, tree and flower, man and beast. It is one great symphony!"[57] These quotations immediately make us think of Van Gogh's ideas on the relationship between color and music, espe-cially the well-known anecdote told by A. Kerssemakers about Van Gogh's habit of constantly comparing notes with colors during his piano lessons in the Nuenen period.[58] It has not been proved that Van Gogh had direct knowledge of the *Farbenlehre* or *Vlechtwerk*, but it is quite possible that he was familiar with German color theory through the intermediary of *dominocratie*.

Nature sermon

Laurillard's *Geen dag zonder God*, first published in 1869, was a very popular
book in its day. It explained many biblical passages in simple terms. The illustra-
tion on the cover is quite interesting in that it shows the main themes of Lauril-
lard's sermons, and some of them make us think of Van Gogh's themes (fig. 16).
Together with *Met Jezus in de natuur*, this book is a valuable source of informa-
tion as to how a theologian of Van Gogh's day interpreted biblical texts and how
he looked at nature. *Met Jezus in de natuur* contains chapters on many Van Gog-
hian themes such as the plowman, the sower, wheat, the sun and rain, darkness
and light. In the introduction to the book, Laurillard wrote: "Many and diverse
are the beauties of nature. Each part of her is full of wonder. Magnificent is her
work, sweet her rest, rich her imagery, uplifting and enchanting her many voiced
song... In every generation there have always been many who, whilst wandering
outside, have 'heard the Lord God walking in the garden', and who were not
only desirous of deciphering God's written hieroglyphics, but also had the gift of
doing so, of understanding the symbolism of nature which God has drawn."[59]
"When they [those who do not see the beauty of nature] hear a sermon taking as
its theme one thing or another from life of the Creation, many of them will say
contemptuously: 'It's only a nature sermon!' ... As far as I am concerned, I think
such a tendency dry and tedious, and I am very glad to be with Jesus in nature,
but most unhappy to be with all those whole or half or quarter theologians in the
library and the school! Yes! with Jesus in nature! — I should have liked to walk
with Him in the fields; I should have liked to sit with Him on the Mountain-top.
Certainly then, with His guidance, I should have learnt to read and understand
words in the great Book of Revelations of the Creation which, in former times,
I could not read, and could not understand."[60]

 In England Spurgeon enjoyed great popularity by way of his "nature ser-
mon". His posthumously published collected sermons entitled *Teachings of
nature in the Kingdom of Grace* contains chapters such as "The ploughman over-
taking the reaper", "Healing beams", "As small as mustard seed", "Supposing
Him to be the gardener", "Harvest time 'is it not wheat harvest to-day?'".[61] His
style of sermon is quite similar to Laurillard's. In the last sermon, called "Har-
vest time 'is it not wheat harvest to-day?' (I Samuel 7:17)", which incidentally
was given in 1854 and was Spurgeon's first printed sermon, he wrote: "It is a fan-
ciful idea that there are 'sermons in stones'; for there really are sermons in
stones ... Happy is the man who only has the mind, and has the spirit to get these
lessons from Nature. Flowers, what are they? They are but the thoughts God
solidified, God's beautiful thoughts put into shape. Storms, what are they? They
are God's terrible thoughts written out that we may read them. Thunders, what

are they? They are God's powerful emotions just opened out that men may hear them. The world is just the materializing of God's thoughts ... His own mighty mind, and everything in the majestic temple that He has made, has a meaning. In this temple there are four evangelists. As we have four great evangelists in the Bible, so there are four evangelists in Nature; and these are the four evangelists of the seasons — spring, summer, autumn, winter."[62]

The anti-dogmatism and the symbolic view of nature in these nature sermons by Laurillard and Spurgeon show a striking similarity to the thought of Van Gogh. Let us quote from three letters written in 1879, 1882 and 1889, and from Anton Kerssemakers' memoir of Van Gogh's Nuenen period. The first passage is a description of a thunderstorm which Van Gogh actually saw in the Borinage: "But during that thunderstorm in the pitch-dark night the flashes of lightning made a curious effect: now and then everything became visible for a moment. Nearby the large, gloomy buildings of the Marcasse mine stood alone, isolated in the open field, that night conjuring up the huge bulk of Noah's Ark as it must have looked in the terrible pouring rain and the darkness of the Flood, illuminated by a flash of lightning." The following incident involving Van Gogh was witnessed by an inhabitant: "On a very hot day a violent thunderstorm burst over our region. What did our friend do? He went out to stand in the open field to look at the great marvels of God, and so he came back wet to the skin."[63]

The second letter was written in The Hague in 1882. Van Gogh had already given up his career as a preacher, but his description of nature preserves the same tone. "I think your Montmartre splendid, and I certainly would have shared your emotion. ... At times there is something indescribable in those aspects — *all nature seems to speak*; and going home, one has the same feeling as when one has finished a book by Victor Hugo, for instance. As for me, I cannot understand why everybody does not see it and feel it; *nature or God does it for everyone who has eyes and ears and a heart to understand*."[64] (my italics)

The following passage is from Kerssemakers' memoir: "... he [Van Gogh] suddenly stood stock-still before a glorious sunset, and using his two hands as if to screen it off a little, and with his eyes half closed, he exclaimed, 'God bless me, how does *that fellow — or God, or whatever name you give him* — how does he do it? We ought to be able to do that too.'"[65] (my italics) Finally, a short well-known passage from Van Gogh's letter about *Wheat field with a reaper* (fig. 31): "There! The 'Reaper' is finished, I think it will be one of those you keep at home — it is an image of death as the great book of nature speaks of it. ..."[66]

In his Amsterdam period, Van Gogh heard Laurillard's sermon several times and he wrote "... it is as if he paints and his work is at the same time high and noble art. He has the feeling of an artist in the true sense of the word."[67] According to Van Gogh, Laurillard was an artist-preacher. Laurillard himself,

as well as many others, would have objected to having the title "artist" applied to a preacher, but throughout the nineteenth century some prominent preachers were indeed artists. As Conrad Cherry said about nineteenth-century American preachers, "preaching was a skill of learning and creative communication which reached more people than novels or poetry, and much of their written theology profited from the artistry of their preaching."[68] Ten Kate, Laurillard and Spurgeon were all artist-preachers and we can perhaps call Van Gogh a preacher-artist who lived in the same religious environment during the late nineteenth century.

Though we do not know for certain whether Van Gogh ever read Laurillard's writings, they did share a similar view of nature and a similar thematic program in their work. In this sense, the relationship between them is somewhat comparable to Caspar David Friedrich's relationship to Ludwig Theobul Kosegarten, a minor poet and Protestant pastor in Pomerania.[69] Like Van Gogh and Laurillard, Friedrich and Kosegarten did not have a close personal relationship, but their work reflects a very similar religious view of nature. Both of these two pairs, Van Gogh-Laurillard and Friedrich-Kosegarten, can be understood within the tradition of the worship of nature, which began in the late eighteenth century. In Germany, this tradition was represented by Claudius and Herder. Kosegarten, called a "Priester der Natur" by Daniel Runge, brother of the painter Philipp Otto Runge, was an important continuator of the movement in Pomerania. Werner Sumowski pointed out that Kosegarten's religious interpretation of nature and denial of the iconographical tradition paved the way for Oehlenschläger's *Aarets Evangelium i naturen og mennesket* (Evangelical calender in nature and man) of 1805 and that it may have been the primary factor stimulating Friedrich's religious view of nature.[70]

In contrast to Kosegarten whose work was hardly known abroad, the work of the Danish poet Oehlenschlaeger and of Claudius had already been introduced into the Netherlands by the time of *dominocratie*. Ten Kate published translations of Oehlenschlaeger's *Correggio* in 1859 and 1868, and Claudius was one of the most popular foreign writers in the Netherlands during the mid-nineteenth century. Laurillard confessed his debt to Claudius in his *Vlechtwerk uit verscheiden kleuren*, and some of his writings show the influence of the German poet. In March 1877 Van Gogh mentions Claudius in a letter and in December of the same year he wrote that he was given Claudius' works by Mendes da Costa.[71] Although most Dutch readers were familiar with Claudius' poetical works in the original German, a selection of his poems was also translated by Hendrik Tollens (1780-1856) as early as 1834.[72] There are few Dutch translations of Oehlenschläger's works, but German translations must have been read in the Netherlands.

Oehlenschläger's *Aarets Evangelium i Naturen og Mennesket*, first pub-
lished in 1805 under the title *Jesu Christi gientagne Liv i den aarlige Natur*, shows
some affinities with Laurillard's *Met Jezus in de natuur*.[73] *Aarets Evangelium* is
a collection of poetical works on Christ, the Virgin Mary and the saints, while
Met Jezus in de natuur is a prose work taking its subject from daily life or agra-
rian labor. But, despite the difference in style, both writings are quite similar in
that they see traces of the saints and religious significance in various phenomena
in nature. Let us quote from the German translation of the introduction and the
last verses of *Aarets Evangelium*.

> Ich habe Dich gesehen in der Blume,
> In blauer Luft, in milden Frühlingsstunden;
> Jetzt klingt die Harfe laut zu deinem Ruhme.
>
> Ich habe Dich in der Natur gefunden,
> Der Gott der Güte blüht durch alles Gute,
> Er lebet noch, und er ist nie verschwunden.
> …
>
> In Deiner Spur, Du Heil'ger! will ich gehen!
> Ich las in der Naturen grossen Buche,
> Jetzt soll es Deine Thaten selbst gestehen.[74]
>
> Hier hat er sich vor mir in dem Gedichte
> Geoffenbart im Wald und auf der Flur;
> Und gern hat sich die heilige Geschichte
> Vermählet mit der heiligen Natur.[75]

The following chapters such as "the Birth of Christ", "the Virgin Mary",
"Joseph" "St. John in the storm", "the Sermon of the Mount", "the Miracle",
"Gethsemane and Golgotha" are also written in the same tone. There is no
chapter on agrarian themes, but the spiritual affinity with Laurillard's *Met Jezus
in de natuur* is indisputable.

The Romantic conception of religious landscape was still alive during the
middle of the nineteenth century in the Netherlands, and it was the preachers in
particular who subscribed to this somewhat retardataire concept during the era
of Realism. It is significant to note that Van Gogh gave up his idea of becoming
a preacher in 1880, because the 1880s were the turning point from the time of
dominocratie to modern culture. Laurillard, Stricker and many other preachers
tried in vain to stop the collapse of Christian society and culture. People began
to leave the church. Clergymen were losing their former status as social and cul-
tural leaders. Theologian-poets were bitterly criticized, ridiculed and gradually
forgotten. Novelists of the new generation became interested in French
naturalism, and art criticism in the modern sense of the word was introduced

from France.[76] The shift of interest from Germany to France was rapid and radical, and this shift can be recognized in Van Gogh's letters in the early 1880s. It is this radical change which made Van Gogh's artistic identity ambiguous: a painter with a "northern romantic" view of nature and with a French Post-Impressionist style.

After the collapse of *dominocratie*, clergymen who were able to find a way to engage in "cultural conversion", together with their children's generation, diverged into various fields: they became literary critics, university professors, artists or art historians. To mention a number of distinguished figures of the "converted" generation, Cornelius Hofstede de Groot (1863-1930), one of the founders of art history in the Netherlands, was the son of a preacher and a grandson of Petrus Hofstede de Groot (1802-86), the most important theologian of the Groningen School. In 1862 Conrad Busken Huet (1826-1886) resigned as Walloon preacher in Haarlem to be a journalist. Allard Pierson (1831-1896), gave up his position as a preacher in 1865 to become a professor of philosophy and aesthetics at the University of Amsterdam. Jacques Perk (1859-1881), one of the major poets of the *Tachtigers*, was the son of preacher M.A. Perk. Van Gogh's cousin Anton Mauve (1838-1888) was the son of Mennonite preacher W.C. Mauve.[77] As mentioned above, Mondrian's father was in close contact with one of the Protestant movements as the director of a Protestant school in Amersfoort.

It is beyond the scope of this study to discuss the legacy of *dominocratie* in the works of all these "domineeszonen" (clergymen's sons), but, as Gerard Brom said about Allard Pierson,[78] many of them must have preserved the preacher-like character in the depths of their hearts even after their "conversion" and after the apparent demise of *dominocratie*. In the following chapters, we will see how Van Gogh preserved the preacher-like character and how he transformed "Christianity" in his life and works.

2. The Church versus the sun: substitution of motifs

The collapse of *dominocratie* was of course not a phenomenon peculiar to the Netherlands. In England and France, for example, this process of secularization had taken place several decades earlier. Ernest Renan, Jules Michelet, Thomas Carlyle and George Eliot, favorite writers of Van Gogh's, epitomize almost fully in their works the transformation of nineteenth-century religious thought.[79] Eliot's translations of Strauss's *Life of Jesus* and Feuerbach's *Essence of Christianity* had been published respectively as early as 1846 and 1854. Religious people who were dissatisfied with orthodox Christian doctrine had to find a place for their religious feelings outside of the Church, and one of the tendencies of religious thought at the time was to find a substitute for God. In his chapter on Carlyle in *Nineteenth-century studies: from Coleridge to Matthew Arnold*, Basil Willey describes Carlyle's contribution as follows: "Substitute the 'Immensities and eternities' for God, substitute 'the Temple of the Universe' for the Church, 'Literature' for the Bible, 'Heroes' for saints, 'Work' for prayer, and the like: do all this, and you have at one stroke destroyed 'superstition' and provided a true religion for honest men in these latter days. Here at last was a creed which *did* 'correspond to fact'."[80] This description can also be applied to Van Gogh's life and art to a considerable degree. His most important substitution was the decision to become a painter, but this "conversion" did not complete his substitution. During the time that his hope was to become a clergyman or a preacher, he had already exhibited a tendency toward naturalizing religion, and even after his conversion he preserved the character of the *domineeszoon* (clergyman's son) in a disguised form.

In Van Gogh's letters we can find numerous examples of substitution or naturalization, some of which we already quoted in Chapter 1.[81] This tendency

was undoubtedly present even before the Borinage period. In a letter written in Dordrecht in 1877, he quoted some verses from the hymnal of Dutch Reformed Church, but in one of them Van Gogh erroneously wrote: "Juich Aarde juich tot God omhoog...".[82] (Rejoice Earth, rejoice to God in the highest...) The original text is "Juich Christenen..." (Rejoice Christians). This could be a simple error caused by confusion on Van Gogh's part with other hymns beginning with "juich aarde", but Hoenderdaal presumes that it is also an unconscious error caused by Van Gogh's pantheistic concept of religion.[83] If Van Gogh, consciously or otherwise, indeed substituted "aarde" for "Christenen" in the quotation, this was literally "substitution" in the sense that Willey employed it with respect to Carlyle. This speculation does not seem to be altogether irrelevant with Van Gogh's later development in mind and as concerns his descriptions of Laurillard's sermons which he heard in that same year, 1877. Interestingly, Van Gogh's descriptions of Laurillard's sermons are almost always accompanied or immediately followed by descriptions of sunlight, stars or the moon.[84] For example, in letter 102 Van Gogh mentions Laurillard's sermon on Ephesians 5:14, "Awake thou that sleepst, and arises from the dead, and Christ shall give thee light", and immediately adds, "...but during the sermon the sun was shining brightly through the windows."[85]

After he became a painter, this tendency toward substitution is much more evident. In Antwerp he wrote, "But I prefer painting people's eyes to cathedrals, for there is something in the eyes that is not in the cathedral, however solemn and imposing the latter may be — a human soul, be it that of a poor beggar or of a streetwalker, is more interesting to me"[86] In various contexts, Van Gogh expresses his wish to substitute something for the old religion. In Arles he expressed his wish more clearly: "I know so well what I want. I can very well do without God both in my life and in my painting, but I cannot, ill as I am, do without something which is greater than I, which is my life — the power to create. ... I want to paint men and women with that something of the eternal which the halo used to symbolize, and which we seek to convey by the actual radiance and vibration of our coloring."[87] In St. Rémy Van Gogh criticized Bernard's religious works and he wrote on his own painting *The garden of St. Paul's hospital* (F659 JH1850): "I am telling you about these two canvases, especially about the first one, to remind you that one can try to give an impression of anguish without aiming straight at the historic Garden of Gethsemane; that it is not necessary to portray the characters of the Sermon on the Mount in order to produce a consoling and gentle motif."[88]

To substitute people's eyes for cathedrals, radiance and vibration of coloring for a halo, the garden of St. Paul's hospital for the Garden of Gethsemane: these are Van Gogh's attempts to humanize or naturalize traditional Christian

themes. In this respect, the juxtaposition of the Bible and Zola's *La joie de vivre* in *Still life with open Bible* cannot be overlooked as one of the best examples of what Willey called the substitution of literature for the Bible.[89] I will discuss the meaning of this controversial painting in detail in the following chapter.

Church tower, the sun

In order to demonstrate the process of Van Gogh's naturalization of religion, I would like to analyze the manipulation and transformation of the church motif in his work. At the beginning of his career, we can discern in Van Gogh's work a Van der Maaten-like use of the church, and religious allusions are still obvious. In *Miners' wives carrying sacks: the bearers of the burden* of 1881, Van Gogh depicted a church tower and a crucifix (fig.19). This drawing was made in Van Rappard's atelier in Brussels about six months after Van Gogh left the Borinage; that is to say, it is certainly a composed atelier work.[90] The scene of miners' wives carrying sacks was perhaps most impressive and characteristic of the Borinage. Cécile Douard, who lived in the Borinage at about the same time, also depicted this subject, and in 1904 Ph. G. Marissiaux took a photograph of a similar scene[91] (fig.20,21). If we compare Van Gogh's drawing, a later watercolor of 1882 (fig.22), Cécile Douard's painting and Marissiaux's photograph, the idiosyncrasies in Van Gogh's conceptions become clear.[92] In both works, Van Gogh depicted a church, most probably to suggest certain religious or biblical implications.

In *Shacks* (fig.23), a drawing made in Etten in 1881, Van Gogh depicted a church tower precisely at the back of the sower's head. This unnatural and somewhat peculiar manner of composition shows clearly how Van Gogh manipulated the motifs to stress the religious implications of the sower.[93] Until his Nuenen period (1884-1885) the tendency to combine the church with agrarian themes is still strong. A plowman and a reaper are also combined with a church in similar ways (fig.24,25). The motif is depicted in the background of digging figures (fig.105 and F860a JH42, sketch in letter 292 JH370) and even in the small window of a weaver's workshop (fig.26 and F24 JH500).[94] These examples show clearly that Van Gogh was manipulating this motif in his work.

Some nineteenth-century painters such as Millet and Breton also depicted churches in combination with landscapes and agrarian themes, but in their work this motif is not depicted or manipulated in the same elaborate or unnatural way as it is in Van Gogh's œuvre. Of course, numerous landscape paintings exhibiting a church tower were made in the nineteenth century, and this motif provides one of the very few vertical accents which contrast with the low horizontal line of

the flat Dutch landscape. Nevertheless, the church tower in some works by Van Gogh and in Van der Maaten's *Funeral procession in the wheat field* is not a motif which was observed by chance in landscapes nor a mere vertical accent introduced into the picture for compositional reasons. In Holland in the nineteenth century, Anton Mauve and Jozef Israëls also used the church motif in a similar but somewhat muted way. In his *From darkness to light* (fig.27) among other works, Israëls depicted a church in an open door or in a small window as Van Gogh did in his *Weaver*.[95] Van Gogh must have seen some of these works. *From darkness to light* was included in the exhibition of *Levende Meesters* (Living Masters) held in 1873 in Amsterdam and it travelled to Vienna for the *Welt Ausstellung*. On March 17, 1873, Van Gogh wrote to Theo: "A fortnight ago I was in Amsterdam to see an exhibition of the pictures that are going from here to Vienna. It was very interesting, and I am curious to know what impression the Dutch artists will make in Vienna."[96] The exhibition mentioned here is undoubtedly the *Levende Meesters*, in which Israëls's *From darkness to light* hung.

Anton Mauve's works such as *Plowing peasant* and *A digger in the dunes* (fig.28,29) display a greater degree of similarity to the works of Van Gogh mentioned above, by virtue of their combinations of a church and a plowman and a church and a digger. Mauve also made some paintings depicting a church in the distance and potato diggers in the foreground.[97] As is well known, he was a cousin as well as a close friend of Van Gogh and gave him instruction in drawing and water color. As I have mentioned briefly in Chapter 1, his father, Willem Carel Mauve, was a Mennonite preacher, first in Zaandam and then in Haarlem. From Van Gogh's letter we know that he heard Anton Mauve preach on Peter's fishing bark and other subjects in imitation of several famous clergymen.[98] It is probably no coincidence that the two Dutch clergymen's sons show the strongest similarity in their use of the church motif. At first glance the combination of a church tower and diggers or a plowman might seem ordinary and conventional, but such combinations are quite rare in Dutch nineteenth-century paintings.[99]

After an intermission of about two years during Van Gogh's Paris period, rural motifs reappear in his works in Arles. Systematic analysis of Van Gogh's motifs reveals that the iconographical function of the church motif in his Dutch periods was taken over by the sun after the Paris period. In *The sower, Wheat field with reaper, Enclosed field with plowman* and *Two women digging* (fig.30, 31 and F450 JH1627, F625 JH1768, F695 JH1923), for example, the sun occupies the place that had previously belonged to a church (see fig.23, 25 and sketch in letter JH374 JH508, F1676 JH36, F1031 JH363). During Van Gogh's Dutch period, the sun is depicted only in a few works and not a single combination with a sower, plowman, digger or reaper is known. On the other hand, after the Paris

period, the combination of a church tower and agrarian labor can be found only in *The mower: Arles in the background* and the three drawings of the same composition (replicas) made after the painting (F545 JH1477, F1490 JH1529, F1491 JH1516, F1492 JH1544). The background motif in this series, however, should rather be classified as the "ville d'Arles", since the church towers form only a part of the entire background. Let us see the frequency of the combinations of respectively a church and the sun with a sower, reaper, plowman or digger, in the form of a chronological table.[100]

		1881	82	83	84	85	86	87	88	89	90
church	sower	2			1						
	reaper				1	1					
	plowman	2			1						
	digger	1		2		1					
the sun	sower								8		
	reaper									4	
	plowman									2	
	digger										1

Drawing conclusions from such a table always involves some risk of simplification and distortion of the facts. However, this quantitative analysis confirms the substitution which was observed during the analysis of the compositions mentioned above. Even if the four versions of *The mower: Arles in the background* are included in the table, the general tendency of the substitution does not change. Although it is for practical reasons impossible to present here, this substitution would become most convincing if one put all the reproductions of the works with a church and the sun side by side and compared their compositions.

The two *Sowers* painted in November 1888 (fig.30 and F450 JH1627) have often been discussed because of their halo-like sun and diagonal tree trunk. The diagonal composition in particular has been related to Gauguin's *Vision after the sermon*, which Van Gogh must have known before he painted the two *Sowers*.[101] Whether Van Gogh intended to use the disk of the sun as a halo for the sower is difficult to prove, but this has nothing to do with Gauguin's influence. The position of the sun is precisely the same as the church in *Shacks* (fig.23), and, needless to say, such an "unnatural" position cannot have been chosen without conscious deliberation on the part of the painter. Although a combination of a figure and the sun was not unprecedented,[102] *The sower* is undoubtedly radical in its subjects — a sower and the sun —, in its composition and of course in its whole concept.

There are, however, some interesting pictorial sources which are likely to

have stimulated Van Gogh's thematic naturalization in *The sower*. In the issue of *Le Courrier Français* published on December 26, 1886, there is an illustration by Heidbrinck called "Après l'inondation la fertilité" (fig.32), which exhibits a striking similarity to Van Gogh's painting in its combination of a sowing figure and the sun.[103] It is almost certain that Van Gogh had seen and was interested in this illustration. This special issue entitled *Le Courrier Français, pour les inondés du Midi* (fig.33) is presently in the Rijksmuseum Vincent van Gogh, and its title can be found in the *Liste des albums et journaux en possession de Theo van Gogh, de la période parisienne de Vincent* which was drawn up by Theo's son, V.W. van Gogh.[104] Heidbrinck's illustration is missing in the copy of *Le Courrier Français* at the Rijksmuseum Vincent van Gogh. It is quite possible that this page attracted Van Gogh's attention and that the painter removed and kept it. Since his youth Van Gogh had demonstrated great interest in popular prints and illustrated magazines such as the *Graphic* and collected them. The importance of such illustrations and prints has often been stressed in Van Gogh studies.[105]

"Après l'inondation la fertilité" is not the only illustration to display the combination of a figure and the sun as a halo. This device was quite common among the illustrators working for *Le Courrier Français* (fig.34,35,36).[106] Illustrators had the advantage of being able to use such a bold compositional device which for the painters of the time was surely considered a violation of conventional and "realistic" pictorial space.

The importance of *Le Courrier Français, pour les inondés du Midi* is not confined to its pictorial influence. This special issue was published to offer financial support to the Midi which suffered enormous damage as a result of the flood of the Rhône in 1886. This publication was just one in a series of manifestations held in late 1886 in aid of the sufferers of the Midi. The most important of these was a series of festivals entitled "Fête du soleil" which took place at the *Palais de l'industrie* in Paris between December 23 and January 6 (fig.37). In the large space of the *Palais* picturesque cottages, a windmill and a tower were built. A gigantic electric light with a circumference of 8 meters, imitating the sun of the Midi, was hung from the ceiling, and under this artificial sunlight Parisiens could enjoy the Tambourin, the Farandole, the Tarasque, the theater of the Midi and the dance of the Arlésiennes (fig.38,39). During this time, the pages of the illustrated magazines were full of articles on and illustrations of the festivals (fig.40,41). *Le Courrier Français* rented one of the stalls in the *Palais de l'industrie* for the sale of their magazines, and a "charmante petite Arlésienne" sold the special issue to the public.[107] The lack of sufficient documents for Van Gogh's Paris period makes it difficult to ascertain whether Van Gogh visited the festival or how he responded to the whole event. But it is quite unlikely that the events and publications could have escaped Van Gogh's attention. The festivals undeni-

ably played a role in Van Gogh's decision to go to the Midi and specifically to Arles, because in Paris he had had the opportunity to see fragments of the culture of the Midi and real Arlésiennes.[108]

It was in a letter to H.M. Livens that Van Gogh first wrote of his idea of going to the Midi. Today this letter is dated by scholars almost unanimously to the summer or autumn of 1886, with the exception of Roland Dorn who recently suggested the possibility of redating it to about a year later.[109] The problem of the dating of this letter is difficult to resolve, but if it is to be redated to 1887, as Dorn suggests, we then have no proof of the fact that Van Gogh was planning to go to the Midi as early as 1886. In that case the *Fête du soleil* had much more, or even definitive, significance for Van Gogh's decision to go to the Midi. Even if the letter does date from 1886, and Van Gogh had already chosen the Midi before the *Fête du soleil*, his choice of Arles may still have been influenced by this festival.[110]

The timing of the festival is also quite significant with regard to Van Gogh's thematic naturalization. It is from 1887 onward that the sun and sunflowers become important motifs in his thematic program. Two small rough sketches from 1884-1885 and 1887 (fig.42,43) show most clearly that the substitution of the sun for the church occurred in about 1887.[111] In both sketches three motifs are depicted; lovers with trees and a church in the former and lovers with sunflowers and the sun in the 1887 drawing. The three motifs are combined in a very similar composition, which shows quite clearly that the church and the trees were replaced by the sun and the sunflowers. In such small sketches, a painter can sometimes express his personal views more clearly than in major works more or less intended for the public, for which the painter has to search for motifs, study them from nature and deploy them within a coherent pictorial space. In other words, a painter can depict and manipulate motifs very easily in such small drawings, without worrying about the final pictorial reality of the motifs rendered.

Imagined suns and sunflowers

We can find similar examples of the manipulation of the sun in Van Gogh's major works as well. His copy after Rembrandt's *Raising of Lazarus* is another and probably the most remarkable example of manipulation from the imagination and the naturalization of motifs (fig.44,45). Van Gogh radically changed the original etching by eliminating Christ and all the other figures except Martha and Mary and by depicting the sun in the background. Jean Leymarie interpreted the replacement of Christ by the sun as an expression of pagan divinity on Van

Gogh's part, but Hulsker does not agree with this interpretation.[112] Hulsker's argument against Leymarie is as follows. The place of Christ in the original print and that of the sun in Van Gogh's painting is not the same. In the etching there is also a source of light — though it is not the sun — at the spot where Van Gogh painted the sun. Christ was eliminated not because of any paganism on Van Gogh's part but rather because of his respect for Christ. When Van Gogh scraped off his religious painting *Christ with angel in the olive garden*, he said that he could not paint such an important figure without a model.[113] Hulsker also points out that the two figures, one with red hair and the other with black hair, were modelled on Madame Roulin and Madame Ginoux. This argument is quite convincing because Van Gogh himself wrote in his description of the painting: "If I still had at my disposal the model who posed for 'La Berceuse,' and the other one whose portrait after Gauguin's drawing you have just received, I should certainly try to carry it out in a large size, this canvas, as the personalities are the characters of my dreams."[114] As some other scholars pointed out, Lazarus, whose beard is painted in red, can be identified as Van Gogh himself. The sun in the picture is described as "the rising sun" by the painter.[115]

From the description in the letter, the painting itself and Van Gogh's own situation when he painted the *Raising of Lazarus*, it would not be an overinterpretation to read this work as Van Gogh's wish for resurrection after his attacks of illness. If this is about what Hulsker intended, I would agree with him, but his criticism of Leymarie, to be more precise, his explanation for the elimination of Christ and the introduction of the sun is not sufficiently convincing. According to Hulsker, the elimination of Christ was caused by Van Gogh's respect for Christ: such an important figure should not be painted without a model. Van Gogh had however already painted Christ and the Virgin Mary in his copy after Delacroix's *Pietà* as well as the figure of an angel (F630 JH1775, F624 JH1778). Moreover, just as in these two copies, Van Gogh *did* have a model for Christ in Rembrandts' *Raising of Lazarus*. As for the rising sun, Hulsker's explanation that there is a source of light in the original etching, gives us no reason why the sun in particular was introduced in the painting.

We have already seen that Van Gogh often employed the motif of the sun and in some cases substituted it for the church motif. The problem of Christ and the sun in the *Raising of Lazarus* should also be understood within this context of naturalization. The rising sun in the painting is probably connected with the theme of resurrection, but the sun of the Midi meant more to Van Gogh. The personal symbolic meaning of the sun in Van Gogh's œuvre can be reconstructed to a considerable degree from his letters as well as from his use of this motif in his works. The following passages from his letter bear witness to the fact that the sun of the Midi was deified in his mind: "Oh! those who don't believe in this sun

here are real infidels. Unfortunately, along with the good god sun three quarters of the time there is the devil mistral."[116] "It might be a real advantage to quite a number of artists who love the sun and colors (amoureux de soleil et de couleur) to settle in the South."[117] The sun of the Midi was for Van Gogh something to be "believed in", "the good god sun" and something to be loved by painters. If we keep in mind these connotations of the Midi sun and the tendency toward naturalization in Van Gogh's thematics, it does not go too far to see a substitution of the sun for Christ in the *Raising of Lazarus*.

Despite the naturalization, Van Gogh's new god, the sun of the Midi, is not free of traditional Christian symbolism. Let us first quote from Laurillard's *Geen dag zonder God* on Psalm 84:12a "For the Lord God is a sun". "This is why the thought could spring up in the poetic soul that the Lord God is a sun. But then we should desire the beams of this sun to shine upon our spirits and our hearts, just as we desire the beams of this sun in nature to bring light and joy into our homes, and life and fruitfulness into our gardens. Indeed, if we believe that we may say, 'The Lord God is a sun,' we must wish our hearts to be as sunflowers, ever turning to the Great Light, in order to receive the full measure of the rays it sends forth."[118]

The sun as a symbol of God or Christ and the sunflower as the symbol of a pious soul is of course not new. In the tradition of emblem books and visual arts, sunflowers were often used as symbols of faith or love. In his *Emblemata* published in 1625, Zacharias Heyns depicted a sunflower facing the sun with the motto "Christi actio imitatio nostra" (Let us imitate Christ) and with a text from John 8:12 "I am the light of the world: he that followeth me shall not walk in darkness, but shall have the light of life" (fig.46).[119] Though I could find no examples in the nineteenth-century "emblem books" made by the clergymen, such symbolism must have survived into the nineteenth century in various publications like Laurillard's text mentioned above. In fact, the Dutch translation of Hieremias Drexelius' *Heliotropium* (*De Sonne-Bloeme ofte Overeenkominge van den menschelijken wille den Godtlijken*) was reprinted as late as 1796 and 1857 (fig.47).[120] Recent iconological studies have revealed that sunflowers were often used in paintings as symbols of profane as well as sacred love. In Otto van Veen's *Amorum Emblemata* of 1608, there is a combination of the sun, a sunflower and a cupid (fig.48). It is not altogether irrelevant to view Van Gogh's sketch of 1887 (fig.43) within the context of this tradition.[121]

Survival of emblems can be recognized in the works of some nineteenth-century painters. In C.D. Friedrich's *The summer* in the Neue Pinakothek in Munich, a sunflower is depicted at the side of lovers.[122] Jan Toorop's *Séduction* of 1886 is also quite interesting in its combination of the three motifs of a church, lovers and a sunflower[123] (fig.49). Toorop depicted a sunflower beside the seduc-

ing young man and a church tower beside the hesitating girl. Though we have no written documents concerning the meaning of these motifs, the church probably symbolizes religion, convention or society and the sunflower is employed as a traditional symbol of love. This painting clearly shows the survival of sunflower symbolism and also the historical background characterized by the opposition of the church and the sunflower. Finally, the cover design by R.N. Roland Holst for the catalogue of the Van Gogh retrospective exhibition of 1892 is also based on this traditional symbolism (fig.50).[124] In this last example, the meaning is obviously secularized, but when we compare it with one of the illustrations in Drexelius' *Heliotropium* (fig.51), it would not be difficult to recognize the survival of the emblematic tradition in the late nineteenth century.

In addition to the *Raising of Lazarus* discussed above, there are some other examples of imaginary suns in Van Gogh's work. In his first letter to Bernard from Arles, Van Gogh made a sketch of his painting *The Langlois Bridge*. The painting was destroyed and only a small fragment remains extant (fig.52 and F544 JH1369). It is a combination of the sun, a bridge and two pairs of lovers. The sun is apparently an imaginary motif, because it is impossible to see the sunset from this spot in March. The painter was standing on the bank of the Arles-Bouc Canal to the south of the bridge, that is to say, he was facing almost directly to the north (fig.53). In the letter to Bernard containing the sketch of *The Langlois Bridge*, Van Gogh wrote about the beauty of Arles and then mentioned the painting of the Langlois Bridge. "Having promised to write you, I will begin by telling you that this country seems to me as beautiful as Japan as far as the limpidity of the atmosphere and the gay color effects are concerned. ... It might be a real advantage to quite a number of *artists who love the sun and colors* to settle in the South. ... At the top of this letter I am sending you a little scratch of a study that engrosses me, because I want to make something of it."[125] After he wrote this letter, the weather got worse, and he had to finish the painting at home. "I have had a setback with the sunset with figures and a bridge that I spoke of to Bernard. The bad weather prevented me working on the spot, and I have completely ruined it by trying to finish it at home. However, I at once began the same subject again on another canvas, but, as the weather was quite different, in gray tones and without figures."[126]

"Another canvas ... in gray tones and without figures" mentioned here is probably the painting in Amsterdam (fig.54). The composition of this painting is quite similar to the sketch in the letter, with the exception of a slight but significant difference in the colors and the figures. In the Amsterdam painting the tower of St. Césaire is depicted behind the center of the bridge. This church tower was indeed visible from this spot in Van Gogh's day. We even have a

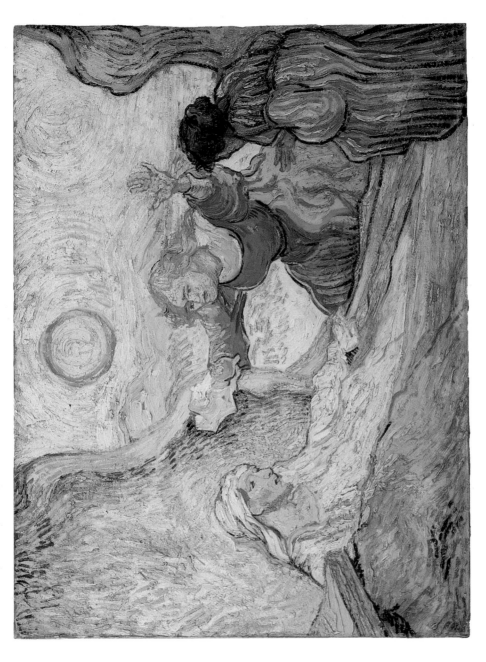

Plate 1. V. van Gogh, *Raising of Lazarus* (copy after Rembrandt) 1890, Rijksmuseum Vincent van Gogh (Vincent van Gogh Foundation), Amsterdam.

photograph taken in 1902 from almost the same angle, in which the tower of St. Césaire is clearly visible behind the center of the bridge[127] (fig.55). In the drawing for Bernard, however, this tower is hidden behind the bridge keeper's house. For this first version Van Gogh had chosen a spot several meters to the right. The differences between these two similar compositions show us some significant points in relation to Van Gogh's manipulation of actual landscapes.

First, in the sketch to Bernard, Van Gogh depicted a sunset which he could not see and added two pairs of lovers. Why he made such manipulations is not clear but it may be understood from the letter in which the sketch was included. As I have already quoted above, Van Gogh wrote about his wish to establish a community of artists in the Midi: "It might be a real advantage to quite a number of *artists who love the sun* and colors to settle in the South." (my italics) The words "artists who love the sun" are of course the key to understanding the imagined sun. By the imagined sun and probably also by the addition of lovers, Van Gogh wished to express a utopian image, which he could not do simply by representing an actual landscape.

Secondly, the failure of the painting with the sun and lovers and the reasonable success of the Amsterdam painting — Van Gogh signed the painting — shows the dilemma with which Van Gogh must have often been confronted. To express his personal ideas or views in a landscape, he had to change reality and manipulate the motifs, or to walk around until he could find an landscape which satisfied his requirements. As Van Gogh himself realized, changing an actual landscape and working from his imagination always involved the risk of losing reality in the representation.[128] In the first version of *The Langlois Bridge*, Van Gogh could not resolve this dilemma. Despite the bad weather he had wanted to paint the landscape in brilliant colors and "ruined" the painting. In the second version, he avoided employing any images which were not observed — the sun, the lovers and the bright colors — and, trying to be faithful to nature, he had to paint in real gray tones.

Thirdly, the absence of the tower of St. Césaire in the sketch for Bernard is also interesting with respect to the problem of the substitution of motifs. When he painted the first version, he was probably standing at a spot where he could not see the church tower. St. Césaire is hidden behind the bridge keeper's house. In the second version the church tower occupies an important place in the composition. It is difficult to know why Van Gogh made this slight but significant change. It seems possible that Van Gogh intentionally chose a spot where he could not see the church tower. For the expression of his ideal community of artists "who love the sun", the church tower is certainly an unsuitable motif.

The imaginary sun also appears in the large drawing *Saintes-Maries-de-la-Mer* (fig.56). Van Gogh depicted the town from the south, while facing almost

directly north. The sun in this drawing is, therefore, an imagined one. In the painted version of the same motif (F416 JH1447), the sun is not depicted. Interestingly, Van Gogh depicted a couple only in the drawing with the imagined sun. As Ronald Pickvance pointed out, the sunset in *Summer Evening* (fig.57; pl.2) is also an imaginary one.[129] The silhouette of the city of Arles in the picture shows that the painter is looking at the city from the north-by-northeast, facing to the south-by-southwest (fig.53). Therefore, he could never see a sunset with this silhouette of the city. Here again, just like in the drawing of Saintes-Maries-de-la-Mer and the destroyed *The Langlois Bridge*, the invented sun is combined with strolling lovers.

In addition to the examples mentioned above, there are more imaginary suns and other imaginary motifs in Van Gogh's work, such as the sunflowers in *The flowering garden* (fig.115; pl.8) which will be discussed in Chapter 6. But it is often difficult to distinguish imaginary motifs from observed motifs. First of all, the location of the depicted scene must be identified, and the major elements of the original landscape would have to remain unchanged today or the original situation would have to be known to us through old photographs or maps. In some cases, however, as described above, clear traces of manipulation can be found. In a rough sketch like the Paris drawing with the sun, sunflowers and a strolling couple (fig.43), manipulation must have been very easy. Even in more serious landscape paintings, the sun or small walking figures can be depicted quite easily from the imagination and without models. Therefore, in the case of these two typical "imaginary motifs" and in some other cases, direct observation or the making of studies do not play a significant role in the creative process.

To return to the problem of substitution, we have seen how the thematic function of the church was taken over by the sun after about 1887, but it does not follow that the church was never depicted after 1887. While Van Gogh had the hope of establishing a community of artists, notable manipulation of the church motif or imaginary churches cannot be found in his work. In landscapes this motif does often appear in the background, but it is mostly depicted in the distant silhouette of the city of Arles. After Van Gogh had nearly given up the idea of the Yellow House, the most remarkable imaginary church appears in *The starry night* (fig.114; pl.7). As is well known, Van Gogh depicted the spire of an imagined church in the Provençal landscape.[130] In his Paris and Arles periods not a single case is known of a church represented as a single major motif, with the exception of two drawings of Notre-Dame and the Panthéon seen from a distance (F1387 JH1098, F1389 JH1096).

In the Auvers period, five paintings are known representing the church at Auvers. One is *The church at Auvers* at the Musée d'Orsay (fig.58), two smaller paintings representing a wheat field in the foreground and the church in the

background (F800 JH2122, F801 JH2123) and the two versions of *Daubigny's garden* (fig.59 and F777 JH2105). In none of these works is the church an imaginary motif as it is in *The starry night*, nor is it combined with agrarian labor. As Van Gogh was living in Auvers during the harvest season, it was possible and would also have been quite easy, in this small village surrounded by wheat fields, to depict the village church with a reaper or with a harvest scene. Van Gogh, however, did not choose this old theme which is so strongly reminiscent of Christian symbolism. He did manipulate the church motif again in compositions which are similar to his works of the Nuenen period. As Ronald Pickvance pointed out, the church in the background of *Daubigny's garden* is depicted much closer to Daubigny's house than it is in reality.[131] It is indeed impossible to include the church from this viewpoint even in this large horizontal canvas. The reason for this manipulation is not clear, but the combination of a church in the background and a garden with a female figure in the foreground is reminiscent of the series of the vicarage garden in the Nuenen period (fig.64 and F1131 JH427, F185 JH484, F1133 JH485). It is only in this series made in Nuenen and *Daubigny's garden* that one female figure in the garden and a church are combined. *The church at Auvers* also has its prototype in two Nuenen paintings (fig.60 and F40 JH507). The combination of one peasant woman and a church can be found only in these two works and *The church at Auvers*. Moreover, Van Gogh depicted a peasant woman in a Dutch peasant's clothes. In Auvers Van Gogh revived themes from Nuenen, but he never went so far as to revive the Van der Maaten-like Christian themes.

The example of the church and the sun is just one aspect of thematic naturalization and substitution. In other motifs and also in the concept of the Yellow House, for example, we can recognize Van Gogh's naturalization and humanization of traditional Christianity. In the following chapters we will see how Van Gogh's other religious themes and his concepts of art and life were developed and transformed throughout his artistic career.

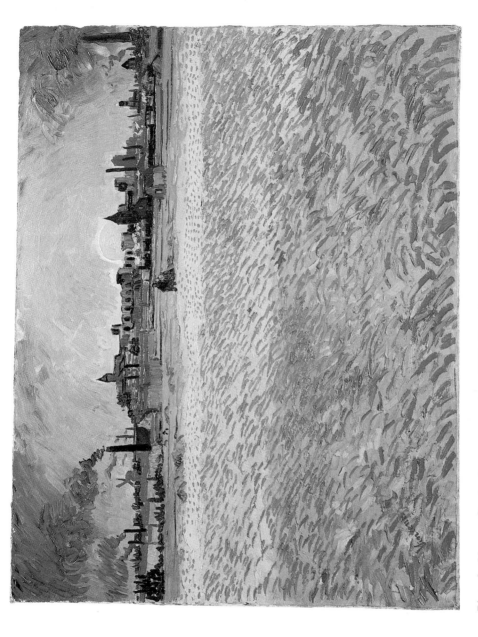

Plate 2. V. van Gogh, *Summer evening*, 1888, Kunstmuseum, Winterthur.

3. Light in the darkness: survival of a Christian concept

Traces of Christianity can be discerned in many of Van Gogh's major themes and motifs. In the previous chapter I have mainly discussed motifs such as church towers, the sun and sunflowers and their symbolic meanings and functions in Van Gogh's thematics. In the present chapter I wish to show how the typically Christian concept of "Light in the darkness" remained alive in Van Gogh's mind and underlay his choice of subject matter, presented in a disguised, naturalized form, throughout his artistic career.

Cimetière de paysans

Shortly after the death of his father, a preacher in Nuenen, Van Gogh painted *The old church tower in Nuenen* (fig.62). The old church tower, which Van Gogh often depicted in his works, was destroyed during his stay in Nuenen. In the painting the tower has already lost its spire. A similar image was depicted a year earlier, in 1884, by Emile A. Breton in his *Old world dying away* (Le vieux monde qui s'en va) (fig.63).[132] Here Breton depicts, in addition to the church tower, the setting sun, trees which have lost their leaves and an old man walking away. No written documents relating to this painting are known to me, but its symbolic meaning seems to be quite intelligible: the decline of Christianity.

I compared these two paintings not because Breton's painting, which was exhibited in the Salon of 1884, might have inspired Van Gogh, nor because the two paintings show thematic similarities, but rather because of the difference between the two. To understand the crucial difference between them, it is sufficient to read Van Gogh's own explanation of *The old church tower in Nuenen*: "I

wanted to express how those ruins show that *for ages* the peasants have been laid
to rest in the very field which they dug up when alive. ... And now those ruins
tell me how a faith and a religion moldered away — strongly founded though
they were — but how the life and the death of peasants remain forever the same,
budding and withering the churchyard. Les religions passent, Dieu demeure, is
a saying of Victor Hugo's whom they also brought to rest recently."[133]

From this passage, as well as from the title *Cimetière de paysans* given by
Van Gogh himself, it is evident that the main theme of the painting is not the
ruin of the church itself but the contrast between the ruin and the graveyard of
peasants, that is to say, between the transience of religions and the eternity of
human life cycles. This contrast, which might be called one of the basic themes
in Van Gogh's œuvre, is not present in the painting by Breton.

Before its destruction, the same church tower was depicted in a series of
drawings in combination with a woman standing in the vicarage garden, and on
one of them he inscribed the title "Mélancolie" (fig.64). This series (F1128
JH466, F185 JH484, F1133 JH485, possibly also F88 JH490, F40 JH507) could
probably be understood as an image of a woman who remains in a state of
melancholy, depressed in the theologians' moral world, for, in a letter from 1884
when this series was made, Van Gogh wrote about Kee Vos-Stricker, for whom
he felt unrequited love: "*That disturbing the tranquillity of a woman,* as theolog-
ical people call it (sometimes theologians *sans le savoir*), is sometimes *the break-
ing of stagnation or melancholy*, which steals over many people, and is *worse
than death itself*."[134] Kee was Van Gogh's cousin, a daughter of Rev. J.P.
Stricker mentioned in Chapter 1, who had been widowed and left with a son. In
1881 Van Gogh had asked for Kee's hand, but she and her father rejected his
proposal. By the words "disturbing the tranquillity of a woman" Van Gogh is
alluding to this affair. A very long letter from December, 1881, gives us the
details on the conflict with Stricker. This affair must have been one of the defini-
tive factors which made Van Gogh feel a strong dislike for the theologians'
God.[135] Van Gogh returned to discuss the affair of three years before in the let-
ter quoted above, because he was then, in 1884, in love with Margot Begemann,
again a daughter of a preacher in Nuenen, Willem Lodewijk Begemann, and
because he was in conflict with his father and with the Begemann family.

Although Van Gogh does not write about the meaning of the combination
of a church and a woman, the inscription "Mélancolie" can be related to the pas-
sage quoted above. The old church tower, then, is used as a symbol of the
theologians' God or traditional Christianity just like it was in *The old church
tower in Nuenen*.

Still life with open Bible

The basic theme "traditional religion versus human life" appears in even sharper contrast in the *Still life with open Bible* (fig.65; pl.3), painted five months later, in October 1885. This painting of Van Gogh's has attracted a great deal of attention from iconologists, especially because of the two inscriptions on it which read "ISAIE LIII" and "EMILE ZOLA, LA JOIE DE VIVRE", and the extinguished candle, a traditional symbol which was often employed in Vanitas representations. The picture was painted about six months after his father's death, and the open Bible had belonged to the elder Van Gogh. Recently this Bible was rediscovered and was given on loan to the Rijksmuseum Vincent van Gogh[136] (fig. 65a). Although the painter made no comments on the symbolic meaning of the painting, the work itself provides a number of keys to interpretation. However, the interpretations made so far by iconologists and psychologists are quite varied.[137] Most scholars have interpreted the juxtaposition of the Bible and *La Joie de vivre* as an opposition between the traditional Christianity of Vincent's father and modern literature, though all of their interpretations are different in detail. This painting is indeed a good example of what Willey called the "substitution of literature for the Bible" in characterizing Carlyle's contribution.[138]

This interpretation is supported by many other sources, both stylistic and iconographical, and we can recognize in them one of the basic themes of Van Gogh's œuvre, namely "Light in the darkness". The contrast between the bright yellow color of *La joie de vivre* and the dark tones of the Bible and the background was not simply an experiment in the color theory, which Van Gogh was then studying. The concept "light in the midst of darkness", which has its source in John 1:5, is what Van Gogh had called "one of the roots or foundations, not only of the Gospel, but of the whole Bible" in a letter written in 1878, shortly before he began his apprenticeship as a preacher.[139] In this letter he quoted a passage from a book on the miners in the Borinage who worked with a lamp in the darkness, and included the sketch "Au charbonnage" in which a crescent moon is depicted as a source of light in the darkness. The theme "light in the darkness" occurs most frequently in his letters during the period when Van Gogh was hoping to become a clergyman or a preacher. Let us quote a few examples: "I cannot sit up so late in the evening any more — Uncle has strictly forbidden it. Still I keep in mind the phrase under the etching by Rembrandt, 'In medio noctis vim suam lux exerit' (in the middle of the night, the light diffuses its strength), and I keep a small gaslight burning low all night; in medio noctis I often lie looking at it...".[140] "How would a man like Father, who so often goes long distances, even in the night with a lantern, to visit a sick or dying man, to speak with him about One whose word is a light even in the night of suffering

and agony — how would he feel about Rembrandt's etchings, for instance, 'The Flight into Egypt in the Night' or the 'Burial of Jesus'?"[141] The etchings of Rembrandt mentioned in the last letter indeed show the effect of light in the darkness (fig.66,67). Four years later, shortly after Van Gogh decided to be an artist, he sent Theo his own drawings *En route* and *Devant les tisons*, in which the theme "light in the darkness" was taken up again[142] (fig.68,69).

The most important key to an understanding of the contrast between the French novels and the Bible can be found in a letter to Wil written in 1887 in Paris: "...and if with good intentions we search the books which it is said *shed light in the darkness* — though inspired by the best will in the world, we find extremely little that is certain, and not always the satisfaction of being comforted personally. And the diseases which we civilized people labor under most are *melancholy* and pessimism. ... I, for instance, feel first of all the need of a thoroughly good laugh. I found this in Guy de Maupassant. ... If on the contrary one wants truth, life as it is, then there are for instance de Goncourt in *Germinie Lacerteux*, *la Fille Elisa*, Zola in *La joie de vivre* and *L'assommoir* and so many other masterpieces. ... The work of the French naturalists, Zola, Flaubert ... is magnificent, and one can hardly be said to belong to one's time if one has paid no attention to it. ... Is the Bible enough for us? In these days, I believe, Jesus himself would say to those who sit down in a state of *melancholy*, It is not here, get up and go forth. Why do you seek the living among the dead?"[143] (my italics) Here French naturalist literature is considered as something which shed "light in the darkness", and with the word darkness Vincent is apparently indicating the "melancholy and pessimism" in the old dogmatic, conventional Christianity of his father. Like in the "Mélancolie" series mentioned above, the word "melancholy", together with "rayon noir", is used in some letters in connection with his father or other theologians.[144]

Thus, French naturalist literature in general had a positive meaning for Van Gogh as opposed to the world of his father's religion. This interpretation of the theme French novels can be supported by the chronological table (see Appendix I) and also by the current interpretations of other still lifes with French novels. With the exception of the *Still life with open Bible* and the *Portrait of Dr. Gachet* (F753 JH2007) of 1890, yellow books (French novels) occur exclusively in works dating from 1887 and 1888. As I will discuss in the following chapters, this was the period during which themes like sunflowers and strolling lovers, what I call "utopian themes", became dominant. In the *Still life with three books* (fig.70) and the *Still life: plaster statuette and books* (F360 JH1349) the titles of the books are legibly rendered, and from the contents of the books, the theme of these paintings has been interpreted as one of love. Moreover, as some scholars have already pointed out, the yellow books are combined with a burning candle in

Gauguin's chair (F499 JH1636) and not with an extinguished candle like the *Still life with open Bible*.[145]

Since the inscription "ISAIE LIII" is more specific than "LA JOIE DE VIVRE", the difference in interpretations is mainly the result of variant interpretations of Zola's book. Nordenfalk is relying exclusively on the title "la joie de vivre" when he interprets the two books as a contrast of joy symbolized by Zola's book and death, sorrow and suffering symbolized by the candle and the biblical passage. Lövgren, Takashina and Werness looked for the symbolic meaning of Zola's book in the contents of the novel. Since *La joie de vivre*, in contrast to its title, is a rather tragic story, Lövgren even denies the contrast with the Bible and claims that the two books together are symbolic of Van Gogh's pessimism. Takashina and Werness see Van Gogh's counterpart in the personages of Pauline and Lazare respectively. However, there is no real reason to believe that the contents of the novel or certain of its personages are particularly significant with respect to the symbolic meaning of the whole composition, and any interpretations based on the contents of the novel remain more or less speculative. I wish to suggest here that the title "La joie de vivre", and not the contents of the novel, is the principal message to be interpreted.

The words "la joie de vivre" are used several times in Van Gogh's letters in a quite symbolic sense. This fact seems to have been overlooked so far in the interpretations mentioned above. Let us quote from three letters written in 1885, 1888 and 1889.[146] The first letter was written shortly after the death of Vincent's father and the painting of the *Still life with open Bible*; "...for it is often true that fortune favors the bold, and whatever may be true about *fortune or 'la joie? de vivre,'* as it is called, one must work and dare if one really wants to live." (my italics) In the second and the third letters "la joie de vivre" is not set in quotation marks and the French words are not retained in translations of the letters. Thus, in the English translation of the letters, the personal meaning that Van Gogh imparts to these words is totally lost. The next passage is about his uncle Vincent who was then seriously ill. "And then to see someone whom you have always seen on the go reduced to such a condition of suspicious helplessness and continual suffering, it certainly doesn't give one *a pleasant or cheery idea of human existence or heighten one's zest for life* (n'augmente pas la joie de vivre)." (my italics) The last letter was written after the collapse of his hopes for the Yellow House: "...the fact is that I am quite well; but, as I told you, my *inclination to take up the joys of life again* (l'envie de recommencer la joie de vivre) can hardly be called strong." Here Van Gogh is most probably referring to his ideal of a community of artists in the Yellow House with the words "la joie de vivre". From these passages it is clear that the title of Zola's novel acquired meanings of its own within Van Gogh's vocabulary. Although its meaning is not distinct, it

connotes "fortune" (geluk), "a pleasant or cheery idea of human existence" (une idée engageante et gaie de la vie humaine) and the ideal communal life of artists.

Apart from the case of "la joie de vivre", Van Gogh sometimes used titles of literary works in his letters in a relatively ambiguous symbolic sense. For example, in his description of *The Night Café* (F463 JH1575) in a letter to Theo, Van Gogh wrote, "So I have tried to express, as it were, the powers of darkness of a low public house (la puissance des ténèbres d'un assommoir)."[147] Here *L'assommoir* by Zola and *La puissance des ténèbres*, the French title of Tolstoy's play, are used to describe what Van Gogh wished to express in the painting. The French translation *La puissance des ténèbres* was published in 1887 during Van Gogh's stay in Paris. The play was performed by André Antoine on February 10th and 17th, 1888 — shortly before Van Gogh left for Arles — at the *Théâtre Libre*, where Van Gogh exhibited his works with Seurat and Signac. If Vincent and Theo knew this play — which seems quite probable — by reading the book or the reviews in periodicals or even by seeing Antoine's performance itself, Theo could have easily imagined the *traktir* (café) in Tolstoy's play and understood the implications of "la puissance des ténèbres d'un assommoir".[148] Indeed, the "assommoir de Père Colombe", an ominous *Leitmotiv* in Zola's novel symbolizing the fall of Gervaise, and the *traktir* where Nikita drinks himself into a stupor, correspond with what Van Gogh wished to express in his *Night Café*.

The yellow book with the title "la joie de vivre" is depicted in another painting, the *Still life with a vase of oleander and books* (fig.71), painted in the summer of 1888 when Van Gogh had the highest hopes of establishing a community of artists in his Yellow House. In this still life, *La joie de vivre* is combined with a vase of oleander instead of the Bible and extinguished candle. Let us view this new motif, oleander, in the light of other works and of some significant descriptions in the letters. It is not very difficult to reconstruct its connotations. Oleanders are often depicted in the garden scenes painted in the summer of 1888, and in the *Portrait of a mousmé* (fig.79) a young Arlésienne, portrayed with the features of a Japanese girl, is holding a branch of oleander in her left hand. Shortly afterward, in September of 1888, Van Gogh wrote about his plan to put two oleander trees at the entrance of the Yellow House, and in April, 1889, he wrote: "The oleander — ah! that speaks of love and is beautiful like the Lesbos of Puvis de Chavannes."[149] The combination with a Japanese *mousmé*, the decoration for the entrance of the Yellow House and the passage "that speaks of love..." show clearly that the oleander is closely related to Van Gogh's imagined utopia of artists, which was based on friendship and love and had Japanese artists as its model. The utopian connotations of Japan will be discussed in the next chapter. There are some traditional Christian and profane meanings of the oleander, but they do not seem to be related closely with the meaning Van Gogh

personally confers upon this plant.[150]

Triptych: olive grove, book shop, wheat field

In 1889, as Van Gogh wrote in the letter to Wil quoted above, he had little hope "de recommencer la joie de vivre", but, interestingly enough, the concept "light in the darkness" was still alive in his mind. Shortly before Van Gogh left Saint-Rémy, he imagined a triptych "olive grove, book shop, wheat field" and described it as follows: "I think that I still have it in my heart to paint a book shop with the front yellow and pink, in the evening, and the black passers-by — it is such an essentially modern subject. Because it seems to the imagination such a rich source of light, say, there would be a subject that would go well between an olive grove and a wheat field, the sowing season of books and prints I have a great longing to do it like a light in the midst of darkness."[151] It is not known if the central panel "a book shop with the front yellow and pink, in the evening" was actually painted after his return to the north. Neither is it clear whether Van Gogh had specific paintings in mind for the wings of the triptych. When he wrote the letter in November, 1889, he had just finished five paintings of olive trees (F710 JH1856, F586 JH1854, F587 JH1853, F707 JH1857, F708 JH1855), and was still working on *Wheat field with rising sun* (F737 JH1862).[152] He may have intended one of the five paintings of the olive trees and *Wheat field with rising sun* for the triptych. However that may be, the books in the yellow and pink show windows of a Paris book shop are described as the light in the darkness in the same way that he described naturalist literature in the letter to Wil.

What Van Gogh called an "essentially modern subject", however, was by no means essentially modern. The subjects of the proposed triptych, an olive grove, a book shop as the "sowing season of books and prints" and a wheat field, undoubtedly have biblical allusions. Van Gogh tried to substitute naturalist literature for the Bible. He tried to shed the light of "la joie de vivre" in the darkness of the melancholy in the theologians' world in the *Still life with open Bible*. But in trying to deny the traditional Christianity and to cure religious melancholy, Van Gogh was undoubtedly following precepts which he had learned from Christianity.

The survival of a Christian theme in a "modern" painting by Van Gogh can also be found in another projected triptych; "sunflowers-La Berceuse-sunflowers" described in a letter from Saint-Rémy (fig.72). The religious character of this triptych has already been discussed by several scholars and their interpretations of Madame Roulin in *La Berceuse* as a "modern madonna" are mainly based on the following passage in a letter written in September 1889. "And I

must tell you — and you will see it in 'La Berceuse,' however much of a failure and however feeble that attempt may be — if I had had the strength to continue, I should have made portraits of saints and holy women from life who would have seemed to belong to another age, and they would be middle-class women of the present day, and yet they would have had something in common with the very primitive Christians."[153]

Recently Evert van Uitert pointed out that since the time of Romanticism the consoling power and function of religion has been taken over by art, and he further related *La Berceuse* to Ary Scheffer's *Christus Consolator* as concerns their common consoling function. A reproduction of Scheffer's painting hung in Van Gogh's room together with Van der Maaten's *Funeral procession in the wheat field*, and both works were favorites among Dutch clergymen.[154] Iconographically, *Christus Consolator* and *La Berceuse* are, of course, totally different, but the comparison is by no means irrelevant. Especially when we read the following passages from Van Gogh's letters, the consoling character of *La Berceuse* becomes clear. The first passage is from a letter written in January 1889 to Gauguin: "And I believe that if one put this picture (*La Berceuse*) such as it is in a fisherman's boat, even of Icelandic fishermen, there would be those who would feel inside there the cradlesong (la berceuse). Ah! my dear friend to make painting like that which is already before us the music of Berlioz and Wagner... *a consoling art* for broken hearts! As yet there are only a few of us like you and me who feel!!!"[155] (my italics) The next passage is from the letter quoted above in which Van Gogh wrote about the "portraits of saints and holy women...". He is complaining that the attacks of illness tend to take a religious turn, and he again writes about "consolation": "...even when suffering, sometimes religious thoughts bring me great consolation."[156] Thus, the *La Berceuse* triptych has a quasi-religious character not only as a "modern madonna" but also as an image with the consoling power which, before Romanticism, was mainly the province of religion.

Let us now return to the concept "from darkness to light". Quite ironically, but perhaps not at all surprisingly, Van Gogh's ideas about religious melancholy, his concept of "from darkness to light" and his search for true religion can be properly characterized by the following passage in Spurgeon's sermon "Healing beams".

"Live in the sunlight: get out of the shadows. There are dreary glens in this world where the sun never shines... Get away from those chill places into the clear light. 'But,' says one, 'I did not know there was a joy for religion.' You do not know true religion, then, for it is 'a thing of beauty, and a joy for ever.'"[157] This passage is strongly reminiscent of the passage in Van Gogh's letter quoted above, in which he talked about French novels as being "light in the darkness"

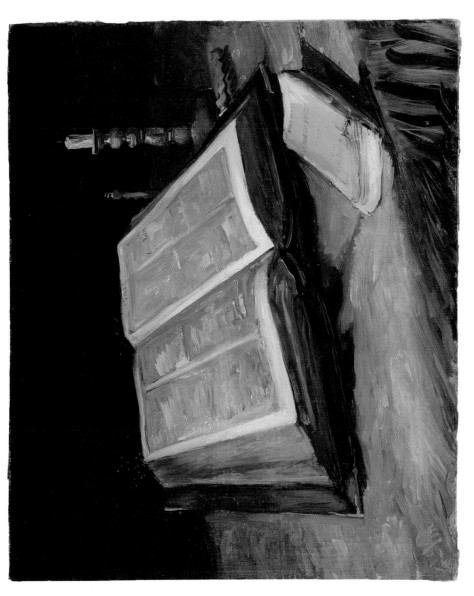

Plate 3. V. van Gogh, *Still life with open Bible*, 1885, Rijksmuseum Vincent van Gogh (Vincent van Gogh Foundation), Amsterdam.

and then wrote: "Is the Bible enough for us? In these days, I believe, Jesus himself would say to those who sit down in a state of *melancholy*, It is not here, get up and go forth. Why do you seek the living among the dead?"[158]

Such a healing power for religious melancholy, which Spurgeon found in the sunlight and Van Gogh found in "la joie de vivre" and later in the sun of the Midi, can be understood in a broader historical context. In the chapter "'Nature' in Wordsworth" of his *The eighteenth century background, studies on the idea of nature in the thought of the period*, Basil Willey points out that the poets and writers who most powerfully felt the healing influence of "Nature" were often those who were most subject to gloominess and nervous depression such as Cowper, Rousseau, Wordsworth, Tennyson, Arnold and Mark Rutherford. He further stated: "...we may conjecture that it was owing to the commanding authority of the idea of Nature at that time, as well to the more obvious sanative virtues of the open-air, that they could find amongst fields and mountains a substitute religion — even, as with Cowper and Rutherford, a *cure* for religion, or at least for *religious melancholy*."[159] (my italics) In his inclination to find a substitute for traditional Christianity and to seek a "cure" for religious melancholy, Van Gogh undoubtedly belonged to this group of artists.

4. Japan as primitivistic utopia: Van Gogh's *japonist* portraits

> J'ai toujour encore présente dans ma mémoire.
> l'émotion que m'a causé cet hiver de Paris à
> Arles. Comme j'ai guetté si cela était déjà
> du Japon! Enfantillage quoi.[160]

In a letter from Arles Van Gogh wrote to Theo: "The weather here remains fine, and if it was always like this, it would be better than the painter's paradise, it would be absolute Japan."[161] Those who have read Van Gogh's letters from Arles cannot fail to have noticed that Japan is regarded as a utopia. He identified the Midi with Japan,[162] and himself with a Japanese bonze in his *Self-portrait as a bonze* (fig.74; pl.4). When Van Gogh first showed an interest in Japanese prints, in 1885, his *japonisme* was nothing but exoticism, but later, at Arles, it developed into a synonym for his utopian ideal. In this sense his *japonisme* was not just a problem of artistic device.

The literature on Van Gogh's *japonisme* is now quite extensive, and many of the stylistic and iconographical influences on his works have been identified.[163] These studies, however, have not explained the core of his *japonisme*, namely as an expression of his utopian thought, nor have they adequately explained his extraordinary enthusiasm for Japan in his Arles period. His japonist portraits, in particular, have not been interpreted properly by these iconographic and stylistic analyses.

My first aim in this chapter is to reconstruct the meaning of the words "Japon" and "japonais" in Van Gogh's letters, and secondly to interpret his japonist portraits as an expression of his utopian ideals. *Japonist* literature of the period — the Goncourts, Loti and S. Bing's periodical *Le Japon Artistique* — and Van Gogh's reaction to it, offer us new keys for the interpretation of his

japonist portraits,[164] namely the portraits of Tanguy, the *Portrait of a mousmé*, the *Self-portrait as a bonze* and the *Self-portrait with a Japanese print* (figs.75,79,74,90; pl.4).

In 1885, during his stay in Antwerp, Van Gogh first announced his interest in *Japonaiserie*. He already owned some Japanese prints at the time, but his interest in them was primarily for their exotic content. "One of the Goncourts' sayings was 'Japonaiserie for ever.' Well, those docks are an extraordinary Japonaiserie, fantastic, peculiar, unheard of — at least one can take this view of it — but above all — Japonaiserie. I mean, the figures are always in action, one sees them in the queerest surroundings, everything fantastic, and at all moments interesting contrasts present themselves."[165] In the same letter, he writes that the Japanese prints which he has pinned on the wall "amuse" him very much.[166] He shows an interest in various motifs such as "little women"'s figures, flowers, knotty thorn branches." His interest in Japonaiserie was stimulated by Edmond de Goncourt's *Chérie*, which he had read in Nuenen,[167] but it is worth stressing that in Antwerp Van Gogh showed no interest in the coloristic aspects of the prints which were later to attract him so strongly. He was mainly concerned with their exotic and expressive character.[168]

It was in Paris, where he saw and studied numerous Japanese prints and read much more about Japan, that the country took on a more serious meaning for Van Gogh, both personally and as an artist. Unfortunately it is almost impossible to trace the evolution of Van Gogh's image of Japan during his stay in Paris, for he wrote few letters during this period.[169] We can only presume that it changed radically, especially during the second half of his Paris period. Van Gogh portrayed Tanguy with Japanese prints in the background, and an Italian woman (Segatori?) with a Japanese decorative pattern (fig.75 and F381 JH1355). The three copies after Japanese prints (F371 JH1296, F372 JH1297, F373 JH1298) were also painted at this time. The earliest letters from Arles show us this change more clearly: "Having promised to write you, I will begin by telling you that this country seems to me as beautiful as Japan as far as the limpidity of the atmosphere and the gay color effects are concerned."[170] Such an image of Japan as a luminous country was not Van Gogh's own invention. In the Goncourts' novels, *Manette Salomon* and *Maison d'un artiste*, which Van Gogh must have read in Paris, we find a similar image of Japan. In *Manette Salomon* the Goncourts describe the atelier of the painter Coriolis de Naz in Paris. Tired from his work, Coriolis takes an album of Japanese prints, and imagines the unknown luminous country. "And those Japanese albums gave birth to a day in that enchanting land, a day without shadow, filled with light. ... The winter, the gray outside, the poor shivering sky of Paris, he banished them all, forgot them there by the side of those seas as limpid as the heavens, ... then those visions of

Japan were cut through by the light of reality, by the wintry sun of Paris, and by the lamp brought into the studio."[171]

Later, in *Maison d'un artiste*, Edmond de Goncourt recollects his collaboration with his brother Jules on *Manette Salomon* and their interest in Japonaiserie. "It is there that you will find those books of sunny prints in which, on the gray days of our dreary winter, with its cold, grimy skies, we made Coriolis (ourselves in fact) seek some of the agreeable light of the empire of the RISING SUN."[172]

These passages cannot be overlooked, coming as they do from one of the most influential novelists and *japonisants* of the day, who also happened to be one of Van Gogh's favorite writers. In the Parisian atmosphere of *japonisme* Van Gogh evidently came to share the view of the Goncourts. Like Coriolis de Naz and the Goncourts themselves, he apparently experienced the "agreeable light of the empire" under the gray sky of Paris.

Portraits of Tanguy

The image of Japan as a luminous land, however, does not offer us enough evidence for a convincing interpretation of the *Portrait of Tanguy* (fig.75).[173] Why is the old art dealer depicted with Japanese prints? What is the meaning of those prints? First let us examine the character of the sitter, Père Tanguy, as described by his contemporaries, Emile Bernard and Van Gogh himself. The following passage by Bernard is the most vivid account.

> Julien Tanguy, who read *Le Cri du Peuple* and *L'Intransigeant* assiduously, believed in that absolute love which brought all mankind together and destroyed the individual struggles of ambition, always so bitter and cruel. Vincent only differed from that ideal in his artistic nature, which impelled him to view this social harmony as a sort of religion and system of aesthetics. ... I am sure that Julien was won over more by Vincent's socialism than by his painting, which he nevertheless venerated as a sort of visible manifestation of inner hopes. But in the meantime, before this era of happiness dawned, both of them were extremely poor, and each gave what he had — the painter his canvases, and the tradesman his colors, his money and his table — to friends, to laborers, or to prostitutes who, when they received paintings, sold them for nothing to junk shops. And all this was done without the slightest self-interest for people they did not even know."[174]

According to Bernard, Tanguy was a naive utopian socialist, and he shared Van Gogh's faith in a utopia, an "era of happiness." The following passage from one of Van Gogh's Arles letters provides a link between this utopian socialism

and Japan. "Here my life will become more and more like a Japanese painter's, living close to nature like a petty tradesman. And that you well know, is a less lugubrious affair than the decadent's way. If I can live long enough, I shall be something like old Tanguy."[175] Here the Japanese painter is regarded as an inhabitant of the ideal society of both Tanguy and Van Gogh. Here then, the image of the Japanese is tinted by Van Gogh's ideal of primitive socialism, and that image overlaps with that of Tanguy.[176] In other words, the juxtaposition of Tanguy and the Japanese prints was not a mere whim. The prints represented a shared utopia, and were thus perfectly appropriate for this naive tradesman.

Another interesting point concerning the *Portrait of Tanguy* is the unusual symmetrical pose, which John House believes may have been borrowed from a Buddha figure.[177] Emile Bernard states in his article on Tanguy: "Vincent painted him seated in a room lined with Japanese *crépons*, wearing a large planter's hat and in a symmetrical frontal pose like a Buddha."[178] Tanguy's symmetrical pose is indeed an unusual one in the history of modern portraiture, and Bernard's and House's comparison with a Buddha figure is not altogether irrelevant. One of the illustrations in Louis Gonse's *L'Art Japonais*, "Statuette de bonze, par Hissatama Oukousou" (fig.76), is remarkably similar to the portrait in its frontality, and especially in its clasped hands.[179] There is a copy of Gonse's book (in the edition of 1883) in the Rijksmuseum Vincent van Gogh as part of the former collection of the Van Gogh family. This, together with the similarity of the pose, suggests that Van Gogh did indeed base his composition on this reproduction.

By depicting Tanguy in the pose of a Japanese bonze against a background of Japanese prints, Van Gogh was expressing a utopian ideal. And in his mind that utopia probably overlapped with the image of another luminous land, the Midi.[180]

Portrait of a mousmé

In February, 1888, Van Gogh arrived at Arles with great expectations of seeing his Japan. In his letters from Arles he frequently described the motifs and his paintings as being "like Japan" or "like a Japanese print." He made drawings with a reed pen, and was planning to make an album of drawings "like a Japanese album" for Gauguin and Bernard (fig.77).[181] Judging from this sketch in letter 492, Van Gogh's model for the "Japanese album" must have been a folding album of Japanese prints such as *Shinsen Kachō no Kei* (Glimpses of newly selected flowers and birds) which was formerly in the collection of the Van Gogh family and is now in the Rijksmuseum Vincent van Gogh[182] (fig.78).

At Arles his image of Japan crystallized further, a process in which Loti's *Madame Chrysanthème* and Bing's monthly magazine *Le Japon Artistique* played an important role. Van Gogh read *Madame Chrysanthème* in June 1888 and mentioned it frequently in his letters, and from them we know that the *Portrait of a mousmé* (fig.79) was inspired by this exotic novel.[183] The somewhat curious features of the *mousmé* in the portrait can be explained by the following passage in which Loti mentions the word "mousmé". "Mousmé is a word for a girl or a very young woman. It is one of the nicest words in Japanese, for it contains suggestions of 'moue' (that sweet, funny little moue they have), and above all 'frimousse' (that impish little face of theirs)."[184] From all the versions of the *Portrait of a mousmé* (especially fig.80), it is obvious that Van Gogh adopted the feature of the mouth of the *mousmé* as described in Loti's novel. One of the illustrations, a portrait of Madame Chrysanthème by Rossi (fig.81), also shows the "moue" as described by Loti, and it must have been a visual source for Van Gogh.[185]

The sitter for Van Gogh's *Portrait of a mousmé* is unknown, but a portrait of a girl in Arles by Christian Mourier-Petersen, a Danish painter who was staying in Arles until May, 1888, shows some resemblance to the *mousmé* (fig.82). The age, hair style and the shape of the eyebrows of the sitters are very similar, though the eyes, nose and mouth in Van Gogh's portrait are totally different from those in Mourier-Petersen's picture. The difference may be the result of the Japanese features which Van Gogh gave to the Arlésiennes. Since Van Gogh painted the *Portrait of a mousmé* after Mourier-Petersen left Arles to stay at Theo's apartment in Paris, there is no possibility that the two painters worked together. Van Gogh always had difficulty in finding models except for a few close friends like Tanguy or the Roulin family, and it is not likely that there were many young girls who were willing to pose for a foreign painter like Van Gogh. It seems possible, therefore, that Van Gogh knew the girl through Mourier-Petersen. If the two portraits were painted from the same model, we can see how Van Gogh transformed the features of the girl, from the slender pale face in Mourier-Petersen's portrait to the "Japanese" face.[186]

In addition to the Japanese features of the girl, the small branch of oleander in her hand should not be overlooked. As noted in Chapter 3 "Light in the darkness", the oleander was a motif with utopian connotations, which is also depicted together with Zola's *La joie de vivre* in the *Still life with a vase of oleander and books* (fig.71).[187] In the *Portrait of a mousmé*, Van Gogh rendered a utopian image through the combination of a Japanese *mousmé* and an oleander branch, as he had done in Paris with the Japanese prints and the old tradesman in the *Portrait of Tanguy*.

Other illustrations in *Madame Chrysanthème* must also have fascinated Van

Gogh. In addition to the portrait of Madame Chrysanthème, there are some interesting illustrations which can be associated with Van Gogh's subjects or his ideas about the Japanese. For example, there are several illustrations of cicadas, of which Van Gogh also made a drawing (fig.83,84), and illustrations of a Japanese painter working with a brush (fig.85). These last two illustrations and the descriptions of this Japanese painter, Monsieur Sucre, must have stimulated Van Gogh to formulate the following impression: "I envy the Japanese the extreme clearness which everything has in their work. ... Their work is as simple as breathing, and they do a figure in a few sure strokes with the same ease as if it were as simple as buttoning your coat."[188]

Although Loti's book is full of distorted images of Japanese life, it did give Van Gogh a vivid impression of the Japanese and helped him to crystallize his own ideal image of Japan. His further reading accelerated this process of crystalization, which reached its culmination shortly before Gauguin's arrival.

Self-portrait as a bonze

In September, 1888, Van Gogh painted a self-portrait which he dedicated to Gauguin (fig.74; pl.4). In it he overtly identified himself with a Japanese monk. He wrote to Gauguin: "But as I also exaggerate my personality, I have in the first place aimed at the character of a simple bonze worshipping the Eternal Buddha."[189] The features of this portrait, the round head, slanted eyes and the nose, are unmistakably those of a Japanese bonze. Here too, one of the illustrations in *Madame Chrysanthème* might have given him a physiognomic model for his self-portrait[190] (fig.86). He probably had little opportunity to see or study the features of a Japanese, so illustrations and reproductions in books would have been the most important sources for him. The clasped hands of the bonze in the reproduction in Gonse's *L'Art Japonais* are not typical of a Japanese bonze, but Van Gogh would have assumed they were the pose of a bonze. Loti's description of the mouth of a *mousmé* ("moue" and "frimousse") is not correct, but it was the first and only description of a Japanese girl that Van Gogh had heard. Lack of knowledge of a foreign country is not a disadvantage for one drawn to the exotic; it is rather one of the preconditions for utopian thought.

"Japonais" as primitivist

Much more important than such "source" problems are Van Gogh's reasons for identifying himself with none other than a Japanese bonze. In this connection we

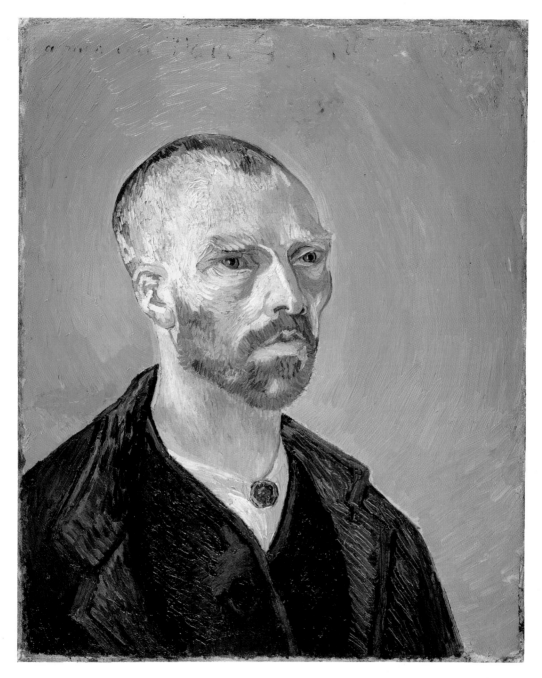

Plate 4. V. van Gogh, *Self-portrait as a bonze*, 1888, Fogg Art Museum, Cambridge, Massachusetts.

should also recall the portraits of Tanguy. Why did he paint Tanguy in a pose reminiscent of a bonze and himself with the features of a bonze? The first clue, I believe, can be found in a letter written about 25 September, 1888, which contains a very interesting and peculiar interpretation of the Japanese.

> If we study Japanese art, we see a man who is undoubtedly wise, philosophic and intelligent who spends his time doing what? In studying the distance between the earth and the moon? No. In studying Bismarck's policy? No. He studies a single blade of grass (*un seul brin d'herbe*). But this blade of grass leads him to draw every plant and then the seasons, the wide aspects of the countryside (*les grands aspects des paysages*), then animals, then the human figure. So he passes his life, and life is too short to do the whole.
>
> Come now, isn't it almost a true religion which these simple Japanese teach us, who live in nature as though they themselves were flowers?
>
> And you cannot study Japanese art it seems to me without becoming much gayer and happier, and *we must return to nature in spite of our education and our work in a world of convention*. (my italics)[191]

Such an image of the Japanese — primitive, religious *homme de la nature* — is not to be found in *Madame Chrysanthème*. Van Gogh is apparently projecting his own ideal onto the Japanese by giving them the character of religious "homme de la nature". In so doing he is creating adherents of what he calls "true religion" as a substitute for Christianity.

Before Van Gogh could formulate such a concrete and original image of the Japanese, he was stimulated by two literary sources: an article by Bing in *Le Japon Artistique* and A. Leroy-Beaulieu's article on Tolstoy in *Revue des Deux Mondes*.[192] Van Gogh was undoubtedly stimulated by these articles, but it does not follow that he derived his image of the Japanese from them. The contents of the two articles are totally different from Van Gogh's letter, and Leroy-Beaulieu does not even mention Japan. Nevertheless, some passages do clarify the formative process of the image of Japan that was going on in Van Gogh's mind. It is obvious that the excerpt from his letter quoted above is based on the following passage in Bing's article:

> But the constant guide whose directions he (the Japanese painter) follows is called *nature*. She is his sole mistress, an adored mistress, whose precepts form the inexhaustible well-spring from which he draws his inspiration. ... He is, at one and the same time, the enthusiastic poet moved by *the grand spectacles of nature*, and the attentive, keen-eyed observer with the ability to capture the intimate mysteries concealed in the infinitesimal. ... In a word, he is convinced that nature contains the primordial elements of all things, and believes that there is nothing in creation, *not even the smallest blade of grass*, which does not deserve a place in the elevated conceptions of art. There, if I am not mistaken, lies the great and salutary les-

son to be distilled from the examples he offered us (my italics apart from "nature").[193]

Van Gogh was not content with Bing's article, because it was "rather dry, and leaves something to be desired,"[194] but he obviously borrowed some of Bing's words, such as "brin d'herbe" and "grands spectacles de la nature" (in Van Gogh's letter 542, "grands aspects des paysages"). He took these fragments from Bing's article and used them to formulate his own vision of the Japanese.

Similarly, Leroy-Beaulieu's article is also reflected in Van Gogh's primitivistic and religious interpretation of the Japanese. Discussing Tolstoy's thoughts on society and religion, Leroy-Beaulieu wrote:

> What is the political and social ideal of this mystic [Tolstoy], who would like to make man live a life so contrary to all the appetites of Adam? What it comes down to is a return to a state of nature, although only after having extinguished in natural man the most deep-rooted of his natural instincts. Mankind must renounce everything productive of honor, beauty, and security of life. Tolstoy revives Rousseau's paradox, with the difference that the abstract being of eighteenth-century Enlightenment has come alive. 'Natural man has taken on the appearance of the *moujik*. Tolstoy, like Rousseau, believes that *all man has to do to be happy is to rid himself of the artificial needs of civilization*. (my italics).[195]

This article is clearly colored by primitivism. Leroy-Beaulieu writes further: "Industrial work, which saps the soul as well as the body, should be abolished, and cities done away with. ... Do not speak to him [Tolstoy] of progress, industry, the sciences, art — they are merely so many grand, empty words."[196]

It must have been this primitivistic interpretation of Tolstoy that gave the strong primitivistic and religious tone to Van Gogh's image of Japan. It was after he read the article that a similar primitivism, the achievement of happiness through a "return to nature" and a rejection of civilization were attributed to the Japanese in the letter quoted above: "And you cannot study Japanese art, it seems to me, without becoming much gayer and happier, and we must return to nature in spite of our education and our work in a world of convention."[197] In this regard, it is especially worth noting that the most remarkable passage on the Japanese in this letter was written immediately after his citation of the passage on Tolstoy's religious thought without even beginning a new paragraph.[198] The two articles seem to have stimulated not only Van Gogh's idealization of Japan but his characterization of Tanguy as well. Tanguy was likened to the Japanese and described as a *"petit bourgeois* living close to nature" in the letter quoted above, which was written shortly after he read Bing's article.[199]

As noted above, *Madame Chrysanthème* and the two articles only stimulated the crystalization of Van Gogh's vision of Japan. The primitivistic ideal of

a religious "homme de la nature" was present in Van Gogh's mind long before he became interested in Japan. As early as 1883 he wrote on culture, civilization and nature: "...I look upon the real human feelings, life in harmony with, not against, nature, as the true civilization, which I respect as such. I ask, what will make me more completely human?" "Millet, however, is the archetype of a *believer*. ... One must not be a City man, but a Country man, however civilized one may be."[200] When he wrote these letters he had the painters of the Barbizon School in mind. As George Levitine has pointed out, Van Gogh belonged to a tradition of nineteenth-century primitivism, beginning with the group of *Barbu*, the Nazarenes and followed by the Pre-Raphaelites, Barbizon and Pont-Aven, and finally the Nabis.[201] These primitivistic painters shared a longing for an unconventional utopia, and they projected their ideal onto a certain historical period, "a golden age" or on an "earthly paradise." Van Gogh's "Japan" was a later variation of such an "earthly paradise". The luminous country in the Far East played the role of a seed around which Van Gogh's ideals crystallized.

Belonging to the primitivistic tradition, and stimulated by the two articles, Van Gogh interpreted the Japanese painter from the context of a European primitivism which had its origins in the eighteenth century. Such an interpretation of Japan was not specific to Van Gogh. As Elisa Evett has pointed out in her recent dissertation and article, Japan was regarded as an ideal primitivistic land by many contemporary critics, such as Teodor de Wyzewa, Louis Gonse, Ary Renan and Gustave Geffroy.[202] It is not clear how far Van Gogh was influenced by their writings, but we can at least say that the view of the Japanese as a religious "homme de la nature" did not originate with Van Gogh. His contemporaries, who were tired of the conventional, industrialized society and longed for a "return to nature," more or less shared his primitivistic view.

Gemeinschaftsideal

Van Gogh's image of the Japanese is more original in that he envisioned them from a *Gemeinschaftsideal*, which was another important aspect of primitivism in the nineteenth century. While Van Gogh was painting his *Self-portrait as a bonze*, to exchange it for a self-portrait by Gauguin, he was preoccupied with the idea of establishing a community of artists in Arles. The following passage from a letter to Bernard reveals his conception of the Japanese as a people living in an ideal community: "For a long time I have thought it touching that the Japanese artists used to exchange works among themselves very often. It certainly proves that they liked and upheld each other, and that there reigned a certain harmony among them: and that they were really living in some sort of fraternal commun-

ity, quite naturally, and not in intrigues. The more we are like them in this respect, the better it will be for us."[203]

The exchange of works was not characteristic of Japanese painters, nor does Bing say anything about such a custom in his article, and to my knowledge it is not mentioned in any of the writings which Van Gogh read. It seems probable that he was again projecting his own ideal onto Japanese painters. As was the case with the two articles mentioned above, he may have been stimulated by very fragmentary passages in some literary sources.

Like "l'homme de la nature," a brotherhood or community of artists had been Van Gogh's ideal since his earliest years. "It must have been a pleasant time when there were so many artists in the Alsace — Brion, Marshall, Jundt, Vautier, Knaus, Schüler, Saal, Van Muyden and a great many more — together with many authors who worked in the same line, like Chatrian and Auerbach."[204] The collaborative ventures of the Goncourts, Erckmann-Chatrian, the illustrators of the English art magazine *Graphic* and the painters of Barbizon were already present in Van Gogh's mind as early as 1882.[205] As his first partner he chose his brother Theo. In his long letter from Drenthe he tried to persuade Theo to become a painter so that they could work together, but Theo was not prepared to give up his work as an art dealer, and instead remained Vincent's financial supporter. In the next four or five years Van Gogh's ideal of a community seems to have made no conspicuous headway. In a letter to H.M. Livens written during his Paris period he first expressed the ideal of the community of artists in the Midi,[206] and when he arrived at Arles in February 1888 he had a very strong desire as well as a concrete plan to establish his community in the Provence. His Arles letters show his preoccupation with the Yellow House. He wrote to Bernard: "Furthermore, the material difficulties of a painter's life make collaboration, the unity of painters, desirable (as much so as in the days of the Guilds of St. Luke). By safeguarding their material existence, by loving each other like comrades-in-arms instead of cutting each other's throats, painters would be happier, and in any case less ridiculous, less foolish and less culpable."[207] Van Gogh urged his friends to join the community, exchanged self-portraits with them in alleged imitation of the "peintres japonais," and decorated a room for Gauguin with his own paintings.[208]

As Pevsner has pointed out, Van Gogh's ideal of the Yellow House undoubtedly belonged to the tradition of the nineteenth-century *Gemeinschaftsideal*.[209] Most of the groups of painters mentioned above in connection with the tradition of primitivism or the "return to nature" shared this ideal to some extent. In this case, though, Van Gogh is more clearly aware of the forerunners of his ideal than he was in the case of the "return to nature." He wrote to Theo: "You know that I think a society of impressionists would be

something of the same nature as the society of the twelve English Pre-Raphael-ites, and I think that it could come into existence."[210] Shortly afterward, Van Gogh actually bought twelve chairs for his Yellow House. In Van Gogh's letters we find only the names of the Pre-Raphaelites, the Barbizon School and the artists in Alsace. The Nazarenes are not mentioned. As noted in Chapter 1, this group was already known in the Netherlands in the 1860s,[211] and possibly Van Gogh knew of the activities of this German group. His total silence about the Nazarenes is not surprising, for the iconographical programs of this Catholic group, representing the saints and allegorical figures, could not have attracted Van Gogh's interest. Nevertheless, whether Van Gogh was aware of this group or not, his concept of the Yellow House had more in common with the Nazarenes than with the Pre-Raphaelites. As Ettlinger has pointed out, the German *Lukasbund* was a quasi-religious community, a *Lebensgemeinschaft* of artists who actually lived in the cloister of S. Isidoro, while the English Brother-hood was rather a political secret society, which never tried seriously to live and work in a common studio and which rejected the idea of giving a religious character to the Brotherhood.[212]

Like the Nazarenes, Van Gogh compared the artist's life to that of the monk: "If you are a painter, they think you are either a fool or a rich man; a cup of milk costs you a franc, a slice of bread two, and meanwhile your pictures are not selling. That is what makes it necessary to combine as the old monks did, and the Moravian Brothers of our Dutch heaths."[213] According to Van Gogh, Theo would be "one of the first, or the first dealer-apostle (marchand apôtre)"[214] The plan for the Yellow House was apparently conceived according to the model of the monks' community. In the concept of the painter-monk one recognizes the aftermath of Wackenroder's *"kunstliebendem Klosterbruder"* and the *Fratelli di San Isidoro*.

The exchange of self-portraits with Gauguin and Bernard, at Van Gogh's request, is also reminiscent of the *Freundschaftsbild* which flourished at the time of the Nazarenes (fig.87,88).[215] Van Gogh had originally requested Bernard's portrait by Gauguin and Gauguin's by Bernard, but he received from them two double portraits. Perhaps neither Gauguin nor Bernard shared Van Gogh's strong *Gemeinschaftsideal*. *The school of Pont-Aven was not a Lebensgemein-schaft* like the *Fratelli di San Isidoro* or the Yellow House Van Gogh wished to establish. Nevertheless, the two double portraits which were realized by Van Gogh's request might be called *Freundschaftsbilder* in the broad sense of the word.

To return to Van Gogh's self-portrait, we now have enough information for a convincing interpretation of this seemingly curious work. As noted above, he conferred his primitivistic and Nazarenean ideals upon Japanese painters. For

him the word "japonais" had the connotation of "l'homme de la nature" of Rousseau, the painter-monk, and the fraternal life of the Nazarenes. It is not fortuitous, then, that he depicted himself as a bonze. He could have chosen another figure from *Madame Chrysanthème* such as the Japanese artist Monsieur Sucre (fig.85), who because of his profession is much closer to him than the anonymous bonze, but he chose none other than a Japanese priest. Here again we can recognize an attempt on Van Gogh's part to create a substitute religion. By giving himself the features of a bonze, Van Gogh painted himself as an inhabitant of his ideal community of "true religion". Of course, Van Gogh had little knowledge of bonzes or Buddhism, but he knew or at least imagined that they were totally different from theologians and their religion. And that was enough for Van Gogh. He just needed something which was free from what he considered was the negative side of traditional Christianity and yet which retained enough force to function as a substitute for Christian religion.

The psychological mechanism of Van Gogh's identification with the bonze is similar to the Nazarenes' identification with Fra Angelico, whom they mistakenly took to be a naive painter-monk.[216] At this point it should be recalled that Père Tanguy, with whom Van Gogh shared his utopian vision, was painted with Japanese prints. The idea of portraying a close friend in imaginary and ideal surroundings is also found in one of the Nazarenes' paintings. In his *Portrait of Franz Pforr* (fig.89), Overbeck depicted his closest friend in a medieval setting — wearing an old German costume, with a pointed arch and a Gothic city, and the Mediterranean in the background. Overbeck was expressing Nazarene ideals when he painted this portrait. Despite numerous iconographical differences, the *Portrait of Tanguy* was also the expression of Van Gogh's and Tanguy's ideal. The Middle Ages in the *Portrait of Franz Pforr* are transformed into Japan in the portrait of Tanguy, but Van Gogh's way of expressing his utopian ideal is quite similar to Overbeck's.[217]

As noted above, the *Self-portrait as a bonze* was painted for Gauguin in exchange for the latter's *Self-portrait "Les misérables"*. Van Gogh's descriptions of these two paintings explain more clearly why he chose the features of a bonze. In a letter to Wil, Van Gogh first mentioned the self-portrait: "I also made a new portrait of myself, as a study, in which I look like a Japanese".[218] In the following letters Van Gogh does not write much about the painting, but after he received Gauguin's self-portrait — at about the same time he read the two articles by Bing and Leroy-Beaulieu — he began to explain his own self-portrait extensively, using the word "Bouddha". Gauguin's painting was accompanied by a letter which contained the following passages: "The mask of a badly dressed bandit, and with the power of a Jean Valjean, with his nobility and his inner gentleness. ... The design of the eyes and the nose, like the flowers in Persian car-

pets, sums up an abstract and symbolic art. The little girlish background with childish flowers is there to bear witness to our artistc virginity. And this Jean Valjean, oppressed and outlawed by society, with his love and his strength, is this not also the image of a present-day Impressionist? And by painting him with my own features you have both my personal likeness and our portrait of all the poor victims of society."[219]

Van Gogh was touched by Gauguin's portrait and its description. The following quotations are from letters of his to Gauguin and Theo: "I have a portrait of myself, all ash-colored. ... But as I also exaggerate my personality, I have in the first place aimed at the character of a simple bonze worshiping the Eternal Buddha. ... It will even be necessary for me to recover somewhat more from the stultifying influence of our so-called state of civilization in order to have a better model for a better picture."[220] "The Gauguin is more studied, carried further. That, along with what he says in his letter, gave me absolutely the impression of its representing a prisoner. Not a shadow of gaity. Absolutely nothing of the flesh, but one can confidently put that down to his determination to make a melancholy effect, the flesh in the shadows has gone a dismal blue. ... I have written to Gauguin in reply to his letter that if I might be allowed to stress my own personality in a portrait, I had done so in trying to convey in my portrait not only myself but an impressionist in general, had conceived it as the portrait of a bonze, a simple worshiper of the eternal Buddha. And when I put Gauguin's conception and my own side by side, mine is as grave, but less despairing."[221]

The Japanese character of the *Self-portrait as a bonze* was Van Gogh's encouraging response to Gauguin's pessimistic view of the miserable situation in which artists found themselves. He contrasted Gauguin's view to his own utopian ideal, Jean Valjean or a prisoner of civilization as opposed to a bonze worshiping Buddha, and melancholy as opposed to gaity.[222] At the same time, Van Gogh's response contained subtle criticism of Gauguin's aesthetics. Concerning Gauguin's comparison of *Les Misérables* to a Persian carpet decoration, Van Gogh wrote to Theo: "What Gauguin says about 'Persian' painting is true. ... But, but, but ... I myself do not belong to the world of the great, not even to any world at all ... and ... I prefer the Greeks and Japanese to the Persians and Egyptians."[223] In contrasting the Persians and Egyptians to the Greeks and Japanese, Van Gogh must have been conscious of the slight but essential differences between Gauguin's primitivism and his own.

Emile Bernard's self-portrait (fig.88), which Van Gogh received together with Gauguin's *Les Misérables*, is not mentioned as frequently as Gauguin's in Van Gogh's letters, but Van Gogh "loved Bernard's very much."[224] It is interesting to note that Bernard modestly painted a Japanese print in a corner of the painting. As already noted, Bernard knew the *Portrait of Tanguy* (fig.75) and

was well acuqainted with the utopian ideals of Van Gogh and Père Tanguy. Small wonder, then, that Bernard knew that the Japanese prints in Tanguy's portraits had utopian connotations for Van Gogh, and he was probably thinking of that utopian ideal when he depicted the Japanese print in his self-portrait. Interestingly enough, the print occupies a modest position in the corner of the painting. Was he expressing his reluctance to join Van Gogh's community, or the very reverse, namely that Gauguin and he might well join it? Bernard's intentions remain ambiguous, but Van Gogh must have been happy to have this painting with the likenesses of two possible members and the Japanese print. In contrast to Gauguin's self-portrait, Van Gogh was able to accept Bernard's without any reservations.

Despite their artistic difference Van Gogh had great respect for Gauguin, and believed that he should be the central figure of the community. Van Gogh, at the height of his utopian dream, sent the *Self-portrait as a bonze* to Gauguin with the dedication "A mon ami Paul Gauguin", the signature "Vincent" and probably "Arles". Gauguin accepted Van Gogh's proposal and came to Arles in October of 1888. Despite Van Gogh's delight, Gauguin was not happy in Arles, preferring the mystic atmosphere of Brittany. Nor did he share Van Gogh's *Gemeinschaftsideal*. At any rate, their collaboration came to a catastrophic end.

A recent technical and historical investigation of the *Self-portrait as a bonze* revealed that the dedication and the signature on the painting had been removed later with a solvent and that the damage was restored by Gauguin sometime between the end of 1893 and June of 1895 (fig.74a). It is not certain who was responsible for the damage to such important aspects of the painting, but Jirat-Wasiutyński suggests that Van Gogh himself may have removed the inscription when he felt his crisis and the collapse of their collaboration coming on in December of 1888.[225] This is still a hypothesis, but it seems quite possible when we consider the significance of this self-portrait.

Self-portrait with a Japanese print

After Van Gogh recovered from his first attack of illness, he painted two self-portraits with a bandaged ear (F527 JH1657, F529 JH1658). In one of them he depicted a Japanese print on the wall[226] (fig.90). If we bear in mind that "Japon" was a synonym for Van Gogh's primitivistic ideal, the meaning of the print becomes clear. It undoubtedly signifies the utopia which he was unable to realize in Arles.[227] Significantly, this self-portrait is the only painting from his Arles period to feature a Japanese print. In the letter in which he first mentioned the *Self-portrait as a bonze*, when his utopian dream was at its height, he wrote: "For

my part I don't need Japanese pictures (japonaiseries) here, for I am always tel-
ling myself that here I am in Japan. Which means that I have only to open my
eyes and paint what is right in front of me, if I think it effective."[228]

Yet the dream was over. He had to paint "Japanese pictures (japonaiserie)"
once again, this time as a recollection of the long history of his utopian ideal
which had first appeared in the portraits of Tanguy. Van Gogh recovered from
his first attack of illness, but he had little hope for the community of artists. In a
letter to Theo, he wrote: "It seems to me impossible or at least pretty improba-
ble, that impressionism will organize and steady itself now. Why shouldn't what
happened in England at the time of the Pre-Raphaelites happen here? The union
broke up."[229] But the idea of a community of artists remained on his mind.
About three months later he wrote: "There remains, however, the idea of an
association of painters, of lodging them in common, some of them: though we
did not succeed, though it is a deplorable and melancholy failure, the idea is still
true and reasonable, like so many others. But we won't begin again."[230] From
Gauguin's letters we know that Van Gogh never completely gave up the idea of
a community of artists. He suggested to Gauguin that they work together again,
but Gauguin refused in an oblique manner. Van Gogh even proposed going to
Brittany himself, but Gauguin's answer was not encouraging.[231] Van Gogh him-
self had also become far less enthusiastic about the idea of a community.

The *Self-portrait with a Japanese print* was Van Gogh's last *japonist* portrait.
After that, he never again depicted Japanese motifs in his works, and in the let-
ters he mentioned Japan only sporadically, without the enthusiasm of his uto-
pian period. After his return to the North, to Auvers, Van Gogh lived close to
Paris, the center of the *japonaiserie*, and he could again have come into contact
with Japanese art and *japonaiserie*. For example, he must have seen the exhibi-
tion of Japanese prints at the École des Beaux-Arts,[232] but the exhibition is men-
tioned only in Theo's letter, not in Vincent's. Together with the sun, sunflowers,
(a basket of) fruit and oleanders, Japanese motifs, including the Japanese fea-
tures in the portraits, are typical utopian motifs, occurring exclusively between
the summer of 1887 and January of 1889. In contrast to the sun, sunflowers and
diggers, however, they were motifs newly introduced into Western painting,
having no traditional meanings in Western culture. Detached from their original
cultural context, Japanese motifs were relatively neutral motifs open to free
interpretations by Western artists, and, needless to say, they were totally free of
biblical allusions or traditional Christian symbolic meanings. That is why Van
Gogh could crystallize his artistic, communal and religious ideals around the
nucleus of Japan. Due to the lack of knowledge about its cultural background
and its relatively neutral character, Japan could function as one of the mirrors
which reflected Van Gogh's ideals most clearly.

5. "In the sweat of thy face shalt thou eat bread": diggers in the œuvre of Van Gogh

In Van Gogh's œuvre representations of agrarian labor are undoubtedly basic themes. He chose almost every kind of rural labor and scenes from the annual cycle of seasons as subjects of his works; plowing, digging, sowing, fields of young green wheat as well as ripe golden wheat fields, harvests, sheaves of wheat, potato planting and digging, wood-cutters, shepherds, wood gatherers and also weavers. These rural themes, which were made quite popular by painters like Millet, Jules Breton, Léon Lhermitte, Bastien-Lepage in France and by the painters of the Hague School in the Netherlands, traditionally had various layers of meaning, and their sources can often be traced back to parables in the Bible.[233] For some of Van Gogh's peasant themes, there are sufficient references and descriptions in his letters, and in that case personal meanings in his works can be reconstructed with a considerable degree of accuracy from the letters and various literary and pictorial sources.

Sowers and reapers are probably the most familiar rural themes in Van Gogh's œuvre with distinct religious and personal connotations. The semantic sources of these motifs are, of course, biblical, but Van Gogh himself came up with several variations on the sower-reaper theme: "For whatsoever a man soweth, that shall he also reap ... he that soweth to the Spirit shall of the Spirit reap life everlasting": "I consider making studies like sowing, and making pictures like reaping."[234] The link with the Bible is especially obvious in Van Gogh's inscriptions on the print *Funeral procession in the wheat field* (fig.2) by J.J. van der Maaten which was discussed in Chapter 1. All of the quotations have some bearing on the subject of the print, but one of them is of particular interest. It is one of the four Latin quotations from the Bible: Mark 4:26-29: "And he said, so is the kingdom of God, as if a man should cast seed into the ground. And should

sleep, and rise night and day, and seed should spring and grow up, he knoweth not how. For the earth bringeth forth fruit of herself first the blade, then the ear; after that, the full corn in the ear. But when the fruit is brought forth, immediately he putteth in the sickle, because the harvest is come." This is a text which was often used by preachers such as Laurillard and Spurgeon, who were contemporaries of Van Gogh. During his Amsterdam period Van Gogh heard Laurillard's sermon on this text and on Van der Maaten's picture.[235]

The reaper as a symbol of death and the comparison between human life and wheat were so deeply rooted in Van Gogh's mind that, at the end of his life, he described one of his late works, *Wheat field with a reaper* (fig. 31) in very similar terms: "For I see in the reaper — a vague figure fighting like a devil in the midst of the heat to get to the end of his task — I see him in the image of death, in the sense that humanity might be the wheat he is reaping. So it is — if you like — the opposite of the sower I tried to do before."[236]

Van Gogh's letters do not contain lengthy descriptions of plowmen, but the following passage from a letter written in 1877 may provide the key to the con-notations which the plowman held for him: "Longfellow says, 'Let him who puts his hand to the plow not look back, and be a man'"[237] The metaphorical signifi-cance of the plowman comes again from the Bible: "And another also said, Lord, I will follow thee; but let me first go bid them farewell, which are at home at my house. And Jesus said unto him, No man having put his hand to the plow, and looking back, is fit for the kingdom of God" (Luke 9:61-62). In "The plow-man", the first chapter of his *Met Jezus in de natuur* (With Jesus in nature), Eliza Laurillard quoted this passage from the Bible and remarked, "That is what I think when I consider such a plowman and it is as if I hear the voice of Jesus say-ing, 'No man, having put his hand to the plow, and looking back, is fit for the kingdom of God'... So, Jesus, Thou hast plowed. 'Forward' was Thy watchword. 'Straight' was Thy rule and Thou didst not look back to see who was plaiting a crown... there is a saying 'Hand to the plow, thus will it God advance'. But I will now amplify that with this thought, 'provided the gaze is directed ever for-ward'".[238] Thus, the traditional and biblical meanings are apparently operative in Van Gogh's plowman.

For other rural themes it is probably possible to make similar semantic reconstructions, but in this chapter I wish to concentrate on the motif of the dig-ger. There are several reasons for this. In their popularity during the nineteenth century as well as in their obvious biblical associations, the opposition sower-reaper is probably more predominant than the digger, but in the œuvre of Van Gogh, the digger is no less important. Much has been written about Van Gogh's sowers and reapers, and their significance and symbolic meanings seem to be sufficiently recognized.[239] But until now little attention has been paid to Van

Gogh's diggers, even though they are portrayed in no less than 85 of his works. This alone is of some significance, for sowers and reapers are only to be seen in about 50 and 35 surviving works respectively. Neither sowers nor reapers, nor any other specific types of figures occur so frequently as do diggers in Van Gogh's œuvre. The chronological table of the works with diggers shows that this motif is entirely absent during certain periods (see Appendix I). This finding is also one of the most striking and remarkable ones among the results of all the chronological tables. Before analyzing the table and the individual works, I would like to trace the traditional meaning of diggers until Van Gogh's time.

Traditional meanings of diggers

Both the iconographical and the literary sources of Van Gogh's diggers are easily traceable to Millet's *Peasants digging* (fig.91) and to the Bible: "In the sweat of thy face shalt thou eat bread, till thou return unto the ground..." (Gen.3:19). The word "digger" does not occur in this quotation, but in a letter written in 1883 Van Gogh refers to the passage in connection with a drawing of a digger: "his bald head, bent over the black earth, seemed to me full of a certain significance, reminiscent, for instance, of 'thou shalt eat thy bread in the sweat of thy brow'."[240] The connection between diggers and the biblical text seems to have prevailed in Van Gogh's time. For example, he had read the following passage in Millet's letter published in Sensier's *La vie et l'œuvre de J.-F. Millet*. "In the plowed fields, and sometimes also on land it is scarcely possible to plow, you see figures digging with a spade or mattock. Every now and then you see one of them straighten up and wipe his forehead with the back of his hand. 'In the sweat of thy face shalt thou eat bread'."[241]

It is difficult to say when and how Van Gogh's association of diggers with the passage from Genesis originated. He must certainly have read the excerpt from Millet's letter, but the idea may also have occurred to him earlier, for instance in 1880, when he copied Millet's *Peasants digging* (fig. 92). The hard labor done by peasants had often been associated with that biblical passage in the past. Edward Wheelwright recollected that Millet was interested in Holbein's engraving *The plowman and death* in *Les simulachres et historiées faces de la mort* (1538), which was described at length by George Sand in the first chapter of *La mare au diable*[242] (fig. 93). In both *Les simulachres de la mort* and *La mare au diable* the illustration is captioned: "A la sueur de ton visaige Tu gagneras ta pauvre vie. Après long travail et usaige, Voicy la Mort qui te convie." Wheelwright refers to Millet's interest in the picture and caption in connection with *La mort et le bûcheron* now in the collection of the Ny Carlsberg Glyptothek in

Copenhagen. The statement "A la sueur de ton visaige Tu gagneras ta pauvre vie", associated as it is with the plowman, is especially significant. Plowing is basically the same kind of activity as digging — both being termed "labour" in French from the Latin *laborare* — but only farmers who were rich enough to own horses and a good deal of land used plows.[243] Poor farmers were obliged to till the land themselves. It was the sight of this backbreaking labor that so impressed Millet and reminded him of "In the sweat of thy face shalt thou eat bread".

André Theuriet devoted one chapter of his *La vie rustique* (1888), illustrated by Léon Lhermitte (fig. 94,95), to "Le Labour",[244] in which a detailed description is given of the tragic existence of the "laboureurs" and their songs. "Oh, what sad truth in the song of Bresse about the people working the land! Poor laborer, his life is full of misery. He is miserable from the day of his birth ... the old song of the Breton peasants is less despairing, for, having bewailed the fate of those who grow the corn it continues: O laborers, you suffer much in life! O laborers, you are most fortunate ... For God has said that the doors of his paradise will be open to those who have wept in the earth ... Everywhere and in all times, the laborer seems to reflect sadly and with conviction on the harsh words of the scriptures: 'In the sweat of thy face shalt thou eat bread'."[245] Here too the *laboureur* is associated with the passage from Genesis. Van Gogh quoted the same Breton song in a letter from 1878: "For who are those that show some sign of higher life? They are the ones who merit the words, 'Laboureurs, votre vie est triste, laboureurs, vous souffrez dans la vie, laboureurs, vous êtes bien-heureux'."[246] Van Gogh had come across the song in the chapter "Complainte du laboureurs" in Emile Souvestres' *Les Derniers Bretons*, which he had read probably before 1878.

Souvestre describes the life of the peasants in Brittany, and quotes a song entitled "Complainte du laboureur", of which Theuriet and Van Gogh quote only an excerpt. "My daughter, when you shall take a husband, do not take a soldier, for his life is the king's; do not take a sailor, for his life is the sea's; but above all do not take a laborer, for his life is one of fatigue and misery ... oh laborers! you lead a hard life in this world. You are poor and you enrich others; you are despised and you honor; you are persecuted and you submit; you are cold and hungry. Oh laborers, you suffer in life, laborers, you are blessed!"[247] Van Gogh had copied out part of this song into a little book, which was probably filled before he became a painter and is now in the collection of the Rijksmuseum Vincent van Gogh. In the letter quoted above, Van Gogh did not quote the Breton song accurately but probably wrote it down from memory, as is often the case with Van Gogh's quotations. That means that he was well aware of the tragic implications of the "laboureurs" even before the beginning of his artistic career.

The popularity of the digger as a theme in the art of the latter half of the nineteenth century is due especially to Millet's series of *Peasants digging*, on which he worked for some twenty years until its culmination in the monumental pastel of 1866.[248] It was in this year that Alphonse Lemerre set up his publishing house, which was given the name "le bêcheur" on account of the device on its publications (fig. 96). Above the head of the digger is written: "FAC ET SPERA" (make and hope). This publishing house, which continued to exist until 1965, issued poems and books by Leconte de Lisle, Verlaine, Anatole France, François Coppée, André Theuriet and also most of the literary works of the painter of peasant life Jules Breton.[249] As the publisher's device and nickname "le bêcheur" indicates, Alphonse Lemerre was undoubtedly one of the most important publishers in the field of *littérature rustique*. Van Gogh mentioned Jules Breton's *Les champs et la mer* as early as 1875, when it was first issued by this publisher.[250]

Since the Middle Ages the digger had been a recurrent theme in illuminated manuscripts, reliefs and in the emblematic literature. As Raimond van Marle has suggested, this iconographic type probably springs from the story of Adam's banishment from Paradise. Work was a punishment, but could also be valued positively, because by tilling the soil man could survive. The theme was used in a positive sense in various emblems, in the sense of "FAC ET SPERA", patient labor and hope.[251] Jacob Cats praised the virtue of patience in his text on the digger, and this text was of course also included in the nineteenth-century edition of Cats' *Alle de wercken* ... edited by J. van Vloten with new illustrations by J.W. Kaiser[252] (fig. 97). In the seventeenth century, some Dutch and French publishers such as Jean Maire in Leiden, Jacques Braat in Dordrecht and Jean Lucas in Rouen used diggers and the words "FAC ET SPERA" in their devices[253] (fig. 98). Presumably Alphonse Lemerre knew one of these publishers' devices and adopted the design in the somewhat modernized form of a naked man and the rising sun.

Such positive meanings in the emblematic tradition, however, can hardly be recognized in the diggers of Millet and Van Gogh. For them the peasant's labor was above all a heavy burden he was forced to bear. Before turning to the significance of the diggers in the œuvre of Vincent van Gogh, it is interesting to examine the chronological table of this motif.

Frequency and manipulation of "diggers"

As noted above, diggers occur much more frequently than any other specific types of figures in Van Gogh's œuvre. The chronological table of the works with

diggers shows that this motif is entirely absent during certain periods[254] (see Appendix I). I have included all types of digging figures under the heading of "digger", with the exception of potato gatherers and plowmen, because these two motifs have different meanings. The criterion for my classification is that one motif and possible variations thereof possess a semantic homogeneity.

Although the potato gatherers are quite similar to the diggers and are often indistinguishable from them, potato gathering should be regarded as a variation on the harvest theme. Their exclusion has not affected the conclusions of my research because the motif does occur frequently in 1884, but not in 1887 and 1888. The distinction between digger and plowman is far more important, because plowmen do occur in 1888.[255] As stated at the beginning of this chapter, Van Gogh described the plowman theme in the sense of "Hand to the plow and do not look back, thus will it God advance" in his letter. Traditionally there were various layers of meaning attached to the theme of the plowman, and the examples from Laurillard and Holbein represent only a few of them. To my knowledge, Holbein's engraving is the only example which connects the passage from Genesis with a plowman. It is possible that there are more examples before or after Holbein, but it is important to note that the two motifs, the digger and the plowman, did not have much in common within the framework of the iconographical tradition.[256] We find at least one description by Van Gogh in the sense of "hand to the plow and do not look back" and that is enough to justify treating the plowman and the digger separately, despite the association of the plowman with the passage from Genesis in Holbein's engraving.

The most remarkable outcome of the chronological table is, in any event, the absence of the "digger" in the years 1884, 1887 and 1888. As far as 1884 is concerned, it is difficult to draw any conclusions because too few works from that year are known. In Jan Hulsker's œuvre catalogue (1977) about 400 works are dated to 1885 and only 137 to 1884, while the number of works from 1885 is also much greater than that from the other years. Only 300 works have been identified as dating from one of his most productive and best documented years, 1888. Owing to the lack of letters in the summer of 1884, it is not impossible, in Hulsker's view, that a number of works were erroneously dated to 1885.[257] Of the 29 works listed under the year 1885 in the chronological table, 26 are dated between July and September; some of them should perhaps be redated to 1884. We must also take into account the possibility that a large number of paintings disappeared when Van Gogh's mother moved out of the parsonage.[258] For this reason I have for the time being excluded the data for 1884 and 1885 from my discussion. The second period during which the motif is absent — 1887 and 1888 — is less problematical. The first ten months in Arles — from February of 1888 until the end of the year — are among the best documented periods in the life of

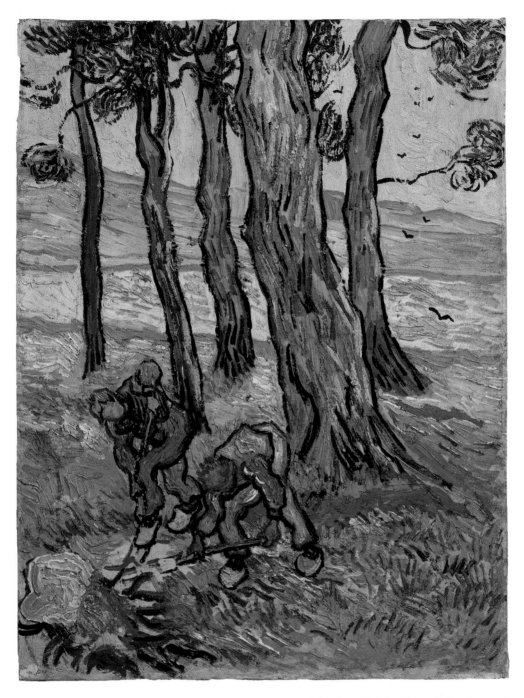

Plate 5. V. van Gogh, *Two diggers among trees*, 1890 (redated), The Detroit Institute of
Arts (Bequest of Robert H.Tannahill), Detroit.

the artist — of any artist, for that matter — and the number of figures counted is probably quite accurate.

The period between the beginning of 1887 and February of 1888, the second half of the time he spent in Paris, is inadequately documented, and there is also some confusion concerning the dating of a number of works from 1886 and 1887. I have nonetheless used the data for these two years, albeit with some reservations, because any potential redatings will have little effect on the conclusions of this research. The four works that have been provisionally dated to 1886 in the table could conceivably be redated to 1887. The date of the *Windmill on Montmartre* (fig.103) is difficult to determine. Welsh-Ovcharov places this work in the early spring of 1887, Hulsker dates it to the end of 1886.[259] On stylistic grounds, however, the four works can hardly be dated any later than the spring of 1887. It is fair to state, therefore, that no diggers occur during the period between the summer of 1887 and the spring of 1889, when Van Gogh painted the *Orchard in blossom with poplars* (fig. 99).

There is of course always the possibility that some works with diggers from this period have been lost, and that indeed would seem to be the main objection to the chronological analysis presented here. But in the case of the diggers this objection is less serious, for there is no mention of diggers in the letters written during this period. The term "digger" or "digging" (in either Dutch or French) occurs more than fifty times in Van Gogh's letters, but in the correspondence from 1887 and 1888 I came across "bêcher" only once, and even then it is used in connection with Tolstoy and not with Van Gogh's own works.[260]

How should all this information be interpreted? Does it have any specific relevance for our knowledge of Van Gogh's œuvre? Quite apart from the problems of dating and of lost works, it is possible to criticize this type of research. It could be argued, for instance, that Van Gogh had far less opportunity to find models of diggers or to watch them at work during 1887 and 1888. But it is not likely that this was the only time during which he was unable to find models or to see diggers at work, because he also worked in Paris in 1886, and in Arles until May, 1889. Besides, Van Gogh could also draw and paint the motif without a model, and without actually seeing these figures in his surroundings. Van Gogh apparently had several types of digging figures in his repertory and he used these in his later composed pictures. Many of the original study drawings of these types have apparently been lost, but in some cases we can discover how Van Gogh reused the same types of diggers in several works. Let us first examine three types of diggers which occur between 1882 and 1886.

TYPE I:
Man digging (F908 JH258 fig. 100) 1882
Sand-diggers in the Dekkersduin (F1028 JH367 fig. 101 left digger) 1883

Churchyard in the rain (F1399 JH1031, F1399a JH1032 fig. 102) 1886
Windmill on Montmartre (F349 JH1184 fig. 103) 1886.

TYPE II:

Man digging (F906 JH260 fig. 104) 1882
Peat-cutters in the dunes (F1031 JH363 fig. 105, digger in the center) 1883
Churchyard in the rain mentioned above (fig.102, figure on the right) 1886

TYPE III:

Man digging (F1656 JH262 fig. 106) 1882
Peat-cutters in the dunes mentioned above (fig. 105, right foreground) 1883
Garden in the snow (F1023 JH343, JH342 fig.107) 1883.
(Probably an original drawing existed on which the lithograph was based.)

It is not certain whether Van Gogh needed his original studies to use a specific type of figure in later compositions. If that was indeed the case, and if he had not taken his drawings with him to Arles, he would not have been able to portray a digger in Arles. But that alone does not explain the absence of diggers between the summer of 1887 and the spring of 1889. The very small digging figure in the *Orchard in blossom with poplars* from 1889 (fig. 99) is certainly not a smaller version of an earlier figure study; this type of digger cannot be found in the earlier works and, moreover, it makes no sense to use and reduce an earlier study for such a tiny figure which can be painted with a few strokes of the brush.[261] Many of the diggers drawn in March and April of 1890, such as the *Study with diggers* (fig. 108), were drawn from memory, for Van Gogh was seriously ill at that time and he certainly would not have been able to obtain a model. When Van Gogh had neither models nor studies at hand he made drawings from memory, which he used in paintings such as *Two diggers among trees* (fig.109; pl.5). The two diggers in the latter composition are traceable to two separate studies (fig. 108 and F1620v JH1934).[262] The absence of diggers in the works from 1887 and 1888 cannot therefore be explained by a lack of models or studies, nor by the absence of diggers at work in his surroundings.

Personal meaning: diggers versus Le Paradou

How do Van Gogh's diggers differ from those of his predecessors and contemporaries? Firstly, Van Gogh did not ascribe biblical meanings only to digging peasants, but to digging figures in general. It is not clear whether the digger in a drawing from 1882 (fig. 100) is a peasant, a laborer in the street, or anyone else in particular. Van Gogh's diggers are not simply peasants or street workers but a more abstract figural type with certain meanings conferred upon them, as was

also "Millet's sower" as described in Van Gogh's letter: "...the *type* distilled from many *individuals*. That's the highest in art, and *there* art sometimes rises above nature — in Millet's 'Sower', for example, there is more soul than in an ordinary sower in the field."[263]

Van Gogh's letters contain other keys to the personal significance of the digger's theme in his work. In two letters to Theo from his Hague period he describes a large composed drawing of *Peat-cutters in the dunes* from 1883 (fig. 105) as a contrast to Le Paradou (paradise) in Zola's *La faute de l'abbé Mouret* which Van Gogh had read in 1882. "I am glad you are having a good time now — 'Le Paradou' must have been glorious indeed. Yes, I should not mind trying my hand at such a thing: and I do not doubt you two would be very good models. However, I prefer to see diggers digging, and have found glory outside Paradise, where one thinks rather of the more severe 'Thou shalt eat thy bread in the sweat of thy brow'." "This 'Peat Cutters' is quite different from 'Le Paradou', but I assure you I also feel for 'Le Paradou'. Who knows, someday I may attack such a Paradou subject.'[264]

Le Paradou in *La faute de l'abbé Mouret* is an enormous garden with an old mansion in ruins, and surrounded by a high wall. This garden is situated in the vicinity of the village of Artaud in the Midi, where Serge Mouret is the local priest. The novel consists of three parts. The village and its surroundings are described in Book I. Next to the village church stands a tall cypress, which is known locally as "Solitaire". Serge Mouret says Mass in the small church, always accompanied by his acolyte, a red-headed boy named Vincent. Serge pays a visit to Le Paradou with his uncle Pascal Rougon, where he meets Jeanbernat, the old gardener and his niece Albine. Her beauty casts a spell on Serge and he cannot get it out of his mind. He prays desperately to the Holy Virgin to help him resist temptation, but then falls unconscious onto the floor of the church. In Book II Serge comes to Le Paradou, where Albine nurses him to recovery. They fall in love under the bright sun of the Midi, and spend their days wandering about in their walled paradise. But one day Serge catches sight of the village of Artaud in the distance through a hole in the wall, and the memories of his past come flooding back, reminding him of how he has sinned. Brother Archangias, who calls himself "gendarme de Dieu", finds Serge and Albine naked in the garden, which results in Serge's return to the church. In Book III Albine begs Serge to come back to Le Paradou. He does not give in, but suffers a hallucination in which nature — trees, animals, hills — and the farmers of Artaud storm the village church. Serge returns to Le Paradou to see Albine, but their idyllic love is not restored because Serge cannot forget his past as a priest. Finally, Albine, pregnant with Serge's child, commits suicide.

From the passage in the letter quoted above, ("'Le Paradou' must have

been glorious indeed. Yes I should not mind trying my hand at such a thing: and I do not doubt you two would be very good models"), and for other reasons as well, it seems quite probable that Van Gogh was not referring to Le Paradou in Zola's novel but to J.E.Dantan's painting *Le Paradou (La faute de l'abbé Mouret)* (fig. 111). Inspired by Zola's novel, Dantan depicted Serge and Albine in Le Paradou scene of Book II. Theo, who then lived in Paris, must have seen this painting in the Salon of 1883 and probably wrote about it in a letter to his brother. The passage quoted above was, presumably, Vincent's reaction to Theo's comments about Dantan's painting. In a letter written about the same time, Vincent wrote that he had seen "Harvest of Lhermitte" in the illustrated catalogue of the Salon. L.A. Lhermitte's *Harvest* was indeed reproduced in the *Catalogue illustré de Salon* of 1883, and in the same catalogue there is also a reproduction of Dantan's *Le Paradou.*[265] Thus, it is probable that Vincent also knew Dantan's painting.

The importance of the two passages in the letters about the peat cutters mentioned above becomes clear in the light of Dantan's painting, Zola's novel and the role therein of Le Paradou. The "you" of the first excerpt refers to Theo and a lady friend and it becomes evident from this passage that they probably had an enjoyable time.[266] Vincent compares them to Serge and Albine in Le Paradou but says that he would still prefer to see the digger "outside Paradise", namely "where one thinks rather of the more severe 'Thou shall eat thy bread in the sweat of thy brow'." In another letter written in 1883, he contrasts Le Paradou to Gethsemane: "Yes, for me, the drama of storm in nature, the drama of sorrow in life, is the most impressive. A 'Paradou' is beautiful, but Gethsemane is even more beautiful."[267] From this passage it is clear that the paradisiacal garden symbolizes an idyllic and utopian life as opposed to Gethsemane and the hardships of the digger, which are symbolic of the tragic fate of man, driven out of Paradise. The diggers portrayed by Van Gogh cannot, therefore, be viewed merely as figure studies but should be seen in a wider context. *Peat-cutters in the dunes* (fig. 105) may contain an allusion to the passage from Genesis, because Van Gogh positioned the small church tower in the center of the composition, just like in *Shacks* (fig. 23).

Although the theme of the digger and digging is rare in Dutch painting, a digging figure combined with a church tower is also to be seen in a painting by Anton Mauve (fig. 29). Mauve was one of the few artists who had painted this subject and, in view of the biblical implications of the theme, it seems more than a coincidence that Vincent and Mauve, both sons of clergymen, should have portrayed diggers against the background of a church tower.[268]

The word "Paradou" occurs once more in a letter written in July 1888 in Arles. Van Gogh had made a trip to Montmajour in the company of his friend

Milliet, and upon his return he described the garden of the abbey as follows: "We explored the old garden together, and stole some excellent figs. If it had been bigger, it would have made me think of Zola's Paradou, tall reeds, and vines, ivy, fig trees, olives, pomegranates with lusty flowers of the brightest orange, hundred-year-old cypresses, ash trees, and willows, rock oaks, half-broken flights of steps, ogive windows in ruins, blocks of white rock covered with lichen, and scattered fragments of crumbling walls here and there among the green. I brought back another big drawing, but not of the garden."[269] It is striking that Van Gogh refers to "Paradou" without mentioning the title of the novel five years after using the term in connection with the peat cutters. He evidently remembered the contents of the novel, or at least the importance therein of Le Paradou quite clearly. He also knew that Theo, who had read many of the same books as he had, would understand the implications of this word in his letter. In the last letter from 1888, however, Van Gogh is showing a preference for tragic themes such as diggers and Gethsemane.

Let us now return to the chronological table. As we have seen, the motif of the digger is entirely absent during the period between the summer of 1887 and the spring of 1889. It was at this time that a wholly different group of motifs came to dominate his work: sunflowers, strolling couples, Japanese prints, French novels and fruit (in a basket) among others.[270] It was also during this period that Vincent dreamed of founding a community of artists in the Midi based on friendship and love. He decorated the rooms of the Yellow House in Arles with his paintings, including the *Sunflowers* and the series called *Jardin de Poète*.[271] The theme of love figures prominently in these paintings as well as in other works of this utopian period: A strolling couple is to be seen in many pictures in the *Jardin de Poète* series, and sunflowers are traditionally regarded as symbols of love.[272]

Interestingly, the utopian motifs or themes of love did not appear only in Arles, but earlier in Paris in 1887. Sunflowers and couples in the garden were already present in Van Gogh's iconography in 1887 (see Appendix I). In spite of the move from Paris to Arles, a distinct thematic continuity is manifested in Van Gogh's works from 1887 and 1888. Certain motifs such as sunflowers, oleanders and baskets of fruit occur almost exclusively during this period. In January, 1888, after his first attack of illness, Van Gogh started working again, but in February he suffered a second attack. It is remarkable that he painted sunflowers, a basket of fruit, and Japanese prints during the interval between those two attacks. The baskets with fruit and the Japanese prints do not recur after that, while sunflowers are only featured as details of three landscapes.[273]

It is precisely during this period in which utopian themes predominate that digging figures, with their connotation of hard labor, are entirely absent. After

his two attacks of mental illness a small digging figure reappears in the *Orchard in blossom with poplars* (fig. 99), painted in April of 1889. In October, 1889, about six months after the *Orchard in blossom with poplars* was painted, Van Gogh wrote from Saint-Rémy, where he was confined indoors for months on end: "I am going to work again on the 'Diggers'"[274], and he made a copy of Millet's *Peasants digging* (fig.110). This is the first time since 1885 that the theme of the digger is mentioned in his letters. This copy was followed by countless diggers, especially in the works executed in March and April of 1890 (fig. 108, 109; pl.5), when Van Gogh was busy, during another period of illness, with a series of *Memories of the north* or *Souvenirs of Brabant*.

The connection between the text in Genesis and diggers, the opposition of tragic and utopian themes, diggers versus Le Paradou, and the chronological frequency of the motif, show convincingly the significance of this basic motif in Van Gogh's œuvre. Like an ominous *Leitmotiv* in a score of music, this theme of banishment from Paradise and its variants constantly reemerges during the tragic moments in Van Gogh's career.

6. Christianity versus nature: Emile Zola's *La faute de l'abbé Mouret*

> Entre, ô nature, avec ta joie,
> Ton soleil et ton mouvement —
> Et qu'on te laisse cette proie
> A dévorer tranquillement!
>
> - Bouilhet, *L'Abbaye*

> Ô Nature! souveraine de tous les être! et vous ses filles adorables vertu, raison, vérité! soyez à jamais nos seules Divinités; c'est à vous que sont dus l'encens et les hommages de la terre. Montre-nous donc, ô nature! ce que l'homme doit faire pour obtenir le bonheur que tu lui fais désirer. ...
>
> - Holbach, *Système de la nature*[275]

Of the many novels by Zola which were read by Van Gogh, I would like to draw particular attention to *La faute de l'abbé Mouret* of the Rougon-Macquart series.[276] I call attention to this novel not because Van Gogh showed greater enthusiasm for it than for other of Zola's works, but because it has striking thematic affinities to Van Gogh's œuvre. Van Gogh first mentioned the novel in August, 1882: "I have read more of Zola: *La faute de l'abbé Mouret* and *Son Excellence Eugène Rougon*, both beautiful."[277] This is the only letter in which the title of *La faute de l'abbé Mouret* appears, but, as noted in the previous chapter, the word "Paradou", the name of a vast garden in the novel, appears in some letters to Theo written in 1883 and also in 1888.[278]

La faute de l'abbé Mouret did have some direct connections with other painters' works. Cézanne's *The rape* (1867) which represents a garden in which a naked man is carrying a woman, was hanging in Zola's room at Médan, and it is said that the painting might have influenced the author of *La faute de l'abbé*

Mouret when he wrote Le Paradou scenes.[279] Zola's novel, in turn, inspired some Salon painters to depict various scenes in the novel (fig.111,112).[280] It is known that Van Gogh tried to illustrate some scenes from Zola's works and that he made a painting inspired by *Germinal*.[281] Such concrete correspondences cannot be found between *La faute de l'abbé Mouret* and Van Gogh's works. Nevertheless, Van Gogh's œuvre and Zola's novel share very similar themes of religion and nature. They also share many literary sources. Zola used the story of the Fall of Man as his model in writing Le Paradou section of Book II. The scene was also mentioned in the previous chapter. In preparing the novel, he also read *L'Imitation de Jésus Christ* which Van Gogh had read with enthusiasm during his study for the ministry. The sources and possible sources pointed out by Zola scholars include *La Bible de l'humanité*, *La montagne*, *L'amour* and *La femme* by Jules Michelet, who was one of the most important influences on Van Gogh as concerns anti-dogmatic religious thought.[282] These common sources already suggest thematic affinities between the novel and Van Gogh's œuvre, and some passages, themes, scenes and figures in the novel are very interesting with regard to Van Gogh's life and work.

Let us begin with two relatively minor points; the acolyte Vincent, a figure in the novel, and the cutting off of an ear, which is one of the most curious but impressive scenes. These two points may be rather trivial coincidences but should be mentioned briefly. Vincent, a young boy from Artaud and the acolyte of Father Mouret, is a minor figure in the novel, but he appears very often throughout the book and assists Father Mouret at Mass and the burial of Albine. Although Van Gogh does not mention him in his letters, he may have been impressed by this urchin of Artaud, for they not only shared the same first name but also the same "unruly red hair" (cheveux rouge en broussaille).[283]

In the whole story this acolyte seldom speaks except during the Mass and the burial. In Book I he plays in the graveyard, where he is found by Brother Archangias, teacher of the Christian school, who rudely pulled Vincent's ear.[284] In the same chapter, there is another scene in which Brother Archangias pulls at the ears of two children.[285] After Le Paradou scenes, in Book III, chapter 5, there is a scene describing the fight between Brother Archangias and Jeanbernat. After he expelled Serge from Le Paradou, Archangias kept a close watch on Father Mouret's movements as "le gendarme de Dieu" in his own words, and Jeanbernat had long hated this rude, humble teacher and his God. In this fight scene Jeanbernat twice threatens to cut off the friar's ear. "'Lower your paws,' he cried. 'Ah, it's you, churchy. I should have known it from the smell. We've got something we have to settle. I swore in the middle of your class to cut your ears off.'"[286] Archangias cries, "I shall destroy you! God desires it. God is in my arm!" Jeanbernat retorts, "'You must see that He's not the strongest, your God.

Plate 6. V. van Gogh, *In the church*, 1882, Rijksmuseum Kröller-Müller, Otterlo.

I am the one who's destroying you. Now I'm going to cut your ears off.' ... And he calmly took a knife from his pocket."[287] Father Mouret managed to stop the fight, but after Albine's suicide, Jeanbernat actually cut off Brother Archangias's ear during Albine's burial, as described in Book III, chapter 16. "Then, as Father Mouret was finishing the prayers, he calmly pulled a knife from his pocket, opened it, and in one stroke, chopped off the friar's right ear. ... 'The left one's for later,' Jeanbernat said peacefully as he threw the ear to the ground."[288]

Specific literary sources for these scenes are not known, or at least they cannot be found in Zola's *Ebauche*. One possible source is the well known episode in the Passion during the arrest of Christ: "Then Simon Peter having a sword drew it, and smote the high priest's servant, and cut off his right ear." (John 18:10) However, it does not seem that any of these scenes in the novel or in the Bible can explain convincingly or can be directly connected with Van Gogh's behavior when he tried to attack Gauguin with a razor and injured his own ear.

Compared with these two points, the thematic affinities between *La faute de l'abbé Mouret* and Van Gogh's œuvre are more significant and convincing. This novel is not merely a traditional story of the "prêtre amoureux", but it is "the history of a man struck in his virility by a primary education, having become neuter, he was reawakened as a man at the age of 25, in the solicitations of nature, but falling back inevitably into impotence" as Zola noted in the *Ebauche*.[289] During its preparation and writing, the thematic dimensions of this story were expanded and it developed into the story of a conflict between nature and religion. In the preparatory note for the dialogue between Serge and Albine, Zola wrote: "The contrast of the small church with the great Paradou" and "It would be the contrast, Serge Catholic to the end, whereas Blanche (in the *Ebauche* Albine is called Blanche) is naturalism, and acts on a sense of instinct and passion." Similarly, Brother Archangias is described as "le dieu de la Bible" and Jeanbernat as "un vieux bonhomme enfoncé dans Voltaire"; an atheist who read Holbach and the *philosophes* of the eighteenth century.[290] The conflict between Christianity and nature — personified and symbolized in Serge and Albine, Brother Archangias and Jeanbernat, the small church of Artaud and the vast Le Paradou, the cypress called "Solitaire" beside the church and the sun of the Midi — became one of the essential themes of this novel. This theme of conflict appears throughout the entire novel in various forms and situations.

As early as Book I, chapter 2, Mouret's Mass is invaded by sparrows, by branches of a service tree protruding through the broken window panes and above all by sunlight. The chapter begins with "The empty church was all white on this May morning."[291] In the cool and pale interior of the church, where the morning sunlight had not yet come through the windows, Father Mouret and Vincent began the Mass. Whereupon Zola introduced sunlight into the pale

interior of the church as follows: "Vincent was lost in the long Latin sentence he was garbling. At that very moment yellow flames came in through the windows: the sun responding to the priest's appeal, was coming to Mass. ... The countryside even joined the sunlight in the church; a large service tree was reaching up next to one of the windows, shooting branches through the broken panes and stretching its buds as if to look inside. The plants on the steps were visible through the main door and threatened to invade the nave. ... A sparrow came to perch on the edge of a hole in the window, looked around and flew away. But he reappeared almost immediately. ..."[292] At the end of the Mass, the church is overwhelmed by sparrows and the sunlight. "Then, turning to kiss the altar, he came back once more ... to bless the church filled with the sunlight's pranks and the sparrows' uproar. ... The triumphant star surrounded crucifix, candlesticks, chasuble, and chalice veil with its own nimbus, and all this gold paled under its rays. After the priest, his head covered, had taken the chalice, genuflected, and left the altar to return to the sacristy ... only the sun remained in the church."[293]

This section is just the beginning of the attack of nature against the church. In Book III, chapter 9, Serge has a hallucination in which the church of Artaud is totally destroyed by trees and animals. The hallucination occurs after his refusal of Albine's entreaty to return to Le Paradou, and the attack of nature is again preceded by sunlight, which gradually increases its brightness in the interior of the church. "The attack was sudden. From the edge of the horizon the entire countryside swooped down on the church: hills rocks, earth, trees. The church cracked under the first blow."[294] Then the inhabitants of the village and the animals attacked the church, and finally, the branches of the growing service tree destroyed it.

> "Then, abruptly, it was over. The service tree, whose tall branches were already penetrating the vault through the broken panes, rushed violently in with an awesome spurt of green. It stood in the middle of the nave and grew out of all proportion. ... Now the giant tree touched the stars. Its forest of branches was a forest of human limbs, legs, arms, torsos, bellies, all sweating sap. Women's hair streamed down, men's heads burst through the bark to laugh like new buds. At the very top, lovers, swooning in their nests, filled the air with the music of their delight and the smell of their fertility. ... The tree of life had just broken into heaven. And it rose higher than the stars. Father Mouret applauded this vision wildly, as if he were damned. The church had been conquered. God no longer had a house. Now God would not bother him any more. He could join the triumphant Albine."[295]

The scene of the intrusion of sunlight into the Mass in Book I, chapter 2, makes us think of several passages from Van Gogh's letters during his Amsterdam period. In some of his letters written in 1877, even before he read *La faute de l'abbé Mouret*, he often discussed the early morning service by Eliza Lauril-

lard. As I have already noted briefly at the beginning of Chapter 2, Van Gogh's accounts of the sermons are often followed by descriptions of sunlight, the moon and the stars. In letter 101, for example, he mentions hearing Laurillard's sermon and immediately notes: "The sun was shining through the windows. ..."[296] In another letter he again mentioned Laurillard's sermon, quoted from a poem about the moon by Andersen and then he wrote: "The moon is still shining and the sun and the evening star, which is a good thing — and they also often speak of the Love of God. ..."[297] In his next letter he mentioned a sermon on Ephesians 5:14 "Awake thou that sleepst, and arise from the dead, and Christ shall give thee light," and immediately he added, "... It was raining as I left the house, and also when the service was over; but during the sermon the sun was shining brightly through the windows."[298] During the sermons Van Gogh does not look at any objects or places in the church but spends his time looking at the sunlight shining through the windows. It is in the sunlight that Van Gogh sees divinity. Although the conflict between the church and nature is still not explicit, "nature" is already stealing its way into Van Gogh's mind just like the sunlight which permeates the church of Artaud.

At the beginning of Father Mouret's Mass in Book I, chapter 2, the whiteness of the church interior is emphasized. The chapter opens with the words: "The empty church was all white on this May morning". Before the sunlight enters the church, the pale interior is described twice: "Behind him the little church was pallid in the morning light," "*Dominus vobiscum*, he said as he turned around and blinked at the church's cold whiteness."[299] In Van Gogh's letters, the white color of the church wall is described with a strong feeling of hatred. "No wonder one becomes hardened there [in the church] and turns to stone; I know it from my own experience. And so your brother 'in question' did not want to be stunned, but nevertheless he had a stunned feeling, a feeling as if he had been standing too long against a cold, hard whitewashed church wall. I still felt chilled through and through, to the depth of my soul, by the above-mentioned real or imaginary church wall. And I did not want to be stunned by that feeling. Then I thought, I should like to be with a woman — I cannot live without love ... that damned wall is too cold for me. ..."[300] About two years later, in 1883, he used the term "hypocrisy" in referring to the church wall: "One must be careful not to fall back on opaque black — on deliberate wrong — and even more one has to avoid the white as of a whitewashed wall, which means hypocrisy and everlasting Pharisaism."[301] In Van Gogh's letters as well as in Zola's novel, the white interior of a church symbolizes the sterility of the clergymen's God or lack of life and love.

Once we understand the connotations which the church interior held for Van Gogh, it is not at all surprising that he did not choose the interior of a

church as a subject of his art. The church interior was undoubtedly an important genre, represented by Johannes Bosboom, a nineteenth-century Dutch artist whom Van Gogh knew very well, but Van Gogh deliberately avoided this subject. *In the church* (fig.113; pl.6), a water color made in 1882 in The Hague, is the only work by Van Gogh known today which represents the interior of a church, but the principal motifs in this water color are apparently the figures on the bench and not the interior. Moreover, Van Gogh filled the pictorial space with figures, leaving little open space and producing a rather exceptional composition, as if to avoid the white church wall which he hated so much. In a letter written in July 1880, Van Gogh stated clearly how he hated the "interior of a church": "I must tell you that with evangelists it is the same as with artists. There is an old academic school, often detestable, tyrannical, the accumulation of horrors, men who wear a cuirass, a steel armor, of prejudices and conventions. ... Their God is like the God of Shakespeare's drunken Falstaff, *le dedans d'une église* (the inside of a church)"[302]

The starry night

The most impressive scene in *La faute de l'abbé Mouret* is undoubtedly that of Serge Mouret's hallucination in Book III. This climactic scene, which is quoted above, is strongly reminiscent of Van Gogh's *The starry night* (fig.114; pl.7), one of the most puzzling and controversial paintings in Van Gogh's œuvre.[303] The motifs in this painting and in the hallucination exhibit strange similarities: a small village church overwhelmed by a gigantic tree, which reaches the stars. Of course, the motifs in the painting and in the hallucination scene do not exactly correspond; I am not trying to say that the painting is a visualization of the hallucination scene. But their similarities do not seem to be merely coincidental.

Many scholars have attempted to give a convincing interpretation of this enigmatic painting. Schapiro and Lövgren interpreted the iconography, especially the twelve stars, as a visualization of a biblical text. Whitman's poems, which Van Gogh actually associated with a starry night in his letters of 1888, are often pointed out as a literary source of inspiration by scholars such as Werness and Takashina. Recently, Boime and Whitney independently studied the astronomical aspects of the representation, which led to new insights as regards the creative process of this painting.[304] Based on his astronomical research, Boime criticized the biblical interpretations by Schapiro and Lövgren and stressed Van Gogh's empirical creative process. He tried further to place the whole iconography of the work within the framework of a non-religious historical context, French ideology after the Franco-Prussian War, quoting Camille Flammar-

ion and Jules Verne among others. Camille Flammarion, a nineteenth-century French astronomer, was also mentioned by Whitney as one of Van Gogh's possible sources of inspiration. However, these astronomical studies have not solved the iconographical problems which the painting poses. Boime and Whitney identify mutually exclusive constellations in the starry sky in the painting; Boime claims that it is Aries, while Whitney identifies Cygnus. Moreover, the swirling pattern in the middle of the sky and the crescent cannot be explained by their astronomical research. Quite ironically, their empirical research has proved that Van Gogh's creative process was *not* empirical. Shortly after the publication of these realistic and non-biblical interpretations, Soth interpreted the painting as a visualization of Van Gogh's naturalized religious feeling. Discussing various pictorial sources, including Van Gogh's own painting *Christ with the angel in the garden of olives* painted in 1888 and scraped off by the painter himself, Soth characterized *The starry night* as the expression of "Van Gogh's *Agony* (in the garden of olives) in its most profound level."

After all these studies, what do we know for certain about this painting? It is very unlikely that Van Gogh was giving visual form to a biblical text in the starry sky, because Van Gogh himself described this painting as "not a return to the romantic or to religious ideas, no."[305] Besides, the biblical passages suggested by Schapiro and Lövgren, in Revelations and Genesis respectively, are mainly concerned with the number of stars and do not explain the whole iconography of this painting convincingly. Therefore, such theological or biblical interpretations should be rejected. The two astronomical studies have thrown new light on this painting, but they cannot convincingly explain the iconography as a whole or the starry sky either, for the starry sky in the picture is not a faithful representation of the eastern sky in June, 1889. Neither was the mountain landscape with the small church painted empirically. There was no church at all in this landscape as viewed from the window of the asylum; furthermore, the church with its long spire is a Dutch style of architecture, totally different from St. Martin in Saint-Rémy or any other Provençal churches. Ronald Pickvance suggested recently that Van Gogh took the cypress from *Wheat field* (F719 JH1725) and the mountain landscape from *Mountain landscape behind the asylum* (F611 JH1723), two canvases which were then drying in Van Gogh's studio, and then combined them in one painting.[306] Judging from all these investigations, there is no doubt that *The starry night* is a composed picture and not an empirical representation of an actual landscape.

In trying to minimize the role of the imagination in the creative process and rejecting the religious interpretations which had prevailed since the studies of Schapiro and Lövgren, Boime placed too much stress on the empirical and non-religious aspects of *The starry night*. For both aspects of his interpretation the

imaginary small church in the painting is undoubtedly the most knotty problem. To explain this motif, he quotes an ironic passage on little church towers from Multatuli's *Max Havelaar*. I do agree with Boime's contention that the small church functions as a contrast to the starry sky, which is "the authentic locus of divine experience", but the passage quoted by Boime is by no means appropriate to contextualize this painting. Although in a letter from 1881 Van Gogh quotes the last passage from Multatuli's *Het gebed van den onwetende* (The prayer of an agnostic) "Oh God, there is no God", in criticizing the clergymen's God, he never became an ironical atheist. The ironical vein of the passage on little church towers as well as the "agnostic" in the poem are alien to Van Gogh.[307] Moreover, there is no specific reason to believe that the passage in *Max Havelaar* should be related to *The starry night*. In the passage quoted by Boime the starry sky does not appear. Although it is possible that Van Gogh read *Max Havelaar*, there is no real evidence to this effect, at any rate it is not mentioned in Van Gogh's letters. The name of Multatuli can be found only once, in the letter mentioned above.

After Multatuli, Boime mentions some other literary sources in the course of his argument such as Andersen, Carlyle, Longfellow and Whitman, whose works reflect the trend toward naturalized religion and who are undoubtedly important and appropriate in understanding *The starry night*. However, Boime's argument gradually goes off onto various tangents: Camille Flammarion, Jules Verne, the ideology of the Universal Exposition of 1889 in Paris. If *The starry night* can be interpreted, as Boime maintains, within the context of French ideology as manifested in the Universal Exposition and the post-Franco-Prussian War era, how can we explain the small imaginary church and how can we understand the influence of or relations with the five other writers, none of whom are French? Although Boime's new interpretation contains many interesting and stimulating insights, it excludes not only the biblical interpretations but also too radically rejects the religious aspects of the painting.

From some passages in the letters which have often been quoted in reference to *The starry night*, it is undeniable that this painting has religious — which is not to say theological or biblical — implications. Let us first quote from some letters written in 1888: "For the second time I have scraped off a study of Christ with the angel in the Garden of Olives. You see, I can see real olives here, but I cannot or rather I will not paint any more without models; but I have the thing in my head with the colors, a starry night, the figure of Christ in blue, all the strongest blues, and the angel blended citron-yellow."[308] This passage is the primary source which led Soth to interpret *The starry night* as a naturalized version of *Christ with the angel in the garden of olives*.[309] At about the same time, Van Gogh advised his sister Wil to read Whitman's poems: "He sees in the

future, and even in the present, a world of healthy, carnal love, strong and frank
— of friendship — of work — under the great starlit vault of heaven a something
which after all one can only call God — and eternity in its place above this
world."[310] The following passage shows most clearly that the starry sky had reli-
gious connotations for Van Gogh. "That does not prevent me from having terri-
ble need of — shall I say the word? — of religion. Then I go out at night to paint
the stars, and I am always dreaming of a picture like this with a group of living
figures of our comrades. ... Victor Hugo says, God is an occulting lighthouse
(the French call it an *eclipsing lighthouse*), and if this should be the case we are
passing throughh the eclipse now."[311]

Van Gogh heard God's voice in the starry sky as early as his Amsterdam
period: "At night there is also a beautiful view of the yard; everything is dead
quiet then, and the lamps are burning and the starlit sky is over it all 'When all
sounds cease, God's voice is heard under the stars.'"[312] During his Saint-Rémy
period Van Gogh did not associate the stars and God as directly as in this letter.
He hesitated to use the word "religion" and stressed the realistic aspects of the
subject, especially after he saw the religious representations of Bernard and
Gauguin. About *The starry night* Van Gogh wrote:

> "When you have looked at these two studies for some time, and that of the
> ivy as well, it will perhaps give you some idea, better than words could, of
> the things that Gauguin and Bernard and I sometimes used to talk about,
> and which we've thought about a good deal; it is not a return to the roman-
> tic or to religious ideas, no. Nevertheless, by going the way of Delacroix,
> more than is apparent, by color and a more spontaneous drawing than
> delusive precision, one could express the purer nature of a countryside
> compared with the suburbs and cabarets of Paris. ... Whether it exists or
> not something we may leave aside, but we do believe that nature extends
> beyond St. Ouen. Perhaps even while reading Zola, we are moved by the
> sound of the pure French of Renan, for instance."[313]

The "two studies" mentioned here and "the ivy" are *Olive trees with the
Alpilles in the background* (F712 JH1740), *The starry night* and *A corner in the
garden of Saint Paul's Hospital: Ivy* (F609 JH1693). As Pickvance pointed out,
the first two works can be considered as pendants. They are quite similar in size,
have the same stylistic characteristics and complementary subjects.[314] The
thematic relationship of these two works, the olive garden and the starry night,
would support Soth's interpretation of *The starry night* as a naturalized version
of *Christ with the angel in the garden of olives*.

What Van Gogh talked about with Gauguin and Bernard is the problem of
working from the imagination and painting religious subjects, which Gauguin
and Bernard did paint, but Van Gogh could not. He stressed further that *The
starry night* was not "a return to the romantic or to religious ideas" but rather the

purer nature of a countryside." Then he mentioned Zola and "the sound of the pure French of Renan." Van Gogh's description of the picture is rather vague and confusing, but if we read it carefully we can recognize several opposing pairs of concepts, namely supernatural versus natural, city versus country and even positivism versus belief. In the passage "it is not a return to the romantic or to religious ideas, no", Van Gogh is firmly rejecting the supernatural. "The purer nature of a countryside compared with the suburbs and cabarets of Paris" is the opposition of country and city, or nature and culture. The contrast between Zola and Renan is apparently the distinction between positivism and unconventional belief. Neither "city" nor "positivism" are so firmly rejected as the supernatural, but Van Gogh wishes rather to express "country" and "belief".

I do not suppose any specific relation between *La faute de l'abbé Mouret* and the name of Zola in the description of *The starry night*. From the context of the description, it is clear that the name of the French naturalist exclusively represents positivism in contradistinction to another French writer, Renan, and has nothing to do with the theme or contents of any particular novel. The word "pure" which is often used in this passage apparently has greater religious implications than Boime and Soth have understood. About two months previously, Van Gogh had written to Wil about Renan's style as follows: "Oh, how right Renan is, and how beautiful that work of his, in which he speaks to us in a French that nobody else speaks. A French that contains, *in the sound of the words*, the blue sky, the soft rustling of the olive trees, and finally a thousand *true* and *explanatory* things which give his history the character of a resurrection."[315] Thus, with the words "the sound of the pure French of Renan," Van Gogh was not simply referring to Renan's style but rather to the almost religious experience which he underwent while reading it.

Renan's *Jésus* was mentioned in Van Gogh's letters from 1875 onward and several pages from this book were transcribed in one of Van Gogh's "poetry albums". The following passages from these pages are quite interesting for their anti-dogmatic character and perhaps also for the use of the word "pure": "He [Christ] pronounced for the first time the word upon which the edifice of eternal religion rests. He founded the *pure cult*, without date, without homeland, that which all elevated souls will practise until the end of time. Not only his religion, that day, was the proper religion for humanity, it was the absolute religion. ... It was *pure religion*, without practices, without temples, without priests; it was the moral judgement of the world conferred upon the consciousness of just men and the people."[316] Van Gogh probably had this book in mind when he wrote the following passage in a letter of April, 1889, about two months before he painted *The starry night*. "Isn't Renan's Christ a thousand times more comforting than so many papier maché Christs that they serve up to you in the Duval establishments

called Protestant, Roman Catholic or something or other churches?"[317]

Thus in Van Gogh's mind "Renan" was on the one hand opposed to Zola's naturalism or positivistic thought and on the other to traditional dogmatic Christianity. "Renan" occupied a mediating place between supernaturalism and positivism, and in this mediating and synthesizing function "Renan" and "the purer nature" in Van Gogh's description of *The starry night* correspond with a concept of nature which had played a role since the end of the eighteenth century. As Joseph Warren Beach pointed out in his *The concept of nature in nineteenth-century English poetry*, this concept was "a synthesis of elements derived from science and religion: the scientific notion of regular and universal laws, the religious notion of divine providence."[318] In the century of transition from Christianity to scientific positivism, the concept of nature played a mediating role between these two incompatible powers. It is in the context of this concept of nature in the sense that Beach indicated that Van Gogh's ambiguous and even confusing description of *The starry night* can best be understood.

The biblical and the non-religious interpretations of *The starry night* correspond respectively to traditional Christianity and to the scientific positivism represented, at least in Van Gogh's mind, by Zola. Schapiro, Lövgren and Boime were all stressing one of the two extreme aspects, either traditional Christianity or positivism, both of which Van Gogh rejected in his description of the painting. Until now scholars have gone to a lot of trouble to give clear-cut, convincing explanations for the starry sky; to be more precise, for the number of the stars and the constellation, and in so doing they misunderstood the essential meaning of the whole composition. Although I do appreciate the contributions of the biblical interpretations as well as the astronomical studies, Soth, who was not troubled about the number of stars in the painting, presents us with the most balanced interpretation of *The starry night*. However eclectic it might sound, the principal theme of *The starry night* is the conflict between religion and nature, between Christian belief and naturalism. In Arles, especially before Gauguin's arrival, nature was predominant in Van Gogh's works, but after he had lost the Yellow House and with it his hopes for a naturalized religion, that is, a quasi-religious community, the stress of his inner conflict increased. Furthermore, the religious subjects painted by Bernard and Gauguin must also have enhanced this emotional strain. To accept their Christian subjects was impossible for Van Gogh, even a self-denial of his *raison d'être*, for his existence as an artist started with his rejection and abandonment of Christianity. Thus, he must have been under great stress during the late Arles and Saint-Rémy periods.

A few months after he painted *The starry night*, Vincent wrote to Theo that he was having religious hallucinations. "I am astonished that with the modern ideas that I have, and being so ardent an admirer of Zola and de Goncourt and

caring for things of art as I do, that I have attacks such as a superstitious man might have and that I get perverted and frightful ideas about religion such as never came into my head in the North."[319] In contrast to the hallucination of Serge Mouret, Van Gogh's had to do with the attack of religion instead of nature, but basically their hallucinations were produced by the same inner conflict, that is, the conflict between Christianity and nature.

The sun of the Midi and vegetal symbolism

In *La faute de l'abbé Mouret*, the sun of the Midi and some plants play an important role. Aside from the invasion of sunlight into the church which was already discussed above, the symbolic role of the sun and vegetal symbolism have been pointed out by some scholars.[320] In this novel the sun, symbol of nature and life, is opposed to the church which represents Christianity and society. After Serge Mouret recovered from his illness, it was under the Midi sun that he experienced human life for the first time. In Book II Zola wrote: "Serge could no longer live without the sun," and he has Serge say: "I want us to live in the sun, far from that fatal shade."[321] As already noted, Serge Mouret fell in love with Albine under the sun of the Midi, in Book II of the novel. Interestingly, it is during his utopian period, 1887-1888, that Van Gogh most often used the combination of the sun with lovers and the sower as shown in the table.

	1880-86	87	88	89	90
The sun-lovers	0	2	6	0	0
The sun-sower	0	0	8	0	0

The following are the JH numbers of the works included in the table. The sun-lovers; 1292, 1308, 1369, 1370, 1446, 1473, 1474, 1546; The sun-sower; 1470, 1471, 1472, 1508, 1543, 1627, 1628, 1629.

Before 1886 and after the collapse of his dreams about the Yellow House, the sun is never combined with lovers or sowers, but with olive trees, the plowman, digging figures (with the red sunset) and most often with the reaper and a wheat field. That is to say, during Van Gogh's utopian period the sun is combined mainly with themes of love and labor relating to fertility, and in this respect the implications of Van Gogh's Midi sun undoubtedly correspond with the symbolic meaning of the Midi sun in Book II of Zola's novel.

Some other motifs in Le Paradou scene show similarities to Van Gogh's motifs in his utopian period, for example, sunflowers and a garden. (Appendix

I) The sun of the Midi, lovers and a garden are of course essential motifs in Book II. Heliotropes often appear in this part of the novel and again when Albine commits suicide. Sunflowers also appear in Book II, chapter 7, and on the first line of the list of flowers and plants in the *Ebauche*, Zola notes "Un bois de Tournesols".[322] Numerous flowers and plants are described in the garden scene, but Zola often describes heliotropes, probably because this flower was traditionally considered to symbolize love.[323] The abundance of flowers in Le Paradou is particularly reminiscent of some of Van Gogh's works made in July 1888. As noted in the previous chapter, Van Gogh used the word "Paradou" that same month in the description of the garden of the abbey of Montmajour.[324]

Shortly after the trip to Montmajour, Van Gogh made a series of representations called *The flowering garden*, of which two paintings — one upright and one horizontal — a drawing and a sketch in a letter are known (fig.115, 116, F1455 JH1512, JH1511). Van Gogh described the flowers in the garden in these representations quite extensively and the detailed descriptions of the garden at Montmajour as well as the "flowering garden" are reminiscent of Le Paradou scene. In a letter to Wil, Van Gogh described *The flowering garden*: "I have a study of a garden one meter wide, poppies and other red flowers surrounded by green in the foreground, and a square of blue blowballs. Then a bed of orange and yellow marigolds, then white and yellow flowers, and at last, in the background, pink and lilac; and also dark violet scabiosas, and red geraniums, and sunflowers, and a fig tree and an oleander and a vine. And in the far distance black cypresses against low white houses with orange roofs — and a delicate green-blue streak of sky."[325] In this letter Van Gogh is describing the upright version (fig.115; pl.8), for no sunflowers are depicted in the horizontal versions (fig.116). Strangely enough, the sunflowers on the right side of the "bed of orange and yellow marigolds" in the upright versions are not visible in the same place in the horizontal versions. The reason for this is not clear, since it is uncertain wich versions were made first. However, if the upright versions can be dated later than the horizontal ones, these sunflowers are apparently imaginative additions.

In the previous chapter we saw that diggers and Le Paradou formed an opposition in Van Gogh's mind and that diggers do not occur in Van Gogh's works between the summer of 1887 and the spring of 1889, his utopian period. Interestingly, diggers appear in Zola's novel only in Books I and III, not in Le Paradou scenes of Book II. In Book I, chapter 6, there is a scene in which a digging peasant greets Father Mouret: "'Hello, Father,' said a passing peasant. The noise of digging beside the road brought him out of his reverie. ... *Sweaty brows* appeared (C'étaient des fronts suants) behind the bushes, puffing chests raised themselves slowly. ..."[326] (my italics) In Book III chapter 15, Jeanbernat digs a

grave for Albine: "The old man was digging a hole at the foot of a mulberry tree. ... 'What do you think you're doing?' asked Dr. Pascal. Jeanbernat straightened again. He *mopped his brow* (essuyait la sueur de son front) on his sleeve."[327] (my italics) Zola, who studied Genesis during the preparation of the novel, is apparently using the biblical motif of the digger and the expressions "des fronts suants", "la sueur de son front" in Books I and III. Zola's use of the motif is quite elaborate, while Van Gogh's choice is intuitive and existential, but the opposition of the digger and Paradise, derived from the story of the banishment in Genesis, apparently underlies both the creative process of *La faute de l'abbé Mouret* and the formative process of Van Gogh's œuvre.

Zola formulated his original idea for *La faute de l'abbé Mouret* at the time of the general plan for the *Rougon-Macquart* series, and as early as 1869, six years before its publication, he wrote: "A novel which will have as a framework the religious passions of the time. ... The product is a priest. I will study in Lucien [Serge Mouret] the *great conflict of nature and religion*. A priest in love, I believe, has never been studied as a human being. There is in it a very beautiful subject for drama, especially by placing the priest under the influences of heredity."[328] (my italics) In many of Van Gogh's letters and works, above all in *The starry night*, we can recognize this "great conflict of nature and religion", which is undoubtedly one of the principal themes in Van Gogh's œuvre.

We may characterize the thematic affinities between *La faute de l'abbé Mouret* and Van Gogh's œuvre as a complex parallel. Zola studied the conflict between Christianity and nature in the personage of Serge Mouret, while Van Gogh actually experienced the conflict. The drama of *La faute de l'abbé Mouret* is situated by Zola in 1866, that is to say, Serge Mouret, who is 25 years old when the novel begins, was born in 1841, twelve years before Van Gogh.[329] These two differences are historically interesting in that they reflect the slow process of secularization in the Netherlands. As students of Zola have pointed out, Zola was, far from being an atheist, a deeply religious man and a pantheist hovering between doubt and faith.[330] In this sense he still shared the problem which haunted Van Gogh all through his life, but as a French novelist he had experienced the waning of Christianity and the rise of positivism much earlier than Van Gogh. He could keep enough distance to observe and study the conflict between Christianity and nature.

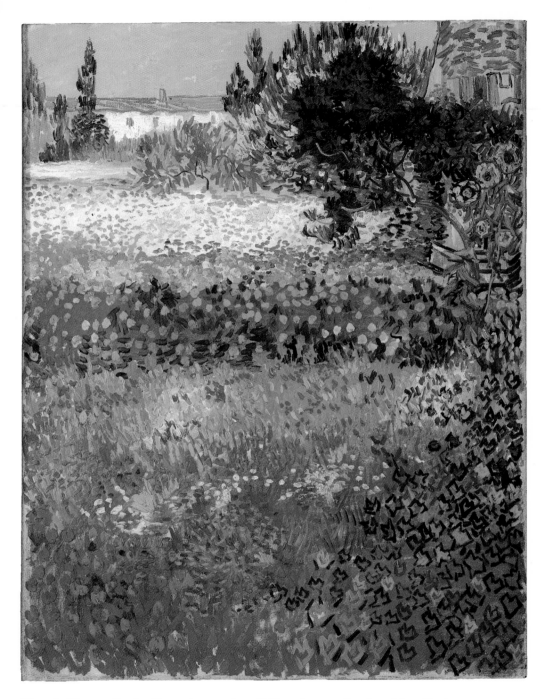

Plate 8. V. van Gogh, *Flowering garden*, 1888, private collection, New York.

7. Conclusion: triumph and defeat of nature

> "Les peintres pour ne parler d'eux — étant morts et enterrés, parlant à une génération suivante ou à plusieurs générations suivantes par leurs œuvres."
> (letter 506)

The present study, which might be called an introductory essay in the study of thematics, has revealed several unknown aspects of Van Gogh's œuvre. In Chapter 1 ("Dominocratie") I attempted to reconstruct the religious and cultural background of nineteenth-century Holland, which apparently played a significant role in Van Gogh's artistic career. Not only for Van Gogh but also for Dutch nineteenth-century art as a whole, a general survey of this neglected field is indispensable. In the following five chapters, I pointed out and discussed Van Gogh's recurrent motifs which play significant roles in Van Gogh's œuvre. The church and the sun motifs discussed in Chapter 2 were chosen for their substitutional functions. In Chapter 3 ("Light in the darkness") I wished to demonstrate the survival of typical Christian concepts in the treatment of the modern theme of "French naturalist novels". Diggers and utopian motifs such as sunflowers, the sun and Japanese prints, were chosen for their incompatible, oppositional characters. *The starry night* was chosen as one of the typical examples of the conflict between the two opposing themes of Christianity and nature.

Needless to say, there are other essential themes such as the sower and the reaper which deserve to be discussed more extensively. There are also other relatively minor motifs which do show interesting traces of having been manipulated in the œuvre, but I have not discussed them extensively, because I was not convinced that all or most of the characteristics of the motifs, such as combinations with other motifs, frequency of occurrence and their meanings, can be suffi-

ciently explained. For example, the traditional meanings of the sower are well known, and it is not difficult to compile and reconstruct the personal meanings which the sower held for Van Gogh from his numerous descriptions in the letters. But it is difficult to convincingly explain the total lack of this motif in 1885 and the great number of reapers in the same year. Such provisional or hypothetical results of this thematic analysis, included in Appendix I with brief comments, will hopefully be explained by future studies.

In many cases, especially in landscapes, analysis is complicated by the problem of distinguishing the painter's existential choice of motifs from incidental factors which nonetheless had great influence on the painter's choice. This process requires favorable conditions, careful consideration and possibly different analytical methods from those used here. However, the results of the present study show clearly that, even by the simple analytical methods used here, thematic aspects of the œuvre can be revealed which can never be recognized by the traditional iconographical approach to individual or groups of works.

Among the thematic aspects discussed in the previous chapters, the most important, I believe, is the naturalization and substitution of Christian or religious themes which underlie the phenomenon of thematic transformation in Van Gogh's œuvre. Since the aspects discussed in each chapter might seem quite varied or even fragmentary, I would like to survey those aspects and place them within the context of nineteenth-century religious and artistic thought.

In his *The concept of nature in nineteenth-century English poetry* mentioned in the previous chapter, Beach discussed the significance of the concept of nature for English poets from Romanticism to the Victorian age, including favorite writers of Van Gogh's such as Carlyle and Whitman.[331] His interpretation of the concept of nature is quite helpful in bringing coherence into the seemingly diverse aspects of Van Gogh's life and works discussed above. It may seem misleading to approach those aspects not from the context of art history but from the context of nineteenth-century poetry. However, in the field of the history of nineteenth-century art, there is no general survey on this subject which is comparable to Beach's work. Through further study of the concept of nature in art, we may be able to find a parallel phenomenon in art and eventually correct or reconsider the following conclusions.

Beach points out first that the nineteenth-century concept of nature was a synthesis of elements derived from science and religion; nature was purposive, harmonious and at the same time benevolent and divine. His subsequent remarks cover most of the important aspects discussed in the first chapters of the present study.

> It is to be observed [...] that this concept of harmonious and purposive nature was most often held by writers who were not orthodox Christians;

that, however religious it might be in its essence, it carried more or less of
a latent protest against the prevailing dogmatic religion. [...] Historically
considered, the faith based on this concept of nature amounted [...] to a
kind of substitute for the Christian religion. It was Christianity freed from
various superstitious, irrational and so to speak, parochial elements, and
yet retaining enough emotional force to satisfy man's craving for a moral
and intelligible universe. [...] The human mind cannot suddenly pass with
ease and comfort from any form of faith to agnosticism or unbelief. It
instinctively provides itself with means for easing off the emotional strain
of such a transition. It provides philosophical bridges from faith to unfaith.
And such a bridge was the romantic cult of nature, considered in the
large.[332]

We have seen several times that the word "nature" implied God or divinity
for Van Gogh. Scientific elements in the concept of nature were not discussed in
the preceding chapters, but they can also be found in Van Gogh's letters. For
example, he wrote in Nuenen: "The *laws* of the colors are unutterably beautiful,
just because they are *not accidental*. In the same way people nowadays no longer
believe in fantastic *miracles*, no longer believe in a God who capriciously and
despotically flies from one thing to another, but begin to feel more respect and
admiration for and faith in nature. ..."[333] The study of color theory was therefore
for Van Gogh not only a technical excercise but also an attempt to substitute the
scientific notion of universal laws implied in the concept of nature for the
superstitious, irrational elements of Christian religion.

If, as Beach says, nature played the role of easing off the great emotional
strain caused by the transition from faith to unbelief, from Christianity to scien-
tific positivism, Van Gogh was certainly one of those who badly needed the
mediation of nature. His transition was so rapid and radical that it must have
caused very great stress. As shown in the previous chapters, substitution and
naturalization did not occur immediately after he became a painter. *La joie de
vivre* in the *Still life with open Bible* of 1885 is one of the first signs of substitution
but such signs are not so discernible in other works of the same period. As noted
in several chapters, Van Gogh's works began to show notable thematic substitu-
tion and naturalization only as late as 1887.

In Van Gogh's career, nature in the sense of a substitute religion reached its
culmination in 1888. In spite of the fact that he tried to paint — and scraped off
— a religious painting, *Christ with the angel in the garden of olives*, themes of
nature dominated Van Gogh's works during this period. Not only in his subject
matter, but also in his concept of the Yellow House and in his *japonisme*, nature
played the role of a substitute religion most powerfully. Once again, what Beach
wrote about nature in nineteenth-century poetry is quite helpful in understand-
ing Van Gogh's concept of a community of artists in the context of naturalized
religion.

"One of the hardest thing for man to bear is spiritual isolation. ... He has
an overpowering impulse to construct a system which will enable him to
feel that he does not stand alone but is intimately associated with some
force or group infinitely more powerful and significant than himself. In
religion he may feel himself thus intimately associated with God and with
other holy beings — the community of saints. With the waning of religious
faith he grasps at nature — at the great benevolent order of things in which
every individual is provided for in the harmonious plan of the whole."[334]

By making the decision to become a painter, Van Gogh broke his intimate
association with the "community of saints" and with the community of Christ-
ians, but he felt himself too weak to stand alone. In September 1888, he wrote
to Theo: "I can very well do without God both in my life and in my painting, but
I cannot, ill as I am, do without something which is greater than I, which is my
life — the power to create."[335] At the end of the same month, he wrote: "That
does not prevent me from having terrible need of — shall I say the word? — of
religion. Then I go out at night to paint the stars, and I am always dreaming of
a picture like this with a group of living figures of our comrades. ..."[336] Thus,
Van Gogh is grasping at nature, at the starry sky, and is trying to establish a new
community, the Yellow House, under the new God, the sun of the Midi. The
nature-religious character of his concept of the Yellow House can be ascertained
by various facts: he bought twelve chairs, found the model for his community in
the communal life of monks and called Theo "the first dealer-apostle".[337]

Van Gogh's primitivistic interpretation of the Japanese, discussed in Chap-
ter 4, can also be understood in the same historical context. Many nineteenth-
century artists associated the word nature with a state of life untouched by
human hand and institutions and consequently they were disposed to think that
primitive people were in many ways superior to the people of more sophisticated
civilizations. This disposition is constantly present in Van Gogh's life, but in his
interpretation and idealization of the Japanese, it revealed itself most clearly and
intelligibly. To Van Gogh's mind, the Japanese was the "noble savage" con-
ceived by Romantic artists; "wise, philosophic and intelligent" people who spent
their time studying "a single blade of grass."[338] It is especially worth emphasizing
that his image of the Japanese was very clearly colored by his concept of nature-
religion. In his *Self-portrait as a bonze*, Van Gogh identified himself not with a
Japanese painter but with a Japanese monk, and the following speculation is the
most telling attestation: "... isn't it almost a *true religion* which these simple
Japanese teach us, who live in nature as though they themselves were flow-
ers?"[339] (my italics)

Van Gogh's concept of the Yellow House and his *japonisme* were both
attempts to supply a substitute for Christianity and to create a new congregation

of believers in naturalized religion. In the utopian period, especially with the arrival of Gauguin at Arles, the community seemed to have been realized. Nature seemed to totally displace Christinanity. But just like the concept of nature ceased to mean purposive or benevolent order for man and lost its power at the end of the nineteenth century, just like Serge Mouret failed to regain Le Paradou, Van Gogh's ideal of the Yellow House was lost. Historically considered, the concept of the Yellow House, the new congregation of naturalized religion and its failure were by no means exceptional nor a purely individual case. Van Gogh was living at the time when the word nature was losing its power. During his short artistic career of ten years, Van Gogh experienced what artists from Romanticism until the *fin de siècle* experienced: liberation from waning Christianity and the triumph and defeat of nature as a substitute for Christian religion. This extremely rapid transition from Christianity to nature-religion must have caused enormous stress in Van Gogh's mind. This transition was accelerated by Van Gogh's personal as well as historical circumstances. He had grown up in a clergymen's family during *dominocratie* and by leaving his native country he entered a much more secularized environment.

After the collapse of the Yellow House, Van Gogh wrote: "Why shouldn't what happened in England at the time of the Pre-Raphaelites happen here?"[340], but during the decades between the Pre-Raphaelite Brotherhood and the Yellow House, the time of nature-religion was rapidly declining. Camille Flammarion, a French astronomer whose writings were discussed in Boime's study on *The starry night* (fig.114; pl.7), published *Dieu dans la nature* in 1867. In the introduction to this book, Flammarion wrote: "In the first hour of our century, the last sigh was heard of the religion of our fathers. In vain would we labor to restore and rebuild it: only phantoms are left now; what is dead cannot be revived."[341]

In the Netherlands, however, the last sigh of the old religion was heard as late as about 1880. What Van Gogh wrote about his *The old church tower in Nuenen* (fig.62), painted shortly after his father's death, is strikingly symbolic: "And now those ruins tell me how a faith and a religion moldered away — strongly founded though they were. ... 'Les religions passent, Dieu demeure' is a saying of Victor Hugo's whom they also brought to rest recently."[342] Like Flammarion, Van Gogh knew that it was impossible to reconstruct the ramshackle old church, but he had believed too deeply and too long in Christianity to erect a totally new construction. What he could do was to build a temple of art on the ruins of his fathers' church.

Notes

1. G.-A. Aurier, "Les isolés, Vincent van Gogh," *Mercure de France* 1 (1890) pp.27-8. "Si l'on refusait, en effet, d'admettre sous cet art naturaliste l'existence de ces tendances idéalistes, une grande part de l'œuvre que nous étudions demeurerait fort incompréhensible. Comment expliquerait-on, par example, *le Semeur*, ... si l'on ne veut songer à cette idée fixe qui hante sa cervelle de l'actuelle nécessité de la venue d'un homme, d'un messie, ... Et aussi cette obsédante passion pour le disque solaire qu'il aime a faire rutiler dans l'embrasement de ses ciels et, en même temps, pour cet autre soleil, pour cet astre végétal, le somptueux tournesol, ... comment l'expliquer si l'on refuse d'admettre sa persistante préoccupation de quelque vague et glorieuse allégorie héliomythique?"

2. Maurice Beaubourg, "Beaux-Arts, les indépendents: la mort de Dubois-Pillet et de Vincent van Gogh," *Revue Indépendente*, (Sept. 1890) pp.397-98. "Il ne faut pas voir un unique tableau de M. Vincent van-Gogh (sic), il faut les voir tous, pour comprendre cette nature complexe et agitée..." Beaubourg (1866-1943) was a symbolist writer and painter. (See *Grand Larousse encyclopédique*, vol.2, Paris 1960.) His name is included in the address book of Theo van Gogh in the collection of the Rijksmuseum Vincent van Gogh. Theo notes in this book: 'Beaubourg (M), 135 Fg Poissonnière (Revue Indépendante). Beaubourg's words are quoted as a motto in: Jan Veth, "Studiën over moderne kunst I. Tentoonstelling van werken door Vincent van Gogh in de Amsterdamsche Panoramazaal," *De Nieuwe Gids* 8 (1893) vol.1, p.427. For the reception of Van Gogh see: Carol Zemel, *The formation of a legend : Van Gogh 'criticism 1890-1920*, Ann Arbor 1980.

3. Karl Jaspers, *Strindberg und Van Gogh, Versuch der pathographischen Analyse unter vergleichende Heranziehung von Swedenborg und Hölderlin*, Munich 1949 (first edition 1926) pp.156-159. The English translation is from K. Jaspers, *Strindberg and Van Gogh*, Tucson, Arizona, 1977, pp.172-176.

4. This concept will be defined under "Methodological problems". For a similar use of the term see Boris Tomashevsky, "Thematics," in: Lemon, L.T. & J.R. Marion, ed., *Russian formalist criticism, four essays*, Lincoln 1965, pp.61-98, and Roland Barthes, *Michelet*, trans. R. Howard, New York 1986, 1987.

5. Roland Barthes, *Michelet par lui-même*, Paris 1954, 1965. (English translation, see note 4)

6. J.A. Schmoll gen.Eisenwerth et al., *Beiträge zur Motivkunde des 19. Jahrhunderts*, Munich 1970. Jan Białostocki, "Romantische Ikonographie," in: *Stil und Ikonographie, Studien zur Kunstwissenschaft*, Cologne 1981 (first ed. 1966), pp.214-262. See also two other arti-

cles in the same book: "Van Goghs Symbolik," pp.263-268; "Die Rahmenthemen und die archetypischen Bilder," pp.144-172.

7. For Van Gogh see C. Nordenfalk, "Van Gogh and literature," *Journal of the Warburg and Courtauld Institutes*, 10, (1947) pp.132-47; J. Seznec, "Literary inspiration in Van Gogh," *Magazine of Art*, 43, (1950), pp.282-88 and 306-7; S. Takashina, *Van Gogh no me* (in Japanese), Tokyo 1984; H.B. Werness, *Essays on Van Gogh's symbolism*, Ph.D. diss., University of California, 1972; E. van Uitert, *Vincent van Gogh in creative competition: four essays from Simiolus*, Zutphen (diss. Amsterdam) 1983. A pioneering work of iconological and psychoanalytical interpretation of one motif in the œuvre is: Meyer Schapiro, "The apples of Cézanne: an essay in the meaning of still-life," in: Meyer Schapiro, *Modern Art, 19th & 20th centuries, selected papers*, New York 1968, pp.1-38.

8. H.Nagera, *Vincent van Gogh: a psychological study*, New York 1967; H.R. Graetz, *The symbolic language of Vincent van Gogh*, London 1963; A.J. Lubin, *Stranger on the earth: a psychological biography of Vincent van Gogh*, New York 1972.

9. Helmut Börsch-Supan and Karl Wilhelm Jähnig, *Caspar David Friedrich, Gemälde, Druckgraphik und bildmässige Zeichnungen*, Munich 1973.

10. See Charles Rosen and Henri Zerner, *Romanticism and realism, the mythology of nineteenth century art*, London & Boston 1984, pp.49-70 "II Caspar David Friedrich and the language of landscape"; Françoise Forster-Hahn, "Recent scholarship on Caspar David Friedrich," *Art Bulletin*, 58 (March 1976) no.1, pp.113-116.

11. The concept of "œuvre" conceived by the painter himself is discussed in: E. van Uitert, op.cit. (note 7) pp.71-92 "Van Gogh's concept of his *œuvre*". For the characteristics of series see: Roland Dorn, *Décoration, Vincent van Goghs Werkreihe für das Gelbe Haus in Arles*, Mainz (Ph.D.diss. Johannes Gutenberg-Universität) 1985.

12. Research on the artistic sources of Van Gogh are quite extensive. For a general survey see: ex.cat. *Vincent van Gogh exhibition*, Tokyo (National Museum of Western Art) 1985 and E. van Uitert & M. Hoyle (ed.), *The Rijksmuseum Vincent van Gogh* Amsterdam 1987.

13. In the sense that Van Gogh had to choose his motifs within the extensive but restricted repertory of natural and artistic sources, his creative process might be comparable to the "bricolage" concept which C. Lévi-Strauss coined to characterize magical or mythological thought in his *La pensée sauvage* (Paris 1962, chapter I "La science du concret" p.26) Lévi-Strauss places the painter between the "bricoleur" and the scientist. See ibid. p.33.

14. For Warburg's methodology with respect to the *Bilderatlas* see: Werner Hofmann, Georg Syamken & Martin Warnke (ed.), *Die Menschenrechte des Auges: über Aby Warburg*, Frankfurt am Main 1980. In addition to Warburg's method, I had Lévi-Strauss's analytic method for myths in mind when I started my research. See Claude Lévi-Strauss, *Anthropologie structurale*, Paris 1958, chapter "La structure des mythes"

15. See "Selected Bibliography" under "1. Van Gogh and religion" and Chapter 1 "Dominocratie".

16. See recent studies in the "Selected Bibliography" under "Religious background".

17. For the meanings of nature, see Basil Willey, *The eighteenth century background, studies on the idea of nature in the thought of the period*, London 1946; A.O. Lovejoy, "Nature as aesthetic norm," in: A.O. Lovejoy, *Essays in the history of ideas*, Baltimore 1948, pp.69-77; Joseph Warren Beach, *The concept of nature in nineteenth-century English poetry*, New York 1936. The concept of nature will be discussed more extensively in the conclusion.

18. "...Maar steeds totaal bedorven, doordat hij de witte randen letterlijk volkrabbelde met citaten uit Thomas à Kempis en uit de bijbel min of meer betrekking hebbend op het onderwerp." (122a) M.B. Mendes da Costa (1851-1938) later became a librarian at the University Library in Amsterdam.

19. The lithograph is presently in the manuscript room of the University Library in Amsterdam (no.XIII C 13a,b). The inscription

by Mendes da Costa: "20 Feb. 1916; Deze gra-
vure is mij door Vincent van Gogh ter ge-
schenke gegeven in 1877 of 1878. De bijschriften
in margine en in verso, met potlood, zijn van
Van Gogh zelf. (signature), 28 Sept. 1926." As
is often the case with Van Gogh, the five Latin
texts are not quoted correctly. John 20:1 on the
reverse side is not quoted in full.

20. *Het boek der Psalmen nevens de
Gezangen bij de Hervormde Kerk van Neder-
land*, Amsterdam 1825, pp.310-311, gezang 189
"De Hoop der Zaligheid". This book is in the
former collection of Van Gogh family in the
Rijksmuseum Vincent van Gogh, but it is not
certain if Vincent was using this edition.

Glad as the man of the land, tired from plowing
Greets the approach of evening
Are we, after all that labor and toil
To see that the day draws to a close
Our hopes for the hours of rest
Shall not eternally languish
But the moment,
So long gaspingly awaited, shall arrive
That hope can soften all our pain
Come, fellow travellers, hold your hands high
For those who await the salvation of the Lord
Mountains are flat and seas are dry
Immeasurable bliss
Sparks, which banishes all pain
Our alienation will be forgotten
And we will be in our homeland

Van Gogh quotes only verses 1 and 6. The text
on the print is slightly different from the origi-
nal one. Probably Van Gogh did not transcribe
the verses from the book but wrote them from
memory. The following is the original text of
verses 1 and 6 in the 1825 edition.

Zoo blij de landman moe' van 't ploegen
De neigend' avondschaduw groet;
Zoo blij zien wij bij al ons zwoegen,
Dat onze dag ten einde spoedt;
Niet eeuwig zal die hope kwijnen,
Die naar het uur der ruste smacht;
Die oogenblik zal haast verschijnen,
Hoe lang ook hijgend ingewacht.

(verse 6)
Die hoop moet al ons leed verzachten:
Komt reisgenoten! 't hoofd omhoog!
Voor hun, die 't heil des Heeren wachten,
Zijn bergen vlak en zeeën droog.

O zaligheid niet aftemeten!
O vreugd, die alle smart verbant!
Daar is de vreemdlingschap vergeten;
En wij, wij zijn in 't vaderland!

I would like to thank to Prof. G.J. Hoenderdaal
who kindly let me know the source of the verse.
A part of the same song is quoted also in a
manuscript at the Rijksmuseum Vincent van
Gogh. This undated manuscript (inv.no.b 1463v
/1962) contains several quotations from Psalms,
hymn-books etc. and Van Gogh's original text.

21. For the "autograph book" of Jones see
Jan Hulsker, *Lotgenoten*, Weesp 1985, pp.82-
84, and Fieke Pabst (ed.), *Vincent van Gogh's
poetry albums*, (Cahier Vincent 1,
Rijksmuseum Vincent van Gogh), Zwolle 1988.
The transcription on the lithograph is slightly
different from the original poem. In the origi-
nal, the fourth verse from the bottom is "The
bell is pealing" and not "The bells are pealing"
as Van Gogh writes. Van Gogh does not quote
the following last four lines: "Shadows are trail-
ing / My heart is bewailing / And tolling within /
Like a funeral bell." I would like to thank Jan
Hulsker who kindly let me know the source of
the English verse.

For Delaroche's print see: Bruno Foucart,
*Le Renouveau de la peinture religieuse en
France, 1800-1860*, Paris 1987, fig. 188.

22. *Photographiën met dichterlijke bijschrif-
ten van J.J.L. ten Kate*, Amsterdam (A. Jager)
s.a. Though this book itself cannot be found in
major public libraries in the Netherlands, I did
find a proof of this book in the Ten Kate ar-
chives in the Nederlands Letterkundig Museum.
It must have been published before 1870,
because the same publisher, A. Jager, pub-
lished *Nieuwe photographiën met dichterlijke
bijschriften* in 1870.

23. For the *bijschriften-poëzie* see
Dieuwertje Dekkers, "De Kinderen der Zee,
de samenwerking tussen Jozef Israëls en
Nicolaas Beets," *Jong Holland* 2 (March 1986)
no.1, pp.36-52, and Bern. Koster Jr., (J. Zim-
merman), "Bijschriften-Poëzie," *De Gids* 22
(1861) II, pp.71-78.

24. In letter 30, Van Gogh made a list of the
prints which were hanging on the wall of his
room. In letter 29 he wrote: "Het zijn enkele
lithographieën, etc. die ik graag in Pa's studeer-

kamer bij 'de begrafenis in het koren' van Van der Maaten zou zien." In Van der Maaten's œuvre this painting was very successful, but rather exceptional, containing very explicit biblical allusions. Van der Maaten's works in general are far more realistic in conception.

25. "Hoorde Zondagmorgen Ds. Laurillard in de vroegpreek over 'Jezus wandelde in het gezaaide.' Hij maakte een grooten indruk op mij — in die preek sprak hij over 'de Begrafenis in het koren' van v.d. Maaten." (101) K. van der Maaten, a son of the painter, writes that B. ter Haar mentioned the painting in his sermon in: *Het leven en de werken van den landschapschilder Jacob Jan van der Maaten, 1820-1879*, typescript, Chailly sur Charens, 1929, p.27. The Rijksbureau voor Kunsthistorische Documentatie in The Hague possesses a copy of this typescript. For J.J. van der Maaten see P.A. Scheen, *Lexicon Nederlandse beeldende kunstenaars 1750-1880*, The Hague 1981.

26. Gerard Brom, *De dominee in onze literatuur*, Nijmegen-Utrecht 1924. See chapter 1 "dominocratie". Dominocratie is a combination of dominee (clergyman) and cratie (cracy). For Brom see: P. Luykx & J. Roes, *Gerard Brom, een katholiek leven*, Baarn 1987. For the cultural background and the theologians' role see two articles in: *Algemene Geschiedenis der Nederlanden*, Haarlem 1977, vol.12, J.A. de Kok, "Kerken en godsdienst: het uitgaan van kerk en school," pp.232-50, and Th. van Tijn, "De schone kunsten," pp.251-66.

27. Brom, op.cit. (note 26) p.9. Probably this is the situation in about 1870 or slightly earlier. The following are the numbers of students at the University of Utrecht in the academic years 1877-78 and 1900-01. 1877-78; theology 136, all faculties 326. 1900-01; theology 208, all faculties 802. (cf. *De Universiteit van Amsterdam 1877-1927 Statistisch beschouwd in vergelijking met de andere Nederlandse Universiteiten*, Amsterdam 1927) In other universities, there were far fewer students of theology with the exception of the Vrije Universiteit in Amsterdam which was established according to the precepts of the reformed community.

28. For Ten Kate and his publications see *Biographisch Woordenboek van Protestantsche Godgeleerden in Nederland*, J.P. de Bie & J.

Loosjes (ed.), The Hague, vol.4, 1931. R.B. Evenhuis, *Ook dat was Amsterdam*, vol.5 "De kerk der hervorming in de negentiende eeuw; de strijd voor kerkherstel," Baarn 1978, pp.219-20. J.J.L. ten Kate, *De schepping, een gedicht*, Utrecht 1866. Letter 105; "...en toen naar Eilandskerk waar Ds. ten Kate, de dichter van de Schepping en schrijver van vele mooie boeken, preekte over Rom. 1:15-17. Het was een zeer volle kerk..."

29. J.J.L. ten Kate, *Christus Remunerator, een harptoon*, new edition, Amsterdam 1858; *Nieuwe photographiën met dichterlijke bijschriften*, Amsterdam 1870; *Kunst en leven, naar origineele cartons*, Amsterdam ca.1870; *De Planeeten*, The Hague-Leiden-Arnhem 1869; *De Jaargetijden*, Groningen 1871, *De Nieuwe Kerk van Amsterdam*, Amsterdam 1885.

30. On the back cover of the 1854 volume of the *Kunstkronijk*, about 30 regular contributors are listed. Among them are many clergymen and theologians including B. ter Haar, J.P. Hasebroek, J.J.L. ten Kate, J.J. van Oosterzee and C.W. Opzoomer.

31. For the complete titles see note 29. Ary Scheffer's *Christus Remunerator* as well as other paintings of his were very popular in the middle of the nineteenth century. Numerous books and articles were written on Scheffer mainly by clergymen. To mention just some of these: T. van Westrheene (ed.), *Scheffer album*, Haarlem 1860; W.Az. Francken, *Ary Scheffer's Christus Remunerator als type van de verheerlijking des Christendoms door de kunst*, Rotterdam 1855; P. Hofstede de Groot, *Ary Scheffer*, Groningen 1872; J.J.L. ten Kate, "Bij Scheffer's 'Drie Koningen'", *Aurora* 1854, pp.245-8; A.L.G. Toussaint, "Ary Scheffer, Drie Koningen," *Kunstkronijk* 6 (1845-46) p.25.

32. For the recent controversy concerning the emblematic interpretation of paintings see Svetlana Alpers, *The art of describing*, Chicago & London 1983, "Appendix, on the emblematic interpretation of Dutch art" pp.229-233, and E. de Jongh's book review in: *Simiolus* 14 (1984) pp.51-59.

33. Reminiscences in letters 94a and A7. For Ch.H. Spurgeon see Ernest W. Bacon, *Spurgeon, heir of the puritans*, London 1967;

Autobiography, compiled from his diary, letters and records 4 vols., London 1897-1900 (Dutch translation by Elisabeth Freystadt, *Het leven van Charles Haddon Spurgeon, Naar bescheiden uit zijn dagboek, aanteekeningen en brieven* Rotterdam 1900-1902); C.S. Adama van Scheltema, *Charles Haddon Spurgeon*, Nijmegen 1892.

34. Ch.H. Spurgeon, *Spurgeon's Juweeltjes*, Leiden 1864, second, third and fourth editions, Amsterdam 1872, 1874 and 1882, fifth edition, Rotterdam 1892. In *Brinkman's catalogus van boeken* 67 titles of translations are listed between 1850 and 1900, but most of them cannot be found in the central catalogue of Dutch libraries in the Royal Library in The Hague.

35. See illustrated editions of Spurgeon's works; *John Ploughman's talk, or plain advice for plain people* London 1868 and later editions; *Farm sermons*, London 1882; *John Ploughman's pictures or more of his plain talk to plain people*, London 1880. Dutch translations; *"Zijn God onderricht hem" schetsen aan landbouw en veeteelt ontleend (Farm Sermons)* trans. by C.S. Adama van Scheltema, ill., Amsterdam 1883; *Jan Ploegers prentjes of meer van zijn praatjes voor eenvoudige lieden*, Amsterdam 1880.

36. John Leighton & Richard Pigot, *Moral emblems with aphorisms, adages, and proverbs of all ages and nations, from Jacob Cats and Robert Farlie*, London 1860.

37. For the Victorian emblematic revival see Karl Josef Höltigen, *Aspects of the emblem, studies in the English emblem tradition and the European context*, Kassel 1986, "IV The Victorian emblematic revival" pp.141-196; Barry V. Qualls, *The secular pilgrims of Victorian Fiction, the novel as book of life*, Cambridge etc. 1982; George P. Landow, *William Holman Hunt and typological symbolism*, New Haven & London 1979.

38. *Alle de wercken van Jacob Cats*, edited by J. van Vloten, illustrated by J.W. Kaiser, 2 vols., Zwolle 1862. A list of subscribers is printed at the beginning of the first volume. In Adriaan Spinniker's *Leerzaame Zinnebeelden* Haarlem 1714, we can find some interesting images such as a plowman, a wheat field, a reaper etc.

39. See Chapter 2, note 121 and fig. 48.

40. For the reward prints and Ten Kate's book see R.P. Zijp, "Religieus beloningsmateriaal op school en zondagsschool," in: *Vroomheid per Dozijn*, Utrecht (Rijksmuseum het Catharijneconvent) 1982, pp.63-67. J.J.L. ten Kate, *Nieuwe Belooning, Kindergedichtjes, naar aanleiding van het boek der Spreuken, oorspronkelijke en vertaald door J.J.L. ten Kate*, Amsterdam ca. 1850, reprint by the Nederlandsche Zondagsschool Vereeniging, Amsterdam 1975. In *Brinkman's catalogus van boeken* several series of Sunday school prints are listed in about 1870.

41. For the theological background see M.E. Tralbaut, "Over de godsdienstige richtingen in Vincent's tijd," in: *Van Goghiana* VII, Antwerp 1970, p.103-8. R.B. Evenhuis, op.cit. (note 28). K.H. Roessingh, *De Moderne Theologie in Nederland, hare voorbereiding en eerste periode*, Groningen 1914. E.H. Cosse, "De geheele godsdienst behoort tot het gevoel: Romantische elementen in kerk en theologie," *De Negentiende Eeuw* 8 (Oct. 1984) no.2, pp.91-107. For the Groningen School see; P. Hofstede de Groot, *De Groninger Godgeleerden in hunne eigenaardigheid*, Groningen 1855. J. Huizinga, "De Groninger Richting," in: *Verzamelde Werken* VIII, Haarlem 1951, pp.139-63. That Vincent's father belonged to the Groningen School is attested to by Vincent's aunt, Maria Johanna Van Gogh, in her diary and also in: *Verzamelde brieven van Vincent van Gogh*, Amsterdam & Antwerp 1974, no.A3.

42. D.F. Strauss, *Das Leben Jesu, kritisch bearbeitet*, Tübingen 1835. At first this book was bitterly criticized by a number of Dutch theologians. P. Hofstede de Groot, the founder of the Groningen School, declared that he would stop the distribution of this book, but Strauss's vision did slowly permeate Dutch theology. See Evenhuis, op.cit. (note 28) p.294, H.W. Obbink, *David Friedrich Strauss: in Nederlandse reacties op zijn theologie in de negentiende eeuw*, Utrecht 1973.

43. "In diepste diepte hebben zij apologeten willen zijn, de moderne theologen der vorige eeuw; de onuitgesproken vraag in al hun werk was deze: hoe prediken wij het Christendom voor 'moderne menschen'?" Quoted in: Cossee,

op.cit. (note 41) p.105. For Stricker see A. Ver-
kade-Bruining, "Vincent's plans to become a
clergyman," *Vincent* 3 (1974) no.4 pp.14-23;
H.P. Berlage, "Levensbericht van Dr. J.P.
Stricker," *Levensberichten der afgestorvene
medeleden van de Maatschappij der Neder-
landsche Letterkunde* (1887) pp.27-55; J.P.
Stricker, *De oorsprong der moderne richting*,
Amsterdam 1874, *Jezus van Nazareth*, Amster-
dam 1868.

44. For Van Gogh and the Methodism see:
G.E. Lawrence, *The methodism of Vincent van
Gogh*, Pillowell 1979 (typescript, a copy in the
library of the Rijksmuseum Vincent van Gogh).
For the sermon see letter no.79 and David
Bruxner, "Van Gogh's Sermon," *Country Life*
(Nov. 11, 1976) pp. 1426-8. The complete trans-
cription of the sermon is recently published.
See: J. Leistra, *George Henry Boughton: God
Speed! Pelgrims op weg naar Canterbury*,
Amsterdam (Rijksmuseum Vincent van Gogh)
1987, pp.56-63.

45. Tralbaut, op.cit. (note 41), A.H. Mur-
ray, "The religious background of Vincent van
Gogh and its relation to his views on nature and
art," *Journal of the American Academy of Reli-
gion*, 44 (supplement, March 1978) no.1, pp.67-
95.

46. "Wel in iedere kerk zie ik God en of de
dominee nu preekt of de pastoor, het is mij het-
zelfde, in het dogma zit het 'm niet, maar in de
geest van het Evangelie en die geest vind ik in
alle kerken." (A7)

47. In addition to this undogmatic concept
of religion, Van Gogh's admiration for the per-
son of Christ might also have its origin in the
Christocentrism of the Groningen School. In his
early years Van Gogh read *L'Imitation de Jésus
Christ* repeatedly, and in 1888 he wrote to Ber-
nard as follows: "The Bible is Christ, for the
Old Testament leads up to this culminating
point ... Christ alone — of all the philosophers,
Magi, etc. — has affirmed, as a principal cer-
tainty eternal life, the infinity of time, the
nothingness of death, the necessity and the
raison d'être of serenity and devotion. He lived
serenely, *as a greater artist than all other artists*,
despising marble and clay as well as color,
working in living flesh." (B8) ("La Bible, c'est

le Christ, car l'Ancien Testament tend vers ce
sommet ... Le Christ seul — entre tous les
philosophes, magiciens, etc., — a affirmé
comme certitude principale la vie éternelle, l'in-
fini du temps, le néant de la mort, la nécessité et
la raison d'être de la sérénite et du dévouement.
Il a vécu sereinement, *en artiste plus grand que
tous les artistes,* dédaignant et le marbre et l'ar-
gile et la couleur, travaillant en chair vivante.")
For the Christocentrism of the Groningen
School see Roessingh, op.cit. (note 41) p.37.

48. For Mondrian and the Réveil see H.
Henkels, *Mondriaan in Winterswijk, een essay
over de jeugd van Mondriaan, z'n vader en z'n
oom*, The Hague (Haags Gemeentemuseum),
1979; ex.cat. *Mondrian: from figuration to
abstraction*, Tokyo (The Seibu Museum of Art)
etc. 1987, text by Herbert Henkels.

49. Robert Rosenblum, *Modern painting
and the northern Romantic tradition*, London
1975. K. Lankheit, "Caspar David Friedrich
und der Neuprotestantismus," *Deutche Viertel-
jahrschrift für Literaturwissenschaft und Geis-
tesgeschichte*, 24 (1950) pp.129-43. For the
reception of Krause in the Netherlands see
Roessingh, op.cit. (note 41), chapter 2.

50. "De kunst in Duitsland" (1861), pp.9-
14, 30-32, 33-34, "Heinrich Heine over Roman-
tiek" (1862) pp.5-8, "De Goethe galerij,
Goethe's vrouwen naar tekeningen van
Wilhelm von Kaulbach" (1862) pp.25-27, "Leo
von Klenze, necrologie" (1865) pp.23-24,
"Peter von Cornelius, necrologie" (1868) pp.33-
37, A. von Zahn, "Friedrich Overbeck" (1872)
pp.68-71, 78-80, 84-87, 90-92.

51. W. van Meurs's note; "...in Paris door
Van Gogh als blijke van zijn gevoel voor Thijs
Maris, aan Thijs Maris te geschenke gegeven.
Op de eerste bladzijde — twee schetsjes van
Th. Maris op de andere bladzijde daarvan por-
tret schetsje van Van Gogh". Another notebook
is presently in the Rijksmuseum Vincent van
Gogh. In this notebook, which was probably
given to Theo, Van Gogh transcribed poems by
Joseph Autran and by Sainte-Beuve and quota-
tions from Michelet's *La Mer*, *L'Oiseau* and
"l'hirondelle (d'après Rückert)". Van Gogh
also transcribed texts from Psalms, Rückert's
Abendfeier, Michelet, H. Conscience etc. in the

How Do I Know My Due Dates?

BOOKS are no longer stamped with a due date

- To view a list of library materials checked out on your account and their due dates, select <u>My Account</u> on the library home page under Services or click on the My Account button in <u>SetonCat</u>. My Account may be checked anytime from on or off campus
- You may renew books once if they are not overdue. Overdue books must be renewed in person at the Circulation Desk
- Please direct questions to the Circulation Desk at 973-761-9435 or send an email to circulation@shu.edu

5/ 12

autograph book of Anne Slade Jones. See J. Hulsker, op.cit. 1985 (note 21) pp.82-84 and Fieke Pabst (ed.), op. cit. (note 21).

52. "Je boekje heb ik volgeschreven en ik geloof dat het goed geworden is." (22) "Ik zend je vandaag in de kist die wij afzenden, 't bewuste boekje." (23) "Ik heb immers in je boekje Meerestille van Heine geschreven? Eenigen tijd geleden zag ik een schilderij van Thijs Maris, dat mij eraan deed denken. Een oud-Hollandsche stad, met rijen bruinrode huizen met trapgevels en hooge stoepen ... grachten met schepen en een groote witte ophaalbrug, waar een schuit met een man aan 't roer onder door gaat, 't huisje van den brug-wachter..." (24) 'Gij hebt evenals ik, de gedichten van Heine en Uhland mooi gevon-den, maar jongen pas op, 't is nog al heel gevaarlijk goed, die illusie duurt niet lang, geef er U niet aan over. Zoudt ge soms die boekjes, die ik voor U uitschreef, weg doen? Later zul-len die boeken van Heine en Uhland U nog wel eens in handen komen en dan zult ge ze met andere gevoelens lezen en met een geruster hart." (49) In the notebook at the Rijksmuseum Vincent van Gogh, Heine's *Meerestille* is not included. In letter 49 Van Gogh wrote, "die boekjes, die ik voor U uitschreef", that is to say, there were more than two notebooks made for Theo. The painting by Maris mentioned in letter 24 is *Souvenir d'Amsterdam* at the Rijksmuseum in Amsterdam. As M. Maris was influenced by German Romanticism, it is not at all surprising that Van Gogh felt affinities between Heine and Maris' painting and that he copied many poems by Heine into the notebook for Maris. For M. Maris and his contact with Goupil's see ex.cat. *De Haagse School, hol-landse meesters van de 19de eeuw*, The Hague (Haags Gemeentemuseum), Paris (Grand Palais), London (Royal Academy of Arts) 1983. p.217.

53. On German influences on Victorian art and literature see William Vaughan, *German Romanticism and English Art*, New Haven & London 1979; C.F. Harrold, *Carlyle and Ger-man Thought 1819-1834*, London 1934; Gisela Argyle, *German elements in the fiction of George Eliot, Gissing, and Meredith*, Frankfurt am Main 1979; Hugh Witemeyer, *George Eliot*

and the Visual Arts, New Haven & London 1979.

54. Eliza Laurillard, *Vlechtwerk uit ver-scheiden kleuren: twintig voordrachten*, Amster-dam 1880. *Geen dag zonder God, stichtelijke overdenkingen voor iederen dag des jaars*, Amsterdam 1869, 1870, 1876 (I have used the third edition of 1876.), *Met Jezus in de natuur*, Amsterdam 1881. For Laurillard see *Biog-raphisch woordenboek* ... (note 11) vol.5, 1943 pp.631-44. Just as Ten Kate, Laurillard also published and edited *bijschriften-poëzy*. E. Laurillard (ed.), *Figuren en Tonen, platen met bijschriften verzameld door Dr. E. Laurillard*, Amsterdam 1882 (illustrations after Rochussen, Alma Tadema, Jozef Israëls, Kruseman, Mari ten Kate, Ary Scheffer etc. texts by I. Da Costa, S.J. van den Bergh, J.P. Hasebroek, W.J. Hofdijk, J.J.L. ten Kate, J.A. Alberdingk Thijm etc.). E. Laurillard, *Kunst-juweeltjes voor de salon-tafel met bijschriften van E. Laurillard*, Haarlem 1871, 2 vols. The "History of Photography" department of the Print Room in Leiden has one copy of this book. E. Lauril-lard, (ed.) *Klimop, gedachten en beelden des geloofs, proza en poëzy*, Amsterdam 1871. (fig.17,18)

55. Laurillard, *Vlechtwerk...* (note 54) p.316, the chapter "kleuren" pp.287-324.

56. ibid. pp.357-8, "Werkelijk bestaat er verwantschap tusschen toon en kleur. Goethe, in zijne *Farbenlehre*, zegt er van, dat toon en kleur als twee stroomen zijn, die uit éénen berg ontspringen, maar dan door verschillende land-schappen loopen ... Welnu, 't is duidelijk waar te nemen, dat ook in dat opzicht, de toon cor-respondeert met de *kleur*. De frissche kleur heeft een helderen toon; de hooge kleur heeft een scherpen toon; de groezelige kleur heeft een temenden toon, en zoo verder." The chap-ter "De muzieknoten" pp.345-62. The following are the titles of the other chapters: Een bezoek in 't Museum Wiertz, Het rijm, Het slapen, De hofnarren, De spin, Brieven, Persoonsnamen, Droomen, Klokken, De zwaan, Bij mijn boekenkast, Woorden afkomstig van ver-ouderde zaken, Zout, Diernamen toegepast op menschen, De schoen, Spotnamen, De hoed, Het lachen.

57. ibid. p.360 "...de gansche schepping Gods is muziek, en de noten zijn; zon en wolk, berg en stroom, boom en bloem, mensch en dier. 't Is ééne groote symphonie!"

58. Letter 435c "Hij vergeleek steeds de schilderkunst met de muziek, en om nog beter begrip te krijgen van de waarde en schakeering der tonen, begon hij bij een oude muziekonderwijzer, tevens organist te E..., pianolessen te nemen. Dit duurde echter niet lang, want daar Van Gogh onder de les steeds de tonen der piano zat te vergelijken met Pruisisch blauw en donker groen of donkere oker tot helder cadmium, dacht de goede man, dat hij met een krankzinnige te doen had, en werd zoo bang van hem, dat hij het lesgeven staakte."

59. Laurillard, *Met Jezus...* (note 54) pp.1-2. "Veel en velerlei is het schoon der natuur. Wondervol zijn al haar deelen. Grootsch is haar arbeid, liefelijk hare rust, rijk hare beeldspraak, verheffend en betooverend haar veelstemmige zang ... In alle geslachten zijn er altijd velen geweest, die, als ze omdoolden buiten, 'de Heere God door den hof hoorden wandelen,' en die bij den lust, ook de gave hadden, om de door God geschreven *hieroglyphen* te ontraadselen, de door God geteekende symboliek der natuur te verstaan." The sense in which the word "hieroglyph" is used in this passage probably derives from German Romantic thought. For this concept see W. Sumowski, *Caspar David Friedrich-Studien*, Wiesbaden 1970, p.20.

60. Laurillard, *Met Jezus...* (note 54) pp.6-7. "Velen hunner zullen van een prediking, die dit of dat uit het leven der schepping tot grondslag heeft, met minachting zeggen: ''t is maar een natuurpreek!' ... Mij aangaande, ik vind zulk een richting dor en vervelend, en van harte gaarne ben ik met Jezus in de vrije natuur, maar zeer ongaarne met al die heele- en halve- en kwart-godgeleerden in de boekerij en de school! Ja! met Jezus in de natuur! — Ik had met Hem willen wandelen door 't veld; ik had met Hem willen dobberen op 't meer; ik had met Hem willen zitten op den bergtop. Zeker had ik dan, onder zijne leiding, in het groote Openbaringsboek der schepping woorden leeren lezen en begrijpen, die ik vroeger niet lezen kon en niet kon verstaan..." The follow-ing are the titles of the chapters: Ploeger, De zaaier, Het zaad dat van zelf groeit, Het onkruid onder de tarwe, Het tarwegraan, Het mostaardzaad, De wijnstok, Vijg en distel: doorn en duif, De leliën des velds, De vogels, Duif en slang, De klokken, De herder, De visscher, De wind, Zon en regen, Duister en licht.

61. Ch.H. Spurgeon, *Teachings of nature in the Kingdom of Grace*, London 1896.

62. ibid. p.321.

63. "Maar bij gelegenheid van dat onweer in den stikdonkeren nacht was het een zonderling effect bij het schijnsel van den bliksem, die nu en dan alles een oogenblik zichtbaar maakte. Dicht bij de groote sombere gebouwen van de mijn Marcasse, alleenstaand, afgezonderd op 't vlakke veld, die dien nacht waarlijk denken deden aan het gevaarte van Noach's Ark, zooals die bij den geweldigen plasregen en in de duisternis van den zondvloed zich bij het licht van den bliksemstraal moge hebben voorgedaan." (130) "Et par un jour de fort chaleur un violan orage fut déchainer sur notre régions. Que fi notre ami, il alla se placer en plain champs pour regardé les grandes merveilles du Dieu et ainsi revenant mouillé jusque os." (143a)

64. "...ik vind Uw Montmartre prachtig, en de emotie die 't bij U teweeg bracht zou ik zeker gedeeld hebben ... Er is soms iets onbeschrijfelijks in die effecten, het is of de heele natuur spreekt, en als men naar huis gaat heeft men een gevoel, als wanneer men een boek van Victor Hugo uit heeft b.v. Ik voor mij kan me niet begrijpen dat niet iedereen het ziet en voelt, de natuur of God doet het toch voor ieder die oogen en ooren heeft, en een hart om te verstaan." (248)

65. "...staat hij opeens stil voor een prachtige zonsondergang en zijn twee handen gebruikende om het eenigszins af te sluiten en met zijn oogen half dicht, roept hij uit: 'Goddomme hoe doet zoo'n kerel of God, of zooals je hem noemen wilt, hoe doet hij dat nu, dat moeten wij toch ook kunnen. God, God, wat is dat mooi, hoe jammer dat wij nu geen opgezet palet klaar hebben, want dadelijk is het weer weg.'" (435c)

66. "Ouf — le faucheur est terminé, je crois que ça en sera un que tu mettras chez toi —

c'est une image de la mort tel que nous en parle le grand livre de la nature..." (604) For the tradition of the concept "The Book of Nature" see Ernst Robert Curtius, *Europäische Literatur und Lateinisches Mittelalter*, Bern & Munich 1948, 1965, chapter 16 "Das Buch als Symbol, 7. Das Buch der Natur" pp.323-329.

67. "Hij schildert als het ware, en zijn werk is tegelijk hooge en edele kunst. Hij heeft het gevoel van een kunstenaar in den waren zin van het woord..." (101a)

68. Conrad Cherry, *Nature and religious imagination: from Edwards to Bushnell*, Philadelphia 1980, p.11.

69. For Friedrich and Kosegarten see W. Sumowski, op.cit. (note 59) pp.11-15.

70. W. Sumowski, op.cit. (note 59) p.13.

71. *Oehlenschlaegers Correggio door J.J.L. ten Kate*, Leeuwarden 1868. See E. Laurillard, *Vlechtwerk uit verscheiden kleuren* (note 54) p.261. E.G. Courrech Staal, "Matthias Claudius in Nederland," *De Nieuwe Taalgids* 11 (1917) pp,41-50. Letter 88 "'Ga niet uit het leven zonder Uw liefde voor Christus op de eene of andere wijze openlijk aan den dag gelegd te hebben,' zegd Claudius." Letter 116 "Van Mendes kreeg ik de werken van Claudius, ook een goed en degelijk boek..."

72. *Liedjes van Matthias Claudius* translated by H. Tollens (*Tollens dichterlyke werken* 7), Leeuwarden 1834.

73. A.G. Oehlenschläger, *Aarets Evangelium i Naturen og Mennesket*, Copenhagen 1884, illustrations by A. Jerndorff. Quotations are from a German edition: *Adam Oehlenschläger's Schriften*, Breslau 1830, vol.18, "Das Evangelium des Jahres, oder das wiederkehrende Leben Jesu in Natur und Menschensinn (eine Allegorie)" pp.157-224.

74. *Adam Oehlenschlägers Schriften* op.cit. (note 73) p.160. (I have seen you in the flower/ In the blue sky, in mild Spring hours/ Now the harp loudly sings your praises/ I have found you in nature/ The god of goodness flourishes in everything good/ He is still alive, and has never disappeared.../ In Your footsteps, You Saint, I wish to follow!/ In nature I read a great book,/ Now it will admit your deeds.)

75. ibid. p.224. (Here in front of me, in the poem/ He revealed himself in the woods and in the field/ And sacred History willingly married sacred nature.)

76. For this change see Brom, op.cit. (note 26) chapter 3 & 4.

77. For Mauve see ex.cat. *De Haagse School...* (note 52). For a brief survey of the *Tachtigers* and the preceding generations see *De beweging van 80, Schrijvers Prentenboek deel 22*, (Nederlands Letterkundig Museum, The Hague), Amsterdam 1982; ex.cat. *'t Is vol van schatten hier...* 2 vols., (Nederlands Letterkundig Museum en Documentatiecentrum, The Hague), Amsterdam 1986. Unfortunately, there is still no standard work on Dutch literature before the *Tachtigers*. For this period see the following two recent books: Marita Mathijsen, *Het literaire leven in de negentiende eeuw*, Leiden 1987; W. van den Berg & P. van Zonneveld (ed.), *Nederlandse literatuur van de negentiende eeuw*, Utrecht 1986.

78. See Brom, op.cit. (note 26) p.99. "Wat van Pierson wordt gezegd, dat hij altijd theoloog is gebleven, geldt van heel ons volk, waar de dominee in allerlei gedaantewisselingen en vermaningen blijft leven."

79. In Van Gogh's letters the following books by Carlyle and Eliot are mentioned. Carlyle: *French Revolution, On heroes, hero-worship and the heroic in history, Oliver Cromwell's letters and speeches with elucidations, Sartor Resartus*. Eliot: *Adam Bede, Felix Holt, Scenes of clerical life, Silas Marner, Romola, Middlemarch*. For more detailed information see F. Pabst & E. van Uitert, "A literary life, with a list of books and periodicals read by Van Gogh," in E. van Uitert (ed.), *The Rijksmuseum Vincent van Gogh*, Amsterdam 1987, pp.68-84.

80. Willey, Basil, *Nineteenth century studies: Coleridge to Matthew Arnold*, London 1949, p.118. Various problems on religion, "nature" and solar mythology in the nineteenth century are discussed in: J.B. Bullen (ed.), *The sun is God: painting, literature, and mythology in the nineteenth century*, Oxford 1989. Although I could not incorporate the results of this recent publication into my work, it certainly

is an essential book to understand the specific problems and the cultural context discussed in Chapters 2, 5, 6 and Conclusion of the present book.

81. See chapter 1, note 63, 64, 65 and 66.

82. See letter 85.

83. The quotation in question is psalm no.113 of *Het boek der Psalmen nevens de Gezangen bij de Hervormde Kerk van Nederland*, Amsterdam 1825. The identification of the quotation and the interpretation of the error are from Prof. G.J. Hoenderdaal's letter (dated 12 September 1986) to the Rijksmuseum Vincent van Gogh.

84. In letter 101, also quoted in chapter 1 (note 25), Van Gogh mentioned Laurillard's sermon on a sower and immediately wrote, "De zon scheen door de ramen..." In letter 101a, Van Gogh wrote, "Ds. Laurillard hoorde ik driemaal, die zou U ook bevallen, want Hij schildert als het ware, en zijn werk is tegelijk hooge en edele kunst. Hij heeft het gevoel van een kunstenaar in den waren zin van het woord, zooals een Anderssen [sic] dat had, als hij b.v. zegt: Elke avond kwam de maan en fluistrend sprak ze mij..." and after the quotation from Andersen, he wrote, "De maan schijnt ook nu nog en de zon en de Avondster, dat is gelukkig en die spreken nog dikwijls van de Liefde Gods..."

85. "Dezen morgen ben ik naar de vroegpreek geweest, en daar was de tekst Eph.5:14, 'ontwaak gij die slaapt en staat op uit de dooden, en Christus zal over U lichten.' Toen ik wegging van hier regende het en ook toen de kerk uitging; gedurende de preek echter had de zon helder door de ramen geschenen." (102)

86. "Echter ik schilder liever de oogen van menschen dan cathedralen, want er zit iets in de oogen wat in de cathedraal niet zit, al is die plechtig en al imponeert die — de ziel van een mensch, al is het een arme schooier of een meid van de straat, is in mijn oog interessanter." (441)

87. "...je sais tellement bien ce que je veux. Je peux bien dans la vie et dans la peinture aussi me passer de bon Dieu, mais je ne puis pas, moi souffrant, me passer de quelque chose plus grand que moi, qui est ma vie, la puissance de créer. ... Je voudrais peindre des hommes ou des femmes avec ce que je ne sais quoi d'éternel, dont autrefois le nimbe était le symbole, et que nous cherchons par le rayonnement même, par la vibration de nos colorations." (531)

88. "Je te parle de ces deux toiles, surtout alors de la première, pour te rappeler que pour donner une impression d'angoisse, on peut chercher à le faire sans viser droit au jardin de Gethsemane historique: que pour donner un motif consolant et doux il n'est pas nécessaire de repésenter les personnage du sermon sur la montagne." (B21)

89. Willey, op.cit. (note 80) p.118.

90. "...Zoodat ik hoop U weldra te ontmoeten, 't geen ik met groot verlangen tegemoet zie, ook daar ik twee teekeningen geschetst heb bij Rappard 'The lampbearers' en 'The bearers of the burden', waarover ik wel met U wilde beraadslagen over de verdere uitvoering. Om ze klaar te krijgen, zal ik op de een of andere manier de noodige modellen moeten hebben, en als dan heb ik het vertrouwen, dat er iets goeds van komt, n.l. een paar composities..." (143) This letter is dated 12 April, 1881.

91. For Cécile Douard and Ph.G. Marissiaux see: ex.cat. *Art et société en Belgique 1848-1914*, Charleroi (Palais des Beaux-Arts de Charleroi) 1980, and ex.cat. *Arbeit und Alltag, soziale Wirklichkeit in der Belgischen Kunst 1830-1914*, Berlin (Neue Gesellschaft für Bildende Kunst), Sept. 1979.

92. For this water color (F994 JH253) Van Gogh probably used models. He made twelve studies of women carrying sacks, but this water color is undoubtedly a composed work. The whereabouts of the studies are not known. See letter 241, R16.

93. This drawing has been related to the description in letter 145 (see de la Faille, 1970), but it is not certain whether the cottage can be identified with the "protestantsche schuur" (Protestant barn).

94. The religious significance of the digger will be discussed later in chapter 5.

95. Judging from the photographs at the Rijksbureau voor Kunsthistorische Documentatie and various reproductions, there are at least two extant versions of *From darkness to light*. For other examples of a church in a window see Max Eisler, *Jozef Israels*, London 1924, plates XXV *The Burial* (From darkness to light), XXXIV *Maternal Joy*, XXXV *The Sexton and his wife* and *Studio* 1902 Sept. p.25 *Working at her Trousseau*.

96. "Ik ben Zondag voor 14 dagen naar Amsterdam geweest om een tentoonstelling te zien van de schilderijen, die van hier naar Weenen gaan. Dat was zeer interessant en ik ben nieuwsgierig wat voor figuur de Hollanders te Weenen maken zullen." (5) Israëls' painting was well received and was reproduced in the review in *Gazette des Beaux-Arts*. See; René Ménard, "Exposition de Vienne," *Gazette des Beaux-Arts*, 8 (1873), pp.183-214. The title "From darkness to light" (Uit duisternis tot licht) is also interesting, because Van Gogh writes "You know how one of the roots or foundations, not only of the Gospel, but of the whole Bible is 'Light that rises in the darkness', *from darkness to light*" (126) This concept, which will be discussed in Chapter 3, can be found in many letters from the Amsterdam and Borinage periods.

97. In addition to *Plowing Peasant* and *A Digger in the dune*, there are some *Potato diggers* by Mauve in which a church tower is slightly visible in the background. See, for example, ex.cat. *De Haagse School*, The Hague (Haags Gemeentemuseum), Paris (Le Grand Palais) and London (Royal Academy of Arts) 1983, cat.no.102. The Prentenkabinet of the Rijksmuseum in Amsterdam possesses a water color of potato diggers (inv.no. A2446), which also shows a similar composition.

98. "Zeg eens, hebt ge ooit Mauve hooren preeken?? ik heb hem verschillende dominees hooren nadoen — eens heeft hij gepreekt over de schuit van Petrus (de preek was verdeeld in 3 stukken, 1e zou hij die schuit gekregen of geërfd hebben, 2e zou hij ze bij gedeelten of aandeelen zich aangeschaft hebben, 3e zou hij ze (schrikwekkende gedachte) gestolen hebben)? Dan preekte hij verder over 'de goede intentiën des Heeren' en over 'den Tigris en den Eufraat'. En toen deed hij Pater Bernhard na: God — God is almachtig — hij heeft de zee gemaakt, hij heeft de aarde gemaakt, en de lucht, en de sterren, en de zon, en de maan, hij kan alles — alles — alles toch — neen Hij is niet almachtig, er is één ding dat Hij niet kan. Wat is dat ding dat God almachtig niet doen kan? God almachtig kan geen zondaar verstooten ..." (164) This is written at the end of the very long letter, in which Van Gogh most strongly attacked the "theologians' God".

99. At the Rijksbureau voor Kunsthistorische Documentatie I checked the reproductions of the principal members of the Hague school. I found few examples of the combination of a church with sowers, reapers or diggers except in the works of Anton Mauve.

100. The following are the JH numbers of the works included in the table. Church: 36, 37, 42, 363, 370, 459, 508, 509, 917, 959; The sun: 1470, 1471, 1472, 1508, 1543, 1627, 1628, 1629, 1753, 1754, 1768, 1769, 1773, 1792, 1923.

101. Van Gogh knew Gauguin's painting through a sketch in Gauguin's letter. See, D. Cooper, *Paul Gauguin: 45 lettres à Vincent, Théo et Jo van Gogh*, The Hague & Paris 1983, p.240.

102. Apollo, for example, was often depicted with the disk of the sun.

103. *Le Courrier Français, numéro exceptionnel, pour les inondés du Midi*, Dec. 26, 1886. This issue is not paginated. Heidbrinck's illustration is on the 17th page.

104. This typescript of two pages, conserved in the library of the Rijksmuseum Vincent van Gogh, contains about 10 titles of periodicals, albums and books. There are two other lists, "Liste des livres français" and "Liste des catalogues" containing about 25 titles.

105. For Van Gogh's interest in illustrated magazines and prints see R. Pickvance, ex.cat. *English Influences on Vincent van Gogh*, (University of Nottingham & Art Council of Great Britain) 1974-75; Chris Krijt, "Young Vincent's art collection," *Vincent* 4 (1975) no.3, pp.24-26.

106. For more examples of this device see: *Le Courrier Français*, Oct. 10, (1886), p.6; Jan. 23, (1887), p.9; March 20, (1887) title page;

April 17, (1887), p.9. This last illustration, F. Lunel's *Premiers Boutons*, is reproduced in: ex.cat. *Vincent van Gogh from Dutch Collections; religion-humanity-nature*, Osaka, (National Museum of Art) 1986, p.141.

107. For more details on these events see *L'Univers illustré*, Dec. 4, 11, 18 (1886), Jan. 1, 8 (1887), *Le Courrier Français*, Dec. 19, 26 (1886), Jan. 2, 9, 16 (1887), *Le Monde illustré*, Dec. 25 (1886), Jan. 1, 8, 15, 23, 29 (1887), *Le Figaro*, Dec. 23 (1886) p.1; Dec. 26 (1886) p.1; Jan. 2 (1887) p.2; Jan. 10 (1887) p.2. All these periodicals and *Le Figaro* are mentioned in Van Gogh's letters. See also following articles in *Revue illustrée*, Dec. 1886-June 1887; C. Hugues, "La Tarasque, légende chrétienne," pp.56-58; L. de Fourcaud, "Causerie," pp.87-89; F. Mistral, "L'Homme populaire," pp.220-225. For the exhibition see; ex.cat. *L'Exposition des maîtres anciens au profit des inondés du Midi*, Paris (École des Beaux-Arts) 1887 Jan.-Feb. The New Year's edition of *L'Univers illustré* reports the success of the festival as follows: "Le Palais de l'Industrie est transformé en cour de Provence... Beaucoup de monde s'était donné rendez-vous au Palais de l'Industrie et beaucoup de jolies femmes, parmi lesquelles riaient de folâtres Arlésiennes, vraies ou fausses, avec leurs costumes rouge éclatants... Bref un spectacle très charmant et très frais, telle est l'impression qui nous reste de cette première soirée." *L'Univers illustré*, Jan. 1 (1887) p.7 & 10. Another article of Jan. 8 (1887) p.22 reports: "Notre dernière promenade au Palais de l'Industrie nous a permi de constater que les fêtes du soleil continuent de jouir d'un éclat exceptionnel."

For the stall see *Le Courrier Français*, Dec. 19 (1886) p.2 "Ce numéro de vingt pages aura pour titre: 'Pour les inondés du Midi.' Il sera vendu 1 franc dans le Palais de l'Industrie pendant toute la durés des fêtes..." ibid. Jan.2 (1887) p.10, J.R., "Les Fêtes du Soleil,", "Cette boutique décorée avec goût par notre ami Quinsac, se trouve près du pont de la foire Beaucaire, à droite dans le Palais... La charmante petite Arlésienne qui a bien voulu nous servir de vendeuse donnera au public tous les renseignements relatifs au *Courrier Français*."

108. In the autumn and winter of 1886 numerous articles and illustrations reporting the flood of the Rhône were published in newspapers and periodicals. See, *L'Univers illustré*, Nov. 13, 27, Dec. 4, 11, *Le Monde illustré*, Nov. 6.

109. Roland Dorn, op.cit. (note 11) p.236.

110. The reason why Van Gogh chose Arles is still unknown. Numerous scholars have speculated on this matter. See Ronald Pickvance, *Van Gogh in Arles*, New York, (The Metropolitan Museum of Art), 1984, pp.11-12. A. Verkade-Bruining, "More about Michelet," *Vincent*, 4 (1971) no.3, pp.22-23. V.van Gogh, *Vezamelde Brieven*, vol.4, pp.335-336, A 11. According to a letter from Theo to Wil, Vincent was planning to go first to Arles and then probably continue on to Marseilles. "Vincent is verleden zondag naar het zuiden gegaan; eerst naar Arles om zich wat te orienteren en dan waarschijnlijk naar Marseille." (quoted in; Jan Hulsker, op. cet. (note 21), p. 391.)

In the 1860's Jules Breton visited Arles with great dreams and high expectations. He was deeply disappointed by its gray melancholic atmosphere. He wrote about this experience in his *La vie d'un artiste* published in 1890. As Van Gogh could not have read this book before his decision to go to the Midi, it cannot have influenced Van Gogh's choice of Arles. Breton's text is however quite interesting in that it shows quite vividly how a nineteenth-century painter imagined and idealized Arles. I will quote some fragments from this text. "Une ville surtout m'attirait: Arles! Arles la Grecque! Ecrit, ce nom m'éblouissait, dit, il me ravissait par son admirable euphonie. Arles! Dans les mirages de mon imagination je la voyais étendue sur les bords de son fleuve de saphir ruisselant comme un cou de paon entre ses murailles blanches et dorées ... De nobles créatures au profil pur, au cou ferme et rond, au teint olivâtre, les parcouraient dans de grandes et simples attitudes; races non seulement douées de la beauté grecque, mais aussi de l'amour et de l'intelligence du beau... La température devait y être douce; l'hiver sa colline l'abritant du côté du nord, l'été les eaux et la brise du fleuve lui apportant la fraîcheur. Telle était l'Arles de mes rêves... Enfin je vis le vrai Midi! Je tombai en extase devant le premier olivier rachitique qui courbait au mi-

stral ses maigres rameaux. J'étais si pressé d'arriver à Arles ... J'arrivai le soir à Avignon, au moment où commençais le crépuscule ... Voici, m'écriais-je, la vraie terre des peintres, la vraie magie de la lumière et de la couleur! Des lignes à désespérer le Poussin! et demain je verrai Arles! Et je te vis, Arles! Ce jour-là le mistral soufflait implacablement. La ville grelottait froide et morne; le Rhône avait la fièvre. Au soleil gris. les rues grises blémissaient dans l'air gris, sous l'azur gris ... Et le spleen me gagna dans cette ville-tombeau." Jules Breton, *La vie d'un artiste*, Paris 1890, pp.245-252.

111. For these motifs see the chronological tables in Appendix I. Richard Thomson has recently identified the landscape in the drawing *Couple strolling under sunflowers* (fig.43) as being western suburbs of Paris seen from one of the bastions of the fortifications. (See R. Thomson, "Van Gogh in Paris: the fortifications drawings of 1887," *Jong Holland* 3 (Sept. 1987) no.3, p.24.) It is not possible to determine to what extent the drawing was made directly from nature or from the imagination. However that may be, the combination of the sun, sunflowers and lovers is not a fortuitous one.

112. Hulsker, op.cit. (note 21) p.592-93. See also Jean Leymarie, *Qui était Van Gogh?*, Geneva 1968, p.165. It is interesting to note that Delacroix also excluded the figure of Christ in his print *The raising of Lazarus* after Rembrandt. Reproduced in: Loys Delteil, *Le peintre-graveur illustré, vol.III, Ingres, Delacroix*, Paris 1908, (reprint New York 1969), "Delacroix, 1er section," no.4.

113. See letter 505, 540.

114. Letter 632 "J'aurais encore à ma disposition le modèle qui a posé la Berceuse, et l'autre dont tu viens de recevoir le portrait d'après le dessin de Gauguin, que certes j'essayerais à exécuter en grand, cette toile, les personalités étant ce que j'aurais rêvé comme caractères."

115. See for example, Evert van Uitert, "Van Gogh, Vincents identificatie met de tot leven gewekte Lazarus," *Vrij Nederland* 36 (1 Feb., 1975) p.23; S. Takashina, op.cit. (note 7) pp.42-43. For the description "the rising sun" see letter 632.

116. "Ah! ceux qui ne croient pas au soleil d'ici sont bien impies. Malheureusement à côté du soleil bon dieu, il y a 3 quarts du temps le diable mistral." (520)

117. "Ayant promis de t'écrire, je veux commencer par te dire que le pays me paraît aussi beau que le Japon pour la limpidité de l'atmosphère et les effets de couleur gaie. ... Il y aurait peut-être un réel avantage pour bien des artistes amoureux de soleil et de couleur, d'émigrer dans le midi. ... En tête de cette lettre, je t'envoie un petit croquis d'une étude qui me préoccupe pour en faire quelque chose." (B2)

118. Eliza Laurillard, *Geen dag zonder God*, Amsterdam 1869, 1870, 1876. p.170 of the 1876 edition. "Daarom kon in eene dichterziel de gedachte ontstaan: God, de Heer, is eene zon. Maar dan moeten wij wenschen, dat het schijnsel dezer zon onzen geest en ons hart bestrale, gelijk wij wenschen, dat het schijnsel der zon in de natuur in onze woning licht en vroolijkheid brenge, en leven en vruchtbaarheid in onzen hof. Ja! als wij wenschen, dat onze gemoed als de zonnebloem zij, steeds naar het Groote Licht zich keerend, om ten volle op te vangen de stralen, die het nederzendt." In the English authorized version, the text is in Psalm 84, verse 11.

119. Zacharias Heyns, *Emblemata*, Rotterdam 1625.

120. Hieremias Drexelius, *Heliotropium seu conformatio humanae voluntatis cum divina*, Cologne 1630; *De sonne-bloeme ofte overeenkominge van den menschelijken wille met den Godtlijkcken*, Antwerp 1638, ... Gent (B. Poelman) 1796, Gent (J. en H. v.d. Schelden) *1857*.

121. Otto van Veen, *Amorum Emblemata*, Antwerp 1608. The University Library in Amsterdam possesses a copy of *Amorum Emblemata* with the Ex-Libris of Vincent van Gogh (fig.61), the painter's cousin, the son and successor of art dealer C.M. Van Gogh.

122. For this painting see: *Neue Pinakothek, Erläuterungen zu den ausgestellten Werken*, Munich 1982, p.97; H. Börsch-Supan & K.W. Jähnig, op.cit. (note 9) cat.no. 164.

123. See ex.cat. *J.Th. Toorop, de jaren 1885 tot 1910*, Otterlo (Rijksmuseum Kröller-Müller)

1978-79, cat.no.15. The interpretation of the sunflower in this catalogue as "beginning of a young happiness" is not sufficiently convincing; at least no concrete source for this interpretation is indicated.

124. Cover illustration for ex.cat. *Vincent van Gogh nagelaten werken,* Amsterdam (Kunstzaal Panorama-gebouw), 1892-93. This illustration is discussed briefly in: ex.cat. *Kunstenaren der idee, symbolistische tendenzen in Nederland, ca.1880-1930,* The Hague (Haags Gemeentemuseum) 1978, p.9-10.

125. Letter B2, see note 117 for the original text.

126. "Ai eu contrariété pour le coucher de soleil avec figures et un pont, dont je parlais à Bernard. Le mauvais temps m'empêchant de travailler sur place, j'ai éreinté complètement cette étude en voulant la finir chez moi. Seulement j'ai aussitôt après recommencé le même motif sur une autre toile, mais le temps étant tout autre, dans une gamme grise, et sans figures." (471)

127. Reproduced in: Jean-Paul Clébert & Pierre Richard, *La Provence de Van Gogh,* Aix-en-Provence 1981, p.71.

128. Van Gogh often wrote about this dilemma in his letters. For example, in September 1888 he wrote: "Si seulement je pouvais arriver à dessiner de tête des figures, j'aurais toujours de quoi faire. Mais, prenez une figure du plus habile de tous les artistes qui croquent sur le vif, Hokusai, Daumier, pour moi ce n'est jamais cette figure ce que serait la figure peinte avec le modèle de ces mêmes maîtres ou d'autres maîtres portraitistes." (542)

129. Pickvance, op.cit. (note 110) p.104, 135. Pickvance also pointed out that the diagonal shadows cast by the olive trees in *Olive trees with yellow sky and sun* (F710 JH1856) are out of alignment with the position of the sun and that *Enclosed field with plowman,* (F625 JH1768) is painted from memory. See ex.cat. *Van Gogh in Saint-Rémy and Auvers,* New York (The Metropolitan Museum of Art) 1986-87, p.160, 124-5.

130. See, for example, Ronald Pickvance, op.cit. (note 129) p.103-107; Albert Boime, "Van Gogh's Starry Night: a history of matter

and a matter of history," *Arts Magazine,* December (1984) pp.86-103. This painting will be discussed later in chapter 6.

131. Pickvance, op.cit. (note 129), p.272-73. For the motifs painted by Van Gogh in Auvers see: Alain Mothe, *Vincent van Gogh à Auvers-sur-Oise,* Paris 1987.

132. Reproduced in: *Catalogue illustré de Salon,* Paris & London 1884.

133. "...ik heb willen zeggen hoe die ruïne aantoont, aldaar *sedert eeuwen* de boeren ter ruste worden gelegd in de akkers zelve, welke zij bij hun leven doorwroeten ... En nu zegt die ruïne tot mij hoe een geloof en godsdienst vermolmde — al was ze hecht gegrondvest, hoe echter het leven en sterven der boertjes almee 't zelfde is en blijft, gelijkmatig uit spruiten en verwelken als 't gras en de bloempjes die daar wassen op dien kerkhofsgrond. Les religions passent Dieu demeure, is een woord van Victor Hugo, dien ze ook pas begraven hebben." (411)

134. "Dat *de rust van eene vrouw verstoren,* zoo als de theologische lui (soms theologen *sans le savoir*) zeggen, is soms een *breken van stagnatie of melankolie,* die veel lui bekruipt en *erger* is dan de *dood* zelf." (377)

135. See letter 164. For the affair with Kee see: Jan Hulsker, op.cit. (note 21) pp.168-180.

136. The Bible is a reprint of the Statenbijbel of 1714. *BIBLIA, Dat is De gantsche H. Schrifture vervattende alle de Canonijcke Boeken des Ouden en des Nieuwen TESTAMENTS, Door Last der Hoogh-Mog: HEEREN STATEN GENERAEL van de Vereenighde Nederlanden, en volgens het Besluyt van de Synode Nationael, gehouden tot Dordrecht in de Jaren 1618 ende 1619, Uyt de Oorspronckelicke talen in onse Nederlandtsche tale getrouwelick over geset...,* Arnhem (W.J. Gordon) 1882, originally published in Dordrecht (Jacob, en Pieter Keur) and Amsterdam (Pieter Rotterdam) 1714. This Bible is signed "Johannes Duyser, Predikant te Helvoirt; Ths: van Gogh, Laatst Predikant te Nuenen 1885" and was owned by the Mennonite and Remonstrant Community in Leiden. For further details see LvT (Louis van Tilborgh), "De Bijbel van Vincents vader," *Van Gogh Bulletin,* no.3, 1988 (publication of the Rijksmuceum Vincent van Gogh). The letters "Het Liij Capittel" (chapter 53)

are printed precisely on the same spot as the inscription "Chap LIII" in the *Still life with open Bible*. On this page only a part of Chapter 53 (from 1 to 6) is printed. In the painting Van Gogh inscribed "ISAIE" but the spelling in the original Bible is "JESAIA". The painter must have changed the Dutch words into French so that the inscriptions can be read by the broader public.

137. Carl Nordenfalk, op.cit. (note 7); Jean Seznec, op.cit. (note 7); Sven Lövgren, *The Genesis of modernism, Seurat, Gauguin Van Gogh and French symbolism in the 1880's*, Bloomington & London 1971 (Stockholm 1959); H.R. Graetz, op.cit. (note 8); S. Takashina, "Books in pictures," (in Japanese) in: *Seiō geijutsu no seishin*, Tokyo 1979, (in Japanese) pp.249-273; H.B. Werness, "Some observations on Van Gogh and the *Vanitas* tradition," *Studies in iconography* (1980) no.6, pp.123-136; G. Pollock, ex.cat. *Vincent van Gogh in zijn Hollandse jaren*, Amsterdam (Rijksmuseum Vincent van Gogh) 1980-1981, p.104.

138. Lövgren and Pollock (see note 137) do not accept the interpretation of the contrast between traditional and modern beliefs. Lövgren interprets the juxtaposition as an expression of pessimism, based on the contents of *La joie de vivre*. Pollock suggests, in contradistinction to the other scholars, that the motifs in the picture signify "related forms of belief, of the practice of the belief, religion which gives meaning to art, art as means to the belief", but her explanation cannot convincingly explain the two inscriptions in the picture. For the phenomenon of substitution see Basil Willey, op.cit. (note 80) p.118. See also Chapter 2 of the present study.

139. "Gij weet wel hoe een der wortels of grondwaarheden van het Evangelie niet alleen, maar van den geheelen Bijbel ook, is 'Licht dat opgaat in de duisternis.' *Door duisternis tot licht*." (126) The concept "from darkness to light" is used as the title of J. Israëls' painting. See Chapter 2, note 96.

140. "Ik mag des avonds niet meer laat opzitten, Oom heeft mij dit zeer streng verboden, toch blijft het woord, dat onder de ets van Rembrandt staat mij in de gedachten: In medio noctis vim suam lux exerit, (in 't midden van den nacht verspreidt het licht zijn kracht), en ik zorg, er den heelen nacht een klein gaspitje blijft branden en leg daar in medio noctis dikwijls naar te kijken ..." (112) For more passages on light see letter 110.

141. "Wat zou iemand als Pa, die zoo menigmaal, des nachts ook, met een lantaarn voorzien, tochten maakt b.v. naar een zieke of stervende, om met hem te spreken over Hem, wiens woord ook nog een licht is in den nacht van lijden en doodsangst, gevoel hebben voor etsen van Rembrandt, zoals de vlucht naar Egypte bij nacht, of de begrafenis van Jezus." (110)

142. The sketches are described in Letter 140.

143. "En met goeden wil zoekende in de boeken waarvan gezegd wordt dat zij licht zijn in de duisternis, vinden we met den besten wil van de wereld al heel bitter weinig zekers en om ons persoonlijk te troosten niet altijd satisfactie. En de ziekten waaraan wij beschaafde lui 't meest laboreeren zijn melancolie en pessimisme ... ik b.v. heb vooral behoefte om eens goed door te lagchen. Dat vond ik in Guy de Maupassant ... Integendeel indien men waarheid wil het leven zooals het is, b.v. de Goncourt in Germinie Lacerteux, la fille Elisa, Zola in La joie de vivre en L'assommoir en zooveel andere meesterwerken ... Het werk van de Fransche naturalisten Zola, Flaubert ... is prachtig en men kan ter nauwernood gezegd worden tot zijn tijd te hooren als men er geen kennis van heeft genomen ... Hebben wij genoeg aan den Bijbel? Tegenwoordig zou geloof ik, Jezus zelf weer zeggen tot hen die melankoliek neerzitten: 't is hier niet, 't is opgestaan. Wat zoekt ge den levende bij de dooden." (W1)

144. For melancholy see note 134. The two words "rayon noir" and "rayon blanc" are borrowed from Victor Hugo's *Quatre-vingt-treize*. The implications of these words in Van Gogh's mind can be discerned from the following passages. "As to people who honestly seek the best, I think what Hugo says so true: *il y a le rayon noir et il y a le rayon blanc*. In my opin-

ion, Father has more the rayon noir and Corot has more the rayon blanc, but both have a rayon d'en haut." (326) In the next letter Van Gogh wrote about his conflict with his father and Tersteeg: "But since then I have tried to explain to you too ... that there is a rayon noir and a rayon blanc and that I have found their (Father and Tersteeg) light to be black and a mere convention compared to the cool honesty of Millet and Corot, for instance." (347) See also letter 348. The "rayon noir" apparently symbolizes the conventional ideas of his father.

145. For the interpretation of the still lifes with French novels see E. van Uitert, op.cit. (note 7) pp.58-59 and 74-76. For *Gauguin's chair* see S. Takashina, op.cit. (note 7) pp.64-94 "chapter 2, Empty Chair". The *Still life with three books* and the *Still life: basket of bulbs* (F336 JH1227) are painted on oval wooden panels. According to the 1970 edition of de la Faille's catalogue raisonné, these panels are lids of Japanese tea boxes. On the back of both panels we can read "Kiritsukōshōgaisha" (fig.73). This is the name of a Japanese company established in 1874, the year after the World Exhibition in Vienna, through the financial support of the Japanese government, to export Japanese art to Europe. The Paris branch of this company was established in 1878 for the World Exhibition of the same year, and was closed in 1884. For this company see; Tsuneo Yoshimizu, *Hana no yōshiki*, Tokyo 1984; Taketoshi Jōzuka, *Umi o wataru ukiyo-e: (the life of Tadamasa Hayashi)*, Tokyo 1981; Yasuko Kigi, *Hayashi Tadamasa to sono jidai*, Tokyo 1987 (all in Japanese). Tadamasa Hayashi, who once worked for Kiritsukōshōgaisha, was in contact with Manzi of Boussod & Valadon, but it is not known if Hayashi was ever in direct contact with Theo or Vincent van Gogh.

146. "...want dat het geluk de dapperen begunstigt is toch wel dikwijls waar, en wat daar ook van zij, van het geluk of 'la joie? de vivre' namelijk, men moet werken en durven, wil men wezenlijk leven." (399 written in April 1885) "Alors de voir quelqu'un qu'on a connu très remuant, réduit à un tel état d'impuissance soupçonneuse et de souffrance continuelle, cela ne donne certes pas une idée engageante et gaie de la vie humaine et n'augumente pas la joie de vivre." (512) "...le fait est que je me porte bien; mais ainsi que je le dis, l'envie de recommencer la joie de vivre n'est guère grande." (W12)

147. "Dans mon tableau de café de nuit, j'ai cherché à exprimer que le café est un endroit où l'on peut se ruiner, devenir fou, commettre des crimes. Enfin j'ai cherché ... exprimer comme la puissance des ténèbres d'un assommoir." (534)

148. To my knowledge Seznec (op.cit. note 7) was the first to point out that "la puissance des ténèbres" was the title of a play by Tolstoy. Comte Léon Tolstoi, *La puissance des ténèbres*, drame en cinq actes, translated by E. Halpérine, Paris 1887. For the Théâtre Libre and the performance of this play see: F. Pruner, *Le Théâtre Libre d'Antoine I: le répertoire étranger*, Paris 1958; *Les luttes d'Antoine: Au Théâtre Libre*, Paris 1964, by the same author. André Antoine, *Le Théâtre Libre, théâtre public fondé par André Antoine*, Paris 1890, contains an appendix with numerous reviews of the premiere of this play. Matei Roussou, *André Antoine*, Paris 1954 (with several photographs of the scenes and actors). For Van Gogh's paintings exhibited in this theater see: J. Rewald, *Post-Impressionism*, London 1978, p.64; B. Welsh-Ovcharov, *Vincent van Gogh: his Paris period, 1886-1888*, Utrecht & The Hague 1976, p.221. "Le tableau du jardin avec amoureux est au Théâtre Libre" (letter 473) According to Welsh-Ovcharov, the exhibition of paintings at the theater was held between November-December of 1887 and January of 1888; that is, shortly before the performance of *La puissance des ténèbres*.

149. "Tu ne saurais croire combien cela me tranquillise, j'ai tellement l'amour de faire une maison d'artiste, mais une de pratique et non pas l'atelier ordinaire plein de bibelots. J'y songe aussi à planter deux lauriers-roses devant la porte dans des tonneaux." (540) "Le laurier-rose — ah — cela parle amour et c'est beau comme le Lesbos de Puvis de Chavannes." (587)

150. See A. Henkel & A. Schöne, *Emblemata, Handbuch zur Sinnbildkunst des XVI und XVII Jahrhunderts*, Stuttgart 1967,

1978. Werness (op.cit. note 137 p.128) suggests that the oleander has a warning function, but this does not agree with the connotations in Van Gogh's descriptions of the oleander.

151. "...je me dis toujours que j'ai encore au cœur de peindre un jour une librairie de romans avec l'étalage jaune, rose, le soir, et les passants noirs — c'est un motif si essentiellement moderne. Parce que ça paraît aussi au figuré un tel foyer de lumière. Tenez, cela serait un motif qui ferait bien entre un verger d'olivier et un champ de blé, les semailles des livres, des estampes. Cela je l'ai bien au cœur pour le faire tel qu'une lumière dans les ténèbres." (615)

152. See R. Pickvance, op.cit. (note 129) cat.nos. 30, 40, 41, 42, 43.

153. "Aussi dois-je te le dire — et tu le vois dans la Berceuse quelque manqué que soit cet essai et faible — eussé-je eu les forces pour continuer, j'aurais fait des portraits des saints et de saintes femmes d'après nature et qui auraient paru d'un autre siècle, et ce seraient des bourgeois d'à présent et pourtant auraient eu des rapports avec des chrétiens fort primitifs." (605) For the interpretations of *La Berceuse* see: B. Welsh-Ovcharov, ex.cat. *Vincent van Gogh and the Birth of Cloisonism*, Toronto (Art Gallery of Ontario) 1981, pp.148-49; H. Arikawa, "La Berceuse: an interpretation of Vincent van Gogh's portraits," *Annual Bulletin of the National Museum of Western Art*, Tokyo, 15 (1981) pp.31-75; E. van Uitert, op.cit. (note 7) pp.46-50; Jean-Louis Bonnat, "Les adresses d'un tableau: "la berceuse" (V. Van Gogh)," *Psychoanalyse à l'université* 12 (July, 1987) pp.373-416. Hulsker does not accept religious interpretations of *La Berceuse* (op.cit. (note 21) p.495).

154. Evert van Uitert, *Het geloof in de moderne kunst*, Amsterdam 1987, pp.22-23. For the prints after Van der Maaten and Scheffer see Chapter 1. Scheffer's *Christus Consolator* is mentioned very often in Van Gogh's early letters. In letter 71 he quotes the words inscribed on the print of *Christus Consolator*, "He has come to proclaim liberty to the captives". For the influence of this painting and other religious subjects on Van Gogh, see: J. Leistra, op.cit. (note 44).

155. A letter from Van Gogh to Gauguin published in: D. Cooper, op.cit. (note 101), letter VG/PG, p.269. "Et je crois que si on plaçait cette toile telle quelle dans un bateau de pêcheurs même d'islande il y en aurait qui sentiraient la dedans la berceuse. Ah! mon cher ami faire de la peinture ce qu'est déjà avant nous la musique de Berlioz et de Wagner ... *un art consolateur* pour les cœurs navrés! Il n'y a encore que quelques uns qui comme vous et moi le sentent!!!"

156. "Je ne suis pas indifférent, et dans la souffrance même quelquefois des pensées religieuses me consolent beaucoup." (605) The passage which immediately follows this one is quite interesting. "Ainsi cette fois-ci pendant ma maladie il m'était arrivé un malheur — cette lithographie de Delacroix la Pietà avec d'autres feuilles était tombée dans de l'huile et de la peinture et d'était abimée." Possibly this "malheur" was not a mere accident but was caused by Van Gogh's religious hallucination.

157. Ch.H. Spurgeon, op.cit. (note 61) p.216. In the sermon "Healing beams (Malachi IV)".

158. Letter W1, See note 143.

159. Basil Willey, *The eighteenth century background: studies on the idea of nature in the thought of the period*, London 1946, p.272.

160. Letter B22 (to Gaugain)

161. "Le temps ici reste beau, et si c'était toujours comme cela, ce serait mieux que le paradis des peintres, ce serait du Japon en plein." (543)

162. See, for example, letters 469, 500: "Mais mon cher frère — tu sais je me sens au Japon;"; "...on aime la peinture japonais on n'en a subi l'influence, tous les impressionistes ont ça en commun, et on n'irait pas au Japon, c.à.d. ce qui est l'equivalent du Japon, le Midi?"

163. Four contributions dealing with this problem which deserve special mention are: M.E. Tralbaut, "Van Gogh's Japanisme," *Mededelingen van de Dienst voor Schone Kunsten der Gemeente 's-Gravenhage* 9 (1954), 1-2, pp. 6-40; F. Orton, "Vincent van Gogh in Paris 1886-1887, Vincent's interest in Japanese

prints," *Vincent: Bulletin of the Rijksmuseum Vincent van Gogh*, 1 (1971), pp. 2-12; ex.cat. *Japanese prints collected by Vincent van Gogh*, Amsterdam (Rijksmuseum Vincent van Gogh) 1978; Akiko Mabuchi, "Van Gogh and Japan," in: ex.cat. *Vincent van Gogh Exhibition*, Tokyo (The National Museum of Western Art) 1985, pp. 154-177. For the literature on *japonisme* in general, see S. Wichmann, *Japonismus*, Hersching 1980; K. Berger, *Japonismus in der Westlichen Malerei 1860-1920*, Munich 1980 and ex.cat. *Le Japonisme*, Paris (Grand Palais), Tokyo (The National Museum of Western Art) 1988.

164. By literature on *japonisme* I mean writings of all kinds — novels, articles, monographs — on Japan. "*Japonist* portraits" are portraits which the painter related to Japan in his letters, or in which Japanese objects are depicted. The term *Japonisme* is not used here in the strict sense of Mark Roskill in his *Van Gogh, Gauguin and the Impressionist Circle*, London 1970, pp. 57-58, but in a more general sense. All of Van Gogh's *japonist* portraits discussed here exhibit both *japonaiserie* and *japonisme* in Roskill's terminology, and I am using the word "Japonisme" here to embrace both terms and to signify the totality of Van Gogh's interest in Japan and Japanese art.

165. "Een van de spreekwoorden van de Goncourts was: 'Japonaiserie for ever'. Wel die dokken zijn een fameuze Japonaiserie, grillig, eigenaardig, ongehoord — ten minste men kan 't zoo zien... — maar vooral — Japonaiserie's. Ik bedoel, de figuren zijn er altijd in beweging, men ziet ze in de zonderlingste entourage, alles grillig, en er onstaan vanzelf telkens interessante tegenstellingen" (437)

166. "Mijn werkplaats is nogal dragelijk, vooral omdat ik een partij Japansche prentjes tegen de muren heb gespeld, die mij erg amuseeren. Ge weet wel van die vrouwen figuurtjes in tuinen of aan het strand, ruiters, bloemen, knoestige doorntakken" (437)

167. E. de Goncourt, *Chérie*, Paries 1884. Van Gogh frequently mentioned this book, particularly the preface, in his letters. (447, 451, 453). For Japonaiserie in French literature, see W.L. Schwartz, *The imaginative interpretation*

of the Far East in modern French literature 1800-1925, Paris 1927.

168. For Van Gogh's interest in this aspect of Japanese prints see his remark on Hokusai in letter 533, and in a letter to Wil: "As tu vu chez nous un tout petit masque de femme japonaise souriante et grasse? Il est bien surprenant d'expression, ce petit masque-là" (W7).

169. For a detailed account of this period see B. Welsh-Ovcharov, op.cit. (note 148); and ex.cat.cit. (note 153); ex.cat. *Van Gogh à Paris* (text by B. Welsh-Ovcharov), Paris (Musée d'Orsay) 1988.

170. "Ayant promis de t'écrire, je veux commencer par te dire que le pays me paraît aussi beau que le Japon pour la limpidité de l'atmosphère et les effets de couleur gaie" (B2)

171. E. and J. de Goncourt, *Manette Salomon*, Paris 1864, chapter 47 (pp. 171-74 in the 1915 edition): "Et un jour de pays féerique, un jour sans ombre et qui n'était que lumière, se levait pour lui de ces albums japonais... l'hiver, le gris du jour, le pauvre ciel frissonnant de Paris, il les fuyait et les oubliait au bord de ces mers limpides comme le ciel..., quand tombait, dans ces visions du Japon, la lumière de la réalité, le soleil des hivers de Paris, la lampe qu'on apportait dans l'atelier." Van Gogh first mentions the novel in letter 604 (September 1889), but he had probably read it before then.

172. E. de Goncourt, *La maison d'un artiste en XIXe siècle*, vol.1, Paris 1881, p. 194: "Là sont ces livres d'images ensoleillées, dans lesquelles, par les jours gris de notre triste hiver, par les incléments et sales ciels, nous faisons chercher au peintre Coriolis, ou plutôt nous cherchions nous-mêmes, un peu de la lumière riant de l'Empire de LEVER DU SOLEIL." Quoted in Schwartz, op.cit. (note 167), p.70. A similar expression, "l'Empire de soleil levant," had been used by Zacharie Astruc in his article "Beaux-Arts, l'Empire de Soleil Levant," *L'Etendard*, 27 February and 23 March 1867.

173. There are in fact four portraits of Tanguy by Van Gogh (F263, F1412, F363, F364). The first, painted early in 1887, has no Japanese prints in the background. The other three versions were painted about a year later. For the identification of the prints, see Orton, op.cit.

(note 163), and F. Orton, "Vincent van Gogh and the Japanese prints, an introductory essay," in ex.cat. cit. (note 163), pp. 14-23. H. Tanaka interprets the choice of prints in "Hokusai, Hiroshige and Van Gogh" (in Japanese), *Bulletin du Musée National d'Art Occidentale* (Tokyo) 5 (1971), pp. 14-24.

174. E. Bernard, "Julien Tanguy, dit le 'Père Tanguy'", *Mercure de France*, 16 December 1908, p. 606: "Julien Tanguy, qui lisait assidûment *Le Cri du Peuple* et *L'Intransigeant*, ayant pour doctrine l'unique amour qui pencherait tous les êtres les uns vers les autres et détruirait les luttes individuelles de l'ambition, toujours si amères et si sanglantes. Vincent ne différait de cet idéal que par sa nature d'artiste, qui voulait faire de cette harmonie social une sorte de religion et d'esthétique... Julien fut séduit, j'en suis certain, beaucoup plus par le socialisme de Vincent que par sa peinture, qu'il vénérait cependant comme une sorte de manifestation sensible des espérances conçues. En attendant cette ère de félicité, tous deux étaient très pauvres, et tous deux donnaient ce qu'ils avaient, le peintre ses toiles, le marchand ses couleurs, son argent et sa table: tantôt à des ouvriers; tantôt à des filles publiques, lesquelles, quant aux tableaux, allaient les vendre pour rien à des brocanteurs. Et tout cela était fait sans nul intérêt, pour des gens qu'ils ne connaissaient même pas."

175. "Ici j'aurai de plus en plus une existence de peintre japonais, vivant bien dans la nature en petit bourgeois. Alors tu sens bein que cela est moins lugubre que les décadents. Si j'arrive à vivre assez vieux, je serai quelque chose comme Père Tanguy." (540)

176. The passage from letter 540 was also used by John House in his brief commentary on Tanguy's portrait in ex.cat. *Post-Impressionism*, London (Royal Academy) 1979-80, p.81. House's interpretation of the portrait of Tanguy is similar to mine but his characterization of Tanguy as "contemplative" strikes me as irrelevant. It is true that Van Gogh compared Tanguy to Socrates in letter 504, but from other letters it is obvious that he did not regard either Tanguy or Socrates as "contemplative." The postman Roulin is also likened to Socrates in letter W5 and 572: "Moi j'ai rarement vu un homme de la trempe de Roulin, il y a en lui

énormément de Socrate, laid comme un satyr ainsi que le disait Michelet." The image of Socrates as a satyr comes from J. Michelet, *L'Amour*, Paris 1858, p.345. Bernard, op.cit. (note 174), p.615, also compares Tanguy to the Greek philosopher.

177. Ex.cat. cit. (note 176), p.81.

178. Bernard, op.cit. (note 174), p. 615: "Vincent a fait un portrait de Tanguy vers 1886. Il l'a représenté assis dans une salle tapissée de crépons japonais, coiffé d'un grand chapeau de planteur et symétriquement de face comme un Bouddha."

179. Louis Gonse, *L'Art japonais*, vol.2, Paris 1883, p.60. The wood sculpture was in the collection of Philippe Burty, and is probably cat.nr.559 in: *Collection Ph.Burty, catalogue de peintures et d'estampes japonaises... et de livres relatifs à l'Orient et au Japon*, Paris 1891. The statue, which is 18 cm high, was made in the eighteenth century.

180. His image of Japan as a luminous and colorful country does not appear to have been Van Gogh's only reason for identifying it with the Midi. The following passage from Ary Renan, "L'Art japonais," *Nouvelle Reveu* 26 (1884), p. 723, is quite interesting in this respect: "Sur cette terre volcanique, à côté de lagune marécageuse, on trouve les aspects d'une Savoie ombragée, le pin et le mélèze à quelques mètres au-dessus des basses rizières, une Holland orientale et une Provence nuageuse, battues par les vagues du Pacifique." (On this volcanic land, by a swampy lagoon, one finds features of a shady Savoie, the pine and the larch a few meters above low-lying rice fields, and oriental Holland and a cloudy Provence, pounded by the waves of the Pacific.) In letter R4 Van Gogh mentions an article of the same year by Ferdinand de Lesseps, "Souvenir d'un voyage au Soudan," *Nouvelle Revue* 26 (1884), pp. 491-516, so it seems likely that he also read Renan's article.

181. See letter 492, with drawing. "Sais-tu ce qu'il faudrait en faire de ces dessins — des albums de 6 ou 10 ou 12, comme les albums de dessins originaux japonais."

182. No. 57 of ex.cat. *Japanese prints collected by Vincent van Gogh*, (note 163). On the

front of this album there is a small sticker with letters which read "A l'Empire Chinois, DECELLE, 53 Rue Vivienne". The name of this shop appears in Didot-Bottin from 1863 to 1874 in 55 Rue Vivienne and then from 1875 to 1885 in 53 Rue Vivienne. See G. Aitken & M. Delafon, *La Collection d'estampes japonaises de Claude Monet*, Maison de Monet, Giverny, 1983, p.18. I am grateful to Shigemi Inaga for this information about Decelle. At the Rijksmuseum Vincent van Gogh there is another album of the same format which is not included in the catalogue *Japanese prints...*, but this album is not complete and does not have a sticker.

183. Cf. letters B7, 505, 509, 511, 514, 519. One oil painting and three drawings of a *mousmé* are known. (F431, F1503, F1504, F1722)

184. P. Loti, *Madame Chrysanthème*, Paris 1973, p. 76: "Mousmé est un mot qui signifie jeune fille ou très jeune femme. C'est un des plus jolis de la langue nippone: il semble qu'il y ait, dans ce mot, de la moue (de la petite moue gentille et drole comme elles en font) et surtout de la frimousse (de la frimousse chiffonnée comme est la leur)."

185. P. Loti, *Madame Chrysanthème, dessins aquarelles de Rossi et Myrbach*, Paris 1887. In June 1888, when Van Gogh read *Madame Chrysanthème*, only the first illustrated edition was available. I have seen only the second edition: Edouard Guillaume, 1888, illustrations by Rossi and Myrbach, but the illustrations must have been the same. According to the *Bibliographie de la France*, the 1888 edition was published after Van Gogh had painted the *Portrait of a mousmé*. The following are the data on the first edition of 1887; *Madame Chrysanthème* 1ère collection E. Guillaume et Cie. Edition du *Figaro*. Dessin et quarelles de Rossi et Myrbach. Gravure de Guillaume frères. In-8 caval. Calmann-Lévy. Avec reliure de l'éditeur: édition dite du Lotus d'Or. The first edition without illustrations was published in 1893. See Lesley Blanch, *Pierre Loti*, traduit par Jean Lambert, Paris 1986, pp. 303-304. From letter 561, we know that Milliet also possessed a copy of this book, which he gave to Gauguin in exchange for his drawings in November.

186. For Van Gogh's relationship with Christian Mourier-Petersen see ex.cat. cit. (note 106) pp. 132-133, Jan Hulsker, op.cit. (note 21) p. 392, 424 and E. van Uitert & M. Hoyle (ed.), op.cit. (note 12) p. 360, cat.no. I.321, *House in a garden*. Presumably Mourier-Petersen gave this painting to Theo as a token of gratitude for Theo's hospitality in Paris.

187. "Tu ne saurais croire combien cela me tranquillise, j'ai tellement l'amour de faire une maison d'artiste, mais une de pratique et non pas l'atelier ordinaire plein de bibelots. J'y songe aussi à planter deux lauriers-roses devant la porte dans des tonneaux." (540) "Le laurier-rose — ah — cela parle amour..." (587)

188. Letter 542 "J'envie aux Japonais l'extrême netteté qu'ont toutes choses chez eux. Jamais cela n'est ennuyeux et jamais cela paraît fait trop à la hâte. Leur travail est aussi simple que de respirer et ils font une figure en quelques traits sûrs avec la même aisance comme si c'était aussi simple que de boutonner son gilet." The following passage from the novel is about Monsieur Sucre: "M. Sucre a peint beaucoup de cigognes dans le courant de sa vie, et il excelle vraiment à représenter des groupes, des duos, si l'on peut s'exprimer ainsi, de ce genre d'oiseau. Peu de Japonais ont le don d'interpréter ce sujet d'une manière aussi rapide et aussi galante: d'abord les deux becs, puis les quatre pattes; ensuite les dos, les plumes, crac, crac, crac, — une douzaine de coups de son habile pinceau, tenu d'une main très joliment posé, — et ça y est, et d'un réussi toujours!" op.cit. (note 184) chapter 33, p.149.

189. "Mais exagérant moi aussi ma personnalité j'avais cherché plutôt le caractère d'un bonze simple adorateur du Bouddha éternel." (553a)

190. See note 185

191. "Si on étudie l'art japonais, alors on voit un homme incontestablement sage et philosophe et intelligent, qui passe son temps à quoi? à étudier la distance de la terre à la lune? non, à étudier la politique de Bismarck? non, il étudie un seul brin d'herbe. Mais ce brin d'herbe lui porte à dessiner toutes les plantes, ensuite les saisons, les grands aspects des paysages, enfin les animaux, puis la figure humaine.

Il passe ainsi sa vie et la vie est trop courte à faire le tout.

Voyons, cela n'est-ce pas presque une vrai religion ce que nous enseigne ces Japonais si simple et qui vivent dans la nature comme si eux-mêmes étaient des fleurs?

Et on ne saurait étudier l'art japonais, il me semble, sans devenir beaucoup plus gai et plus heureux, et il nous faut revenir à la nature malgré notre éducation et notre travail dans un monde de convention" (542)

192. S. Bing, "Programme," *Le Japon Artistique* 1 (1888); A. Leroy-Beaulieu, "La religion en Russie: les réformateurs — le Comte Léon Tolstoi, ses précurseurs et ses émules," *Revue des Deux Mondes* (15 September 1888), pp.414-43. Van Gogh read these articles at the end of September 1888; see letters 540 and 542.

193. Bing, op.cit. (note 192), p. 7: "Mais le guide constant dont il suit les indications s'appelle *la nature*: c'est elle son seul maître: un maître vénéré, dont les préceptes constituent la source intarissable où il puise ses inspiration.. Il est à la fois le poète enthousiaste ému par *les grands spectacles de la nature* et l'observateur attentif et minutieux qui sait surprendre les mystères intimes que recèle l'infiniment petit... En un mot, il est persuadé que la nature renferme les éléments primordiaux de toutes choses et, suivant lui, il n'existe rien dans la création, *fût-ce un infime brin d'herbe*, qui ne soit digne de trouver sa place dans les conceptions élevés de l'art. Voilà, si je ne me trompe, la grande et salutaire leçon que nous pourrons dégager des examples qu'il nous offre." The words in italics are echoed in Van Gogh's letter 542 and are reminiscent of the following passage on Millet's father in: A. Sensier & P. Mantz. *La vie et l'œuvre de J.F. Millet*, Paris 1881, p. 6: "Il aimait à observer les plantes, les arbres et les animaux. Prenant des brins d'herbe, il disait à son fils François: 'Vois donc comme c'est beau, vois donc comme cet arbre est grand et bien fait; il est aussi beau à voir qu'une fleur.'" (He [Millet's father] loved to observe plants, trees and animals. Taking some grass he would say to his son François: "Look, isn't it beautiful? See how large and well-made that tree is, it's as lovely a sight as a flower.") The description of the Japanese in Gonse, op.cit. (note 179), vol 1,

Paris 1883, pp. 138-39, is similar.

Van Gogh was enthusiastic about the reproduction of an anonymous Japanese drawing, *Brin d'herbe* in the first issue of *Le Japon Artistique*. It is reproduced in M. Roskill, op.cit. (note 164) fig. 65.

194. Letter 540. It is hardly surprising that Van Gogh was unhappy with Bing's text. The purpose of Bing's publication was ro revitalize the decorative arts by introducing Japanese influences, and that was not at all what Van Gogh expected of Japan. The idea of innovation through the study of nature probably did not originate with Bing. Interestingly enough, Michelet had already made the same proposal in his *L'Insecte*, Paris 1857, pp. 187ff and 384.

195. Leroy-Beaulieu, op.cit. (note 192), p. 435: "Quel est l'idéal politique et social de ce mystique (Tolstoy) qui prétend imposer aux hommes une vie si contraire à tous les appétits du vieil homme? C'est, à bien des égards, le retour à l'état de nature, après avoir, il est vrai, extirpé de l'homme de la nature les plus invétérés des instincts naturels. L'humanité doit renoncer à tout ce qui fait l'honneur, la beauté, la sécurité de la vie. Tolstoi reprend le pardoxe de Rousseau. Seulement, chez lui, l'être abstrait des philosophes du XVIIIe siècle est devenu un être vivant: 'l'homme de la nature' a pris corps dans le *moujik*. Comme Rousseau, Tolstoi croit que, *pour être heureux, les hommes n'ont qu'à s'émanciper des besoins factices de la civilisation.*" (my italics).

196. Leroy-Beaulieu, op.cit. (note 192), pp. 435-36: "Le travail industriel, non moins malsain pour l'âme que pour le corps, devrait être aboli, et les villes supprimées... Ne lui objectez pas le progrès, l'industrie, les sciences, l'art: autant de grands mots vides."

197. See note 191 for the original French text.

198. See letter 542.

199. See letter 540 "Ici j'aurai de plus en plus une existence de peintre japonais, vivant bien dans la nature en petit bourgeois. Alors tu sens bien que cela est moins lugubre que les décadents. Si j'arrive à vivre assez vieux, je serai quelque chose comme le père Tanguy." Speak-

ing of the Roulin family, Van Gogh used the word "Russians": "Mais j'ai fait des portraits de *toute une famille*, celle du facteur dont j'ai déjà précédemment fait la tête... tous des types et bien français quoique cela aie l'air d'être des Russes" (560) What Van Gogh meant by "the look of Russians" is not clear, but the words seems to be related to the primitivistic image of Russians in Leroy-Beaulieu's article. If we did not know that Van Gogh had read Leroy-Beaulieu's article, the comparison between Roulin's family and Russians would seem quite curious.

200. "... ik het echt menschelijke, het leven met de natuur mee, niet tegen de natuur in, als beschaving beschouw en respecteer. Ik vraag: wat maakt mij 't meest tot mensch?" (336) "Millet is echter de type van een *geloofsman...* Men moet niet zijn een Stadsmensch maar een Natuurmensch, al is men beschaafd of wat ook." (333) A similar contrast of "city versus country" can also be found in the following passage: "... ik wou wel eens met de natuur alleen zijn — zonder stad." (316)

201. For the tradition of primitivism see George Levitine, *The dawn of bohemianism: the Barbu rebellion and primitivism in Neoclassical France*, University Park & London 1978; ex.cat. *Search for innocence: primitive and primitivistic art of the 19th century*, College Park (University of Maryland Art Gallery) 1975. Levitine gives Van Gogh a brief mention on pp. 133-34. for the late nineteenth to the twentieth century see R. Goldwater, *Primitivism in modern art*, New York 1967; ex.cat. *"Primitivism" in 20th century art*, New York (The Museum of Modern Art) 1984. Maurice-Ary Leblond's *L'idéal du XIXe siècle, le rêve du bonheur d'après Rousseau et Bernardin de Saint-Pierre, les théories primitivistes et l'idéal artistique du socialisme*, Paris 1909, should also be added to the list. Although written at the beginning of the century, it contains many suggestions for further study of the primitivistic ideal in art which are still valid today.

202. Elisa Evett, *The critical reception of Japanese art in Europe in the late 19th century*, Ann Arbor 1982; and "The late nineteenth-century European critical response to Japanese art:

primitivistic leanings," *Art History* 6 (1983), pp. 82-106.

203. "J'ai depuis longtemps été touché de ce que les artistes japonais ont pratiqué très souvent l'échange entre eux. Cela prouve bien qu'ils s'aimaient et se tenaient, et qu'il régnait une certaine harmonie entre eux: qu'ils vivaient justement dans une sorte de vie fraternelle, naturellement, et non pas dans les intrigues. Plus nous leur ressemblerons sous ce respect-là mieux on s'en trouvera" (B18)

204. "Het was toch een aardige tijd toen er in den Elzas zooveel artisten waren, Brion, Marchal, Jundt, Vautier, Knaus, Schüler, Saal, v. Muyden en zeker nog veel meer — tegelijk met een partij schrijvers die in dien zelfden geest werkten, zoals Chatrian and Auerbach" (232, written in 1882)

205. "Dan slechts wanneer men zich serieus combineert tot het samen werken aan iets wat voor één mensch teveel is (b.v. Erckmann-Chatrian in hun werken) of (de teekenaars van de Graphic) vind ik het iets uitstekends" (R16). "Er was een corps schilders, schrijvers, artisten, enfin, die ondanks hun verdeeldheden eenheid hadden, en eene kracht waren... Ik spreek van den tijd toen Corot, Millet, Daubigny, Jacque, Breton jong waren, in Holland Israëls, Mauve, Maris etc." (247).

206. "...I will, if you like, share my lodgings and studio with you so long as I have any. In spring — say in February or even sooner I may be going to the South of France, the land of the blue tones and gay colors" (459a)

207. "L'Union des peintres désirable (tout autant qu'à l'époque des corporation Saint-Luc). En sauvegardant, la vie matérielle en s'aimant comme des copains au lieu de manger le nez, les peintres seraient plus heureux et en tout les cas moins ridicules, moins sots et moins coupables" (B11). In letter B18 Van Gogh explains the character of the community: "L'Idée de faire une sorte de Franc-Maçonnerie des peintres ne me plaît pas énormément. Je méprise profondément les règlements, les institutions, etc., enfin je cherche autre chose que les dogmes qui, bien loin de régler les choses, ne font que causes des disputes sans fin."

208. For Van Gogh's exchange of works see Roskill, op.cit. (note 164, chapter 4, and M. Roskill, "Van Gogh's exchange of work with Emile Bernard in 1888," *Oud Holland* 86 (1971), pp. 142-79; See also W. Jaworska, *Gauquin et l'école de Pont-Aven*, Paris 1971, p. 67. It is worth noting that Vincent had exchanged portraits (photographs) with Theo back in 1873. See letters 4 and 5. The *Poet's Garden* and *Sunflower* series were intended as decorations for the Yellow House. For the *Poet's Garden* see J. Hulsker, "The poet's garden," *Vincent, Bulletin of the Rijksmuseum Vincent van Gogh* 3 (1974), no.1, pp. 22-32; E. van Uitert, "Vincent van Gogh in anticipation of Paul Gauguin," *Simiolus* 10 (1978-79), pp. 182-99 (also op.cit. (note 7) pp. 27-44); J. House, "In detail: Van Gogh's *The poet's garden*, Arles," *Portfolio* (September-October 1980), pp. 28-33; Roland Dorn, op.cit. (note 11)

209. N. Pevsner, "Gemeinschaftsideale unter den bildenden Künstlern des 19. Jahrhunderts," *Deutsche Vierteljahrschrift für Literaturwissenschaft und Geistesgeschichte* 9 (1931), pp. 125-54.

210. "Tu sais que je crois qu'une association des impressionistes serait une affaire dans le genre de l'association des 12 préraphaelites anglais, et que je crois qu'elle pourrait naître" (498). The term "impressionistes" was often used by Van Gogh and Gauguin to signify their own group as well as that of Monet and Pissarro. In September Van Gogh bought precisely twelve chairs for his Yellow House; see letter 534.

211. See Chapter 1, note 50.

212. See L.D. Ettlinger, "Nazarener und Präraffaeliten," in: *Festschrift für Gert von der Osten*, Cologne 1970, pp. 209-210.

213. "Si on est peintre, ou bien vous passez pour un fou ou bien pour un riche... Voilà ce pourquoi il faut se combiner comme faisaient les vieux moines, les frères de la vie commune de nos bruyères hollandaises" (524). See also letter 556.

214. In letter 544 Vincent included Theo in his imaginary community when he wrote: "Tu serais ainsi un des premiers ou le premier marchand apôtre." Van Gogh's idea of the painter-monk was first pointed out by Pevsner, op.cit. (note 209).

215. For the *Freundschaftbild* see K. Lankheit, *Das Freundschaftsbild der Romantik*, Heidelberg 1952.

216. Cf. Keith Andrews, *The Nazarenes, a brotherhood of German painters in Rome*, Oxford 1964, pp. 21 and 88. It seems that Van Gogh also imagined Fra Anglico as a pious, naive painter-monk: "Se dire de nos jours que celui-là (Millet) s'est mis à peindre en pleurant, que Giotto, qu'Angelico peignaient à genoux, Delacroix si navré, si ému... presqu'en souriant" (W20). For the image of Fra Anglico see also E. van Uitert, *Het geloof in de moderne kunst*, Amsterdam 1987, pp. 21-22,

217. For the *Portrait of Franz Pforr*, see ex.cat. *Die Nazarener in Rom, ein deutscher Künstlerbund der Romantik*, Rome & Munich 1981, p. 158.

218. "J'ai aussi fait un nouveau portrait de moi-même comme étude où j'ai l'air d'un japonais." (W7) This self-portrait is described in the following letters: W7, 537, 539, 540, B18, 553a, 545. See further V. Jirat-Wasiutyński, H. Travers Newton et.al., *Vincent van Gogh's Self-Portrait Dedicated to Paul Gauguin, an historical and technical study*, Center for Conservation and Technical Studies, Harvard University Art Museums, Cambridge, Massachusetts, 1984.

219. D. Cooper, op.cit. (note 101) p. 243-45, letter 33, 25 September 1888: "Le masque de bandit mal vêtu et puissant comme Jean Valjean qui a sa noblesse et sa douceur intérieure... Le dessin des yeux et du nez semblables aux fleurs dans les tapis persans résume un art abstrait et symbolique. Ce petit fond de jeune fille avec ses fleurs enfantines est là pour attester notre virginité artistique. Et ce Jean Valjean que la société opprime mis hors la loi, avec son amour, sa force, n'est-il pas l'image aussi d'un impressioniste d'aujourd'hui? Et en le faisant sous mes traits vous avez mon image personnelle ainsi que notre portrait à tous pauvres victimes de la société."

220. "J'ai un portrait de moi tout cendré ... Mais exagérant moi aussi ma personnalité

j'avais cherché plutôt le caractère d'un bonze simple adorateur du Bouddha éternel. Il m'a coûté assez de mal mais il faudra que je le refasse entièrement si je veux réussir à exprimer la chose" (553a).

221. "Le Gauguin est plus étudié, poussé loin. C'est ce qu'il dit dans la lettre et cela me fait décidément avant tout l'effet de représenter un prisonnier. Pas une ombre de gaieté. Ce n'est pas le moins du monde de la chair, mais hardiment on peut mettre cela sur le compte de sa volonté de faire une chose mélancolique, la chair dans les ombres est lugubrement bleuie ... j'ai écrit à Gauguin en réponse à sa lettre, que s'il m'était permis à moi aussi d'agrandir ma personnalité dans un portrait, j'avais en tant que cherchant à rendre dans mon portrait non seulement moi, mais en général un impressioniste, j'avais conçu ce portrait comme celui d'un Bonze, simple adorateur du Bouddha éternel. Et lorsque je mets à côté la conception de Gauguin et la mienne, le mien est aussi grave mais moins désespéré" (545).

222. For the contrast between melancholy and gaity see Chapter 3.

223. "Pour ce que dit Gauguin de 'persan" c'est vrai ... Mais mais mais ... je ne suis pas moi ni du grand monde ni même du monde ... et ... aux Persans et Egyptiens je préfère et les Grecs et les Japonais" (544). "Grecs" in this passage probably refers to primitive Greek art before the classical period. Such a comparison between the art of Greece and Japan was not exceptional in Van Gogh's day; see, for example, E. Pottier, "Grèce et Japon," *Gazette des Beaux-Arts* (August 1890), pp. 105-32.

224. Letter 545 "Le Gauguin est remarquable d'abord, mais moi j'aime fort celui de Bernard."

225. V. Jirat-Wasiutyński, H. Travers Newton et al, op.cit. (note 218) p. 21.

226. For this painting and the identification of the Japanese print see D. Cooper, "Two Japanese prints from Vincent van Gogh's collection," *Burlington Magazine* 99 (1957), pp. 204-07. The print on the wall is obviously a deliberate insertion for it is not reflected in the mirror. The authenticity of this painting has

long been doubted by several scholars for stylistic reasons.

227. Orton, op.cit. (note 173), p.22 had already reached the same conclusion: "Presumably he is making a specific contrast between the empty canvas on the easel and the print, the world of Japan. In other words, the scene in the Japanese print, a summation of all that the thought of as typifying Japanese life, signifies the emotional, moral, and even aesthetic values he had been unable to find in Arles." Whether the canvas was intended as a contrast to the print and whether it is empty remain unclear, but as far as the Japanese print is concerned Orton's interpretation is accurate.

228. "Pour moi ici je n'ai pas besoin de japonaiseries, car je me dis toujours qu'ici je suis au Japon. Que consequemment je n'ai qu'à ouvrir les yeux et à peindre droit devant moi ce qui me fait de l'effet" (W7)

229. "Il me semble à moi maintenant impossible, au moins assez improbable, que l'impressionisme s'organise et se calme. Pourquoi n'adviendra-t-il pas ce qui est arrivé an Angleterre lors des Préraphaelites. La société s'est dissoute" (571)

230. "Reste cependant que l'idée d'association des peintres, de les loger en commun quelques-uns, quoique nous n'ayons pas réussi, quoique c'est une faillite déplorable et douloureuse, cette idée reste vraie et raisonnable, comme tant d'autres. Mais pas recommencer" (586)

231. "Merci de votre lettre et de vos propositions projetées, elle m'ont donné beaucoup à réfléchir et je vous avoue que je trouve la vie ensemble possible très possible mais avec beaucoup de précautions." Cooper, op.cit. (note 101), p. 297, letter 39, 28 January 1890. "Votre idée de venir en Bretagne au Pouldu me paraît excellente si elle était réalisable", ibid., p. 323, letter 42, ca. 24 June 1890.

232. For the exhibition of Japanese prints see: ex.cat. *Exposition de la gravure japonaise à l'École Nationale des Beaux-Arts*, Paris 1890.

233. For Van Gogh and rural themes in nineteenth-century art see: Evert van Uitert, "Vincent van Gogh, boerenschilder", in: ex.cat.

Van Gogh in Brabant, 's-Hertogenbosch (Noordbrabants Museum) 1987-88, pp. 14-46 (English edition: *Van Gogh in Brabant*, 's-Hertogenbosch (Noordbrabants Museum) 1987-88, pp. 14-46)

234. Letter 110, 233: "Zoo wat de mensch zaait dat zal hij ook maayen en die naar de Geest zaait zal uit den Geest het eeuwige Leven maayen" This passage is from Galatians 6:7-8, but is slightly altered. "Het studies maken beschouw ik als zaaien, en het schilderijen maken is oogsten."

235. Letter 101: "Hoorde Zondagmorgen Ds. Laurillard in de vroegpreek over 'Jezus wandelde in het gezaaide'. Hij maakte een grooten indruk op mij — in die preek sprak hij ook over de gelijkenis van den zaaier, en over den man, die het zaad in den akker strooide, en voorts sliep en opstond dag en nacht, en het zaad sproot uit en wies op, en werd lang, en hij wist zelf niet hoe; ook sprak hij over 'de Begrafenis in het koren' van v.d. Maaten." The passage quoted from the book of Mark is used, for example, in: E. Laurillard, *Met Jezus in de natuur*, Amsterdam 1881, chapter III 'Het zaad, dat van zelf groeit' pp. 19-23; Ch.H. Spurgeon, *"Zijn God onderricht hem" Schetsen aan landbouw en veeteelt ontleend (Farm Sermons)*, translated by C.S. Adama van Scheltema, Amsterdam 1883, pp. 228-250, "Wat de veldarbeiders wel en wat zij niet in staat zijn te doen". The English texts from the Bible are from: *The Holy Bible, containing the Old and New Testament in the King James version*, Nashville & New York 1977.

236. "Ik zag toen in die maaier — een onduidelijk figuurtje dat zwoegt als een duivel in de volle hitte om zijn werkje af te krijgen — ik zag er het beeld in van de dood, in die zin dat de mensheid het koren is dat men oogst. Het is dus, als je wilt, het tegengestelde van die 'Zaaier' die ik eerder geprobeerd had." (604)

237. "Longfellow zegd: 'there are thoughts, that make the strong heart weak', maar daar staat ook bovenal: 'Laat hem die de hand aan de ploeg slaat, niet omzien en wees een man'." (105) The English quotation is from Longfellow's poem *My Lost Youth*. I am indebted to A. Karagheusian for this information.

238. Laurillard, op.cit. (note 235) pp.11-13. "Zoo, denk ik, bij de aanschouwing van dien degelijken ploeger, en 't is mij, als hoor ik daarbij de stem van Jezus, die spreekt: 'niemand, die zijne hand aan den ploeg slaat, en ziet naar hetgeen achter is, is bekwaam tot het Koninkrijk Gods.' ... Zoo, Jezus! hebt Gij geploegd. 'Vooruit!' was uwe leus, 'Recht' was uw regel, en Gij keekt niet om naar wie een kroon vlochten... Een spreekwoord zegt: 'Hand aan den ploeg, zoo zal 't God vorderen'. Maar dat vul ik nu aan met deze gedachte: 'mits het oog steeds vooruit blijve zien'."

239. See for example S. Takashina, op.cit. (note 7) chapters 4 and 5, pp. 123-160.

240. "...zoo'n kale kruin voorovergebogen over de zwarte aarde vond ik wel iets, waar een zekere betekenis in lag, als doende denken b.v. aan 'ge zult uw brood eten in 't zweet uws aanschijns.'" (277)

241. Alfred Sensier & Paul Mantz, op.cit. (note 193) p. 130: "Dans les endroits labourés, quoique, quelquefois, dans certains pays peu labourables, vous voyez des figures bêchant, piochant. Vous en voyez une de temps en temps se redressant les reins, comme on dit, et essuyant le front avec le revers de la main. 'Tu mangera ton pain à la sueur de ton front'." This biblical text seems to have often been quoted with reference to Millet. See also André Michel, "J.F. Millet et l'exposition de ses œuvres à l'Écolé des Beaux-Arts," *Gazette des Beaux-Arts* 29 (1887), p. 19; Sensier & Mantz, op.cit. (see above) p. 157.

242. Edward Wheelwright, "Personal recollections of Jean-François Millet," *Atlantic Monthly* 38 (September 1876) no. 277, pp. 262-3: "Millet's picture of *La mort et le bûcheron* was not painted until several years after I had left Barbizon, but the subject had already been long in his mind. One day in my room he took up a copy of George Sand's *La mare au diable*, and read attentively the first chapter, in which the author describes at length an engraving after Holbein, underneath which was inscribed this quatrain in old French: 'A la sueur de ton visage, Tu gagnerais ta pauvre vie. (sic) Après long travail et usaige Voicy la mort qui te convie'." *Les simulachres et historiées faces de la*

mort, Lyon 1538. George Sand, *La mare au diable*, Paris 1846. For Millet's *La mort et le bûcheron* see: Kirsten H. Powel, "Jean-François Millet's death and the woodcutter," *Arts Magazine* 61 (1986) 4, pp. 53-59.

243. For peasant life in the nineteenth century see Tina Jolas & Françoise Zonabend, "Tillers of the fields and woodspeople," in: R. Forster & O. Ranum (ed.), *Rural society in France, selections from the Annales economies, societies, civilizations*, Baltimore & London 1977, pp. 126-151.

244. André Theuriet, *La vie rustique*, Paris 1888, pp. 43-50.

245. ibid., pp.48-9: "Ah! elle est tristement vraie, la chanson bressane sur les gens qui labourent la terre! Le pauvre laboureur, il a bien de malheur. Le jour de sa naissance. L'est déjà malheureux ... La vieille chanson des paysans bretons est moins désespérante, car, après avoir plaint la destinée de celui qui fait pousser le blé, elle ajoute Ô laboureurs, vous souffrez bien dans la vie! Ô laboureurs, vous êtes bien heureux! Car Dieu a dit que la porte charretière de son paradis serait ouverte pour ceux qui auraient pleuré sur la terre ... Partout et à tous les ages, le laboureur semble ruminer tristement et d'un air convaincu la dure parole de l'Écriture: 'Tu gagneras ton pain à la sueur de ton front'." Earlier, in 1885, Lhermitte had made a set of drawings, *Les mois rustiques*, for various numbers of *Le Monde illustré*. See E. van Uitert, op.cit. (note 233).

246. "Want wie zijn het in wie men het duidelijkst iets hoogers opmerkt, het zijn zulken op wie het woord van toepassing is: laboureurs vous êtes bien-heureux'..." (121)

247. Emile Souvestre, *Les derniers Bretons*, Paris 1858 (ed. princ. 1843) pp. 226-7: "Ma fille quand tu choisiras un mari, ne prends pas un soldat, car sa vie est au roi; ne prends pas un marin, car sa vie est à la mer; mais surtout ne prends pas un laboureur, car sa vie est à la fatigue et au malheur ... Ô laboureurs! vous menez une vie dure dans le monde. Vous êtes pauvres et enrichissez les autres; on vous méprise et vous honorez; on vous persécute et vous vous soumettez dans la vie, laboureurs, vous êtes bien heureux!" The passage "laboureurs

votre vie est triste" is found only in Van Gogh's letter and not in the books by Theuriet and Souvestre. It is clear from some other quotations in Van Gogh's letters that he did not always cite texts accurately, but rather quoted from memory. This is also true of the quotations from the Breton song. Souvestre had already been mentioned by Van Gogh in letter 109 of 1877. For Van Gogh's poetry albums, see Fieke Pabst, op.cit. (note 21) (For Souvestre, p.29).

248. For Millet's *Peasants digging* see ex.cat. *Jean-François Millet*, Paris (Grand Palais) 1975-6, pp.159-66 (Le dossier des 'Deux Bêcheurs'); ex.cat. *Jean-François Millet*, Boston (Museum of Fine Arts) 1984, pp. 28, 29, 104, 105, 174, 175; Jonas and Zonabend, op.cit. (note 243).

249. For Alphonse Lemerre see *Grand Larousse encyclopédie*, vol.6, Paris 1962; P. Dresse, "La fin de l'Homme qui bêche ou le Parnasse au pilon," *Le Thyrse, Revue d'art et de littérature* 58 (1965), pp. 349-52; Guy le Clerc'h, "Alphonse Lemerre disparaît sans laisser de traces," *Figaro littéraire*, 30 Sept.-6 Oct. 1968, no.1169, p.27; Michel Legris, "La librairie Lemerre disparaît," *Le Monde*, 7-8 Feb. 1965, p. 18.

250. See letter 27.

251. For the iconographical tradition of the digger see Raimond van Marle, *Iconographie de l'art profane au Moyen-Age et à la Renaissance et la décoration des demeures*, The Hague 1931, pp.387-401. For the emblematic literature see A. Henkel and A. Schöne, op.cit. (note 150) chapter 5 ("Menschenwelt/Stände und Teatigkeiten"), pp. 1093-5.

252. Jacob Cats, *Alle de wercken van Jacob Cats, bezorgd door Dr. J. van Vloten ... met ruim 400 platen op staal gebracht door J.W. Kaiser*, 2 vols., Zwolle (De Erven J.J. Tijl) 1862. The text and illustration of the digger is in "Hof Gedachten" XIX Op het ploegen, missen en spitten in d'aerde, p. 487-88. As mentioned in chapter I, a list of subscribers is included after the title page in this nineteenth-century edition, which contains the names of C.M. van Gogh in Amsterdam, a certain H.H. Van Gogh in The Hague and the firm Blussé & van Braam, a bookshop in Dordrecht where Van

Gogh worked for several months in 1877. During the First International "Word & Image" Conference at the Vrije Universiteit in Amsterdam in 1987, Bernard F. Scholz discussed the characteristics of the illustrations in the 1862 edition of Cats. Summaries of the papers read during the conference will be published in *Word & Image*.

253. See: *Marques typographiques des imprimeurs et librairies qui ont exercé dans les Pays-Bas et marques typographiques des imprimeurs et librairies belges établis à l'étranger*, 2 vols., Ghent 1894, vol.2 "Delft", "Dordrecht", "Leiden", "Rotterdam"; R. Laurent-Vibert & M. Audin, *Les marques de librairies et d'imprimeurs en France aux dix-septième et dix-huitième siècles*, Paris 1925, no 171.

254. A drawing of a digger (F1307 JH853), which is dated 1885 by both Hulsker (1977) and de la Faille (1970), must be redated to before May 1883, since this figure is used in the composition *Peat-cutters in the dunes* (fig. 105, extreme right, background) of that date. The dating of SB 2/11 has not yet been established, but in view of the presence of a plaster model on the same sheet, this sketch of a digger was probably done during Van Gogh's period of study in Cormon's studio in 1886. For the redating of *Two diggers among trees* (fig. 109) see note 262. According to Van Gogh's own description, *Two peasant women digging* (F695 JH1923) and the drawing for them (F1586v JH1924) are representations not of digging, but of "a turnip field with women gathering green stuff in the snow". (letter 629a) Nevertheless I have included these two works in the table as important works in the "Souvenir of Brabant" series. It makes no difference to the discussion whether they are included or not.

255. Potato gathering was certainly not the most backbreaking type of labor, as Theuriet writes in his chapter "la récolte des pommes de terre": "La dernière récolte de l'année est la moins fatigante", op.cit. (note 244), p.23. For the chronological table of "plowman" see Appendix I. JH1, 36, 37, 374, 1836, 1837 are combinations of a sower and a plowman. There are very few works and few descriptions of plowmen in the letters, making it difficult to draw any conclusions from this table. It further-more shows little correspondence with the chronological table of "diggers". See the table in Appendix I.

256. See Henkel and Schöne, op.cit. (note 150), pp. 1089-93; Van Marle, op.cit. (note 251), pp. 384-99. References to diggers are rarely found in the writings of the nineteenth century preachers, but the plowman theme was used rather frequently. See for example Ch.H. Spurgeon, op.cit. (note 235) "De Ploeger", pp. 101-124, "Het ploegen op rotsen", pp. 125-144; Ch.H. Spurgeon, *Jan Ploeger's prentjes of meer van zijn eenvoudige praatjes voor eenvoudige lieden*, translated by M.S. Bromet, illustrated, Amsterdam 1880; "Laat den ploeg niet stilstaan om een muis te vangen", pp. 44-46 (fig. 10), "Waar de ploeg niet gaat, schiet het onkruid zaad", pp. 125-127, (original edition, *John Ploughman's pictures, or more of his plain talk for plain people*, illustrated, London 1880). For the eighteenth century see: Marie-Pascale Bault, "'La leçon de labourage', par François-André Vincent (1746-1816)," *Gazette des Beaux-Arts*, 110 (July-August 1987) pp. 11-16. In his dissertation Roland Dorn investigated the possibility of a semantic source for Van Gogh's plowman in Zola's *La terre*. He does not reject the biblical implications of this motif, but lays more emphasis on Zola's novel. "Van Gogh waren aber auch wirklichkeitsnähere Deutungen geläufig. In Emile Zola's 'La Terre' (1887) sind die Feldarbeiten in Jahreszyklus Leitmotive, deren stetige, unabänderbare Wiederkehr die absolute und unerbitterliche Macht der Erde über Bauern charakterisiert." Roland Dorn, op.cit. (note 11), p. 122.

257. Jan Hulsker, *Van Gogh en zijn weg*, Amsterdam 1977, p. 121.

258. See *Verzamelde Brieven...* vol.IV, no. A15. Not included in the English edition of the letters.

259. Reproduced in color in: John Rewald, *The History of Impressionism*, New York 1973, p. 539. For the dating see Bogomila Welsh-Ovcharov, op.cit. (note 148) p.232; Hulsker, op.cit. (note 257) p.261.

260. Letter 543 "Lui-même [Tolstoy] gentilhomme s'est fait ouvrier, sait faire des bottes, sait réparer les poêles, sait mener la charrue et

bêcher la terre."

261. Although the *Orchard in blossom with poplars* has a very radical composition, the tree trunks in the foreground are apparently not imaginative additions. The center of Arles is viewed from the southwest through the three poplar trees; the tower of St. Trophime and the large barracks are visible in the background of the orchard. Van Gogh was standing on the bank of the Arles-Bouc Canal, behind the row of poplars which are painted in the *Langlois Bridge* (F397 JH1368). (See fig. 53) However, Van Gogh undoubtedly chose this particular spot deliberately in order to obtain this peculiar effect, and the digger is most probably an imaginative addition. The combination of a digger with an orchard is unusual and the digger is apparently painted too large for a figure actually viewed from this distance.

262. Both De la Faille (1970) and Hulsker (1977) date this painting to the autumn of 1889, but the two diggers in it are to be found in two drawings which both catalogues date to March-April 1890, namely (F1620v JH1934) for the digger on the left and (fig. 108) for the one on the right in the painting. It is unlikely that the painting was done before the two drawings, so that either the *Two diggers among trees* must be redated to March-April 1890 or the two drawings must be dated six months earlier, to the autumn of 1889. This second possibility seems less likely, however. The technical examination done by the Detroit Institute of Art reveals that there are no traces of later retouching. Two paintings of diggers are dated to the period March-April 1890, namely *Two women digging (F695 JH1923)* and *Two diggers* (F694 JH1922). The first can be dated with certainty on the basis of the letters and a study for it also exists (F1586v JH1924). The two figures in *Two diggers* are also to be found in a drawing with six figures (F1602v JH1927). This painting is described as being "After Millet" by both De la Faille and Hulsker, but the original work by Millet is unknown.

263. "... n.l. *de type* geconcentreerd uit veel *individu's*. Dat is het hoogste van de kunst, en *daar* is soms de kunst boven de natuur ... als b.v. in Millet's zaaier meer ziel is dan in een gewoon zaaier op 't veld." (257)

264. Emile Zola, *La faute de l'abbé Mouret*, Paris 1875. Van Gogh mentions this novel for the first time in letter 226. The quotation is from letter 286 "Ben blij ge wat geniet dezer dagen — Le Paradou zal echt geweest zijn. Ja ik zou er niets op tegen hebben zooiets eens te proberen; en gijlieden zoudt goede modellen zijn, daar twijfel ik niet aan. Toch, ik zie nog liever spitters, en vond het buiten 't Paradijs, nl. daar waar men meer denkt aan het strengere 'ge zult Uw brood eten in 't zweet uws aanschijns' mooier"; Letter 287 "Dit nl. de turfspitters is een ander landschap dan precies 'Le Paradou'. En wilt ge gelooven dat ik toch ook voor Le Paradou gevoel heb? Wie weet of ik op een goeden dag zoo 'n Paradougeval nog niet eens opvat."

265. See *Catalogue illustré de Salon (1883)*, Paris-London. p.66: J.E. Dantan, *Le Paradou (La Faute de l'Abbé Mouret)* and p.189: L.A. Lhermitte, *La Moisson*. This catalogue and *La Moisson* are mentioned in letter 285.

266. Little is known about this lady friend called Marie. See Jan Hulsker, op.cit. (note 21) p.230.

267. Letter 319 "Ja voor mij het drama van de storm in de natuur, het drama van smart in het leven, is wel het beste. Een 'Paradou' is mooi, doch Gethsemane is toch mooier."

268. The dating of Mauve's picture has not yet been established. I discussed the manipulation of the church motif in Chapter 2 "The church versus the sun". To my knowledge, Van Gogh and Anton Mauve were the only Dutch painters to depict a digger in combination with a church tower.

269. "Nous avons alors à nous deux exploré le vieux jardin, et y avons volé d'excellentes figues. Si c'eut été plus grand, cela eut fait penser au Paradou de Zola, de grands roseaux, de la vigne, du lierre, des figuiers, des oliviers, des grenadiers aux fleurs grasses du plus vif orangé, des cyprès centenaires, des frênes et des saules, des chênes de roche, des escaliers démolis à demi, des fenêtres ogivales en ruine, des blocs de blanc rochers couverts de lichen, et des pans de murs écroulés épars çà et là dans la verdure; j'en ai encore rapporté un grand dessin, non pas du jardin cependant." (506)

270. See the chronological tables of these motifs in Appendix I. These tables still have to be processed and analysed, like that of the diggers, but it is clear that these motifs appear most frequently during Van Gogh's utopian period. The sunflower is a typically utopian motif which appears almost exclusively in 1887-8. Works with sunflowers from other periods are either replicas of the painting of 1888 or the sunflowers occupy an inconspicuous place in the composition. Most of the French novels appear in works of 1887, Japanese prints in 1887 and January of 1889. Oleanders, of which Van Gogh wrote, "Le laurier-rose — ah — cela parle amour" (letter 587), occur almost exclusively in 1888.

271. For the *Jardin de Poète* series and the decoration of the house see Jan Hulsker, op.cit. (note 208); E. van Uitert, op.cit. (note 7) p. 27; John House, op.cit. (note 208); Dorn, op.cit. (note 11).

272. For the symbolic meaning of sunflowers, see Chapter 2.

273. See the chronological tables in Appendix I.

274. "Je vais encore travailler aux Bêcheurs, ..." (611)

275. Bouilhet, "L'Abbaye" in *Dernières chansons*. Quoted in R. Ripoll, *Réalité et mythe chez Zola*, Paris 1981, vol.1, p. 550. P.H. Baron d'Holbach, *Système de la nature*, 1770, vol.2, 1780 ed. p. 415. According to Ripoll, Bouilhet's poem was the source of inspiration for the hallucination scene in Book III of *La faute de l'abbé Mouret*. The hallucination of Father Mouret will be discussed later in this chapter. Holbach is mentioned in Book III chapter 15 of the novel.

276. Emile Zola, *La faute de l'abbé Mouret*, Paris 1875. I have used the 1879 (15th) edition published by Charpentier. For the English translation, I have used: E. Zola, *The Sin of Father Mouret*, translated by Sandy Petrey, Lincoln (Nebraska) & London 1969.

277. Letter 226 "Ik heb nog van Zola gelezen: La faute de l'abbé Mouret, en Son Excellence Eugène Rougon, ook mooi."

278. See Chapter 5, notes 264, 267, 269.

279. See Jean Adhémar, "De quelques sources iconographiques des romans de Zola," in: ex.cat. *Emile Zola*, Bibliothèque Nationale 1952, p.XII. *The rape*: cat.no. 101 of Lionello Venturi, *Cézanne, son art, son œuvre*, Paris 1936.

280. Ex.cat. *Emile Zola* (note 279) cat.no. 171. In addition to the two works by Dantan and Caucaunier, works by Anaïs Beauvais and Saurand are also mentioned, but I could not find reproductions of the last two works.

281. See letter 212 "En dat kleine boekje [Une page d'amour] van hem is aanleiding, dat ik zeer zeker *alles* ga lezen van Zola, van wien tot nu toe ik alleen een paar kleine brokstukken kende, waarvoor ik een illustratie heb beproeven te maken: 'Ce que je veux', en een ander stuk dat een oud boertje beschreef, precies een teekening van Millet." For Zola and Van Gogh, see A.M. Hammacher, "Van Gogh — Michelet — Zola," *Vincent* 4 (1975) no.3, pp. 2-21. The influence of *Germinal* is discussed in this article.

282. For *La faute de l'abbé Mouret* and Michelet see R. Ripoll, "Le symbolisme végétal dans *La Faute de l'abbé Mouret*: réminiscences et obsessions," *Cahiers Naturalistes*, 31 (1966) pp. 11-22. For the creative process of *La Faute de l'abbé Mouret* see: E. Zola, *Les Rougon-Macquart*, vol.1, Paris (Fasquelle et Gallimard) 1960, pp. 1674-1687; E.Zola, *La Faute de l'abbé Mouret*, Paris (Garnier-Flammarion) 1972, introduction by Colette Becker, pp.11-36. The following are the studies on Zola and especially on *La faute de l'abbé Mouret*, which were essential for the preparation of the present chapter. Roger Ripoll, *Réalité et mythe chez Zola*, 2 vols, Paris (thesis) 1981; F.W.J. Hemmings, "Emile Zola et la religion, à propos de *La Faute de l'abbé Mouret*," *Europe, revue littéraire mensuelle* (Paris) (April-May 1968) pp. 129-135; Philip Walker, "The survival of romantic pantheism in Zola's religious thought," *Symposium* 23 (1969) no. 3-4, pp. 354-365; F.W.J. Hemmings, "The secret sources of *La Faute de l'abbé Mouret*," *French Studies* 13 (1959) pp. 226-239.

283. Zola, *La Faute...* 1979, (note 276) Book I chapter 1, p.5.

284. ibid. Book I chapter 5, p.28. "Ah! vaurien, tu manques l'école, et c'est dans le cimetière qu'on te trouve! ... Le prêtre avança. Il reconnut Vincent, qu'un Frère des écoles chrétiennes tenait rudement par une oreille. L'enfant se trouvait comme suspendu au-dessus d'un gouffre qui longeait le cimetière..."

285. ibid. Book I chapter 5, p.33 and 34.

286. ibid. Book III chapter 5, p.316. "Bas les pattes! cria-t-il. Ah! c'est toi, calotin! J'aurais dû te flairer a l'odeur de ton cuir ... Nous avons un compte à régler ensemble. J'ai juré d'aller te couper les oreilles au milieu de ta classe."

287. ibid. p. 318 Book III chapter 5. "Je t'extermine. C'est Dieu qui le veut. Dieu est dans mon bras." "Tu vois bien qu'il n'est pas le plus fort, ton bon Dieu. C'est moi qui t'extermine ... Maintenant, je vais te couper les oreilles. Tu m'as trop ennuyé. / Et il tirait paisiblement un couteau de sa poche."

288. ibid. Book III chapter 16, p. 426-427. "Puis, comme l'abbé Mouret achevait les raisons, il tira tranquillement un couteau de sa poche, l'ouvrit, et abattit, d'un seul coup, l'oreille droite du Frère ... — La gauche sera pour une autre fois, dit paisiblement Jeanbernat en jetant l'oreille par terre."

289. Quoted in Ripoll, op.cit. (note 275) vol.1, p. 533. "l'histoire d'un homme frappé dans sa virilité par une éducation première, devenue être neutre, se réveillant homme à vingt-cinq ans, dans les sollicitations de la nature, mais retombant fatalement à l'impuissance"

290. ibid. p. 548. "Opposition de la petite église avec la grande Paradou" "Ce sera l'opposition, Serge catholique jusqu'à la fin, tandis que Blanche (in the *Ebauche* Albine is called Blanche) est le naturalisme, et va dans le sens de l'instinct et de la passion." The text is from the manuscript (nouvelles acquisitions françaises no. 10294, f.4, Bibliothèque Nationale, Paris). The descriptions of Archangias and Jeanbernat are respectively from the manuscript no. 10294 f.4 and f.9. Quoted in Ripoll (note 275) p. 535 and p.1029.

291. Zola, *La Faute...* 1879 (note 276) Book I chapter 2, p.7. "L'église, vide, était toute blanche, par cette matinée de mai."

292. ibid. Book I chapter 2, p. 10-11. "Vincent marmotta une longue phrase latine dans laquelle il se perdit. Ce fut alors que des flammes jaunes entrèrent par les fenêtres. Le soleil, à l'appel du prêtre, venait à la messe. ... Même la campagne entrait avec le soleil: à une des fenêtres un gros sorbier se haussait, jetant des branches par les carreaux cassés, allongeant ses bourgeons, comme pour regarder à l'intérieur; et, par les fentes de grande porte, on voyait les herbes du perron, qui menaçaient d'envahir la nef. ... Un moineau vint se poser au bord d'un trou; il regarda, puis s'envola; mais il reparut presque aussitôt ..."

293. ibid. Book I chapter 2, p.15. "Puis, s'étant retourné pour baiser l'autel, il [Father Mouret] revint ... bénissant l'église pleine des gaités du soleil et du tapage des moineaux. ... L'astre triomphant mettait dans sa gloire la croix, les chandeliers, la chasuble, le voile du calice, tout cet or palissant sous ses rayons. Et lorsque le prêtre, prenant le calice, faisant une génuflexion, quitta l'autel pour retourner à la sacristie ... l'astre demeura seul maître de l'église."

294. ibid. Book III chapter 9, p. 374. "Brusquement, l'attaque eut lieu. Du bout de l'horizon, la campagne entière se rua sur l'église, les collines, les cailloux, les terres, les arbres. L'église, sous ce premier choc, craqua."

295. ibid. Book III chapter 9, p. 376-377. "Puis, brusquement, ce fut la fin. Le sorbier, dont les hautes branches pénétraient déjà sous la voute, par les carreaux cassés, entra violemment, d'un jet de verdure formidable. Il se planta au milieu de la nef. Là, il grandit démesurément. ... Maintenant, l'arbre géant touchait aux étoiles. Sa forêt de branches était une forêt de membres, de jambes, de bras, de torses, de ventres, qui suaient la sève; des chevelures de femmes pendaient; des têtes d'hommes faisaient éclater l'écorce, avec des rires de bourgeons naissant; tout en haut, les couples d'amants, pâmés au bord de leurs nids, emplissaient l'air de la musique de leur jouissance et de l'odeur de leur fécondité. ... L'arbre de vie venait de

crever le ciel. Et il dépassait les étoiles. L'abbé Mouret applaudit furieusement, comme un damné, à cette vision. L'église était vaincue. Dieu n'avait plus de maison. A présent, Dieu ne le gênerait plus. Il pouvait rejoindre Albine, puisqu'elle triomphait."

296. Letter 101 "... ook sprak hij [Laurillard] over 'de Begrafenis in het koren van v.d. Maaten. De zon scheen door de ramen, er waren niet heel veel menschen in de kerk..."

297. "De maan schijnt ook nu nog en de zon en de Avondster, dat is gelukkig en die spreken nog dikwijls van de Liefde Gods ..." (101a)

298. "Toen ik wegging van hier regende het en ook toen de kerk uitging; gedurende de preek echter had de zon helder door de ramen geschenen." (102)

299. Zola, *La Faute...* (note 276) 1979, Book I chapter 2, p.7, 8, 10: "L'église, vide, était toute blanche". "Derrière lui, la petite église restait blafarde des pâleurs de la matinée," "*Dominus vobiscum*, dit-il en se tournant, le regard noyé, en face des blancheurs froides de l'église."

300. "Geen wonder dat men aldaar verstokt en versteent, ik weet dat door eigen ervaring. En dus wat betreft uw onderhavige broeder, die wilde zich niet laten overdonderen, maar dat neemt niet weg dat hij een gevoel had van overdondering, een gevoel net alsof hij te lang tegen zoo'n kouden, harden, gewitten kerkmuur had gestaan ... Er bleef mij steeds een verkoeling in merg en been zitten n.l. in 't merg en been van mijn ziel, door den voornoemden denkbeeldigen of ondenkbeeldigen kerkmuur. En ik wilde door dat fatale gevoel mij niet laten overdonderen zei ik dan. Toen dacht ik bij mezelf: ik zou wel eens bij een vrouw willen zijn, ik kan niet leven zonder liefde, zonder vrouw ... die verdomde muur is mij te koud ..." (164)

301. "Nu moet men zorgen niet te vervallen in opaque zwart — in bepaalde slechtheid, en nog meer moet men 't wit als van een gewitten muur vermijden, dat de schijnheiligheid is en het eeuwige phariseïsme." (306)

302. "Tu dois savoir qu'avec les évangélistes cela est comme avec les artistes. Il y a une vieille école académique souvent exécrable, tyrannique, l'abomination de la désolation enfin, des

hommes ayant comme une cuirasse, une armure d'acier de préjugés et de conventions ... Leur Dieu c'est comme le dieu de l'ivrogne Falstaff de Shakespeare 'le dedans d'une église', 'the inside of a church'" (133)

303. For the hallucination scene see note 294, 295.

304. Meyer Schapiro, *Van Gogh*, New York 1950, p. 30f; S. Lövgren, op.cit. (note 137) pp. 172-191; Albert Boime, "Van Gogh's *Starry Night*: A history of matter and a matter of history," *Arts Magazine*, (Dec. 1984), pp. 86-103; Ch.A. Whitney, "The Starry Nights of Vincent van Gogh," (a paper read during Van Gogh symposium at the Metropolitan Museum in New York on 16 and 17 Nov. 1984); Ch.A. Whitney, "The skies of Vincent van Gogh," *Art History*, 9 (Sept. 1986) no.3, pp. 351-362; H.B. Werness, "Whitman and Van Gogh: Starry Nights and other similarities," *Walt Whitman Quarterly Review*, 2 (Spring 1985) no.4, pp. 35-41; J. Schwind, "Van Gogh's 'Starry Night' and Whitman: a study in source," *Walt Whitman Quarterly Review*, 3 (Summer 1985) pp. 1-15; S. Takashina, op.cit. (note 7) pp. 162-196; Lauren Soth, "Van Gogh's Agony," *Art Bulletin*, 68 (1986) no.2, pp. 301-313.

305. "...ce n'est pas un retour au romantique ou à des idées religieuses, non." (595)

306. R. Pickvance, ex.cat. cit. (note 129) p. 103.

307. Boime, op.cit. (note 304) p. 89, The following is the passage from Multatuli quoted by Boime; "The fanaticism which thought it a duty to place towers on edifices erected in honor of this or that saint did not last long enough to complete them, and the spire which is intended to point the faithful to heaven usually rests a couple of stages too low on its massive base, reminding one of the man without thighs at the fair. Only the *little towers*, the *little steeples* on village churches, have ever been completed." The text is from Chapter V of *Max Havelaar*. See letter 164. "En 't komt geloof ik niet bij haar op, dat God eigenlijk misschien pas begint, als we dat woord zeggen, waarmee Multaluli zijn Gebed van een Onwetende besluit: 'O God, daar is geen God'. Zie die God van de dominees, ik vind hem zoo dood als een pier.

Maar ben ik daarom een atheist? De dominees beschouwen me zoo — que soit — maar zie ik heb lief, en hoe zou ik liefde kunnen voelen als ik zelf niet leefde, en anderen niet leefden, en als we dan leven, daar is iets wonders in. Noem nu dat God, of de menschelijke natuur, of wat ge wilt, maar er is een zeker iets, dat ik niet definieeren kan in een systeem, ofschoon het erg levend en werkelijk is, en zie dat is nu God of net zoo goed als God." This is the same letter in which Van Gogh wrote about the white church wall (see note 300). Multatuli is mentioned only in this letter.

308. Letter 540 "J'ai pour la deuxième fois gratté une étude d'un Christ avec l'ange dans le jardin des oliviers. Parce qu'ici je vois oliviers vrais, mais je ne peux ou plutôt je ne veux pas non plus le peindre sans modèles, mais j'ai cela en tête avec de la couleur, la nuit étoilée, la figure du Christ bleue, les bleus les plus puissants, et l'ange jaune citron rompu."

309. Soth, op.cit. (note 304) p.312.

310. "Il voit dans l'avenir et même dans le présent, un monde de santé d'amour charnel large et franc — d'amitié — de travail avec le grand firmament étoilé quelque chose qu'en somme on ne sait appeler que Dieu et l'éternité remis en place au-dessus de ce monde." (W8)

311. "Cela n'empêche, que j'ai besoin terrible de — dirai-je le mot — de religion — alors je vais la nuit dehors pour peindre les étoiles, et je rêve toujours un tableau comme cela avec un groupe de figures vivantes des copains ... Victor Hugo dit: Dieu est un phare à l'éclipse, et alors certes maintenant nous passons par cet éclipse." (543)

312. "Des avonds is het ook een prachtig gezicht op de werf, waar dan alles doodstil is en de lantaarns branden, en de sterrenhemel er boven. 'When all sounds cease, God's voice is heard, under the stars'." (100)

313. "Lorsque pendant quelque temps tu auras vu ces deux études, ainsi que celle du lierre, mieux que par des paroles je pourrai peut-être te donner une idée des choses dont Gauguin, Bernard et moi avons quelquefois causé et qui nous ont préoccupé; ce n'est pas un retour au romantique ou à des idées religieuses, non. Ce-

pendant en passant par le Delacroix, davantage que cela paraisse, par la couleur et un dessin plus volontaire que l'exactitude trompe-l'œil, on exprimerait une nature de campagne plus pure que la banlieue, les cabarets de Paris ... Que cela existe ou n'existe pas nous le laissons de côté, mais nous croyons que la nature s'étend au delà de St. Ouen. Peut-être tout en lisant Zola, nous sommes émus par le sons du pur français de Renan par exemple." (595)

314. Pickvance, op.cit. (note 129) p. 101.

315. "Ah, comme Renan est dans le juste et quelle belle œuvre que la sienne de nous parler dans un français comme aucun autre ne le parle. Un français où il y a *dans le son des mots* le ciel bleu et le bruissement doux des oliviers et mille choses enfin *vraies* et *explicatives* qui font de son histoire une résurrection." (W11)

316. Ernest Renan, *Jésus*, Paris 1864, p. 148 & 167. "Il [Christ] dit pour la première fois le mot sur lequel reposera l'édifice de la religion éternelle. Il fonda *le culte pur*, sans date, sans patrie, celui que pratiqueront toutes les âmes élevées jusqu'à la fin des temps. Non-seulement sa religion, ce jour-là, fut la bonne religion de l'humanité, ce fut la religion absolue ... C'était *la religion pure*, sans pratiques, sans temple, sans prêtre; c'était le jugement moral du monde décerné à la conscience de l'homme juste et au bras du peuple." (my italics) These pages are copied by Van Gogh in an album of poetry in the collection of the Rijksmuseum Vincent van Gogh. Renan's *Jésus* is also in the library of the museum. See E. van Uitert & M.Hoyle (ed.), op.cit. (note 12) p. 80; Fieke Pabst (ed.), op.cit. (note 21) p. 26. See also letter 23, 26, 587, W11, 597 for Van Gogh's reading of Renan's books.

317. Letter 587 "Le Christ de Renan n'est-il pas mille fois plus consolant que tant de christs en papier mâché qu'on vous servira dans les établissements Duval appelés les églises protestantes, catholiques ou n'importe quoi?"

318. Joseph Warren Beach, op.cit. (note 17) p.5.

319. Letter 607 "Je suis étonné qu'avec les idées modernes que j'ai, moi si ardent admirateur de Zola et de Goncourt et des choses artistiques que je sens tellement, j'ai des crises

comme en aurait un superstitieux et qu'il me vient des idées religieuses embrouillées et atroces telles que jamais je n'en ai eu dans ma tête dans le nord." See also letter 605 "...mais ce qui me gêne c'est de voir à tout moment de ces bonnes femmes qui croient à la vierge de Lourdes..."

320. See R. Ripoll, op.cit. (1966 and 1981) (note 282) and Colette Becker, op.cit. (note 282). Aspects on solar mythology in English literature and painting are discussed in: J.B. Bullen, op.cit. (note 80).

321. Zola, *La Faute...*, Book II chapter 3, p.152 and Book II chapter 8, p.197 "Serge ne pouvait plus vivre sans le soleil," "Je veux que nous vivons au soleil, loin de cette ombre mortelle."

322. Zola, *Ebauche*, Bibliothèque Nationale, Paris, (Mss. n.a.Fr. 10294) p. 48. On the first line of the list "Un bois de Tournesol". In Book II, chapter 7; "Ils s'égarèrent au milieu d'un bois de tournesols..." Zola, *La Faute...* (note 276) p. 189.

323. For the traditional meaning of the heliotrope see for example A. Henkel & A. Schöne, op.cit. (note 150). For sunflowers see Chapter 2 "The Church versus the sun".

324. Letter 506 "Nous avons alors à nous deux exploré le vieux jardin, et y avons volé d'excellentes figues. Si c'eut été plus grand, cela fait penser au Paradou de Zola, de grands roseaux de la vigne, du lierre, des figuiers, des oliviers..."

325. "Ik heb een studie van een tuin van een meter breed, op den voorgrond klaprozen en andere roode bloemen in groen, dan een vak blauwe klokken. Dan een vak oranje en gele afrikanen, dan witte en gele bloemen, en eindelijk op den achtergrond rose en lila en nog scabioses, donker violet, en roode geraniums en zonnebloemen en een vijgeboom en laurier rose en een wingerd. Aan 't eind zwarte cypressen tegen lage witte huizen met oranje dak — en een fijn groen-blauwe strook lucht." (W5)

326. "Bonjour, monsieur le curé, lui dit un paysan qui passa. Des bruits de bêche, le long des pièces de terre, le sortaient encore de son recueillement ... *C'étaient des fronts suants* apparaissant derrière les buissons, des poitrines haletantes se redressant lentement..."

327. "Le vieux, à grands coups de bêche, creusait un trou, au pied d'un mûrier ... — Que faites-vous donc là? demanda le docteur Pascal. Jeanbernat se redressa de nouveau. Il essuyait *la sueur de son front* sur la manche de sa veste."

328. Quoted in: Zola, *Les Rougon-Macquart* (note 282) p. 1674-1675. Manuscript no.10.345 in the Département des Manuscrits, Bibliothèque Nationale, Paris. "Un roman qui aura pour cadre les fièvres religieuses du moment... Le produit est un prêtre. J'étudierai dans Lucien la grande lutte de la nature et de la religion. Le prêtre amoureux n'a jamais, selon moi, été étudié humainement. Il y a là un fort beau sujet de drame, surtout emplaçant le prêtre sous des influences héréditaires."

329. Manuscript no. n.a.Fr.10294, f.28, Bibliothèque Nationale.

330. For Zola and religion see: F.W.J. Hemmings, op.cit. (note 282) and Philip Walker, op.cit. (note 282)

331. Joseph Warren Beach, op.cit. (note 17). For the concept of nature see also the books mentioned in Introduction (note 17) and M.H. Abrams, *Natural supernaturalism, tradition and revolution in Romantic & literature*, New York & London 1971 and J.B. Bullen (ed.), op.cit. (note 80).

332. ibid. pp. 4-5.

333. Letter 371 "De *wetten* van de kleuren zijn onuitsprekelijk prachtig, juist omdat het *geen toevalligheden* zijn. Evenals men tegenwoordig niet meer in willekeurige *wonderen* gelooft, niet meer in een God die grillig en despotiek van den hak op den tak springt, doch juist voor de natuur meer respect en bewondering en geloof begint te krijgen..."

334. Beach, op.cit. (note 17) pp. 8-9.

335. "Je peux bien dans la vie et dans la peinture aussi me passer de bon Dieu, mais je ne puis pas, moi souffrant, me passer de quelque chose plus grand que moi, qui est ma vie, la puissance de créer." (531)

336. "Cela n'empêche, que j'ai un besoin terrible de — dirai-je le mot — de religion — alors

je vais la nuit dehors pour peindre les étoiles, et je rêve toujours un tableau comme cela avec un groupe de figures vivantes des copains." (543)

337. "Tu serais ainsi un des premiers ou le premier marchand apôtre." (544)

338. For the concept of the "noble savage" see: H.N. Fairchild, *The noble savage: a study in Romantic naturalism*, New York 1928. The words "wise, philosophic..." and "a single blade of grass" are from letter 542.

339. "...cela n'est-ce pas presque une vraie religion ce que nous enseignent ces Japonais si simples et qui vivent dans la nature comme si eux-même étaient des fleurs?" (542)

340. "Pourquoi n'adviendra-t-il pas ce qui est arrivé en Angleterre lors des Préraphaélites." (571)

341. Camille Flammarion, *Dieu dans la nature*, Paris 1867, p. VIII of the third edition (1871). "La première heure de notre siècle a sonné le dernier soupir de la religion de nos pères. En vain s'efforcera-t-on de restaurer et de reconstruire: ce ne sont plus maintenant que des simulachres; ce qui est mort ne saurait ressusciter."

342. "...en nu zegt die ruïne tot mij hoe en geloof en godsdienst vermolmde — al was ze hecht gegrondvest... Les religions passent, Dieu demeure, is een woord van Victor Hugo, die ze ook pas begraven hebben." (411)

Appendix I: Chronological tables

This appendix contains chronological tables of the frequency of occurrence of principal motifs in Van Gogh's œuvre. Most of the significant recurring motifs are included. The numbers and letters in the tables are from: Jan Hulsker, *Van Gogh en zijn weg*, Amsterdam 1978 (English edition, *The complete Van Gogh, paintings, drawings, sketches*, Oxford & New York 1980) with the exception of numbers preceded by F, J, SK or S. For these letters see "Abbreviations" below. The numbers under the year 1880 are of the works made in or before 1880.

Abbreviations

F: catalogue numbers of J.B. de la Faille, *The works of Vincent van Gogh*, Amsterdam 1970.
J: works listed in "Juvenilia" in the de la Faille catalogue
SK: sketchbooks listed in "Juvenilia"
L: letter numbers in *Verzamelde Brieven van Vincent van Gogh*, Amsterdam & Antwerp 1974. Used for sketches included in the letters.
S: catalogue numbers of J. van der Wolk, *De schetsboeken van Vincent van Gogh*, Amsterdam 1986. (S7/150 means sketchbook 7, page 150.)
r: recto
v: verso
*: redated works etc. (see notes under the table)
?: used when the identification of the motif is not certain.

List of tables		*List of tables in alphabetical order*	
1. plowman	19. one man	birds 25	oleander 15
2. sower	20. one woman	boat 27	olive tree 16
3. digger	21. two men	books 30	one man 19
4. reaper	22. two women	bridge 10	one woman 20
5. harvest	23. cattle	church 8	plowman 1
6. wheat field	24. horse	coach 26	reaper 4
7. weaver	25. birds	couple 18	self-portrait 36
8. church	26. coach	cattle 23	shoes 32
9. windmill	27. boat	cypress 17	sower 2
10. bridge	28. fruits	digger 3	stars 12
11. sun	29. French novels	empty chair 33	sun 11
12. stars	30. books	French novels 29	sunflower 14
13. moon	31. Japanese prints	fruits 28	two men 21
14. sunflower	32. shoes	harvest 5	two women 22
15. oleander	33. empty chair	hearth, stove 34	weaver 7
16. olive tree	34. hearth, stove	horse 24	wheat field 6
17. cypress	35. window	Japanese prints 31	windmill 9
18. couple	36. self-portrait	moon 13	window 35

1. *Plowman*

1880	1881	1882	1883	1884	1885	1886	1887	1888	1889	1890
	1		374	459				1374	F1512v	1882
	36			512				1502	1768	S7/107
	37			514				1586	1769	
								1587	1836	
								1596	1837	
									F1724v	

2. *Sower*

1880	1881	1882	1883	1884	1885	1886	1887	1888	1889	1890
	1	274	350	509		S2/60		1470	1836	1897
	5	275	374	556				1471	1837	1898
	17	276	392					1472		1899
	18	277						1508		1901
	25							1543		1902
	26							1596		1903
	27							1617		1916
	28							1627		1936
	31							1628		1937
	32							1629		1955
	33									1956
	36									
	37									
	44									
	53									

The most interesting observation from this table is the lack of this motif in 1885. Only two works are listed in the Nuenen period, when Van Gogh was certainly able to see sowers working in the field. See also the comments under "Reaper".

3. *Digger*

1880	1881	1882	1883	1884	1885	1886	1887	1888	1889	1890
D	29	114	337	513?	599	1031			1685	1889
	30	131	342		603	1032			1833	1890
	38	132	343		807	1184			1860	1905
	39	185	363		826	S2/11			1861	1906
	42	258	364		827					1909
	43	260	366		830					1911
	54	261	367		842					618*
	55	262	369		844					1913
			370		848					1915
			853**		849					1922
					850					1923
					851					1924
					852					1926
					859					1927
					860					1928
					874					1847**
					875					1929
					877					1934
					878					1935
					888					1947
					890					1948
					892					S7/13
					893					S7/108
					898					
					899					
					903					
					904					
					959					

*618; Stylistically it certainly belongs to the series of drawings made around March-April, 1890. Its pose is similar to the digger in 1911.
**853, 1847; see Chapter 5, notes 254 and 262.
Probably 513 should be seen as potato planting.

4. *Reaper*

1880	1881	1882	1883	1884	1885	1886	1887	1888	1889	1890
	2			508	854			1477	1744	1932
					856			1479	1753	1933
					857			1482	1754	2084
					858			1516	1773	2085?
					861			1529	1782	2086?
					862			1544	1783	2087?
					863				1792	2088?
					864					S7/93
					865					
					866					
					867					
					915					
					916					
					917					

The great number of works executed in the summer of 1885 is very striking. Before 1884 only two works are known. Since the reaper was well known as a symbol of death, we may be able to explain this finding in relation to the death of Van Gogh's father in March of 1885. This is still hypothetical, however, for the number of surviving works from 1884 is low. For this problem see Chapter 5. Interestingly, sowers, often depicted before 1884, are totally lacking in 1885. This contrast corresponds to the semantic contrast between these two motifs: sower and reaper as symbols of birth and death.
It is not certain if the figures in 2085, 2087, 2088 can be identified as reapers.

5. *Harvest: wheat field with sheaves, without reaper*

1880	1881	1882	1883	1884	1885	1886	1887	1888	1889	1890
					881			1438	1744	1943
					911			1439	1761	2085
					912			1440	1781	2087
					913			1441	1785	2088
					914			1442	1795	2098
					918			1478		2099
					919			1480		2100
								1481		2119
								1484		2121
								1501		2123
								1502		2125
								1514		
								1517		
								1525		
								1527		
								1530		
								1540		

6. *Wheat field: without specific activities*

1880	1881	1882	1883	1884	1885	1886	1887	1888	1889	1890
							1273	1417	1706	1980
							1274	1418	1721	2003
							1287	1473	1722	2018
								1474	1723	L643
								1475	1724	2034
								1476	1725	2038
								1483	1726	2039
								1515	1727	2053
								1546	1728	2054
									1755	2059
									1756	2097
									1757	2101
									1790	2102
									1862	2103
									1872	2117

This motif first occurs in 1887. No works are known from the Dutch period.

7. *Weaver*

1880	1881	1882	1883	1884	1885	1886	1887	1888	1889	1890
			437	442						
			439	443						
				444						
				445						
				448						
				449						
				450						
				451						
				452						
				453						
				454						
				455						
				456						
				457						
				462						
				471						
				478						
				479						
				480						
				481						
				482						
				483						
				489						
				499						
				500						
				501						
				502						
				503						

In contrast to the sower, digger or reaper, this motif never reappears in later works. This can be explained partly by the fact that Van Gogh had little opportunity to see looms outside of Nuenen, but above all by the character of the motif. The weaver is certainly not a motif like some of the sowers, diggers, or strolling lovers, which the painter could depict without models.

8. *Church*

1880	1881	1882	1883	1884	1885	1886	1887	1888	1889	1890
L32	E	97	363	446	598	1096		1473	1731	2006
JXVIII	5	98	370	447	600	1098		1474	1732	2104
JXV	36	120	413	449	604	1101		1477	1835	2105
JXIX	37	151	423	452	606	1102		1490	2124*	2106
JXXV	42	152	426	458	761			1497a		2122
L82	58	157	427	459	767			1507		2123
		158	428	468	770			1516		
		160	431	476	771			1529		
		161	432	481	772			1544		
		162	433	484	774			1546		
		163	435	485	917			1592		
		167	436	490	954			1593		
		175		500	955			1594		
		178		507	959					
		190		508	960					
		253		509	965					
				521	974					

All examples of the church motif are included in this table, including church towers which are depicted only as a part of the silhouette of a city in the distance and which do not occupy a prominent place in the composition. If such cases are excluded, most of the entries for 1886 and 1888 disappear from the table. For the significance of this distinction, see Table in Chapter 2.

*Redated to 1889. See J. Rewald, *Post-Impressionism*, London 1978, p. 339.

9. *Windmill*

1880	1881	1882	1883	1884	1885	1886	1887	1888	1889	1890
JXVI	6	118	383	503	897	1053	1221	1473	1794	1943
L123	15	136			909	1115	1222	1474		
	59	164			911	1116	1240	1496		
		165			913	1170	1241	1497		
					915	1171	1244	1544		
					918	1172	1245	1546		
					919	1173				
					947	1174				
					965	1175				
						1176				
						1177				
						1181				
						1182				
						1184				
						1185				
						1186				
						1188				
						S6/28				
						S6/29				
						S6/31				
						S6/63				
						S6/77				

Combined with harvest scenes (913, 915 etc.), lovers (1182, 1188, 1240 etc.), a digger (1184) and a plowman (1794), it certainly is a significant motif. The windmill in *Enclosed field with plowman* (1794) is an imaginary motif. See, R. Pickvance, ex.cat. *Van Gogh in Saint-Rémy and Auvers*, New York (Metropolitan Museum of Art), 1986-87, p.125

10. *Bridge*

1880	1881	1882	1883	1884	1885	1886	1887	1888	1889	1890
JIIr		99	342		944	1109	1268	1367		2022
		L170	343		947		1270	1368		2023
		115	386				1297	1370		S7/71
		116	405				1321	1371		S7/130?
		121	408				1322	1377		
		156	415				1323	1382		
			416				1324	1392		
			425				1325	1405		
							1326	1420		
							1327	1421		
								1468		
								1469		
								1490		
								1507		
								1556		
								1557		
								1558		
								1570		
								1571		
								1603		
								1604		

This category contains all kinds of bridges, including tiny bridges as in 99, 342 and even a wooden plank between a boat and a river bank in 415, 416, 1556, 1557, 1558, 1570, 1571. It is worth noting that this motif was depicted very often in 1887 and 1888, especially between the summer of 1887 and October of 1888. (29 works are listed) Even if the works with wooden planks are excluded, 22 remain in this short period of about 15 months. Interestingly, Van Gogh suddenly ceased to employ this motif in October, 1888, and after that there are only four works from 1890. The last work dating from 1888 is *The Trinquetaille Bridge* (1604) completed around October 10th. The sudden disappearance of this motif may be related to Gauguin's arrival on the 23rd of October. Since no significant reference to this motif can be found in Van Gogh's letters, it is difficult to give a convincing explanation. Since the motif also occurs often during the Drenthe period (Sept.-Nov.1883, 5 works in 2 months), when Van Gogh was persuading Theo to become a painter and to work with him, it might be related to his ideal of collaboration.

11. *The Sun*

1880	1881	1882	1883	1884	1885	1886	1887	1888	1889	1890
		177		467	762		1223	1369	1706	1900
				518			1291	1370	1728	1919
							1308	1375	1753	1920
							F1375	1446	1754	1923
								1450	1768	1972
								1470	1769	
								1471	1773	
								1472	1792	
								1473	1836	
								1474	1837	
								1490	1843	
								1497a	1856	
								1507	1862	
								1508	1863	
								1531		
								1543		
								1546		
								1597		
								1626		
								1627		
								1628		
								1629		

Together with the moon and the stars, the sun is a motif typical of the Arles and Saint-Rémy periods. See Chapter 2.

12. *Stars*

1880	1881	1882	1883	1884	1885	1886	1887	1888	1889	1890
								1574	1731	1982
								1588	1732	1983
								1592		2031
								1593		
								1594		

13. *Moon*

1880	1881	1882	1883	1884	1885	1886	1887	1888	1889	1890
L126								1588	1731	1981
								1615	1732	1982
								1616	1746	1983
									1747	
									1750	
									1761	

14. *Sunflower*

1880	1881	1882	1883	1884	1885	1886	1887	1888	1889	1890
						1115	1305	1510	1666	2109
						1166	1306	1511	1667	2114
							1307	1559	1668	S7/90
							1308	1560	1766	S7/91
							1329	1561		
							1330	1562		
							1331			

8 works are listed in 1889 and 1890, but five of them are repetitions of the works from 1888, and in the remaining three works the motif is depicted only as a very small detail. One of the typical utopian motifs. See Chapters 2 and 6.

15. *Oleander*

1880	1881	1882	1883	1884	1885	1886	1887	1888	1889	1890
							1311?	1499	1687	
								1500	1688	
								1509	1707?	
								1510		
								1511		
								1512		
								1513		
								1519		
								1520		
								1534		
								1545		
								1566		
								1567		
								1578		
								1583		
								1584		

The absence of this motif before 1887 and in 1890 can be explained by the fact that the oleander is a plant typical of the South of France, but judging by the great number of works in 1888 and also taking into account the connotations of this plant, it can be regarded as one of the utopian motifs. See Chapter 3.

16. *Olive tree*

1880	1881	1882	1883	1884	1885	1886	1887	1888	1889	1890
									1740	1981
									1741	
									1755	
									1756	
									1757	
									1758	
									1759	
									1760	
									1766	
									1791	
									1853	
									1854	
									1855	
									1856	
									1857	
									1858	
									1859	
									1867	
									1868	
									1869	
									1870	
									1873	
									1878	
									S7/5	

Although difficult to identify, there may be some olive trees in the series of drawings made in Montmajour between May and July of 1888. In the same year *Christ with the angel in the garden of olives* was painted, but destroyed by the painter himself. (See letter 505 and 540.) Thus one cannot say that olive trees were not depicted in 1888. Nevertheless, since Van Gogh could certainly see olive groves during his Arles period (see for example letter 540), the great difference between the Arles and Saint-Rémy periods requires an explanation. This tree must have been bound up with the biblical subject "Christ in the garden of olives" in Van Gogh's mind. See Chapter 3 and Chapter 6.

17. *Cypress*

1880	1881	1882	1883	1884	1885	1886	1887	1888	1889	1890
								1372	1664	1887
								1377	1725	1888
								1388	1726	1889
								1389	1730	1890
								1390	1731	1906
								1396	1732	1924
								1398	1746	1948
								1402	1747	1969
								1420	1748	1981
								1421	1749	1982
								1422	1750	1983
								1476	1755	2078
								1480	1756	
								1484	1757	
								1491	1790	
								1512	1797	
								1513	1800	
								1515	1801	
								1517	1873	
								1530		
								1531		
								1532		
								1583		
								1586		
								1587		
								1596		
								1615		
								1616		
								1618		
								1619		
								1627		
								1629		
								1630		
								1631		

F639 (no JH number) is not included, because its authenticity is doubtful. Although the number of works in 1888 surpasses that of 1889, cypresses are not a significant motif in the works from 1888, except for no.1615. In 1888 cypresses are depicted as a minor detail in the background. As an important element in the composition, this motif is typical for the Saint-Rémy period. No.1664, *Still life with oranges, lemons, blue gloves and branches of cypress*, painted in January, 1889, is quite interesting in its combination of motifs. A basket of fruit is one of the typical utopian motifs which occur in the late Paris period, the early Arles period and again in January, 1889, after the first attack of illness. (See table 28 "Fruits", 31 "Japanese prints")

18. *Couple: man & woman*

1880	1881	1882	1883	1884	1885	1886	1887	1888	1889	1890
		230	432		954	1027	1240	1369	1689	1943
		233	433		955	1028	1258	1370		1981
		247	435		964	1029	1280	1377		2041
		248			965	1112	1281	1473		2042
						1177	1287	1474		
						1179	1291	1501		
						1182	1308	1546		
						1183	F1375	1577		
						1188		1583		
								1592		
								1593		
								1594		
								1601		
								1602		
								1614		
								1615		
								1616		
								1621		
								1622		

Strolling couples in a crowd are excluded. This motif is often combined with a church, a windmill, the sun, moon or starry sky in the background. Roughly speaking, it is most often combined with a church in the Dutch period, with windmills around 1885-86, and then with the sun, moon or starry sky. This transformation might be understood from the same context as the phenomenon of "substitution" discussed in Chapter 2. It seems that the windmill occupied a mediating place in the process of the substitution of the sun for the church.

Combination of a couple with a church, a windmill and the sun, moon or stars.

a couple with:	until 1885	1886	1887-88	1889-90
church	7	0	1 (7)*	0
windmill	1	5	0 (3)**	1
the sun, moon, stars	0	0	11	1

*As noted in Chapter 2 (table), it is difficult to determine whether the small church towers in the silhouette of Arles can be grouped in the category of "church", since the motif, when depicted as a part of Arles, could have totally different — and positive — layers of meaning. If these works are included (in this table 1473, 1474, 1546, 1592, 1593, 1594), the number of works in 1887-88 rises from 1 to 7 and it alters the results of the table considerably. (The remaining entry is 1622, one of the series of *Les Alyscamps*.) It should be noted however that in all of these six works the sun or the starry sky is depicted above the silhouette of Arles.
**Windmills which are only details of the silhouette of Arles are also depicted with strolling couples (1473, 1474, 1546). The frequent combinations of a windmill with a strolling couple can be partially explained by the fact that Van Gogh very often worked in Montmartre, where in his day many windmills and strolling people could be seen, but this does not fully explain the results of the table. It seems that the windmill motif occupied an mediating place in the process of the substitution of the sun for the church, since it often occupies the place where a church or the sun was otherwise depicted. Compare, for example, 915, 917 & 1773; 36, 1794 & 1768; 435, 965, 1240, 1370 & 1473. Not only chronologically but also in its character, the windmill takes a place between the church and the sun, between man-made and natural. A windmill is also man-made but functions thanks to the power of nature. Due to this duplicity, the windmill was used in some emblem books. See for example Zacharias Heyns, *Emblemata*, Rotterdam 1625.

19. *One man: in landscape*

1880	1881	1882	1883	1884	1885	1886	1887	1888	1889	1890
L141	3	97	382	464	602	1176	1254	1360	1767	1919
	4	100		477	604	1186	1260	1491	1808	1992
	12	121			638		1288	1492	1840	2080
	58	124			761			1555	1841	2081
		163			954				1844	
		164			955				1845	
		165							1846	
		166							1849	
		177							1850	
									1851	
									1875	

20. *One woman in landscape*

1880	1881	1882	1883	1884	1885	1886	1887	1888	1889	1890
		146	418	466	761	1114	1255	1444	1843	1989
		179	419	470	805		1259	1447		2005
		180	425	484	808		1262	1550		2006
		182	426	485	956		1307	1613		2078
		183		490	962					S7/86
		270		507						2104
				518						2105
				519						2106
				522						

In 1884 often combined with a church tower. For this combination see Chapter 3.

21. *Two men*

1880	1881	1882	1883	1884	1885	1886	1887	1888	1889	1890
L123		186			958	1023	1218	1502	1849	1910
					966	1181	1266		1850	1913
						1183	1297		1851	1916
						S3/3				1945
										1946
										1968
										1969
										1982
										1983
										2115

22. *Two women*

1880	1881	1882	1883	1884	1885	1886	1887	1888	1889	1890
		148		458	674	1019	1217	1582	1748	1887
					959	1022	1265	1583	1804	1888
					960	1113	1283	1584	1861	2110
					977			1591	1871	2111
								1630	S7/6	2112
								1631		

23. *Cattle*

1880	1881	1882	1883	1884	1885	1886	1887	1888	1889	1890
J1	1		388	504					1836	1881
			389	505					1837	2023
				511						2064
				512						2095
				514						S7/69

24. *Horse*

1880	1881	1882	1883	1884	1885	1886	1887	1888	1889	1890
SKII	36	192	368		883	1082		1368	1768	1880
	37	193	405					1373	1769	1941
	52	227	422					1374	1794	1969
			424					1382	1835	1974
								1392		1982
								1439		1983
								1440		2061
								1496		2062
								1497a		2073
								1502		2074
								1527		2084
								1540		2089
								1554		2090
								1586		F1724v
								1587		S7/141
								1596		S7/145
								1626		S7/146
										S7/147
										S7/149
										S7/150
										S7/151
										S7/152
										S7/153
										S7/154

The great number in 1888 and 1890 is striking. (In 192 and 1880 donkeys, not horses, are depicted.)

25. *Birds, flying (not in still lifes)*

1880	1881	1882	1883	1884	1885	1886	1887	1888	1889	1890
JXIIIr	1	97	342	490	715	1179	1274	1451	1682	1882
JXVI	2	115	343	505	730	1184	1350	1470	1782	1884
L121	3	118	366	508	770		1351	1495	1836	2095
	4	124	381	509	772			1497a	1837	2096
	12	125	416	511	913			1503	1847	2099
	15	138	428	556	918			1514		2100
	26	146	431		949			1518		2117
	27	150						1539		2119
	28	152								2121
	31	154								
	32	156								
	36	157								
	37	166								
	52	205								
	58	229								
	59	247								
		248								
		253								
		274								

26. *Coach*

1880	1881	1882	1883	1884	1885	1886	1887	1888	1889	1890
JSKII							1284	1368		1969
								1382		1982
								1392		1983
								1439		2019
								1440		2062
								1502		2089
								1554		2090
								1605		S7/125
								1606		S7/149

27. *Boat*

1880	1881	1882	1883	1884	1885	1886	1887	1888	1889	1890
		166	381		973	1109	1257	1367		2021
		173	415				1268	1368		S7/106
		174	416				1270	1382		
		187	424				1271	1392		
		205					1275	1404		
		227					1276	1452		
		247					1297	1453		
		248					1325	1455		
							1326	1458		
							1327	1459		
								1460		
								1461		
								1464		
								1468		
								1469		
								1497a		
								1505		
								1526		
								1528		
								1541		
								1542		
								1556		
								1557		
								1558		
								1570		
								1571		
								1592		
								1593		
								1594		

28. *Fruit: in a basket*

1880	1881	1882	1883	1884	1885	1886	1887	1888	1889	1890
	82*				926		1237	1363	1664	
					927		1239	1424		
					928		1337	1425		
					930		1339	1426		
					935		1340	1427		
					936		1341	1428		
							1342			
							1343			

One of the typical utopian themes, occuring almost exclusively between 1887 and January of 1889. Oranges and lemons occur exclusively in 1887 and 1888. Since these motifs must have been available almost everywhere, the absence of them before 1886 and after January 1889 is very remarkable. Many of the works from 1887 to 1889 are signed; two of them have dedications, one to Theo (1339) and one to Lucien Pissarro (1340); the one for Theo has an original painted frame by Van Gogh. Unfortunately, very few references to this motif can be found in Van Gogh's letters.
* The authenticity of 82 seems doubtful for stylistic reasons.

29. *French novels: yellow books*

1880	1881	1882	1883	1884	1885	1886	1887	1888	1889	1890
					946		1226	1362		2007
							1332	1566		
							1349	1612		
								1632		
								1633		
								1636		

For this motif see Chapter 3.

30. *Books: including French novels*

1880	1881	1882	1883	1884	1885	1886	1887	1888	1889	1890
	63	225			946		1226	1362	1656	1892
		226					1332	1566		1893
		278					1349	1612		1894
		279						1624		1895
		280						1632		1896
		359						1633		2007
								1636		

31. *Japanese prints*

1880	1881	1882	1883	1884	1885	1886	1887	1888	1889	1890
							1296	1350*	1657*	
							1297	1351		
							1298	1352		

*1350, 1351 and 1352 are dated in the winter of 1887-1888. 1657 is from January, 1889. See Chapter 4.

32. *Shoes*

1880	1881	1882	1883	1884	1885	1886	1887	1888	1889	1890
	81					1124	1233	1364		1955
	89						1234	1569		
							1235			
							1236			

33. *Empty chair & bench*

1880	1881	1882	1883	1884	1885	1886	1887	1888	1889	1890
	9	199		441	699		1208	1410	1686	1963
	65				700		1218	1412	1693	1964
					791			1585	1694	1965
					792			1608	1698	1966
								1609	1705	2104
								1610	1711	2105
								1611	1771	2106
								1635	1793	
								1636	1841	
									1842	
									1849	
									1850	
									1851	

When many chairs are depicted in cafe or restaurant scenes, they are excluded. For the pictorial sources of this motif, see letter 252 and R. Pickvance, *English Influences on Vincent van Gogh*, London etc. 1974-75, p.24.

34. *Hearth, stove*

1880	1881	1882	1883	1884	1885	1886	1887	1888	1889	1890
	L140	91		441	700				1686	1961
	34	95			701				1805	1962
	35	96			789				1834	1963
	51	139			790					1964
	64	140			791					1967
	65	141			792					
	74	143			796					
	80	155			797					
		267			798					
		268			799					
					894					
					895					
					896					

35. *Window*

1880	1881	1882	1883	1884	1885	1886	1887	1888	1889	1890
JSKII	23	90	L268	441	699		1218	1359	1704	1954
	68	94	339	449	700		1238	1608	1771	1957
	69			452	702			1609	1793	1960
	70			462	703			1610	1806	1961
	71			478	705			1611	1807	
				481	706					
				482	707					
				486	708					
				487	709					
				493	710					
				494	711					
				495	712					
				496	713					
				500	714					
				501	715					
				502	716					
				503	717					
					718					
					719					
					720					
					775					
					776					

36. *Self-portrait*

1880	1881	1882	1883	1884	1885	1886	1887	1888	1889	1890
						1089	1199	1344*	1657	
						1090	1209	1345	1658	
						1194	1210	1353	1665	
						1195	1211	1354	1770	
						1196	1224	1356	1771	
						1197	1225	1581	1772	
						1198	1248	1634	1780	
							1249		1793	
							1299			
							1300			
							1301			
							1302			
							1303			
							1304			
							1309			
							1310			
							1331*			
							1333			
							1334			

*nos.1344-1356 are from the winter of 1887-1888. No.1331 is a portrait of a man, probably a self-portrait, discovered by X-ray underneath the sunflowers. (See *Berner Kunstmittelungen* no.258-259 Nov. 1987-Jan. 1988.) In 1771 and 1793, two replicas of *Vincent's bedroom in Arles*, there are self-portraits hanging on the wall (respectively 1772 and 1665).

Appendix II: Zionskapel in the Barndesteeg: Van Gogh as a Sunday school teacher

At the beginning of 1878 Van Gogh, who was rapidly losing his interest in and his will to continue his studies for the ministry, began to work at the Sunday school of Rev. Adler in the Barndesteeg in Amsterdam, one of the poorest areas in the city. In his letters from the Amsterdam period Van Gogh mentions having met some other preachers such as Rev. MacFarlane of the English Church at the Begijnhof and a certain French clergyman called Gagnebin, but it seems that Van Gogh had the closest contact with Rev. Adler. The name of this preacher appears twice in Van Gogh's letters. In letter 119, written on 18 February, 1878, Van Gogh first mentioned Adler and his Sunday school. "At one o'clock I had to be at the Sunday school of an English clergyman, Adler, in the Barndesteeg; he has a small but very neat old church there. However, the school was held in a little room where even at that hour, in the middle of the day, the gaslight had to be turned on. There were perhaps twenty children from that poor section. Though he is a foreigner, he preaches in Dutch (but the service is in English); he teaches his Bible class in Dutch too, and does it very well. I had brought with me a sketch of the map of the Holy Land which I made for Father's birthday, in red crayon and on strong brown paper, and I gave it to him; I thought that little room would be a nice place for it, and I am glad it hangs on the wall there now. I had met him at Mr. McFarlane's, the incumbent of the English church in the Beguinage [Begijnhof] whom I had ventured to call on..."[1]

According to the description in the auction catalogue of his library, A.C. Adler (? — 1907, fig.117) had been teaching classical languages in Heidelberg for about 35 years before he became a preacher at the Zionskapel of the English Church (Engelsche Episcopale Zionskapel)[2] (fig.118,119). The exterior and interior of the Zionskapel can be seen in the photographs of H.M.J. Misset's drawings, now in the Gemeentearchief in Amsterdam, but we have no further information on Adler himself or on the Sunday school. Judging from obituaries and other sources, Adler was active in the Jewish community. The Zionskapel itself was built in 1846 by the British Society for Promoting Christianity amongst the Jews, a department of the Church of England.[3]

From the correspondence between Theo and his parents, which has been partly published by Hulsker, we know more about how worried about and disappointed his

parents were about Vincent's going to work at the Sunday school.[4] On 2 March, his mother wrote to Theo that Vincent did not want to continue his studies for the University but wanted a job (as a teacher) in the church. Two letters written by Rev. Van Gogh to Theo at the beginning of April show that the father was trying to persuade Vincent to leave his job, but his son wished to continue with it.

In a letter dated 3 April, Van Gogh wrote, "The light in the little Sunday-school room in Barndesteeg is only small, but let me keep it burning. For that matter, if I should not, I do not think Adler is the man to let it go out."[5] It seems that Van Gogh was thinking of the possibility of leaving his job at the Sunday school, but after this letter neither the Sunday school nor Adler is mentioned again. It is not clear, therefore, when he left the school. In July, 1878, Van Gogh left Amsterdam, and in August he went to the Borinage to become an evangelist.

Notes

1. Letter 119 "Daarna moest ik om 1 uur in een zondagschool zijn van een Engelsch predikant Adler, in de Barndesteeg, hij heeft daar een klein maar zeer net oud kerkje. De school werd echter gehouden in een klein kamertje, waar ook op dat uur, dus midden op den dag, het licht moest worden aangestoken. Er waren misschien een 20 kinderen uit die arme buurt. Hoewel hij een vreemdeling is, zoo preekt hij toch in 't Hollandsch (maar de Engelsche dienst) en doet zijn catechisaties ook in 't Hollandsch, maar zeer aardig en handig; had de schets van die kaart van het Heilige Land, die ik voor Pa's verjaardag maakte, met rood krijt en op stevig bruin papier, meegenomen en gaf hem die, want ik vond dat kamerje er een aardig plekje voor en ben blij zij daar aan den muur hangt. Had hem bij Mr. MacFarlane ontmoet, de dominee van dat Engelsche kerkje op het Begijnhof, waar ik het had gewaagd een bezoek te brengen..."

2. On the Engelsche Episcopale Zionskapel and A.C. Adler see the following literature. Writings by Adler: *De messias als profeet, eene lezing in hoofdzaak gehouden voor Joden en Christenen, in de Zion's kapel, Amsterdam*, Rotterdam ca. 1900; *Wat hebben wij van de offeranden der wet van Mozes te denken?*, Rotterdam 1901; *Lezing voor Joden en Christenen te Amsterdam gehouden*, Amsterdam ca. 1928. J. Loosjes, *History of Christ Church (English Episcopal Church)*, Amsterdam 1932, p. 48. H.J.M. Roetemeijer, "De Bruininsten in

Amsterdam," *Ons Amsterdam* 21 (July 1969) no.7, pp. 194-201. *Amstelodamum*, (monthly) 9 (1922) p. 75: "...En dan was er in de Barndesteeg de Episcopale Zionskapel. Voor ruim vijftig jaar heette die kerk 'de man in het hemd', naar het witte kleed, dat de voorganger droeg." (A.J. Drews). *Catalogus van de zeer belangrijke en kostbare bibliotheken nagelaten door wijlen de Heeren Dr. A.C. Adler, ongeveer 35 jaar Leeraar in de Klassieke Talen te Heidelberg, en later Predikant der Engelsche Episcopale Zionskapel, te Amsterdam....*, Amsterdam 1908 (auction catalogue). Obituaries of Adler in: *De Spiegel, weekillustratie voor het christelijk gezin*, 1 (28 Sept. 1907) no.52, pp. 410-411; *De Week, geïllustreerd*, 6 (28 Sept. 1907) no.26, p. 408. The Zionskapel was sold in 1911. A poster for this auction is in the Gemeentearchief in Amsterdam (O 934.063).

3. See Roetemeijer, op.cit. (note 2) p. 200. At the Gemeentearchief in Amsterdam, the Stadtarchiv, Universitäts Bibliothek and also the Ruprechts-Karls-Universität in Heidelberg, no archives or manuscripts concerning A.C. Adler could be found.

4. Jan Hulsker, op.cit. (note 21) pp. 107-110.

5. Letter 121 "'t Is maar een heel klein lichtje, dat in het kamertje van de Zondagschool in de Barndesteeg, laat mij het brandende houden; trouwens als ik het niet doe geloof ik niet dat Adler een man is die het zou laten uitgaan."

Selected bibliography

1. Van Gogh and religion

Bruxner, David, "Van Gogh's sermons," *Country Life* (Nov. 11, 1976) pp. 1426-8.

Fowlie, W., "The religious experience of Van Gogh," in: *College art journal*, 9 (1950) no.3, pp.317-324.

Hemert, G. van, "Evangelie-dienaar?" *De heraut* (1972) no.9, pp.247-259.

Hartlaub, G.F., *Kunst und Religion, Ein Versuch über die Möglichkeit neuer religiöser Kunst,* Leipzig, 1919.

Honegger, H.C., *The religious significance of Vincent van Gogh 1853-1890,* (original manuscript dated July 29, 1940) Newtown BEE etc. 1941.

Jansen, J.G.B., "De barmhartige samaritaan uitgebeeld door Rembrandt en Vincent van Gogh," in: J.G.B. Jansen, *Barmhartige Samaritaan in rovers handen,* Apeldoorn 1974, pp.185-194.

Lawrence, G.E., *It will go on: the faith and works of Vincent van Gogh*, Pillowell 1976.

Lawrence, G.E., *The methodism of Vincent van Gogh*, Pillowell 1979.

Meier-Graefe, J., *Vincent van Gogh, Der Roman eines Gottsuchers*, Berlin & Vienna 1932.

Miedema, R., *Vincent van Gogh en het evangelie*, Amsterdam 1950.

Murray, A.H., "The religious background of Vincent van Gogh and its relation to his views on nature and art," *Journal of the American Academy of Religion*, 44 (1978, March) 1, pp.68-96.

Nizon, Paul, "Van Gogh's Kopien unter dem Zeichen religiöser Malerei," *Du*, (May 1961), p.8.

Noël-Emile Laurent, Menton, *Vincent van Gogh en religion* (typescript), Saint Vincent de la Folie de la Croix, 1962.

Nouwen, H.J.M., "Compassion: solidarity, consolation and comfort; Vincent van Gogh's painting and his letters to Theo reveal an evangelical dedication to sympathy that was itself a vocation, It was a contemplative's calling rather than an activist's", *America*, 134 (1976) no.10, pp.195-200.

Secrétan-Rollier, "Looking through Vincent's book of psalms," *Vincent* 2 (1972/73) no.4, pp.21-24.

Stellingwerff, J., "Vincent Willem van Gogh als domineeszoon," in: *Aksent, maandblad protestants geestelijke verzorging Nederlands krijgsmacht*, 1963, no.1.

Tralbaut, M.E., "Over de godsdienstige richtingen in Vincent's tijd," in: M.E. Tralbaut, *Van Goghiana VII*, Antwerp 1970, p.103-108.

———, "Over een predikthema van Vincent van Gogh," in: M.E. Tralbaut, *Van Goghiana VI*, Antwerp 1968, pp.111-117.

———, "Vincent van Gogh und die Religion", in: M.E. Tralbaut, *Van Goghiana III*, Antwerp 1966.

Tyabij, Badr-ud-din, "Van Gogh as a modern prophet", in: Tyabij, Badr-ud-din, *Chaff and grain; essays*, Bombay 1962, p.14-20.

Verkade-Bruining, A., "Vincent's plans to become a clergyman," *Vincent*, 3 (1974) no.4, pp.14-23.

———, "Vincent's plans to become a clergyman (2)," *Vincent*, 4 (1975) no.1, pp.9-13.

2. Van Gogh

Arikawa, H., "La Berceuse: an interpretation of Vincent van Gogh's portraits," *Annual bulletin of the National Museum of Western Art*, Tokyo, 15 (1981) pp.31-75.

Arnold, Matthias, "Stilleben mit Büchern, Vom Vanitas-Motiv zur symbolischen Sebstdarstellung," *Kunst & Antiquitäten*, 5 (1985) pp. 18-30.

Aurier, G.-Albert, "Les isolés, Vincent van Gogh," *Mercure de France*, (Jan. 1890) pp.24-29.

Beaubourg, Maurice, "Beaux-Arts, les indépendents: la mort de Dubois-Pillet et de Vincent van Gogh," *Revue Indépendente*, (Sept. 1890), pp.391-402.

Boime, Albert, "Van Gogh's *Starry Night*: a history of matter and a matter of history," *Arts Magazine*, (Dec.1984) pp.86-103.

Bonnat, Jean-Louis, "Les adresses d'un tableau: 'la Berceuse' (V. van Gogh)," *Psychoanalyse à l'Université*, 12 (July, 1987) pp.373-416.

Chetham, Ch., *The role of Vincent van Gogh's copies in the development of his art*, New York 1976.

Clébert, J.P. & Richard, P., *La Provence de Van Gogh*, Aix-en-Provence 1981.

Cooper, Douglas, "Two Japanese prints from Vincent van Gogh's collection," *Burlington Magazine*, (June 1957), pp.204-7.

————— (ed.), *Paul Gauguin : 45 lettres à Vincent, Theo et Jo van Gogh*, The Hague & Paris 1983.

Dorn, Roland, *Décoration, Vincent van Goghs Werkreihe für das Gelbe Haus in Arles*, (diss. Johannes Gutenberg-Universität) Mainz 1985.

Faille, J.B. de la, *The works of Vincent van Gogh*, Amsterdam 1970.

Feilchenfeldt, W., *Vincent van Gogh & Paul Cassirer; Berlin*, (Cahier Vincent 2, Rijksmuseum Vincent van Gogh), Zwolle 1988.

Gogh, Vincent van, *Lettres de Vincent van Gogh à Emile Bernard*, Paris 1911.

—————, *Verzamelde Brieven van Vincent van Gogh*, Amsterdam & Antwerp 1974.

—————, *The complete letters of Vincent van Gogh*, 3 vols., London & New York 1958, 1978.

Graetz, H.P., *The symbolic language of Vincent van Gogh*, New York 1963.

Hammacher, A.M., "Van Gogh-Michelet-Zola," *Vincent*, 4 (1975) no.3, pp.2-21.

—————, A.M. & R., *Van Gogh, a documentary biography*, London 1982.

Hoffman, Konrad, "Zu Van Goghs Sonnenblumenbildern," *Zeitschrift für Kunstgeschichte*, 31 (1968) no.1, pp.27-58.

House, John, "In detail: Van Gogh's The Poet Garden, Arles," Portfolio, (Sept.-Oct. 1980) pp.28-33.

Hulsker, Jan, *Van Gogh door Van Gogh*, Amsterdam 1973.

—————, *Van Gogh en zijn weg, Al zijn tekeningen en schilderijen in hun samenhang en ontwikkeling*, Amsterdam 1978 (English edition: *The complete Van Gogh, paintings, drawings, sketches*, Oxford & New York 1980.)

—————, "The Poet's Garden," *Vincent*, 3 (1974) no.1, pp.22-32.

————, *Lotgenoten, het leven van Vincent en Theo van Gogh*, Weesp 1985.

————, "Book reviews: B. Welsh-Ovcharov, *Van Gogh à Paris*, R. Pickvance, *Van Gogh in Arles, Van Gogh in Saint-Rémy and Auvers*, A. Mothe, *Vincent van Gogh à Auvers-sur-Oise*", *Simiolus*, 18 (1988) no.3, pp.177-192.

Japanese prints collected by Vincent van Gogh, ex.cat., Amsterdam (Rijksmuseum Vincent van Gogh) 1978.

Jaspers, Karl, *Strindberg und Van Gogh, Versuch der pathographischen Analyse under vergleichende Heranziehung von Swedenborg und Hölderlin*, Munich 1949 (ed.princ.in 1926).

Jirat-Wasiutyński, V., H. Travers Newton et al., *Vincent van Gogh's Self-portrait dedicated to Paul Gauguin, an historical and technical study*, Center for Conservation and Technical Studies, Harvard University Art Museums, Cambridge, Massachusetts, 1984.

Johnson, R., "Vincent van Gogh and the vernacular: his southern accent," *Arts Magazine*, 52 (June 1978) pp.131-35.

————, "Vincent van Gogh and the vernacular: the poet's garden," *Arts Magazine*, 53 (Feb. 1979) pp.98-104.

Karagheusian, A., *Vincent van Gogh's letters written in French: differences between the printed versions and the manuscripts*, New York 1984.

Kōdera, Tsukasa, "Japan as primitivistic utopia: Van Gogh's *japonisme* portraits," *Simiolus*, 14 (1984) no.3-4, pp.189-208.

————, "Van Gogh and the Dutch theological culture of the nineteenth century," in: *Vincent van Gogh, International symposium*, Tokyo 1988, pp.141-170.

————, ex.cat. *Vincent van Gogh from Dutch collections: religion — humanity — nature*, Osaka (The National Museum of Art) 1986.

————, "Zur Herkunft des Gemäldes," (about *Sunflowers* F376) *Berner Kunstmittelungen*, 258/259 (Nov. 1987-Jan. 1988) pp.9-10.

————, "'In het zweet uws aanschijns': spitters in Van Goghs œuvre," in: ex.cat. *Van Gogh in Brabant*, 's-Hertogenbosch (Noordbrabants Museum) 1987-88, pp.59-71 in English version of the catalogue: "'In the sweat of thy face'. Diggers in Van Goghs œuvre,")

Leymarie, Jean, *Qui était Van Gogh?*, Geneve 1969.

Lövgren, S., *The Genesis of Modernism: Seurat, Gauguin, Van Gogh and French Symbolism in the 1880s*, Stockholm 1959.

Lubin, A., *Stranger on the earth*, New York & London 1972.

Marx, P., "Van Gogh and George Eliot," *Essays in Arts and Sciences*, 9 (May 1980) no.1, pp.45-57.

Mothe, Alain, *Vincent van Gogh à Auvers-sur-Oise*, Paris 1987.

Nagera, H., *Vincent van Gogh, a psychological study*, New York 1967.

Nordenfalk, Carl, "Van Gogh and literature," *Journal of the Warburg and Courtauld Institutes*, 10 (1947) pp.132-47.

Orton, F., "Vincent van Gogh in Paris, 1886-1887, Vincent's interest in Japanese prints," *Vincent*, 1 (1971) no.3, pp.2-12.

———, & Pollock, G., *Vincent van Gogh: artist of his time*, New York 1978.

Pabst, Fieke, (ed.) *Vincent van Gogh's poetry albums*, (Cahier Vincent 1, Rijksmuseum Vincent van Gogh), Zwolle 1988.

Pickvance, Ronald, ex.cat. *English influences on Vincent van Gogh*, (University of Nottingham & Art Council of Great Britain), 1974-75.

———, ex.cat. *Van Gogh in Arles*, New York (The Metropolitan Museum of Art) 1984.

———, ex.cat. *Van Gogh in Saint-Rémy and Auvers*, New York (The Metropolitan Museum of Art) 1986-87.

Pollock, G., ex.cat., *Vincent van Gogh in zijn Hollandse jaren*, Amsterdam (Rijksmuseum Vincent van Gogh) 1980-1981.

Rewald, John, *Post-Impressionism, from Van Gogh to Gauguin*, London & New York 1978, 3rd rev.ed.

———, "Theo van Gogh, Goupil and the Impressionists," *Gazette des Beaux-Arts*, ser.6, 81 (Jan.-Feb., 1973) pp.1-108.

Richard, Pierre, "Vincent van Gogh's Montmartre," *Jong Holland*, 4 (1988) no.1, pp.16-21.

Roskill, Mark, *Van Gogh, Gauguin and the Impressionist Circle*, London 1970.

———, "Van Gogh's exchange of work with Emile Bernard in 1888," *Oud Holland*, 86 (1971) pp.142-79.

Schapiro, Meyer, *Van Gogh*, New York 1950.

———, "The still life as personal object: a note on Heideggar and Van Gogh," in: *The reach of mind essays in memory of Kurt Goldstein*, New York 1968, pp.203-9.

Schwind, Jean, "Van Gogh's 'Starry Night' and Whitman: a study in source," *Walt Whitman Quarterly Review*, 3 (Summer 1985) pp.1-15.

Seznec, Jean, "Literary inspiration in Van Gogh," *Magazine of Art*, 43 (1950), pp.282-88 & 306-7.

Soth, Lauren, "Van Gogh's Agony," *Art Bulletin*, 68 (June 1986) no.2, pp.301-313.

Stellingwerf, J., *Werkelijkheid en grondmotief bij Vincent Willem Van Gogh*, Amsterdam 1959.

Takashina, Shūji, *Van Gogh no me* (in Japanese), Tokyo 1984.

Tanaka, Hidemichi, "Hokusai, Hiroshige and Van Gogh," (in Japanese) *Bulletin du Musée National d'Art Occidentale*, Tokyo, 5 (1971) pp.14-24.

Thomson, Richard, "Van Gogh in Paris: The fortifications drawings of 1887," *Jong Holland*, 3 (Sept. 1987) no.3, pp.14-25.

Tilborgh, Louis van (ed.), ex.cat., *Van Gogh en Millet*. Amsterdam (Rijksmuseum Vincent van Gogh) 1988-89.

Tralbaut, M.E., "Van Gogh's Japanisme," *Mededelingen van de dienst voor schone kunsten der gemeente 's-Gravenhage*, 9 (1954) 1-2, pp.6-40.

——, *Van Gogh, le mal aimé*, Lausanne 1969.

Trembley, Anne, "Vincent van Gogh: Sonneblumen 1887," *Berner Kunstmitteilungen*, 258/259 (Nov. 1987-Jan. 1988) pp.1-10.

Uitert, Evert van, *Vincent van Gogh in creative competition: four essays from Simiolus*, Zutphen (diss. Amsterdam) 1983.

——, & M. Hoyle (ed.), *The Rijksmuseum Vincent van Gogh*, Amsterdam 1987.

——, (ed.) ex.cat. *Van Gogh in Brabant*, 's-Hertogenbosch (Noordbrabants Museum) 1987.

——, "Vincents identificatie met de tot leven gewekte Lazarus," *Vrij Nederland*, 36 (1 Feb. 1975), p.23.

——, "Mystieke elementen in de kunst van Gauguin en Van Gogh," *Handelingen van het acht en dertigste Nederlands filologencongres, gehouden te Nijmegen, 16-17 April 1984*, pp.177-194.

Verkade-Bruining, A., "More about Michelet," *Vincent*, 4 (1975) no.3, pp.22-23.Veth, Jan, "Studiën over moderne kunst I : tentoonselling van werken door Vincent van Gogh in de Amsterdamsche Panoramazaal," *De Nieuwe Gids*, 8 (1893) part 1, pp.427-436.

Vincent van Gogh exhibition, ex.cat., Tokyo (National Museum of Western Art) 1985.

Vincent van Gogh, International Symposium, Tokyo (The Tokyo Shimbun) 1988.

Welsh-Ovcharov, B., (ed.) *Van Gogh in perspective*, Englewood Cliffs, N.J., 1974.

——, *Vincent van Gogh: his Paris period, 1886-88*, Utrecht & The Hague 1976.

——, ex.cat. *Vincent van Gogh and the birth of Cloisonism*, Toronto (Art Gallery of Ontario) & Amsterdam (Rijksmuseum Vincent van Gogh) 1981.

——, ex.cat. *Van Gogh à Paris*, Paris (Musée d'Orsay) 1988.

Werness, H.B., *Essays on Van Gogh's symbolism*, Ph.D. diss. University of California, 1972.

——, "Whitman and Van Gogh: Starry Nights and other similarities," *Walt Whitman Quarterly Review*, 2 (Spring 1985) no.4, pp.35-41.

——, "Some observations on Van Gogh and the vanitas tradition," *Studies in*

iconography, (1980) no.6, pp.123-136.

Whitney, Charles A., "The starry nights of Vincent van Gogh," (unpublished manuscript for the Van Gogh symposium held on Nov.16-17, 1984 at the Metropolitan Museum of Art in New York)

———, "The skies of Vincent van Gogh," *Art History*, 9 (Sept. 1986) no.3, pp.351-362.

Zemel, Carol, *The formation of a legend: Van Gogh criticism 1890-1920*, Ann Arbor 1980.

3. Art historical literature

Andrews, Keith, *The Nazarenes, a brotherhood of German painters in Rome*, Oxford 1964.

Arbeit und Alltag, soziale Wirklichkeit in der Belgischen Kunst 1830-1914, ex.cat., Berlin (Neue Gesellschaft für Bildende Kunst) 1979.

Art et société en Belgique 1848-1914, ex.cat., Charleroi (Palais des Beaux-Arts) 1980.

Berger, K., *Japonismus in der westlichen Malerei 1860-1920*, Munich 1980.

Bernard, E., "Julien Tanguy, dit le Père Tanguy," *Mercure de France*, 16 (Dec.16, 1908) pp.606-16.

Białostocki, Jan, *Stil und Ikonographie*, Cologne 1981.

Börsch-Supan, Helmut & Jähnig, Karl Wilhelm, *Caspar David Friedrich, Gemälde, Druckgraphik und bildmässige Zeichnungen*, Munich 1973.

Breton, Jules, *La vie d'un artiste*, Paris 1890.

Bullen, J.B. (ed.) *The sun is God: painting, literature, and mythology in the nine- teenth century*, Oxford 1989.

Cats, Jacob, *Alle de wercken van Jacob Cats*, edited by J. van Vloten, ill. by J.W. Kaiser, 2 vols., Zwolle 1862.

Dekkers, Dieuwertje, "De kinderen der zee, de samenwerking tussen Jozef Israëls en Nicolaas Beets," *Jong Holland*, 2 (March 1986) no.1, pp.36-52.

Drexelius, Hieremias, *Heliotropium seu conformatio humanae voluntatis cum divina*, Cologne 1630.

Eisler, Max, *Jozef Israels*, London 1924.

Ettlinger, L.D., "Nazarener und Präraffaeliten," in: *Festschrift für Gert von der Osten*, Cologne 1970, pp.205-20.

Evett, Elisa, *The critical reception of Japanese art in Europe in the late 19th cen- tury*, Ann Arbor 1982.

———, "The late nineteenth-century European critical response to Japanese art: primitivistic leanings," *Art History*, 6 (1983) pp.82-106.

Goldwater, R., *Primitivism in modern art*, New York 1967.

De Haagse School, ex.cat. The Hague (Haags Gemeentemuseum), Paris (Grand Palais) & London (Royal Academy of Arts), 1983.

Henkels, H., *Mondriaan in Winterswijk, een essay over de jeugd van Mondriaan, z'n vader en z'n oom*, The Hague (Haags Gemeentemuseum) 1979.

——, ex.cat. *Mondrian: from figuration to abstraction*, Tokyo (The Seibu Museum of Art) etc. 1987.

Hefting, Victorine, ex.cat. *J.Th. Toorop, de jaren 1885 tot 1910*, Otterlo (Rijksmuseum Kröller Müller) 1978-79.

Hofmann, W., G. Syamken & M. Warnke (ed.), *Die Menschenrecht des Auges: über Aby Warburg*, Frankfurt am Main 1980.

Hofmann, W. (ed.), *Luther und die Folgen für die Kunst*, Munich 1983.

Holbein, H., *Les simulachres et historiées faces de la mort*, Lyon 1538.

Jaworska, W., *Gauguin et l'école de Pont-Aven*, Paris 1971.

Jean-François Millet, ex.cat., Paris (Grand Palais) 1975-76.

Jean-François Millet, ex.cat., Boston (Museum of Fine Arts) 1984.

Jōzuka, Taketoshi, *Umi o wataru ukiyo-e,* (the life of Hayashi Tadamasa), (in Japanese) Tokyo 1981.

Kigi, Yasuko, *Hayashi Tadamasa to sono jidai*, (in Japanese) Tokyo 1987.

Kunstenaren der idee, symbolistische tendenzen in Nederland, ca.1880-1930, ex.cat., The Hague (Haags Gemeentemuseum) 1978.

Lankheit, K., "Caspar David Friedrich und der Neuprotestantismus," *Deutsche Vierteljahrschrift für Literaturwissenschaft und Geistesgeschichte*, 24 (1950) pp.129-43.

——, *Das Freundschaftsbild der Romantik*, Heidelberg 1952.

Leblond, M.-A., *L'Idéal du XIXe siècle, le rêve du bonheur d'après Rousseau et Bernardin de Saint-Pierre, les théories primitivistes et l'idéal artistique du socialisme*, Paris 1909.

Leistra, Josefine, ex.cat. *George Henry Boughton: God Speed! Pelgrims op weg naar Canterbury*, Amsterdam (Rijksmuseum Vincent van Gogh), 1987.

Levitine, George, *The dawn of bohemianism: the Barbu rebellion and primitivism in Neoclassical France*, University Park & London 1978.

——, et al., ex.cat. *Search for innocence: primitive and primitivistic art of the 19th century*, College Park (University of Maryland Art Gallery) 1975.

Loti, Pierre, *Madame Chrysanthème*, ill. by Myrbach & Rossi, Paris 1888.

——, *Madame Chrysanthème*, Paris 1973.

Maaten, K. van der, *Het leven en de werken van den landschapschilder Jacob Jan van der Maaten, 1820-1879*, typescript, Chailly sur Charens 1929. (a copy at the Rijksbureau voor Kunsthistorische Documentatie in The Hague)

Merlhés, Victor (ed.), *Correspondance de Paul Gauguin, documents témoignages*, Paris 1984.

Die Nazarener in Rom, ein deutscher Künstlerbund der Romantik, Rome & Munich 1981.

Pevsner, N., "Gemeinschaftsideale unter den bildenden Künstlern des 19.Jahrhunderts," *Deutsche Vierteljahrschfirt für Literaturwissenschaft und Geistesgeschichte*, 9 (1931) pp.125-54.

Post-Impressionism, ex.cat., London (Royal Academy) 1979-80.

Powell, K.H., "Jean-François Millet's death and the woodcutter," *Arts Magazine*, 61 (1986) 4, pp.53-59.

Primitivism in 20th century art, ex.cat., New York (The Museum of Modern Art) 1974.

Rosen, Charles & Zerner, Henri, *Romanticism and realism, the mythology of nineteenth century art*, London & Boston 1984.

Rosenblum, R., *Modern painting and the northern Romantic tradition*, London 1975.

Sambrook, James (ed.), *Pre-Raphaelitism: a collection of critical essays*, Chicago & London 1974.

Schapiro, M., *Modern art : 19th & 20th centuries, selected papers*, New York 1978.

Schmoll gen. Eisenwerth, J.A. et al., *Beiträge zur Motivkunde des 19. Jahrhunderts*, Munich 1970.

Schwartz, W.L., *The imaginative interpretation of the Far East in modern French literature 1800-1925*, Paris 1927.

Sensier, Alfred & Paul Mantz, *La vie et l'œuvre de J.-F. Millet*, Paris 1881.

Sumowski, W., *Caspar David Friedrich-Studien*, Wiesbaden 1970.

Uitert, Evert van, *Het geloof in de moderne kunst*, Amsterdam 1987.

Vaughan, William, *German Romanticism and English Art*, New Haven & London, 1979.

Veen, Otto van, *Amorum Emblemata*, Antwerp 1608.

Wichmann, S., *Japonismus*, Hershing 1980.

Yoshimizu, Tsuneo, *Hana no yōshiki*, (in Japanese) Tokyo 1984.

4. Non-art historical literature

a. Books and articles

Argyle, Gisela, *German elements in the fiction of George Eliot, Gissing, and Meredith*, Frankfurt am Main 1979.

Barthes, Roland, *Michelet par lui-même*, Paris 1954, 1965. (English trans. by Richard Howard, *Michelet*, New York 1987.)

Beach, Joseph Warren, *The concept of nature in nineteenth-century English poetry*, New York 1936.

Berg, W. van den & Zonneveld, P. van, (ed.) *Nederlandse literatuur van de negentiende eeuw, twaalf verkenningen*, Utrecht 1986.

Cherry, Conrad, *Nature and religious imagination: from Edwards to Bushnell*, Philadelphia 1980.

Crocker, L.G., *Nature and culture: ethical thought in the French Enlightenment*, Baltimore 1963.

Ehrard, Jean, *L'idée de nature en France dans la première moitié du XVIIIe siècle*, 2 vols., Paris 1963.

Emile Zola, ex.cat., Paris (Bibliothèque Nationale) 1952.

Fairchild, Hoxie Neale, *The noble savage: a study in Romantic naturalism*, New York 1928.

Flammarion, Camille, *Dieu dans la nature*, Paris 1867.

Goncourt, E. & J. de, *Manette Salomon*, Paris 1864.

——, E. de, *La maison d'un artiste en XIXe siècle*, Paris 1881.

Gonse, Louis, *L'Art japonais*, Paris 1883.

Hemmings, F.W.J., "Emile Zola et la religion, à propos de *La Faute de l'abbé Mouret*," *Europe, revue littéraire mensuelle*, (Paris), (April-May 1968) pp.129-135.

——, "The secret sources of *La Faute de l'abbé Mouret*," *French Studies*, 13 (1959) pp.226-239.

Höltgen, Karl Josef, *Aspects of the emblem, studies in the English emblem tradition and the European context*, Kassel 1986.

Jolas, Tina & Françoise Zonabend, "Tillers of the fields and woods people," in: Forstr, R. & O. Ranum (ed.), *Rural society in France, selections from the Annales: economies, societies, civilizations*, Baltimore & London 1977, pp.126-151.

Leighton, John & Richard Pigot, *Moral emblems with aphorisms, adages, and proverbs of all ages and nations, from Jacob Cats and Robert Farlie*, London 1860.

Leroy-Beaulieu, Anatole, "La religion en Russie," *Revue des deux mondes*, (Sept.15, 1888) pp.414-43.

Lévi-Strauss, Claude, *La pensée sauvage*, Paris 1962.

——, *Anthropologie structurale*, Paris 1958.

Loti, Pierre, *Madame Chrysanthème*, Paris 1887, 1888.

Mathijsen, Marita, *Het literaire leven in de negentiende eeuw*, Leiden 1987.

Michelet, Jules, *L'Amour*, Paris 1858.

Nieuwenhuys, Rob et al., *De beweging van 80*, Amsterdam 1982.

Ripoll, Roger, *Réalité et mythes chez Zola*, Paris 1981.

——, "Le symbolisme végétal dans *La Faute de l'abbé Mouret*; réminiscences et obsessions," *Cahiers Naturalistes*, 31 (1966) pp.11-22.

Sand, George, *La mare au diable*, Paris 1846.

Souvestre, Emile, *Les derniers Bretons*, Paris 1858.

Theuriet, André, *La vie rustique*, Paris 1888.

Todorov, Tzvetan (ed.), *Théorie de la littérature, textes des formalistes russes*, Paris 1965.

Tolstoi, Comte Léon, *La puissance des ténèbres*, drame en cinq actes, trans. by E. Halpérine, Paris 1887.

Tomashevsky, Boris, "Thematics," in: L.T. Lemon & M.J. Reis (ed.), *Russian formalist criticim, four essays*, Lincoln (Nebraska) 1965.

Walker, Philip, "The survival of Romantic pantheism in Zola's religious thought," *Symposium*, 23 (1969) no.3-4, pp.354-365.

Witemeyer, Hugh, *George Eliot and the visual arts*, New Haven & London 1979.

Willey, Basil, *The eighteenth century background: studies on the idea of nature in the thought of the period*, London 1946.

————, *Nineteenth century studies: Coleridge to Matthew Arnold*, London 1949.

Zola, Emile, Ébauche, (manuscript) Paris (Bibliothèque Nationale, mms.n.a. Fr.10294).

————, *La faute de l'abbé Mouret*, Paris 1875, 1879, 1972.

————, *Les Rougon-Macquart*, Paris 1972.

b. periodicals

Le Courrier Français, 1886-1888

Le Figaro, 1886-1888.

Le Monde illustré, 1886-1888

Revue illustrée, 1886-1888

L'Univers illustré, 1886-1888.

5. Religious background

a. Studies

Algemene Geschiedenis der Nederlanden, Haarlem 1977, vol.12.

Bacon, E.W., *Spurgeon, heir of the puritans*, London 1967.

Bie, J.P. de & Loosjes, J., (ed.) *Biographisch Woordenboek van Protestantsche Godgeleerden in Nederland*, 5 vols. The Hague 1919-1949.

Brom, Gerard, *De dominee in onze literatuur*, Nijmegen & Utrecht 1924.

Cosse, E.H., "De geheele godsdienst behoort tot het gevoel: Romantische elementen in kerk en theologie," *De Negentiende Eeuw*, 8 (Oct.1984) no.2, pp.91-107.

Evenhuis, R.B., *Ook dat was Amsterdam, vol.5, "De kerk der hervorming in de negentiende eeuw: de strijd voor kerkherstel"*, Baarn 1978.

Huizinga, J., "De Groninger Richting," in: *Verzamelde werken* VIII, Haarlem 1951, pp.139-63.

Obbink, H.W., *David Friedrich Strauss: in Nederlandse reacties op zijn theologie in de negentiende eeuw*, Utrecht 1973.

Paris, Bernard J., "George Eliot's religion of humanity," in: G.R. Creeger (ed.), *George Eliot: a collection of critical essays*, Englewood Cliffs N.J., 1970, pp.11-36.

Roessingh, K.H., *De Moderne Theologie in Nederland, hare voorbereiding en eerste periode*, Groningen 1914.

Zijp, R.P., "Religieus beloningsmateriaal op school en zondagsschool," in: *Vroomheid per dozijn*, Utrecht (Rijksmuseum het Catharijneconvent) 1982, pp.63-67.

b. Sources

Adama van Scheltema, C.S., *Charles Haddon Spurgeon*, Nijmegen 1892.

Berlage, H.P., "Levensbericht van Dr.J.P. Stricker," *Levensberichten der afgestorvene medeleden van de Maatschappij der Nederlandse Letterkunde*, (1887) pp.27-55.

Het boek der Psalmen nevens de Gezangen bij de Hervormde Kerk van Nederland, Amsterdam 1825.

Het evangelie der natuur, een boek voor ieder huisgezin, 3 vols. ill., Amsterdam 1858. (This book seemed to be quite important for the present study, but it could not be found in any major libraries in the Netherlands. Its title was listed in the auction catalogue of the libraries of J.P. Stricker and others mentioned below.)

Francken, W.Az., *Ary Scheffer's Christus Remunerator als type van de verheerlijking des Christendoms door de kunst*, Rotterdam 1855.

Heliotropen: gedachten in gedichten, texts by E. Laurillard, S.J. van den Bergh, J.P. Hasebroek etc., Leiden 1864.

Hofstede de Groot, P., *Ary Scheffer*, Groningen 1872.

———, *De Groninger Godgeleerden in hunne eigenaardigheid*, Groningen 1855.

Kate, J.J.L. ten, "Bij Scheffer's 'Drie Koningen'," *Aurora*, (1854) pp.245-8.

———, *Christus Remunerator, een harptoon*, new edition, Amsterdam 1858.

———, *De jaargetijden*, ill., Groningen 1871.

———, *Kunst en leven, naar origineele cartons*, Amsterdam ca.1870. ills. by J. van Sande Bakhuijzen, Mari H. ten Kate, W. Roelofs, Ch. Rochussen, J. Bosboom, Herman F. ten Kate, J. Weissenbruch, C. Springer etc.

———, *Nieuwe belooning, kindergedichtjes, naar aanleiding van het boek der Spreuken, oorspronkelijke en vertaald door J.J.L. ten Kate*, Amsterdam ca.1850, reprint Amsterdam 1975.

————, *De Nieuwe Kerk van Amsterdam*, ill., Amsterdam 1885.

————, *Nieuwe photographiën met dichterlijke bijschriften*, ill., Amsterdam 1870.

————, *Photographiën met dichterlijke bijschriften van J.J.L. ten Kate*, Amsterdam. (This book cannot be found in any of the public libraries in the Netherlands, but a proof of this book is at the Nederlands Letterkundig Museum in The Hague.)

————, *De planeeten*, ill., The Hague, Leiden & Arnhem 1869.

————, *De schepping*, ill., Deventer 1867.

Koster Jr, Bern., (J. Zimmerman), "Bijschriften-Poëzie," *De Gids*, 22 (1861) II, pp.71-78.

Laurillard, Eliza, (ed.) *Bloesems en paarlen, gekozen uit Nederlandse poëzie*, ill., Zutphen 1881.

————, (ed.) *Figuren en tonen, platen met bijschriften verzameld door Dr. E. Laurillard*, ill., Amsterdam 1882. (illustrations by Rochussen, Alma Tadema, Israëls, Scheffer etc.)

————, *Geen dag zonder God, stichtelijke overdenkingen voor iederen dag des jaars*, Amsterdam 1876, (the first edition in 1869)

————, (ed.) *Klimop, gedachten en beelden des geloofs, proza en poëzy, ontleend aan den Christelijken Volks-Almanak*, 12 ills. second series, Amsterdam 1871.

————, *Kunst-juweeltjes voor de salon-tafel met bijschriften van E. Laurillard*, 2 vols.,ill., Haarlem 1871.

————, *Met Jezus in de natuur*, Amsterdam 1881.

————, *Vlechtwerk uit verscheiden kleuren: twintig voordrachten*, Amsterdam 1881.

Catalogus van de belangrijke bibliotheek over Godgeleerdheid en kerkgeschiedenis, land- en volkenkunde, staats- en zedengeschiedenis, natuurwetenschap, taal- en letterkunde en kunst, nagelaten door wijlen Dr. E. Laurillard, auction catalogue (16 Nov., 1908) Amsterdam (H.G.Bom) 1908.

Lichtstralen, texts by E. Laurillard, B. ter Haar Bz., P.H. Hugenholtz Jr. etc., ill., Leiden 1890.

Oehlenschläger, A.G., *Aarets Evangelium i Naturen og Mennesket*, Copenhagen 1884, ills. by A. Jerndorff.

————, *Adam Oehlenschläger's Schriften*, Breslau 1830, vol.18, "Das Evangelium des Jahres, oder das wiederkehrende Leben Jesu in Natur und Menschensinn (eine Allegorie)," pp.157-224.

Oehlenschlägers Correggio door J.J.L. ten Kate, Leeuwarden 1868.

Spurgeon, Ch.H., *Autobiography, compiled from his diary, letters and records*, 4 vols., London 1897-1900. (Dutch translation by E. Freystadt, *Het leven van*

Charles Haddon Spurgeon, naar bescheiden uit zijn dagboek, aanteekeningen en brieven, Rotterdam 1900-1902).

———, *Farm Sermons*, London 1882.

———, *Gems from Spurgeon, being chiefly extracts from his authorized sermons*, London 1859.

———, *Jan Ploegers plaatjes bij nieuwe praatjes*, ill. Amsterdam 1880.

———, *Jan Ploegers prentjes of meer van zijn praatjes*, ill., Amsterdam 1880.

———, *John Ploughman's Pictures or more of his plain talk to plain people*, London 1880.

———, *John Ploughman's Talk, or plain advice for plain people*, London 1868, 1901.

———, *Laat Uw licht schijnen! of: Sermonen in kaarsen*, trans. by C.S. Adama van Scheltema, ill., Nijmegen 1893 (third edition). First edition published in 1891.

———, *Praatjes van Jan Ploeger*, translated by C.S. Adama van Scheltema, Amsterdam 1884.

———, *Spurgeon's juweeltjes*, Leiden 1864.

———, *Teachings of nature in the Kingdom of Grace*, London 1896.

———, *"Zijn God onderricht hem" Schetsen aan landbouw en veeteelt ontleend (Farm Sermons)*, trans. by C.S. Adama van Scheltema, ill., Amsterdam 1883.

Strauss, D.F., *Das Leben Jesu, kritisch bearbeitet*, Tübingen 1835.

Stricker, J.P., *Jezus van Nazareth*, Amsterdam 1868.

———, *De oorsprong der moderne richting*, Amsterdam 1874.

Catalogus van de belangrijke bibliotheken nagelaten door wijlen en verzameld door de heeren, Mr. G. Andreae Pz. ...Dr. J.P. Stricker..., Amsterdam (H.G.Bom) 1887.

Toussaint, A.L.G., "Ary Scheffer, Drie Koningen," *Kunstkronijk*, 6 (1845-46) p.25.

Vervolgbundel op de evangelische gezangen uitgegeven op last van de synode der Nederlandsche Hervormde Kerk, Amsterdam etc. 1869. (coll. library of the Rijksmuseum Vincent van Gogh)

Westrheene, T. van (ed.), *Scheffer album*, Haarlem 1860.

c. periodicals

De Huisvriend, geïllustreerd magazijn gewijd aan letteren en kunst, lectuur voor iedereen, 1880-1890

Kerkelijke courant, weekblad voor de Nederlandsche Hervormde Kerk, 1880-1890

Kunstkronijk, 1840-1890

List of Illustrations

Chapter 1

1. M.B. Mendes da Costa.
2. J.J. van der Maaten, *Funeral procession in the wheat field*, lithograph (with inscriptions by Van Gogh), University Library, University of Amsterdam.
3. M.B. Mendes da Costa's certification on the reverse side of fig. 2.
4. "Ecce Homo! met dichterlijk bijschrift van J.J.L. ten Kate", from: J.J.L. ten Kate, *Photographiën met dichterlijke bijschriften van J.J.L. ten Kate*, Amsterdam s.a., Rijksmuseum Vincent van Gogh (Vincent van Gogh Foundation), Amsterdam.
5. J.J.L. ten Kate.
6. J.J.L. ten Kate, *Kunst en leven*, Amsterdam ca. 1870, title-page.
7. J.J.L. ten Kate, *Kunst en leven*, Amsterdam ca. 1870, from the chapter "Uit het Visschers-leven" (From the fishers' life) with the reproduction of: Louis Meijer, *Op zee* (At sea).
8. W.T.C. Dobson, *De ploeg* (The plow), from: J.J.L. ten Kate, *Nieuwe photographiën met dichterlijke bijschriften*, Amsterdam 1870.
9. Jozef Israëls, *Na den storm* (After the storm), from J.J.L. ten Kate, *Nieuwe photographiën met dichterlijke bijschriften*, Amsterdam 1870.
10. "Laat den ploeg niet stilstaan om een muis te vangen" (Don't leave the plow stopped to catch a mouse), from: Ch.H. Spurgeon, *Jan Ploegers prentjes of meer van zijn praatjes voor eenvoudige lieden*, Amsterdam 1880.
11. "De gelijkenis van den zaaier" (The parable of the sower), from: Ch.H. Spurgeon, *"Zijn God onderricht hem", Schetsen aan landbouw en veeteelt ontleend* (Farm sermon), trans. C.S. Adama van Scheltema, Amsterdam

1883.

12. J.J.L. ten Kate, *Nieuwe belooning kindergedichtjes*, Amsterdam ca. 1850, reprint, Amsterdam 1975.

13. J.P. Stricker.

14. V. van Gogh, notebook with quotations from Heine, Goethe etc., 16.5x21cm, Teylers Museum, Haarlem.

15. Eliza Laurillard.

16. Cover illustration for E. Laurillard, *Geen dag zonder God*, Amsterdam 1876 (third ed.).

17. "De herder" (The shepherd), with the text by E. Laurillard, from: E. Laurillard (ed.), *Klimop*, Amsterdam 1871 (see note 54).

18. "Herman en Dorothea," with the text by J.P. Hasebroek, from: E. Laurillard (ed.), *Klimop*, Amsterdam 1871 (see note 54).

Chapter 2

19. V. van Gogh, *Miners' wives carrying sacks, "The bearers of the burden"*, 1881 (F832 JHE) pen and pencil, washed, 43x60cm, Rijksmuseum Kröller-Müller, Otterlo.

20. Cécile Douard, *Miners' wives carrying sacks*, 1891, 130x190cm, Musée des Beaux-Arts de la ville de Mons, Mons, Belgium.

21. Ph.G. Marissiaux, photograph of a mining district near Liège, 1904, Archive Photographique, Musée de la vie Wallone, Liège, Belgium.

22. V. van Gogh, *Miners' wives carrying sacks*, 1882 (F994 JH253) water color, heightened with white, 32x50cm, Rijksmuseum Kröller-Müller, Otterlo.

23. V. van Gogh, *Shacks*, 1881 (F842 JH5) black chalk, pencil, pen, heightened with white and gray, 45.5x61cm, Museum Boymans-van Beuningen, Rotterdam.

24. V. van Gogh, *Peasants working in the fields*, 1881 (JH37) sketch in letter 150.

25. V. van Gogh, *Wheat field with a reaper*, 1885 (F1301recto JH917) black chalk, heightened with white, 27x38.5cm, Rijksmuseum Kröller-Müller, Otterlo.

26. V. van Gogh, *Weaver*, 1884 (F1118 JH452) pencil, pen, brown ink, 32x40cm, Rijksmuseum Vincent van Gogh (Vincent van Gogh Foundation), Amsterdam.

27. Jozef Israëls, *From darkness to light*, 1863, reproduction from: *Gazette des Beaux-Arts*, 1873, p.205.

28. Anton Mauve, *Plowing peasants*, water color, 45.7x60cm, Rijksmuseum,

Amsterdam.

29. Anton Mauve, *A digger in the dunes*, from *Anton Mauve, Vier en Twintig phototypiën*, Amsterdam (C.M. van Gogh) 1896.

30. V. van Gogh, *The sower*, 1888 (F451 JH1629) 32x40cm, Rijksmuseum Vincent van Gogh (Vincent van Gogh Foundation), Amsterdam.

31. V. van Gogh, *Wheat field with a reaper*, 1889 (F617 JH1753) 72x92cm, Rijksmuseum Kröller-Müller, Otterlo.

32. Heidbrinck, "Après l'inondation la fertilité," from: *Le Courrier Français, numéro exceptionnel pour les inondés de Midi*, (Dec.26, 1888).

33. Henri Pille, "Pour les inondés du Midi," cover illustration, *Le Courrier Français*, (Dec.26, 1888), Rijksmuseum Vincent van Gogh (Vincent van Gogh Foundation), Amsterdam.

34. A. Willette, "Grégoire!," illustration to the titles page of *Le Courrier Français*, (July 4, 1886).

35. Quinsac, "Assez d'eau comme ça, cria Dieu le père à saint Médard, si tu ne fermes pas tes robinets à l'instant, je t'expulse du Paradis!...," from: *Le Courrier Français*, (June 27, 1886) p.4.

36. F. Lunel, "Les Courses Anglaises à l'Hippodrome," from: *Le Courrier Français*, (Jan. 23, 1887) p.9.

37. "Grandes fêtes Parisiennes au profit des inondés du Midi," advertisement in *Le Chat Noir*, no.258 (Dec.18, 1886) p.828.

38. "Les fêtes du soleil au Palais de l'Industrie...," from: *L'illustration*, (Jan.1, 1887) pp.8-9

39. "Les fêtes du soleil au Palais de l'Industrie," from: *Le Monde illustré*, (Jan.1, 1887) p.5.

40. A. Willette, "Allons! viens, mon p'tit homme, c'est au profit des inondés du Midi!...," from: *Le Courrier Français*, (Dec.26, 1888).

41. P. Quinsac, "Une Arlésienne," from: *Le Courrier Français*, (Jan. 9, 1887) p.3.

42. V. van Gogh, *A couple on the road*, 1885? (F1338 JH964 SB1/25), pencil, pen, 7x12.5cm, private collection, The Netherlands.

43. V. van Gogh, *Couple strolling under sunflowers*, 1887 (FSD1720 JH1308) pencil, 13.5x21cm, Rijksmuseum Vincent van Gogh (Vincent van Gogh Foundation), Amsterdam.

44. (= Plate 1) V. van Gogh, *Raising of Lazarus* (copy after Rembrandt) 1890 (F677 JH1972) oil on thick paper, lined with canvas, 50x65cm, Rijksmuseum Vincent van Gogh (Vincent van Gogh Foundation), Amsterdam.

45. Rembrandt van Rijn, *Raising of Lazarus*, (Bartsch 73), etching, Rijksmuseum Vincent van Gogh (Vincent van Gogh Foundation), Amsterdam.

46. "Christi, actio imitatio nostra," from: Zacharias Heyns, *Emblemata*, Rotterdam 1625.
47. Hieremias Drexelius, *Heliotropium seu conformatio humanae voluntatis cum divina*, Cologne 1630.
48. Emblem from: Otto van Veen, *Amorum Emblemata*, Antwerp 1608.
49. Jan Toorop, *Séduction*, 1886, 67x77cm, Rijksmuseum Kröller-Müller, Otterlo.
50. Richard Roland Holst, cover illustration to ex.cat. *Vincent van Gogh, nagelaten werken*, Amsterdam (Kunstzaal Panorama-gebouw) 1892-93.
51. Illustration to: Hieremias Drexelius, *Heliotropium seu conformatio humanae voluntatis cum divina*, Cologne 1630.
52. V. van Gogh, *The Langlois bridge*, sketch in letter B2 (JH1370) private collection, Paris.
53. Arles.
54. V. van Gogh, *The Langlois bridge*, 1888, (F400 JH1371) 58.5x73cm, Rijksmuseum Vincent van Gogh (Vincent van Gogh Foundation), Amsterdam.
55. Photograph of the Langlois bridge, 1902. Rijksmuseum Vincent van Gogh.
56. V. van Gogh, *Saintes-Maries-de-la-Mer*, 1888 (F1436 JH1446) pen, 43x60cm, coll. Oscar Reinhart "Am Römerholz", Winterthur.
57. (= Plate 2) V. van Gogh, *Summer evening*, 1888 (F465 JH1473) 74x91cm, Kunstmuseum, Winterthur.
58. V. van Gogh, *The church at Auvers*, 1890 (F789 JH2006) 94x74cm, Musée d'Orsay, Paris.
59. V. van Gogh, *Daubigny's garden*, 1890 (F776 JH2104) 53x104cm, Hiroshima Museum of Art, Hiroshima.
60. V. van Gogh, *The old church tower in Nuenen, with a peasant woman*, 1884 (F88 JH490) 47.5x55cm, Bührle collection, Zurich.
61. Marius Bauer, Ex Libris of Vincent van Gogh, a cousin of the painter and the son of C.M. van Gogh, pasted on the cover of Otto van Veen, *Amorum Emblemata*, Antwerp 1608, University Library, University of Amsterdam (see note 121).

Chapter 3

62. V. van Gogh, *The old church tower in Nuenen*, 1885 (F84 JH772) 63x79cm, Rijksmuseum Vincent van Gogh (Vincent van Gogh Foundation), Amsterdam.
63. E.A. Breton, *Old world dying away*, reproduction from *Catalogue illustré*

78. *Shinsen kachō no kei* (Glimpses of newly selected flowers and birds), Rijksmuseum Vincent van Gogh (Vincent van Gogh Foundation), Amsterdam.
79. V. van Gogh, *Portrait of a mousmé*, 1888 (F431 JH1519) 74x60cm, National Gallery of Art, Washington.
80. V. van Gogh, *Portrait of a mousmé*, 1888 (F1503 JH1533) pen, reed pen, 31.5x24cm, Thomas Gibson Fine Art, Ltd., London.
81. Rossi, *Madame Chrysanthème*, illustration to P. Loti, *Madame Chrysanthème*, Paris 1888.
82. Christian Mourier-Petersen, *Young woman from Arles*, 1888, 41.2x33.5cm, Hirschsprung Collection, Copenhagen.
83. *Cicadas*, illustration to P. Loti, *Madame Chrysanthème*, Paris 1888.
84. V. van Gogh, *Sketch of three cicadas*, sketch included in letter 603, 1889 (F1445 JH1765) pen, 20.5x18cm, Rijksmuseum Vincent van Gogh (Vincent van Gogh Foundation), Amsterdam.
85. Rossi, *Monsieur Sucre*, illustration to P. Loti, *Madame Chrysanthème*, Paris 1888.
86. Myrbach, *Funeral procession*, illustration to P. Loti, *Madame Chrysanthème*, Paris 1888.
87. Paul Gauguin, *Self-portrait, "Les Misérables"*, 1888, 45x55cm, Rijksmuseum Vincent van Gogh (Vincent van Gogh Foundation), Amsterdam.
88. Emile Bernard, *Self-portrait*, 1888, 46.5x55.5cm, Rijksmuseum Vincent van Gogh (Vincent van Gogh Foundation), Amsterdam.
89. Friedrich Overbeck, *Portrait of Franz Pforr*, 1810, 62x47cm, Staatliche Museum Preußischer Kulturbesitz, Berlin.
90. V. van Gogh, *Self-portrait with a Japanese print*, 1889 (F527 JH1657) 60x49cm, Courtauld Institute Galleries, London.

Chapter 5

91. Jean-François Millet, *Peasants digging*, photograph from the collection of Vincent van Gogh, Rijksmuseum Vincent van Gogh (Vincent van Gogh Foundation), Amsterdam.
92. V. van Gogh, *Peasants digging* (after Millet), 1880 (F829 JHD) pencil, charcoal, 37x62cm, Rijksmuseum Kröller-Müller, Otterlo.
93. H. Holbein, *The plowman and death*, from: *Les simulachres et historiées faces de la mort*, Lyon 1538.
94. Léon Lhermitte, title page of André Theuriet, *La vie rustique*, Paris 1888.

72x92cm, Rijksmuseum Vincent van Gogh (Vincent van Gogh Foundation), Amsterdam.

Chapter 6

111. J.E. Dantan, *Le Paradou (La faute de l'abbé Mouret)*, reproduction from *Catalogue illustré de Salon*, Paris & London 1883, p.66.
112. J.-D.Caucaunier, *La faute de l'abbé Mouret*, reproduction from *Catalogue illustré de Salon*, Paris & London 1889, p.189.
113. (= Plate 6) V. van Gogh, *In the church*, 1882 (F967 JH225) water color, pen, pencil, 28x38cm, Rijksmuseum Kröller-Müller, Otterlo.
114. (= Plate 7) V. van Gogh, *The starry night*, 1889 (F612 JH1731) 73x92cm, The Museum of Modern Art (Lillie P. Bliss Bequest), New York.
115. (= Plate 8) V. van Gogh, *Flowering garden*, 1888 (F430 JH1510) 95x73cm, private collection, New York.
116. V. van Gogh, *Flowering garden*, 1888 (F429 JH1513) 72x91cm, Haags Gemeentemuseum, The Hague.

Appendix

117. A.C. Adler, from: *De Spiegel*, (1906) p.411.
118. M.J. Misset, *Zionskapel*, 1911, Gemeentearchief (Historisch Topografische Atlas), Amsterdam.
119. M.J. Misset, *Zionskapel*, 1911, Gemeentearchief (Historisch Topografische Atlas), Amsterdam.

Illustrations

1. M.B. Mendes da Costa.

2. J.J. van der Maaten, *Funeral procession in the wheat field*, lithograph (with inscriptions by Van Gogh), University Library, University of Amsterdam.

3. M.B. Mendes da Costa's certification on the reverse side of fig. 2.

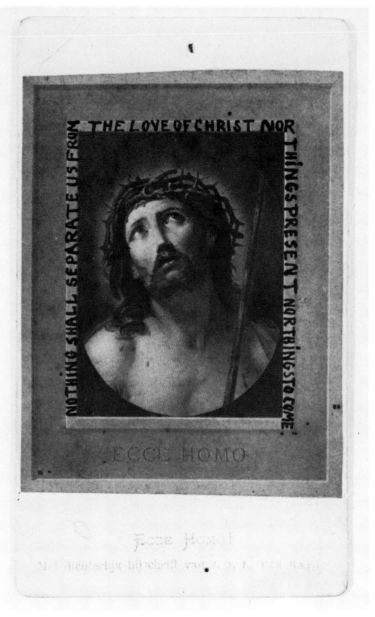

4. "Ecce Homo! met dichterlijk bijschrift van J.J.L. ten Kate",
from: J.J.L. ten Kate, *Photographiën met dichterlijke bijschrif-
ten van J.J.L. ten Kate*, Amsterdam s.a., Rijksmuseum Vin-
cent van Gogh (Vincent van Gogh Foundation), Amsterdam.

5. J.J.L. ten Kate.

KUNST en LEVEN.

— NAAR ORIGINEELE CARTONS. —

POËZY

VAN

J. J. L. TEN KATE.

AMSTERDAM,
JAN LEENDERTZ.

BUITEN.

B. C. KOEKKOEK.

6. J.J.L. ten Kate, *Kunst en leven*, Amsterdam ca. 1870, title-page.

LOUIS MEIJER.

OP ZEE.

II.

Stil, eenzelvig, kruipen de uren
 Voor wie achterbleef aan 't strand:
IJvrig, binnen de enge muren,
 Rept zich toch de vrouwenhand;
Over 't Bijbelblad gebogen,
 Droomt de grijze 't oud verhaal,
Tot de jeugd, der school ontvlogen,
 Toespringt op het dampend maal...
Woelig, wisslend, vliën de weken
 Voor de wakkre zoons der zee,
Sints men 't kustlicht zag verbleeken
 Bij het deinzen van de reê.
Doe de blanke zeilen zwellen,
 Zuidenwind, en wakker aan!
Doe de ranke kielen snellen
 Door den Noorder-Oceaan!
Stijgt, gij baren! rolt, gij waatren,
 't Lied dat klinkt van boord tot boord,
Daar de wimpels vroolijk klaatren,
 Op uw vasten maatslag voort!
Roert de handen, wakkre gasten,
 Ieder tot zijn taak bereid!
Wat verlicht de zwaarste lasten?
 Eenheid bij verscheidenheid!

7. J.J.L. ten Kate, *Kunst en leven*, Amsterdam ca. 1870, from the chapter "Uit het visschers-leven" (From the fishers' life) with the reproduction of: Louis Meijer, *Op zee* (At sea).

DE PLOEG.

(SPREUKEN SAL. XXIV : 27, 30—34.)

Beploeg, mijn zoon! uw akker eerst, | Daar was de steenen muur verwoest,
Dan kunt gij rusten bij den haard. | De grond bedekt met woekerkruid.
'k Heb straks eens luiaards land gezien: | Ik nam ter harte wat ik zag,
Daar schoot de distel op uit de aard. | En trok er deze leering uit:

Wat slapens hier, wat sluimrens daar,
Gerust, geluierd wat men kan....
Zoo nadert de Armoede als een dief,
't Gebrek als een gewapend man!

J. J. L. TEN KATE.

NA DEN STORM.

Hoe vreeslijk heeft de storm gewoed, | Daar staroogt de arme visschersvrouw
Den langen bangen nacht! | In 't eindeloos verschiet,
Nu stilt de wind; de morgen lucht. | Of zij geen pinkjen naadren ziet.
Maar angstig, met bedrukt gemoed, | De grijze moeder, stom van rouw.
Houdt Liefde ginds de wacht. | Bidt, maar verroert zich niet.

Het argelooze kind alleen,
Alsof het niets weêrvoer,
Heeft niets gehoord van 't stormrumoer.
„En vreest gij niets?" — „Ik vreezen? neen,
„Mijn vader zit aan 't roer!"

J. J. L. TEN KATE.

8. W.T.C. Dobson, *De ploeg* (The plow), from: J.J.L. ten Kate, *Nieuwe photographiën met dichterlijke bijschriften*, Amsterdam 1870.

9. Jozef Israëls, *Na den storm* (After the storm), from J.J.L. ten Kate, *Nieuwe photographiën met dichterlijke bijschriften*, Amsterdam 1870.

LAAT DEN PLOEG NIET STILSTAAN OM EEN MUIS TE VANGEN.

Dit spel brengt niet veel voordeel aan. Denk eens aan: een man, jongen en vier paarden staan stil om een *muis* te bekijken! Wat zou onze oude vriend Tusser daarvan gezegd hebben? Ik denk hij zou op deze wijze gerijmd hebben:

> Een ploeger die stil houdt voor muis of voor mug,
> Verdient wèl een zweepslag of tien op zijn' rug.

10. "Laat den ploeg niet stilstaan om een muis te vangen" (Don't leave the plow stopped to catch a mouse), from: Ch.H. Spurgeon, *Jan Ploegers prentjes of meer van zijn praatjes voor eenvoudige lieden*, Amsterdam 1880.

DE GELIJKENIS VAN DEN ZAAIER.

Als nu een groote schare bijeenvergaderde, en zij van alle steden tot Hem kwamen, zoo zeide Hij deze gelijkenis: Een zaaier ging uit om zijn zaad te zaaien; en als hij zaaide, viel het eene bij den weg en werd vertreden, en de vogelen des hemels aten dat op. En het andere viel op eene steenrots, en opgewassen zijnde, is het verdord, omdat het geen vochtigheid had. En het andere viel in het midden van de doornen, en de doornen mede opwassende, verstikten het. En het andere viel op de goede aarde, en opgewassen zijnde, bracht het honderdvoudige vrucht voort. Dit zeggende, riep Hij: Wie ooren heeft om te hooren, die hoore.

Luk. VIII : 4—8.

11. "De gelijkenis van den zaaier" (The parable of the sower), from: Ch.H. Spurgeon, *"Zijn God onderricht hem", Schetsen aan landbouw en veeteelt ontleend* (Farm sermon), Amsterdam 1883.

12. J.J.L. ten Kate, *Nieuwe belooning kindergedichtjes*, Amsterdam ca. 1850, reprint, Amsterdam 1975.

13. J.P. Stricker. 15. Eliza Laurillard.

14. V. van Gogh, notebook with quotations from Heine, Goethe etc., Teyl-
ers Museum, Haarlem.

GEEN DAG ZONDER GOD.
Stichtelijke overdenkingen
VOOR
IEDEREN DAG DES JAARS,
door
Dr. E. LAURILLARD.

DERDE DRUK.

AMSTERDAM D.B.CENTEN.

Lith.v Tresling & Cᵒ Amst

16. Cover illustration for E. Laurillard, *Geen dag zonder God*, Amsterdam 1876 (third ed.).

DE HERDER.

(Bij het plaatje.)

door

Dr. E. LAURILLARD.

I.

De herder leidt vol zorg zijn schapen,
 Bij 't rijzen van den morgen, uit,
En voert ze heen naar 't malsche weigras,
 Of brengt ze in 't geurig heidekruid.

En als gevaar zijn kudde nadert, —
 Hij draagt niet te vergeefs zijn staf:
Hij treedt voornit als haar beschermer,
 En weert van haar het onheil af.

17. "De herder" (The shepherd), with the text by E. Laurillard, from: E. Laurillard (ed.), *Klimop*, Amsterdam 1871 (see note 54).

HERMAN EN DOROTHEA.

(*Bij het titelplaatje.*)

door

J. P. HASEBROEK.

Kent gij den Bard, den onvolprezen Zanger,
Die op den troon der Dichtkunst onzes tijds
Den schepter voert, een eeuwhelft lang, en langer,
En hulde ontvangt van Peking tot Parijs?
Wie roept niet: GÖTHE! en biedt dien Dichterkoning
Zijn lauwer meê met de andre lauwren aan?
En toch!.. Bij al die hulde- en eerbetooning,
O GÖTHE! er zijn,·die op een afstand staan.

Wanneer gij, zoon der edele Germanen,
Het heiligdom, gewijd aan Liefde en Echt,,
Ontheiligt, door daarheen een weg te banen,
Waarop zich vleesch aan vleesch onheilig hecht,

18. "Herman en Dorothea," with the text by J.P. Hasebroek, from: E. Laurillard (ed.), *Klimop*, Amsterdam 1871 (see note 54).

19. V. van Gogh, *Miners' wives carrying sacks, "The bearers of the burden"*, 1881 Rijksmuseum Kröller-Müller, Otterlo.

20. Cécile Douard, *Miners' wives carrying sacks*, 1891, Musée des Beaux-
Arts de la ville de Mons, Mons, Belgium.

21. Ph.G. Marissiaux, photograph of a mining district near Liège, 1904,
Archive Photographique, Musée de la vie Wallone, Liège, Belgium.

22. V. van Gogh, *Miners' wives carrying sacks*, 1882, Rijksmuseum Kröller-Müller, Otterlo.

23. V. van Gogh, *Shacks*, 1881, Museum Boymans-van Beuningen, Rotterdam.

24. V. van Gogh, *Peasants working in the fields*, 1881 sketch in letter 150.

25. V. van Gogh, *Wheat field with a reaper*, 1885, Rijksmuseum Kröller-Müller, Otterlo.

26. V. van Gogh, *Weaver*, 1884, Rijksmuseum Vincent van Gogh (Vincent van Gogh Foundation), Amsterdam.

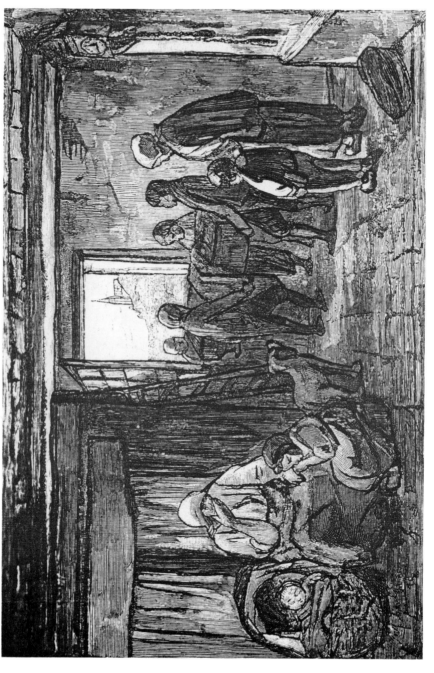

27. Jozef Israëls, *From darkness to light*, 1863, reproduction from: *Gazette des Beaux-Arts*, 1873, p.205.

28. Anton Mauve, *Plowing peasants*, 45.7x60, Rijksmuseum, Amsterdam.

29. Anton Mauve, *A digger in the dunes*, from *Anton Mauve, Vier en Twintig phototypiën*, Amsterdam (C.M. van Gogh) 1896.

30. V. van Gogh, *The sower*, 1888, Rijksmuseum Vincent van Gogh (Vincent van Gogh Foundation), Amsterdam.

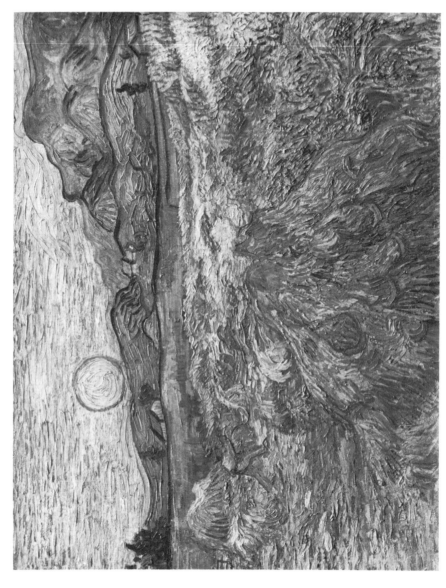

31. V. van Gogh, *Wheat field with a reaper*, 1889, Rijksmuseum Kröller-Müller, Otterlo.

32. Heidbrinck, "Après l'inondation la fertilité," from: *Le Courrier Français, numéro exceptionnel pour les inondés de Midi*, (Dec.26, 1888).

33. Henri Pille, "Pour les inondés du Midi," cover illustration, *Le Courrier Français*, (Dec.26, 1888), Rijksmuseum Vincent van Gogh (Vincent van Gogh Foundation), Amsterdam.

35. Quinsac, "Assez d'eau comme ça, cria Dieu le père à saint Médard, …," from: *Le Courrier Français*, (June 27, 1886) p.4.

34. A. Willette, "Grégoire!," illustration to the titles page of *Le Courrier Français*, (July 4, 1886).

37. "Grandes fêtes Parisiennes au profit des inondés du Midi," advertisement in *Le Chat Noir*, no.258 (Dec.18, 1886) p.828.

36. F. Lunel, "Les Courses Anglaises à l'Hippodrome," from: *Le Courrier Français*, (Jan. 23, 1887) p.9.

LES FÊTES DU SOLEIL AU PALAIS DE L'INDUSTRIE, ORGANISÉES PAR LA PRESSE AU PROFIT DES INONDÉS DU MIDI

1. Côté mérional. — 2. Intérieur d'une partie. — 3. Le moulin à huile. — 4. Début du télégraphie. — 5. Le chalet. — 6. Vue d'ensemble. — 7. L'embarcation.

38. "Les fêtes du soleil au Palais de l'Industrie…," from: *L'illustration*, (Jan.1, 1887) pp.8-9

LES FÊTES DU SOLEIL AU PALAIS DE L'INDUSTRIE. — LA PROCESSION DE LA TARASQUE. — LA FARANDOLE. — LES LUTTEURS DE M. MARSEILLE. (Dessin de M. GÉRARDIN.)

39. "Les fêtes du soleil au Palais de l'Industrie," from: *Le Monde illustré*, (Jan.1, 1887) p.5.

41. P. Quinsac, "Une Arlésienne," from: *Le Courrier Français*, (Jan. 9, 1887) p.3.

40. A. Willette, "Allons! viens, mon p'tit homme, c'est au profit des inondés du Midi!...," from: *Le Courrier Français*, (Dec. 26, 1888).

42. V. van Gogh, *A couple on the road*, 1885? private collection, The Netherlands.

43. V. van Gogh, *Couple strolling under sunflowers*, 1887, Rijksmuseum Vincent van Gogh (Vincent van Gogh Foundation), Amsterdam.

45. Rembrandt van Rijn, *Raising of Lazarus*, (Bartsch 73), etching, Rijksmuseum Vincent van Gogh (Vincent van Gogh Foundation), Amsterdam.

44. V. van Gogh, *Raising of Lazarus* (copy after Rembrandt) 1890, Rijksmuseum Vincent van Gogh (Vincent van Gogh Foundation), Amsterdam.

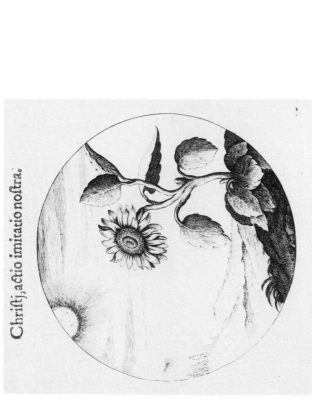

47. Hieremias Drexelius, *Heliotropium seu conformatio humanae voluntatis cum divina*, Cologne 1630.

46. "Christi, actio imitatio nostra," from: Zacharias Heyns, *Emblemata*, Rotterdam 1625.

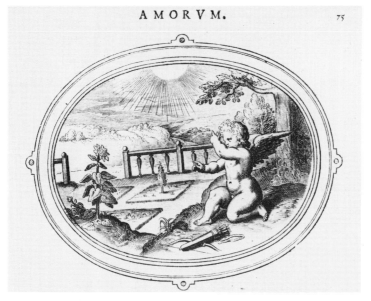

48. Emblem from: Otto van Veen, *Amorum Emblemata*, Antwerp 1608.

49. Jan Toorop, *Séduction*, 1886, Rijksmuseum Kröller-Müller, Otterlo.

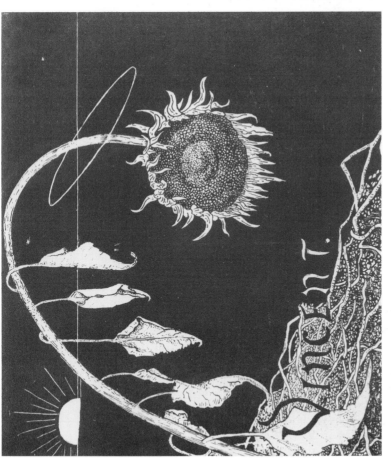

51. Illustration to: Hieremias Drexelius, *Heliotropium seu conformatio humanae voluntatis cum divina*, Cologne 1630.

50. Richard Roland Holst, cover illustration to ex.cat. *Vincent van Gogh, nagelaten werken*, Amsterdam (Kunstzaal Panorama-gebouw) 1892-93.

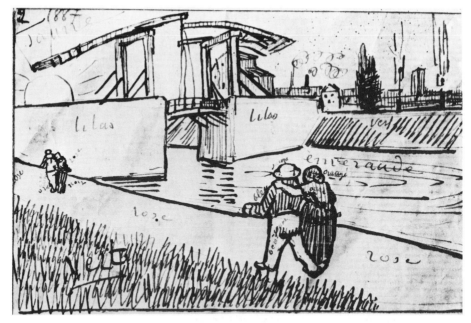

52. V. van Gogh, *The Langlois bridge*, sketch in letter B2 private collection, Paris.

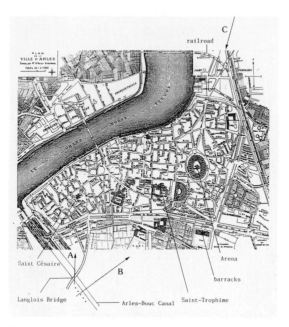

53. Arles.

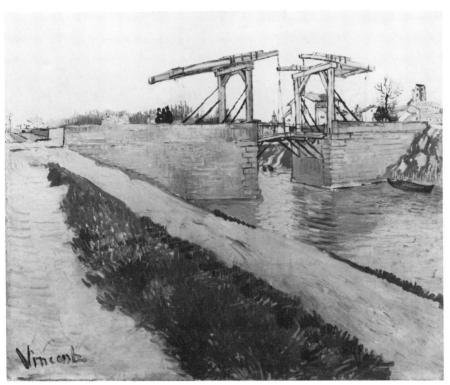

54. V. van Gogh, *The Langlois bridge*, 1888, Rijksmuseum Vincent van Gogh
 (Vincent van Gogh Foundation), Amsterdam.

55. Photograph of the Langlois Bridge, 1902, Rijksmuseum Vincent van Gogh.

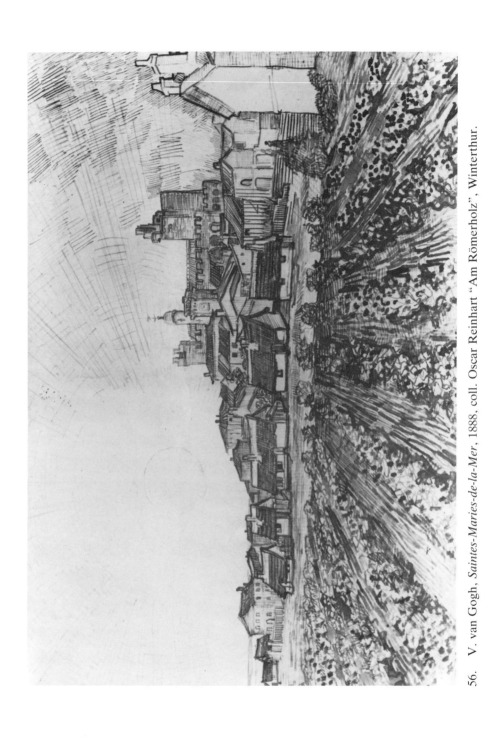

56. V. van Gogh, *Saintes-Maries-de-la-Mer*, 1888, coll. Oscar Reinhart "Am Römerholz", Winterthur.

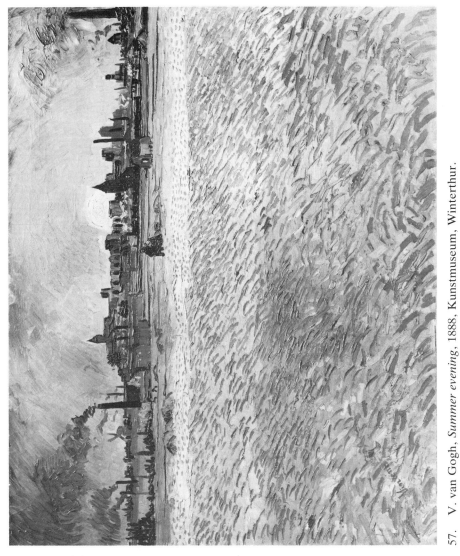

57. V. van Gogh, *Summer evening*, 1888, Kunstmuseum, Winterthur.

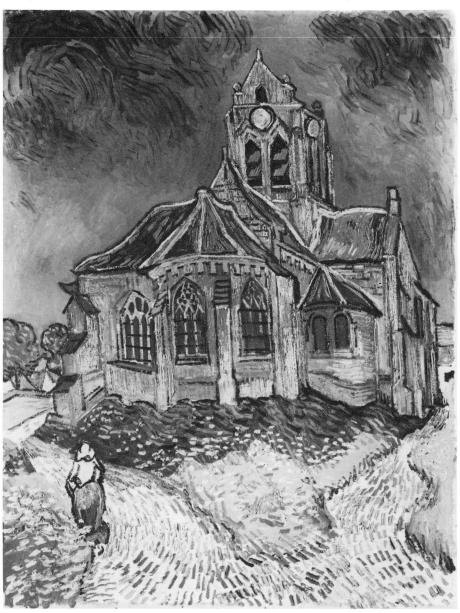

58. V. van Gogh, *The church at Auvers*, 1890, Musée d'Orsay, Paris.

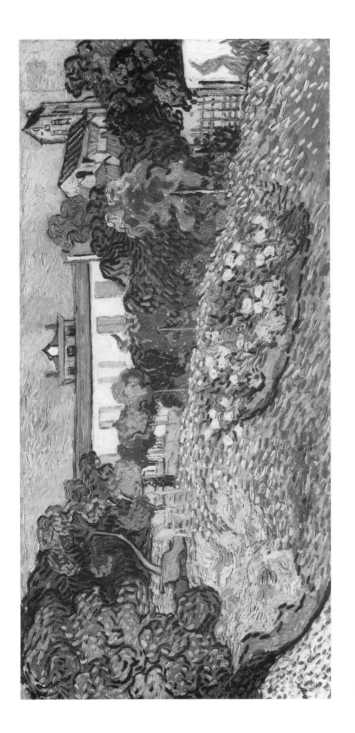

59. V. van Gogh, *Daubigny's garden*, 1890, Hiroshima Museum of Art, Hiroshima.

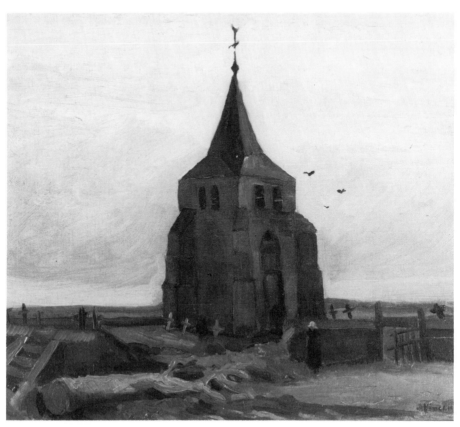

60. V. van Gogh, *The old church tower in Nuenen, with a peasant woman*, 1884, Bührle collection, Zurich.

61. Marius Bauer, Ex Libris of Vincent van Gogh, a cousin of the painter and the son of C.M. van Gogh, pasted on the cover of Otto van Veen, *Amorum Emblemata*, Antwerp 1608, University Library, University of Amsterdam (see note 121).

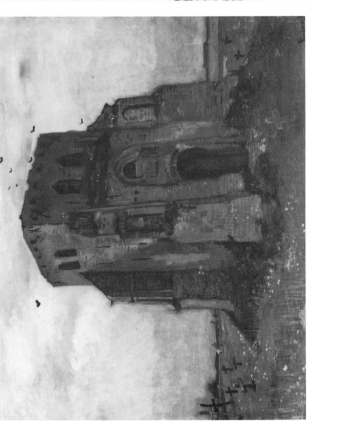

62. V. van Gogh, *The old church tower in Nuenen*, 1885, Rijksmuseum Vincent van Gogh (Vincent van Gogh Foundation), Amsterdam.

63. E.A. Breton, *Old world dying away*, reproduction from *Catalogue illustré de Salon*, Paris & London 1884.

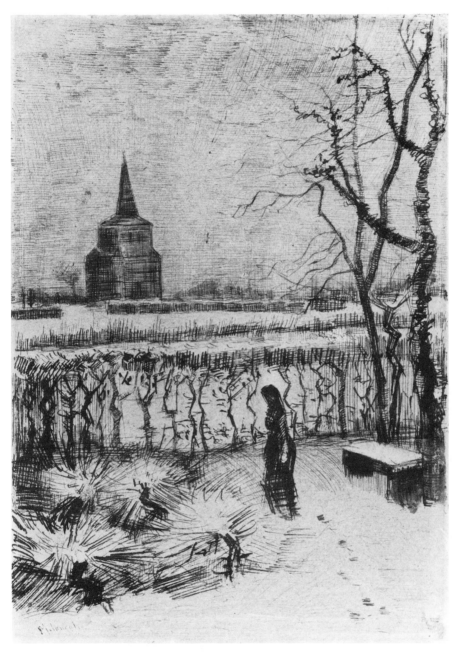

64. V. van Gogh, *Mélancolie*, 1884, Rijksmuseum Vincent van Gogh (Vincent van Gogh Fondation), Amsterdam.

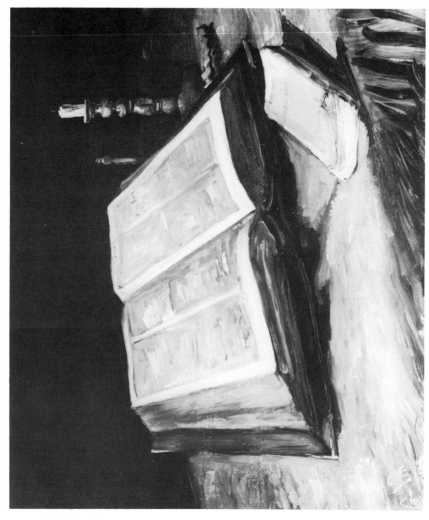

65. V. van Gogh, *Still life with open Bible*, 1885, Rijksmuseum Vincent van Gogh (Vincent van Gogh Foundation), Amsterdam.

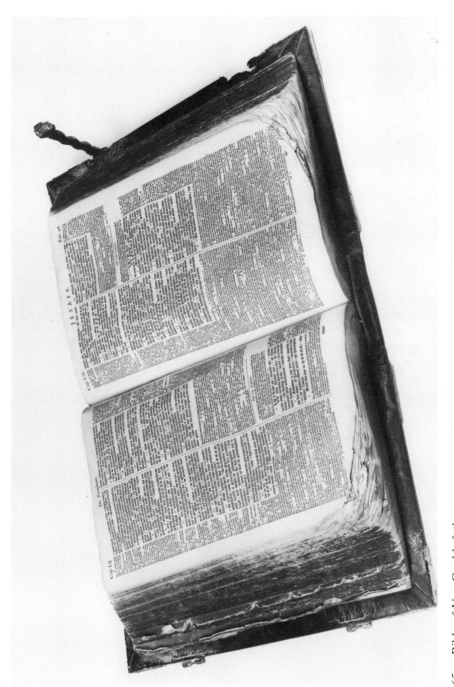

65a. Bible of Van Gogh's father.

67. Rembrandt van Rijn, *The entombment*, etching, ca.1654 (Bartsch 86), Teylers Museum, Haarlem.

66. Rembrandt van Rijn, *The flight into Egypt*, etching, 1651 (Bartsch 53), Teylers Museum, Haarlem.

69. V. van Gogh, *Devant les tisons*, sketch reproduced in letter 140, Rijksmuseum Vincent van Gogh (Vincent van Gogh Foundation), Amsterdam.

68. V. van Gogh, *En route*, sketch reproduced in letter 140, Rijksmuseum Vincent van Gogh (Vincent van Gogh Foundation), Amsterdam

70. V. van Gogh, *Still life with three books*, 1887, Rijksmuseum Vincent van Gogh (Vincent van Gogh Foundation), Amsterdam.

71. V. van Gogh, *Still life with a vase of oleander and books*, 1888, The Metropolitan Museum of Art (Gift of Mr. & Mrs. John L. Loeb), New York.

72. V. van Gogh, *La Berceuse tryptich*, 1889, sketch in letter 592, Rijksmuseum Vincent van Gogh (Vincent van Gogh Foundation), Amsterdam.

73. Reverse side of the *Still life with three books* (fig.70) (note 145)

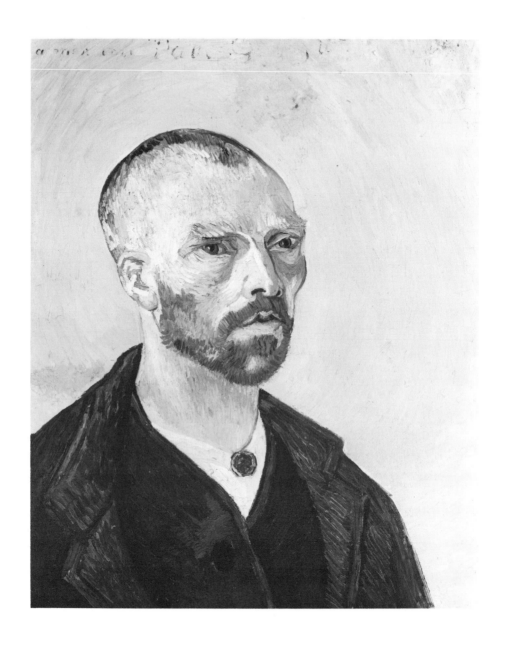

74. V. van Gogh, *Self-portrait as a bonze*, 1888, Fogg Art Museum, Cambridge, Massachusetts.

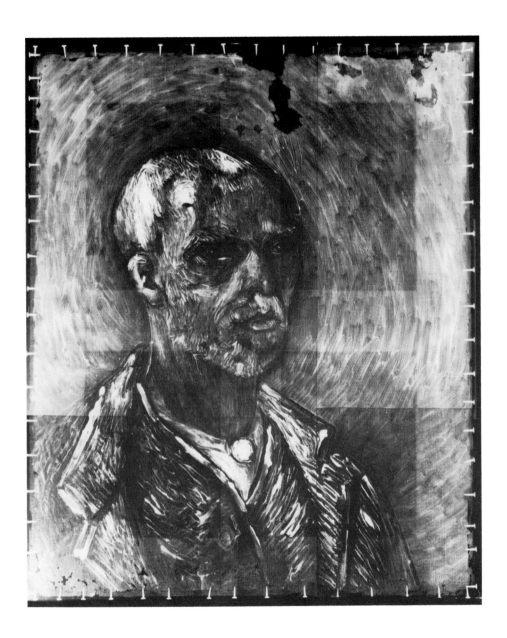

74a. V. van Gogh, *Self-portrait as a bonze*. X-ray photograph.

STATUETTE DE BONZE, PAR HISSATAMA OUKOUSOU.

(Bois sculpté de la collection de M. Ph. Burty.)

76. "Statuette de bonze, par Hissatama Oukou-
sou," from: L. Gonse, *L'Art japonais*, Paris
1883, p. 60.

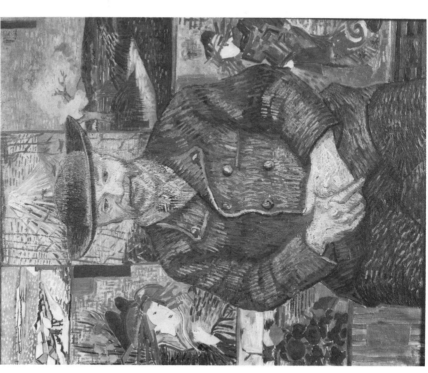

75. V. van Gogh, *Portrait of Tanguy*, 1887, Musée Rodin, Paris.

77. V. van Gogh, *Album of drawings*, sketch in letter 492, Rijksmuseum Vincent van Gogh (Vincent van Gogh Foundation), Amsterdam.

78. *Shinsen kachō no kei* (Glimpses of newly selected flowers and birds), Rijksmuseum Vincent van Gogh (Vincent van Gogh Foundation), Amsterdam.

79. V. van Gogh, *Portrait of a mousmé*, 1888, National Gallery of Art, Washington.

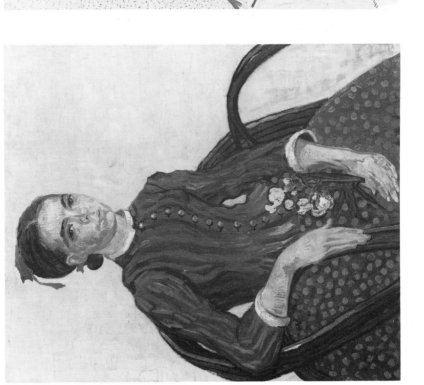

80. V. van Gogh, *Portrait of a mousmé*, 1888, Thomas Gibson Fine Art, Ltd., London.

81. Rossi, *Madame Chrysanthème*, illustration to P. Loti, *Madame Chrysanthème*, Paris 1888.

82. Christian Mourier-Petersen, *Young woman from Arles*, 1888, Hirschsprung Collection, Copenhagen.

83. *Cicadas*, illustration to P. Loti, *Madame Chrysanthème*, Paris 1888.

84. V. van Gogh, *Sketch of three cicadas*, sketch included in letter 603, 1889, Rijksmuseum Vincent van Gogh (Vincent van Gogh Foundation), Amsterdam.

85. Rossi, *Monsieur Sucre*, illustration to P. Loti, *Madame Chrysan-thème*, Paris 1888.

86. Myrbach, *Funeral procession*, illustration to P. Loti, *Madame Chrysanthème*, Paris 1888.

87. Paul Gauguin, *Self-portrait*, *"Les Misérables"*, 1888, Rijksmuseum Vincent van Gogh (Vincent van Gogh Foundation), Amsterdam.

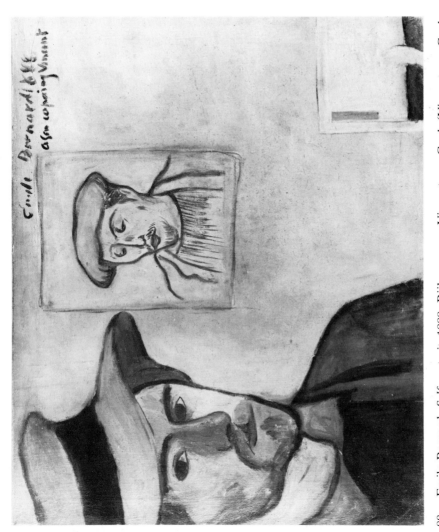

88. Emile Bernard, *Self-portrait*, 1888, Rijksmuseum Vincent van Gogh (Vincent van Gogh Foundation), Amsterdam.

89. Friedrich Overbeck, *Portrait of Franz Pforr*, 1810, Staatliche Museum Preußischer
Kulturbesitz, Berlin.

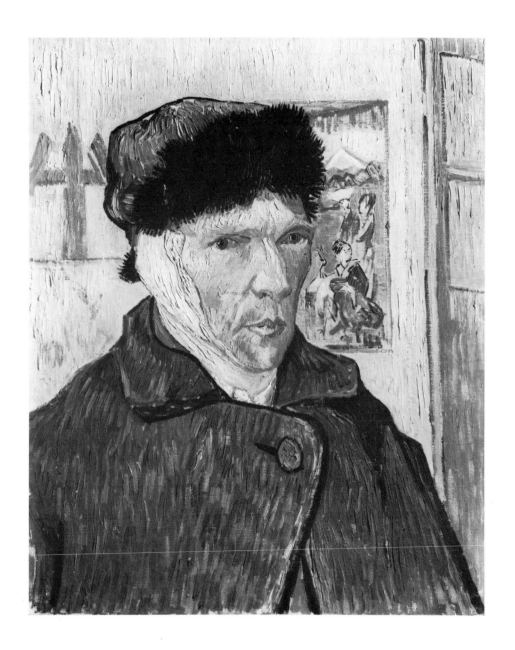

90. V. van Gogh, *Self-portrait with a Japanese print*, 1889, Courtauld Institute
Galleries, London.

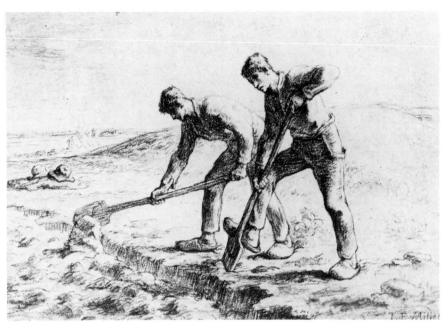

91. Jean-François Millet, *Peasants digging*, photograph from the collection of Vincent van Gogh, Rijksmuseum Vincent van Gogh (Vincent van Gogh Foundation), Amsterdam.

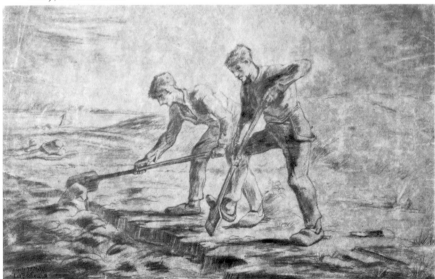

92. V. van Gogh, *Peasants digging* (after Millet), 1880, Rijksmuseum Kröller-Müller, Otterlo.

In ſudore vultus tui veſceris pane
tuo.

GENE. I

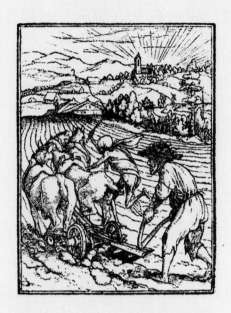

A la ſueur de ton uiſaige
Tu gaigneras ta pauure uie.
Apres long trauail,& uſaige,
Voicy la Mort qui te conuie.
G iij

93. H. Holbein, *The plowman and death*, from:
 Les simulachres et historiées faces de la mort,
 Lyon 1538.

LA VIE RUSTIQUE.

deux ne creuse plus avant et ne murmure le moindre cri de révolte. Cette résignation de l'homme courbé vers la glèbe date de loin. On la retrouve dans les *Moissonneurs* de Théocrite, dans le *Moretum* de Virgile. Elle est gravée sur les figures hâves et gravement mélancoliques de ces paysans qui vident silencieusement leur verre, dans le beau tableau de Lenain, qui est au musée Lacaze. Partout et à tous les âges, le laboureur semble ruminer tristement et d'un air convaincu la dure parole de l'Écriture : « Tu gagneras ton pain à la sueur de ton front. »

94. Léon Lhermitte, title page of André Theuriet, *La vie rustique*, Paris 1888.

95. Léon Lhermitte, *Plow*, illustration to André Theuriet, *La vie rustique*, Paris 1888.

JULES BRETON

LES CHAMPS

ET

LA MER

PARIS

ALPHONSE LEMERRE, ÉDITEUR

31, PASSAGE CHOISEUL, 31

M DCCC LXXV

96. Device of the publisher Alphonse Lemerre (Title page of Jules Breton, *Les champs et la mer*, Paris 1875.)

XIX. OP HET PLOEGEN, MISSEN, EN SPITTEN IN D'AERDE.

97. J.W. Kaiser, *Op het ploegen, missen, en spitten in d'aerde*, emblem from: Jacob Cats, *Alle de wercken van Jacob Cats, bezorgd door Dr. J. van Vloten...*, Zwolle 1862.

98. Device of the publisher Jacques Braat, from: *Marques typographiques des imprimeurs et librairies...*, Ghent 1894.

99. V. van Gogh, *Orchard in blossom with poplars*, 1889, Neue Pinakothek, Munich.

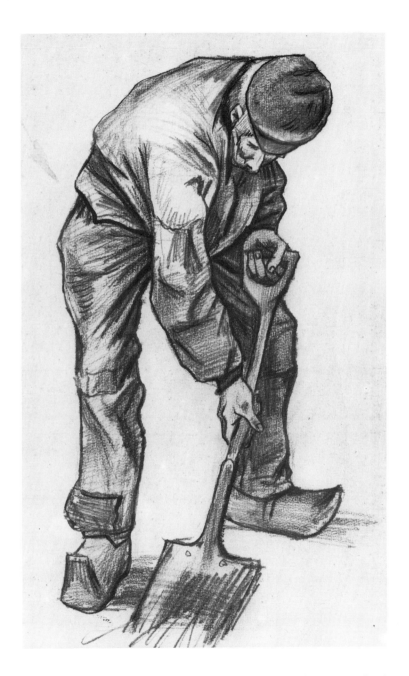

100. V. van Gogh, *Man digging*, 1882, Rijksmuseum Vincent van Gogh
 (Vincent van Gogh Foundation), Amsterdam.

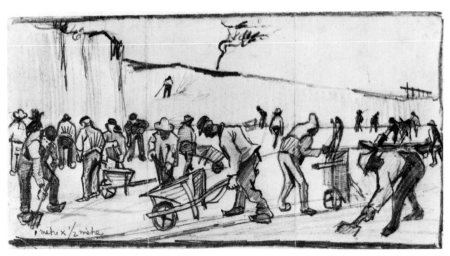

101. V. van Gogh, *Sand-diggers in the Dekkersduin near The Hague*, 1883, sketch in
letter 288, Rijksmuseum Vincent van Gogh (Vincent van Gogh Foundation),
Amsterdam.

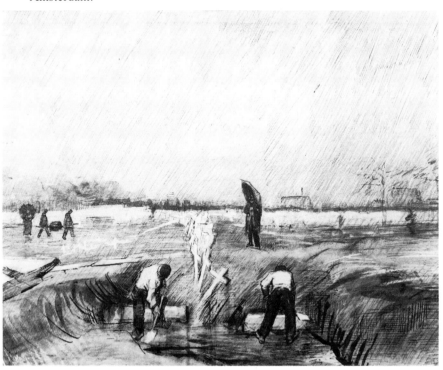

102. V. van Gogh, *Churchyard in the rain*, 1886, Kröller-Müller, Otterlo.

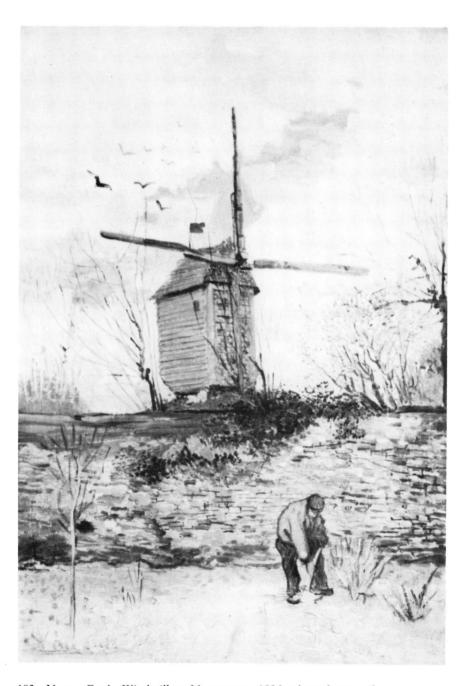

103. V. van Gogh, *Windmill on Montmartre*, 1886, whereabouts unknown.

104. V. van Gogh, *Man digging*, 1882, Rijksmuseum Vincent van Gogh
(Vincent van Gogh Foundation), Amsterdam.

105. V. van Gogh, *Peat-cutters in the dunes*, 1883, whereabouts unknown.

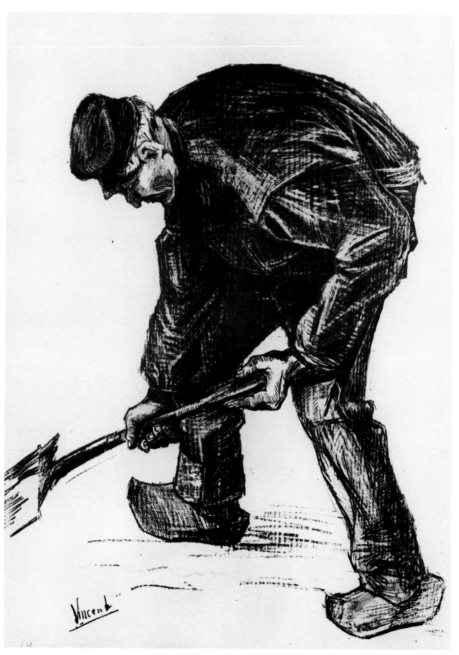

106. V. van Gogh, *Man digging*, 1882, Rijksmuseum Vincent van Gogh (Vincent van Gogh Foundation), Amsterdam.

107. V. van Gogh, *Garden in the snow*, sketch in letter 276, Rijksmuseum Vincent van Gogh (Vincent van Gogh Foundation), Amsterdam.

108. V. van Gogh, *Study with diggers*, 1890, Rijksmuseum Vincent van Gogh (Vincent van Gogh Foundation), Amsterdam.

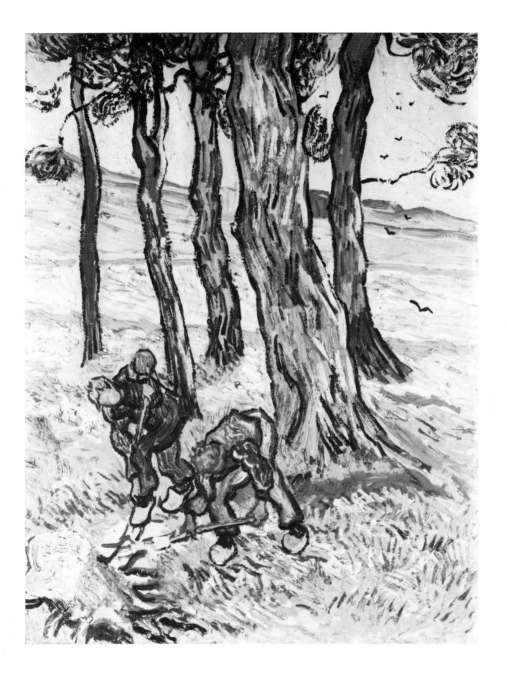

109. V. van Gogh, *Two diggers among trees*, 1890 (redated), The Detroit Institute of
Arts (Bequest of Robert H. Tannahill), Detroit.

110. V. van Gogh, *Peasants digging* (after Millet), 1889, Rijksmuseum Vincent van Gogh (Vincent van Gogh Foundation), Amsterdam.

111. J.E. Dantan, *Le Paradou (La faute de l'abbé Mouret)*, reproduction from *Catalogue illustré de Salon*, Paris & London 1883, p.66.

112. J.-D.Caucaunier, *La faute de l'abbé Mouret*, reproduction from *Catalogue illustré de Salon*, Paris & London 1889, p.189.

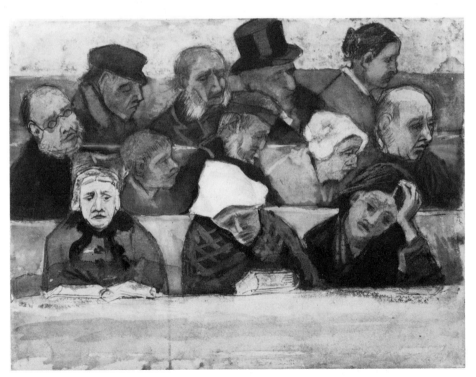

113. V. van Gogh, *In the church*, 1882, Rijksmuseum Kröller-Müller, Otterlo.

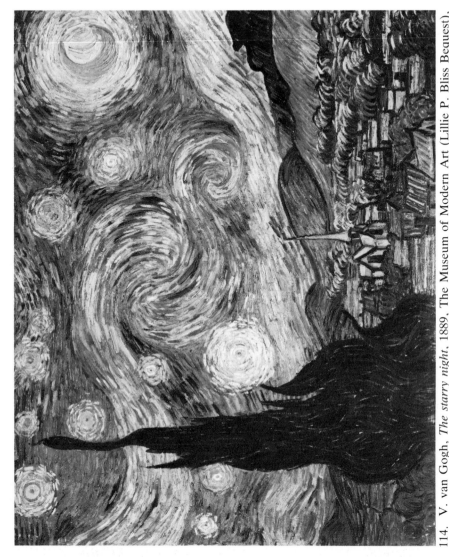

114. V. van Gogh, *The starry night*, 1889, The Museum of Modern Art (Lillie P. Bliss Bequest), New York.

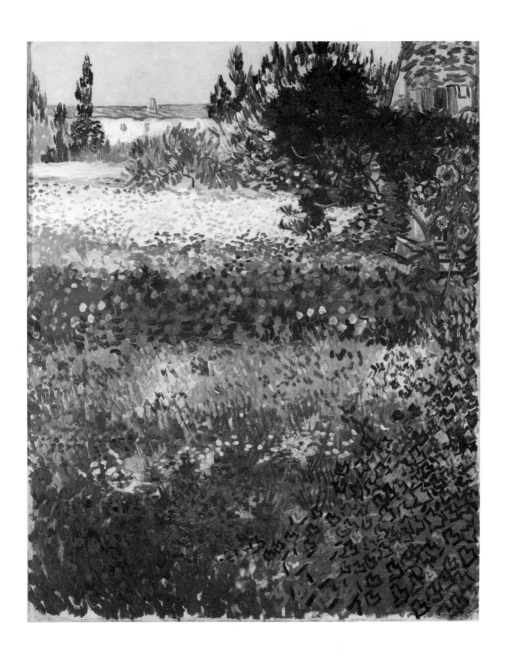

115. V. van Gogh, *Flowering garden*, 1888, private collection, New York.

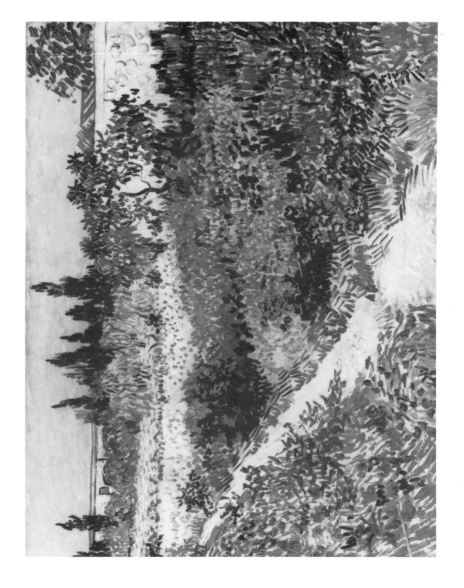

116. V. van Gogh, *Flowering garden*, 1888, Haags Gemeentemuseum, The Hague.

117. A.C. Adler, from: *De Spiegel*, (1906) p.411.

118. M.J. Misset, *Zionskapel*, 1911, Gemeentearchief (Historisch Topografische Atlas), Amsterdam.

119. M.J. Misset, *Zionskapel*, 1911, Gemeentearchief (Historisch Topografische Atlas), Amsterdam.

Photographic acknowledgements

Gemeentearchief, Amsterdam: 117, 118, 119
Rijksmuseum, Amsterdam: 28
Rijksmuseum Vincent van Gogh, Amsterdam: 4, 13, 24, 26, 30, 33, 34, 35, 36, 37, 43, 44, 45, 50, 52, 54, 55, 62, 64, 65, 65a, 68, 69, 70, 72, 73, 77, 78, 84, 87, 88, 91, 100, 101, 104, 106, 107, 108, 110
Universiteitsbibliotheek, Universiteit van Amsterdam, Amsterdam: 2, 3, 6, 7, 8, 9, 11, 46, 47, 48, 51, 61, 93, 97, 98
Staatliche Museum Preußischer Kulturbesitz (photograph: Jörg P. Anders), Berlin: 89
Fogg Art Museum, Cambridge, Massachusetts: 74, 74a
Hirschsprung Collection, Copenhagen: 82
Detroit Institute of Arts, Detroit: 109
Teylers Museum, Haarlem: 14, 66, 67
Haags Gemeentemuseum, The Hague: 116
Nederlands Letterkundig Museum, The Hague: 1, 5, 15
Rijksbureau voor Kunsthistorische Documentatie, The Hague: 42, 105
Hiroshima Museum of Art, Hiroshima: 59
Archive Photographique, Musée de la vie Wallone, Liège, Belgium: 21
Courtauld Institute Galleries, London: 90
Thomas Gibson Fine Art Ltd., London: 80
Bayerische Staatsgemäldesammlungen, Munich: 99
Metropolitan Museum of Art, New York: 71
Museum of Modern Art, New York: 114
Rijksmuseum Kröller-Müller, Otterlo: 19, 22, 25, 31, 49, 92, 102, 113
Réunion des musées nationaux, Paris: 58

Musée Rodin (photograph: Adelys), Paris: 75
Museum Boymans-van Beuningen, Rotterdam: 23
National Gallery of Art, Washington: 79
Kunstmuseum, Winterthur: 57
Sammlung Oskar Reinhart "Am Römerholz", Winterthur: 56
Sammlung E.G. Bührle, Zürich: 60

Index

In the OCULI series (Editors: Rob Ruurs and Bert W. Meijer) the following titles have been published:

1. RUURS, Rob: *Saenredam: The Art of Perspective.* Amsterdam/Groningen, 1987.
2. FALKENBURG, Reindert L.: *Joachim Patinir: Landscape as an Image of the Pilgrimage of Life.* Amsterdam/Philadelphia, 1988.
3. KŌDERA, Tsukasa: *Vincent van Gogh. Christianity versus Nature.* Amsterdam/Philadelphia, 1990.